Catalog

Catalog

An Illustrated History of
Mail-Order Shopping

Robin Cherry

Princeton Architectural Press
New York

Published by
Princeton Architectural Press
37 East Seventh Street
New York, New York 10003

For a free catalog of books, call 1-800-722-6657.
Visit our website at www.papress.com.

Editor: Lauren Nelson Packard
Designer: Arnoud Verhaeghe

Photo Credits:
Smithsonian: Warshaw, Baby Warshaw and
Holton Collections, Archives Center, National
Museum of American History, Smithsonian
Institution
Pages 19, 48,58,66,67, 84, 86, 116, 134, 135, 138–
41, 194, 215, 256,258–9,260–61

JC Penney: JC Penney Archives Collection at
DeGolyer Library, Southern Methodist University
Pages 59, 62, 64, 65, 73
Page 106 © 2008 Eddie Bauer, Inc. Used by
permission.

Sears Archives
Pages 19–22, 40–46, 51–47, 60-63, 83,85, 87–103,
108-113, 118–128, 130–131, 133, 168–69, 192–3,
195,197–98, 201, 214, 216, 222–3, 236–44,246–47,
256, 265

Trixie+Peanut
Pages 150–51

Neiman Marcus
Page 68-71, 74–75, 97, 107, 133, 142–43, 149, 152,
154–63, 170–72, 174–87, 202,205, 207, 224–5,
228–9, 248–9, 256, 262, 264, 266–9

Williams Sonoma
Pages 28, 29, 133

Special thanks to: Nettie Aljian, Sara Bader,
Dorothy Ball, Nicola Bednarek, Janet Behning,
Becca Casbon, Carina Cha, Penny (Yuen Pik) Chu,
Russell Fernandez, Pete Fitzpatrick, Jan Haux,
Clare Jacobson, Aileen Kwun, Nancy Eklund
Later, Linda Lee, Laurie Manfra, Katharine Myers,
Jennifer Thompson, Paul Wagner, Joseph Weston,
and Deb Wood of Princeton Architectural Press—
Kevin C. Lippert, publisher

Library of Congress Cataloging-in-Publication
Data

Cherry, Robin.
 Catalog : an illustrated history of mail order
shopping / Robin Cherry.—1st ed.
 p. cm.
 ISBN 978-1-56898-739-2 (alk. paper)
 1. Mail-order business—United States—History.
I. Title.
 HF5466.C45 2008
 381'.1420973—dc22
 2008022501

Contents

Acknowledgments

This book is dedicated to the memory of my father, who sent me boxes of mail order catalogs when I was in college, never imagining where it would lead. I miss you, Dad.

Thanks to Abigail Koons, my agent, who said she was looking for "quirky non fiction" and agreed to take on a first-time author and Lauren Nelson Packard, my editor at Princeton Architectural Press, who succeeded in tackling what my mother calls "my congenital problem with punctuation."

I couldn't have pulled together the images for this book without the help of a number of archivists and contacts from museums and companies around the country. I'm especially indebted to Arlene May at the Sears Archive, Susan B. Fine and Kay Peterson at the Smithsonian Museum of American History archives, Joan Gosnell at the JC Penney archives at Southern Methodist University, and Ginger Reeder at Neiman Marcus. I'm also thrilled that Virginia Herz of The Robert May Estate let me use the original image of Rudolph-the-Red-Nosed Reindeer.

Last but not least, I owe a special thanks to my mother for making it possible for me to take the time to research and write this book and for constantly saying, "I can't wait to see it." Here it is.

"By your eyebrow pencils, your encyclopedia, and your alarm clocks shall you be known."

—Sinclair Lewis, in his foreword to David L. Cohn's 1940 book, *The Good Old Days: A History of American Morals and Manners as Seen Through the Sears Roebuck Catalogs*

Introduction

Everyone remembers his or her favorite catalog, from the Sears Christmas Wish Book to the J. Peterman Owner's Manual. Edward R. Murrow and Walter Cronkite even called Stanley Marcus each year to find out the latest "His and Hers" gift in the Neiman Marcus Christmas Book. Gift items ranged from mink riding chaps and million dollar jewels to "His and Hers" windmills, dinosaurs, hot air balloons, and submarines. Mail order catalogs show how we lived—even if we did so in space-dyed Orlon pullovers and knee-high polyurethane boot socks from the Sears Catalog of 1971. They reveal how we dressed, decorated our houses, worked, played, and got around. They show how prices have escalated and how both language and graphic design have evolved. They reflect our economic, political, and cultural times, and they show how our ideals of beauty have changed over time.

The history of mail order starts in 1872 when traveling salesman Aaron Montgomery Ward realized he could offer his rural customers better prices by eliminating the middleman and selling goods to his customers directly. Former railway agent Richard Sears started his company in 1886, beginning one of the greatest rivalries in American business. Ward and Sears were followed by catalogs selling everything from food and flowers to medieval weapons and mummy tombs through the mail.

A number of advances in industry made the dramatic growth of mail order possible: rural free delivery, started in 1896, delivered mail and catalogs directly to the houses of rural residents (who previously had to travel long distances to their post offices to collect their mail); the expansion of the railroad lowered the cost of transportation; refrigerated railroad cars made it possible to deliver perishable goods across the country; and standardized clothing sizes—developed during the Civil War for soldiers' uniforms—made it viable to sell clothing through the mail. Finally, technological advances in production made it feasible to mass produce items in the quantities required for national distribution.

CHRONOLOGY

1865–1890

Immigration, industrialization, and rising prosperity characterized the years following the Civil War. Bicycles were at the peak of their popularity and young women found new freedom thanks to the invention of women's bicycles and the social acceptance of bloomers. Consistent with growing prosperity, voluptuous women were prized. Children's dress demonstrated the social status of their parents. Clothing was formal, ornate, and restrictive.

1890–1914

Frivolity characterized the Gay Nineties and the Belle Époque (1895–1914), but the specter of war signaled the end of an era. The growing popularity of the car required "traveling clothes." The Gibson Girl, with her high collared blouse, long flowing hair, and impossibly small waist, was the feminine ideal. To achieve this ideal, Sears encouraged "fat folks" to take Dr. Rose's Obesity Powders. Parcel Post, which delivered packages directly to people's homes, was introduced in 1913.

1914–1920

Men went off to fight and women were left at home to run the factories. They gladly gave up their corsets to save metal for the war; the amount of metal salvaged from corset straps was enough to build two warships. Hemlines shortened to conserve fabric. Lillian Gish was the feminine ideal.

1920–1930

The Roaring Twenties were a heady postwar cocktail of jazz, speakeasies, and flapper dresses. Ladies had slimmer silhouettes thanks to wartime rationing and the right to vote thanks to the passage of the Nineteenth Amendment. People had time for leisure and self-improvement; athletic activities became more popular. Book-of-the-Month Club, founded in 1926, advertised that reading the monthly selections would make a person more "attractively interactive" and therefore better able to handle social situations. The adult bicycle became passé thanks to the popularity of the automobile; both Sears and Montgomery Ward introduced children's bicycles in 1920. Prompted by urbanization and the popularity of the automobile, Sears opened its first retail store in 1925. Louise Brooks was the feminine ideal.

1930–1950

The twenties culminated in the Great Depression and the period leading up to WWII. FDR, president from 1933–1945, encouraged America to stay optimistic. The fall 1930 Sears catalog proclaimed that "thrift is the spirit of the day. Reckless spending is a thing of the past." Fashion became much more conservative and austere until well after the end of WWII. As men went off to war and women returned to the factories, Rosie the Riveter, in her overalls and scarf,

represented the generation's female icon. Escapist entertainment was popular; both *The Wizard of Oz* and *Gone with the Wind* were released in 1939. Judy Garland dolls and Scarlett-inspired fashions appeared in the following year's catalogs. Western Wear, with its clearly delineated images of good and evil, was especially popular during these times of unrest. In 1943, to support the war effort, Sears printed a full-page listing of merchandise not available in the catalog. Items included aluminum cookware, copper teakettles, lawnmowers, plows, plywood, and children's cowboy boots. All scrap metal was recycled and children did their part by saving foil candy wrappers. Television sets made their first catalog appearance in 1949.

1950–1965

The fifties were an aggressively positive decade. Eisenhower, a war hero, was elected president in 1953. The world seemed to stabilize in the aftermath of war, though the fear of communism spurred McCarthyism and the second Red scare. The nuclear family (mother, father, 1.54 children) was glorified in advertising and film. Doris Day was the feminine ideal. Book-of-the-Month Club sold over one hundred million books. Although the introduction of the birth control pill in 1960 led to a relaxation in social attitudes, the revolutionary lifestyle and dress of the sixties didn't really begin until the middle of the decade. The early sixties were more Jackie Kennedy than Woodstock.

1966–1979

The teenagers of the fifties turned into the young hippies of the late sixties and seventies. The Civil Rights Act was passed in 1964. The legendary concert at Woodstock took place in 1969. The space race between the United States and U.S.S.R. was featured on

children's toys and pajamas. Mattel introduced Major Matt Mason, Man in Space, in 1967. Neil Armstrong landed on the moon in 1969. Mission accomplished, Matt Mason was discontinued in 1970.

The seventies found Americans trying to come to terms with the Vietnam War, women's lib, and the energy crisis. Microwave ovens and the early videogame (PONG) were introduced. New catalogs started to appear. The Horchow Collection was founded in 1971. Banana Republic was founded in 1978. With antiwar sentiment running high, boy's action figures engaged in sports and outdoor activities rather than the military. The energy crisis caused a dramatic spike in the popularity of bikes and mopeds. The moped, long popular in Europe, hadn't made inroads in America because the Department of Transportation lumped it in with motorcycles. Frenchman Serge Seguin, who convinced Motobecane that the American market was ripe for the moped, got the National Highway Traffic Safety Administration to change the classification and forty-eight out of fifty states to accept mopeds. By 1977, over 250,000 Americans owned the half-bicycle/half-motorcycle.

1980–1989

After the humiliation of the Iran hostage crisis, President Reagan declared it was "morning again in America." Americans were optimistic and ostentatious. This was the decade of power dressing, yuppies, *Dallas*, and *Dynasty*. Functional and formal clothing prevailed. The female ideal was a big-shouldered toss-up between *Dynasty*'s Alexis Carrington (Joan Collins) and Krystle Carrington (Linda Evans); *Wall Street*'s Gordon Gekko (Michael Douglas) was the eighties male icon. Youth culture, so dominant over the past two decades, lost its influence. Cabbage Patch Kids were all the rage,

gracing Montgomery Ward's 1984 Christmas catalog and the cover of *Newsweek*. Growth in shopping malls was unprecedented; more than 16,000 were built between 1980 and 1990. Unable to keep up, Montgomery Ward discontinued its catalog in 1985.

1990–1999

The United States won the first Gulf War and the Soviet Union collapsed. The dot-com boom of the late nineties churned out young millionaires overnight; business casual was the order of the day and youth culture returned with a vengeance. The stock market went wild; the Dow Jones Industrial Average rocketed from 3,000 to 11,000. The old way of doing things was under attack. Both malls and catalogs were threatened because the internet made online shopping easier than ever. A July 1998 *TIME* magazine advised readers to "Kiss Your Mall Good-Bye: Online Shopping is Cheaper, Quicker, Better." Sears folded its Big Book catalog in 1993 though it continued to mail specialty catalogs.

2000–present

The spread of the internet changed the economics of catalogs. Even a catalog that can't afford paper and postage can survive on-line. Niche catalogs flourish. However, the burst of the dot-com bubble, showed that, for most companies, on-line was another channel, not a replacement. People still like to lie on their sofa and shop. When the holidays approach, everyone's mailbox continues to overflow with mail-order catalogs. In 2007, Sears brought back the Wish Book and mailed its first Christmas catalog in thirteen years.

DESIGN, COPY, AND TYPOGRAPHY

Over time, catalog design evolved from a simple listing of items to an illustrated omnibus listing, with dozens, if not hundreds, of items on every page. As the catalogs matured, however, they evolved from visibly pushy to persuasive in both tone and design. Richard Sears was known for his particularly fanciful advertising copy. Sears is said to have written all six hundred pages of the early catalogs. Eventually, even Sears had to tone down the hyperbole and rely more on facts to sell products. Without salespeople to close the deal, catalogs' reputations lived and died based on accurately representing the quality of their merchandise. As John Wanamaker said on the occasion of the Philadelphia department store's fiftieth anniversary, "Don't impose on poor dumb merchandise responsibilities that it cannot bear."

At the end of the 1800s, catalog design was influenced by the Victorian fashion for ornate, elaborate typefaces, flamboyantly decorated with curlicues and filigrees. Throughout the early 1900s, catalogs used primarily serif fonts. The advent of Art Deco in the twenties introduced more geometric, sans serif fonts, which were used to convey progress and modernity. Since sans serif fonts are harder to read, they were used primarily for headlines, and serif fonts are still used for the body copy. Sans serif type remained fashionable throughout the thirties and forties. Seen as type that eliminated nonessentials, it suited the thrift and scarcity of the period.

Type from the fifties was clean, fresh, and optimistic, and was complemented with a liberal use of color. In the late fifties, a new wave of graphic designers, like Milton Glaser and Seymour Chwast, developed exciting new fonts. These bold new types, known as eclectic modern and psychedelia, were ideal for introducing innovations like the microwave oven and videogames. Catalog typography in the sixties and seventies was innovative and exuberant.

The 1984 introduction of the Macintosh computer changed graphic design forever. The touchstone for digital typography was *Emigré* magazine, founded by graphic designer Rudy VanderLans and typographer Zuzana Licko. Inspired by the Mac's bitmapped fonts that were used for low-resolution dot matrix printers, VanderLans and Licko led graphic design into the digital realm. While some praise the duo for courage and innovation, others called their Mac-generated typefaces ugly and lacking in depth. At the close of the twentieth century, catalog type was clean, though increasingly sterile, and catalogs were no longer at the vanguard of graphic design. The Montgomery Ward and Sears catalogs were gone.

Celebrities from radio, television, movies, and sports have always appeared in and influenced catalogs. In the thirties, one-third of all dolls sold were Shirley Temple dolls. There were Judy Garland dolls, Lone Ranger costumes, Joan Crawford hats, and clothing lines from Arnold Palmer, Stephanie Powers, and Cheryl Tiegs. In the eighties, tennis star Yvonne Goolagong modeled sportswear and Sears offered Dorothy Hamill exercise equipment. Dolls included the Flying Nun, I Dream of Jeannie, and Broadway Joe Namath and his Mod-About-Town Wardrobe.

Catalogs also served a number of ancillary purposes over the years. Little girls used them to make paper dolls. In fact, two eleven-year-old girls made the following request to Sears: "Please put feet on your ladies in your catalog so they will make nicer paper dolls. Please don't put the prices on their legs." Teachers used catalogs to teach reading, while homemakers decorated the walls with them. They helped immigrants assimilate to their new country by giving

them exposure to American fashions and household goods and making them available at a reasonable cost. And they were used for bathroom reading and, in extreme cases, as toilet paper; when Sears introduced glossy paper in the thirties, they received numerous letters of complaint. In Canada, boys sometimes strapped a catalog to each shin to make goalie pads for hockey.

Mail order has also attracted the attention of criminal minds. In 1989, over $1 million in fraudulent mail-order purchases were made by New Jersey inmates. The racket was discovered when an inmate was seen sporting a watch from Tiffany—no word on whether the blue box gave him away.

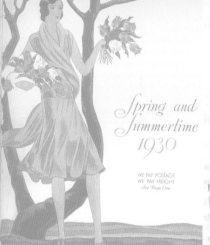
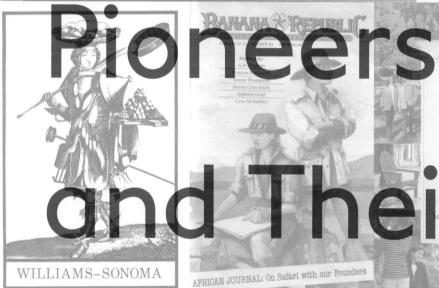

The Pioneers and Their Successors

1

The Pioneers and Their Successors

Montgomery Ward started it all, followed shortly thereafter by Richard Sears, thus beginning the most famous rivalry in American business. These two generalists were followed by specialty catalogers like Neiman Marcus, Frederick's of Hollywood, Lillian Vernon, and many more.

Montgomery Ward

When former store clerk and traveling salesman Aaron Montgomery Ward started the world's first mail-order business in 1872, there were approximately 38 million people living in the United States, 74 percent of whom lived in rural areas. (Today, the United States population is closer to 294 million; 25 percent live in rural areas.)

People had little choice but to buy what they needed from the local general store. And the general store, as both a monopoly and the middleman between wholesaler and customer, could, and often did, gouge its customers. General stores were also limited in what they could stock. Ward thought he could offer better prices and selection

to rural Americans by selling goods directly to them through the mail, thus eliminating the middleman. His first customers were the Patrons of Husbandry, better known as the Grange, a protest movement formed by farmers to fight high prices.

Ward's first catalog was a one-page listing of 162 items that included hoop skirts, grain bags, and a "very stylish" writing desk. From that single sheet, no one could have imagined mail order would grow into a $100 billion industry. By 1883, the Montgomery Ward catalog had 240 pages with some ten thousand items ranging from buggies and corsets to curios and cutlery. By the mid-twentieth century, the catalog was over one thousand pages long.

During the Depression, Ward's business suffered, and the board brought in tough, ornery businessman Sewell Avery to run the company. In 1944, Avery was ordered by the War Labor Board to renew a labor contract. An avowed opponent of both the government and the New Deal, he defied the orders of President Roosevelt and was the subject of a famous photograph of soldiers physically removing Avery from his office while still seated in his chair. A Ward executive suggested that they put the picture on the cover of the next catalog with the headline "We take orders from everybody."

Chicago's railroad tracks actually ran through Ward's warehouse, making it fast and inexpensive for Ward's to ship their merchandise. We have Ward's to thank for coining the phrase "Satisfaction Guaranteed or Your Money Back" as well as for Rudolph the Red-Nosed Reindeer, who was created by copywriter Robert L. May as part of a 1939 Christmas promotion. Rejected Rudolph names included Rollo (too breezy) and Reginald (too British). Gene Autry recorded the song, which went on to become the second-best-selling Christmas song of all time, after "White Christmas."

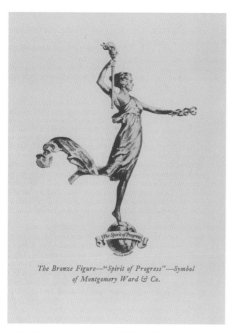

The Bronze Figure—"Spirit of Progress"—Symbol of Montgomery Ward & Co.

–1.1– This bronze statue stood in front of the administration building at Montgomery Ward.

In 1946, in recognition of its prominence in Americans' lives, the booklovers' society, the Grolier Club, chose the catalog as one of the one hundred most influential books in America. Ward's models that would go on to bigger and better things included Gregory Peck and Lauren Bacall in the forties; John Davidson, who modeled underwear, in the fifties; Ali MacGraw, who modeled a wedding dress, in the sixties; and Angelina Jolie, who modeled prom dresses, in the seventies.

In 1980, a disgruntled Ward's employee wrote "f*ck" on the picture of a bedroom wall over "Create your dream bedroom." It ran in eight million catalogs. In 1982, a printer was printing both Ward's spring/summer catalog and *Playboy* and either as a prank or an accident, someone inserted Miss March's centerfold into some of the catalogs. (It was inserted in the women's jeans section although Miss March was wearing nothing more than a tiny silver pendant.)

A catalog marketer purchased the Montgomery Ward trademark and relaunched it, primarily as an online merchant, in 2004. They held a contest for the best "Montgomery Ward Memory." The winner recounted that when she was four years old, her family's pastor stopped by, and her grandmother told her to "go and fetch that book I read so often and love so much." She returned with the Montgomery Ward catalog.

Sears Roebuck & Company

Sears entered the picture in 1886 when Richard Sears, a Minnesota railway agent, purchased a shipment of watches that had been refused by a jeweler and sold them to his fellow agents along his route. Pleased with his success, he started the R.W. Sears Watch Company. A few years later, Sears moved to Chicago and placed an ad: "WANTED: Watchmaker with reference who

–1.2–

can furnish tools." Alvah Roebuck answered the ad and Sears, Roebuck & Co. was born in 1892. They mailed their first catalog in 1893. What started as a mail order watch business expanded to include products from clothing to houses, and was once responsible for over one percent of the United States Gross National Product. Sears was so much a part of family life that when a little boy was asked by his Sunday school teacher where the Ten Commandments came from, he said, "from Sears."

Another of the most significant figures in the history of Sears was Julius Rosenwald, whose family company supplied menswear to Sears. Rosenwald joined the company in 1895 when Roebuck left and Sears needed additional financing. A meticulous businessman, he encouraged the company to diversify and helped increase sales dramatically. When Sears's poor health forced him to give up the presidency in 1908, Rosenwald took over. Although he would remain Chairman of the Board for the rest of his life, he gave up the presidency in 1922, so he could devote himself to philanthropy. He joined forces with Booker T. Washington, who persuaded him that the miserable state of African-American education was one of the most pressing social issues of the day. Rosenwald became a trustee of Washington's Tuskegee Institute and through his foundation funded the creation of over 5,000 schools in poor African-American communities. Rosenwald also helped to establish Chicago's Museum of Science and Industry.

Sears's shipping operation was so well organized that Henry Ford studied it before setting up his assembly line in Detroit. F.D.R. said the best way to convince Russians of the superiority of the American way of life over communism was to bomb Russia with Sears catalogs. Sears catalogs actually served a number of roles in international affairs. When Rosenwald accompanied the

–1.3–

–1.4–

20

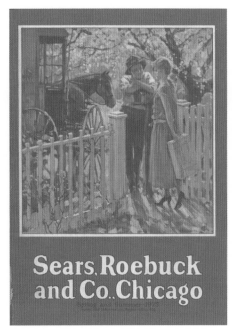

−1.5−

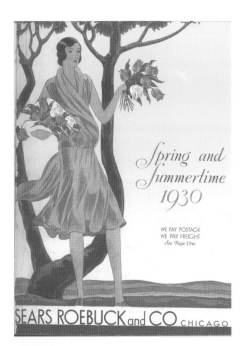

−1.6−

Secretary of War to France near the end of World War I, he boarded the boat with a small carry-on and four massive wooden boxes whose contents he didn't reveal. As he toured the American hospitals in France, the Secretary realized that Rosenwald had given out catalogs to the wounded soldiers. When asked why, Rosenwald said that he knew that most of the boys came from farms or small towns and that the catalog would remind them of their lives back home. "The catalog," he said, "helps our soldier boys to escape the miseries of war and live happily again, if only for a little while, amid the scenes of their childhood at home." All of the catalogs also offered gifts that people could send to their family members serving overseas—something they continue to this day.

In 1946, the United States government sent old catalogs from Montgomery Ward and Sears to some of its overseas offices to serve as a weapon of anti-Communist propaganda. In 1955, Sears's own foreign sales agent sent 3,500 copies of the fall/winter catalog to 255 overseas offices. Sears's contribution to the downfall of communism can't be determined, but it did have an impact on U.S.-Soviet relations. Russian diplomats read the catalogs to figure out what to wear when visiting the United States.

When NASA's first astronauts returned from space in 1970, NASA quarantined them to guard against the possibility that alien organisms, capable of destroying life on Earth, had invaded their bodies. To make the astronauts feel at home, NASA decorated their "Lunar Receiving Laboratory" with Early American furniture from Sears.

The 1897 Sears Catalog was reproduced in 1971 with an introduction by S. J. Perelman, who called it "a fairyland for kiddies from nine to ninety, a garden of wonders appealing to every taste." The publisher, Fred Israel, received an order for the book from the then U.S. ambassador to South

Vietnam on embassy stationery. Israel was stunned to notice that the stationery had a watermark with a turreted fortress with the word "Conqueror." In his response, Israel added the following postscript: "I noticed the watermark on your stationery, and I am wondering if it is apt." Bunker responded, on watermark-free stationery, that he had been unfamiliar with the watermark.

In 1971, following Jordan's expulsion of the Palestinians, West Bank refugees in the Jordan River Valley were sheltered in Ted Williams-branded tents from Sears. Unfortunately, the tents, designed for casual summer camping, were destroyed by violent sandstorms.

Sears offered everything one could need in life—and beyond. One woman sent back medicine she had ordered for her husband, because he had died before it arrived. Sears sent a letter of condolence accompanied by their "special tombstone catalog."

The Sears Catalog was selected as one of three hundred books in an exhibit called *America through American Eyes* shown at the Moscow Book Fair in 1981. Other titles included a book of Allen Ginsburg's poetry, Dr. Seuss's *The Butter Battle Book*, *The Fallacy of Star Wars* by The Union of Concerned Scientists, and Jane Fonda's *Workout Book*. Music Mountain, a chamber music series that has been held in Connecticut since 1931, is performed in a concert hall built by Sears in 1930. It is the only cultural institution the company ever built and is listed in the National Register of Historic Places.

The Sears catalog also played a significant role in the work of American artists and writers. In 1956, folk artist Elijah Pierce's wood carving *Obey God and Live (Vision of Heaven)* depicts his moment of religious conversion. It came when he reached for the Sears catalog instead of the Bible and was struck unconscious by what he perceived to be the hand of God. Southern novelist

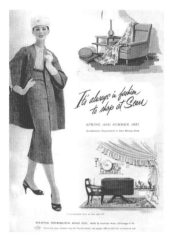

–1.7– Sears fashion, 1957

Harry Crews, the son of tenement farmers, said, "There were hardly any books where I grew up. I used to read the Sears catalog and imagine those people in it as characters." He recalls marveling at the "perfect people" who were in sharp contrast to those around him. In 1972, Pulitzer prize–winning American composer William Schuman wrote the "Mail Order Madrigals," setting to music a listing of pills and tonics for feminine conditions from the 1897 Sears catalogs. The four choral madrigals are titled "Attention, Ladies!," "Superfluous Hair," "Sweet Refreshing Sleep," and "Dr. Worden's Pills." In 1989, Lewis Nordan's collection of short stories, *The All-Girl Football Team*, included one in which a boy and his mother escape reality by creating a fantasy world based on characters from the Sears catalog.

Sears enlisted actor and noted art collector Vincent Price to make fine art available to the general public from 1962 to 1971. The American public was in good company: Price also served on Jackie Kennedy's White House Art Committee. His personally selected collection offered original works by

Rembrandt, Chagall, and Picasso, as well as lesser-known artists. Sears also convinced football and baseball greats Gale Sayers, Brian Griese, and Tom Seaver to appear in an ad for their "Twill-look Double-Knits made of 100 percent Fortrel polyester."

Hammacher Schlemmer

Opened as a hardware store in the Bowery in New York in 1848, Hammacher Schlemmer is credited with starting the oldest mail-order business though their first catalog wasn't published until 1881. In the early 1900s, there were no service stations, so the catalog offered a Motorist Touring Kit so drivers could fix the flat tires or blown gaskets on their new "horseless carriages." In 1916, in preparation for the Russian Revolution, a member of the Russian government's staff purchased a sample of every piece of hardware offered in the company's 1,000-page catalog to use as manufacturing masters. The store was even the subject of a song called "Hammacher Schlemmer, I Love You," which was sung by comedian Fred Allen in the 1929 Broadway production, *The Little Show*. Lyrics include: "Hammacher Schlemmer, I love you / Roebuck and Sears, I adore you / If you want to buy a bassinet or buy a hog / Don't be in a fog, use our catalogue / Hammacher Schlemmer / You're sweet and dear / Hammacher Schlemmer I repeat dear / Macy's and Gimbel's have plenty of thimbles / But I love you." The company continues to be known for being first to introduce a number of well-known products, which have included the pop-up toaster (1930), the electric shaver (1934), the steam iron (1948), the electric toothbrush (1955), the microwave oven and telephone answering machine (1968), Mr. Coffee's automatic coffee maker (1973), the cordless phone (1975), and the food processor (1976). They publish America's longest running catalog.

Orvis

Founded in 1856 as a fly-fishing outlet and mail-order concern, Orvis mailed a niche catalog to a small group of existing customers as early as 1861 (and lay claim to being the first mail-order catalog). Their primary business, however, was retail until 1965, when Leigh Perkins bought the company and turned it into a mail-order powerhouse offering products suitable for the "country lifestyle" of affluent sportsmen and women. Perkins usually had terrific instincts, though when he ignored the counsel of his colleagues and insisted that Orvis customers would buy scores of Lucite toilet seats inlaid with salmon-fishing flies, he was sorely mistaken.

J .C. Penney

The aptly named James Cash Penney founded a retail store to sell clothing and dry goods in Kemmerer, Wyoming, in 1902. The son of a Baptist minister and farmer, the ethically minded Penney called his first store The Golden Rule. By 1913, Penney had thirty-six stores and changed the store's name to J. C. Penney. Wal-Mart founder Sam Walton got his start working for Penney's. Penney didn't mail his first catalog until 1963, but it was a smashing success; sales topped $1 billion in 1979. Because Penney's studios were in New York, a number of celebrities-to-be got their starts in the catalog. Kim Basinger, Pam Dawber, Susan Dey, Whitney Houston, Ricky Schroder, Brooke Shields, Phoebe Cates, Matthew Fox, and Angelina Jolie were all Penney's models.

Caswell-Massey

America's oldest apothecary, founded in 1752, issued their first catalog in 1904. The company took an extended break from mail

order but came back with a new catalog in 1963. Their Number Six cologne was George Washington's favorite; he gave it to the Marquis de Lafayette to thank him for his help during the Revolutionary War. Before the Battle of Little Bighorn, General Custer brushed his teeth with a Caswell-Massey toothbrush; it was found at his "last stand." And their almond cold cream was a favorite of President and Mrs. Eisenhower who ordered some for the White House after his election.

National Bellas Hess

Founded as National Cloak and Suit in 1888, the company was rechristened National Bellas Hess in 1910. Once one of the country's preeminent mail-order firms, the company shifted their focus away from mail order and went bankrupt in 1974. The company lives on in law school textbooks; in 1968, the Supreme Court ruled in favor of National Bellas Hess and against the state of Illinois, declaring that the state could only collect taxes from companies that had nexus (physical presence) there.

Spiegel

Founded as a home furnishings store in downtown Chicago in 1865, Spiegel went bankrupt in 1893. After they reorganized, they decided to offer everything on credit; their slogan was "We Trust the People." When they started their mail-order catalog in 1905, they were the first catalog to offer credit through the mail, adapting their slogan to "We Trust the People—Everywhere." Catalog sales reached $1 million by 1906. Spiegel introduced apparel in 1912 and in 1957 was the first catalog to send buyers to the Paris fashion shows. A number of mergers and acquisitions followed, including the purchase and subsequent spin-off of Eddie

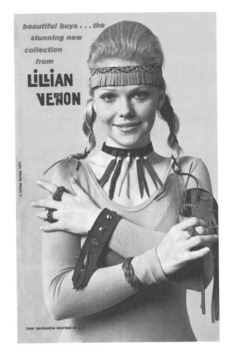

–1.8–

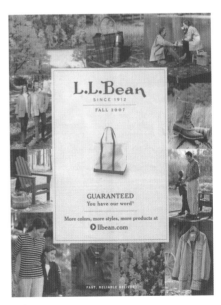

–1.9–

SCENTED
LAVENDER
WANDS

ORDER BY PHONE: 1-800-326-0500 11

−1.10− Caswell Massey, 2007

Bauer. Spiegel declared bankruptcy in 2003 and emerged from bankruptcy protection in 2005.

Aldens

Founded in 1899 as the Chicago Mail Order Millinery, the company dropped millinery from the name in 1906. The name was later changed to Aldens, after Henry and Jane Alden, the company's popular—and entirely functional—men's and women's fashion buyers. The company was an extremely successful mail-order business until it was acquired by a conglomerate that folded it in 1982.

Neiman Marcus

The great Dallas department store was founded in 1907, and their first catalog was mailed in 1926. The Neiman Marcus catalog really came into its own, however, when Stanley Marcus and his brother, Edward, created the "His and Hers" gift section for their annual Christmas Book. Inspired by journalists searching for holiday features, the gifts section is a tradition that the brothers' successors continue to this day.

The first "His and Hers" gift, a pair of Beechcraft airplanes costing $176,000, premiered in 1960. Other noteworthy items have included a Swarovski crystal-encrusted Mr. and Mrs. Potato Head ($8,000 each), a custom-fitted suit of armor ($20,000), and customized action figures made to look like the people who order them ($7,500). Modes of transport have always been a Neiman Marcus hallmark and have included an NM-Burberry London taxi ($589,000); a personal zeppelin ($10 million); and lots of submarines, jets, cars, and motorcycles. Models in the Christmas Book have included Lauren Hutton, Cindy Crawford, Heidi Klum, Morgan Fairchild, Cybill Shepherd, and Andie MacDowell. Before becoming her country's United Nations ambassador, Princess Elizabeth of Togo also modeled for the catalog. Artists Ludwig Bemelmans (of *Madeline* fame), Saul Steinberg (the renowned *New Yorker* artist best known for his cover depicting "A New Yorker's View of the World"), Pop artist Robert Indiana (who riffed on his famous LOVE image when he did an "NM68" cover for Neiman Marcus), and legendary artist Al Hirschfeld (known as "The Line King" for his pen and ink drawings of Broadway's stars) all designed covers. The celebrated store was also known to carry items that customers didn't even know they'd need. Marcus stocked a set of Steuben crystal plates with Mexico's crest "because sooner or later somebody will be going to call on the President of Mexico and need a proper gift." Texas-born Ike Eisenhower's wife, Mamie, ordered her inaugural gown from Neiman's.

Frederick's of Hollywood

When Frederick Mellinger suggested that his boss at the Lower East Side lingerie store in New York sell black lingerie in addition to white, he was fired. He joined the Army and noticed the racy Hollywood pinup posters around the barracks. He talked with his fellow soldiers, who confirmed his instinct: men would be delighted if women switched from white underwear to something a little sexier. Returning from Europe after World War II, he started Frederick's of Hollywood in 1946 to sell sophisticated European-style lingerie to American women. Mellinger was responsible for many innovations in lingerie, including the push-up bra, the thong, and the water bra. He once hired a team of industrial designers from the Army Corps of Engineers to help with research and development. Pamela Anderson was a Frederick's model pre-*Baywatch*.

Lillian Vernon

Pregnant with her first child, Vernon started her multimillion-dollar business on her kitchen table with $2,000 of wedding money. In 1951, she placed a $495 ad for a personalized belt and purse; it brought in $32,000 in orders. Vernon wasn't her original last name; Hochberg was. She named the company by combining her first name with the town where she lived: Mt. Vernon, New York. When the company achieved success, she legally changed her name to match.

L.L. Bean

The famous outdoor equipment company was founded by Leon Leonwood Bean in 1912 to promote his newly invented Maine hunting shoe (a.k.a. the "Bean boot"). The company had an inauspicious beginning: Bean had to refund the money for ninety of the first one hundred boots sold when the soles separated from the tops. In 1951, Bean decided to keep the Freeport store open twenty-four hours a day and removed the locks from the doors. Today, L.L. Bean is the second biggest tourist attraction in Maine.

Lands' End

Founded in 1963 by sailing enthusiast Gary Comer, Lands' End was originally targeted at sailors and offered racing sailboat equipment, duffle bags, rain suits, and some sweaters. The first catalog was called the Lands' End Yachtsman's Equipment Guide, and it included a typo (the apostrophe was in the wrong place). Since Comer couldn't afford to reprint, he kept the mistake and continues to spell it the original way, much to the dismay of English teachers the world over. Lands' End was one of the first companies to use a "magalog," a catalog with photographs and articles interspersed with the merchandise.

Thompson Cigar

Founded in Key West in 1915, Thompson Cigar is the oldest mail-order cigar company in the U.S. The company still holds Postal Permit #1 for Tampa.

Burpee Seeds

The company was started in 1876 by an eighteen-year-old plant lover whose mother was willing to lend him $1,000 of "seed money." By 1915, Burpee was mailing one million catalogs a year.

Omaha Steaks

Founded in 1917 by J. J. Simon, a Latvian refugee, the company mailed its first catalog in 1963. When Simon's son bought a build-

ing called the Table Supply Co., he moved the Co. to the right and inserted the word "Meat." Thus, the company was known as the "Table Supply Meat Co." until 1966, when the name was changed to Omaha Steaks International. Today, it's the country's largest direct marketer of steaks and frozen foods.

Johnson Smith

During the twenties and thirties, Johnson Smith sold novelties and practical jokes that provided an escape from WWI and the Depression. The catalog still exists under the name Things You Never Knew Existed.

Jackson & Perkins

This mail-order rose business grew out of a display at the 1939 World's Fair in New York. Visitors purchased roses but asked if they could have them mailed home so they wouldn't have to carry them. When they told their friends, orders poured in from all over.

Abercrombie & Fitch

Founded as a retail store selling sporting goods in 1892, they mailed their first catalog in 1909. It was known as "the place" to buy hip flasks during Prohibition. The company outfitted many legendary outdoorsmen (and women) including Teddy Roosevelt, Charles Lindbergh, Amelia Earhart, and Ernest Hemingway (who is said to have purchased the gun he used to commit suicide from the company). Hollywood stars like Clark Gable, Greta Garbo, and Katharine Hepburn were also customers. When the company was acquired by The Limited in 1988, it was transformed into a sexy lifestyle brand and is now the controversial epitome of young cool. The company was spun off from The Limited in 1999. Photographer

WHAT IS A CAPITALIST?

The best definition of a capitalist I have heard lately comes from the fertile brain of my friend Bill Feather who writes and edits his own THE WILLIAM FEATHER MAGAZINE. Bill says:—

"At the bottom of the scale of human labor is the shiftless man of all work who demands payment for his labor at the end of each day. To the extent that capitalists are wage-earners, they are no exception in wanting their wages at regular intervals. BUT . . . the earmark of a capitalist is his willingness *to wait* for his earnings. The experienced capitalist figures in long periods . . . five, ten, twenty years. This takes nerve, patience, self-control. It is foolish to denounce the man who has schooled himself to wait. His willingness to sacrifice the present for the future is of benefit to us all. His price is moderate . . . six to ten per cent a year . . . so small in fact that it does not appeal at all to the imagination of 90% of human beings. . . ."

–1.11– Vermont Country Store

Bruce Weber, known for his racy and homoerotic images, shot the catalog photos from 1999 to 2003. Detractors accuse the company of using pornography to sell clothing to young people.

A&F has long been a fixture in popular culture. In the song "When the Idle Poor Become the Idle Rich" from 1947's *Finian's Rainbow*, the newly rich blend in "with clothes from Abercrombie-Fitch." Decades later, in *Buffy the Vampire Slayer*, a character observes that the aftermath of a frat house massacre "looks like someone murdered an Abercrombie & Fitch catalog."

Figi's

In 1944, federal cheese inspector John Figi decided to sell Wisconsin cheese through the mail. He sent out 1,500 postcards and received forty-three orders. Since he didn't have a car to get his cheese to the post office, he borrowed a red wagon and used it to deliver them.

The Vermont Country Store

Founded by Vrest Orton in 1945, Vermont Country Store's first catalog featured thirty-

six items on twelve pages. It was mailed to Orton's Christmas card list. Today, VCS specializes in the "practical and hard-to-find." "Hard-to-find" includes a skip down memory lane for "lost" candies and foods, as well as bygone beauty and household products. When he was starting out, Orton asked for and received the following advice from Mr. (L. L.) Bean: "Don't oversell your products. It's better for customers to open the package and have the item be better than you said it was."

Eddie Bauer

Originally a sporting goods retailer in Seattle, Bauer's first invention was a badminton birdie (the Bauer shuttlecock) that remains the sport's standard. After almost freezing to death, he invented a quilted, down-insulated jacket, The Skyliner. During World War II, the U.S. Army Air Corps ordered over 50,000 Bauer jackets. Their first catalog was mailed in 1945. In 1963, Eddie Bauer outfitted James Whittaker, the first American to summit Everest. In 1970, the company's focus shifted from sporting goods to casual wear. In 1971, it was acquired by General Mills, which sold it to Spiegel in 1988. When Spiegel declared bankruptcy in 2003, Eddie Bauer became a stand-alone company once again.

The Collin Street Bakery

Founded in Corsicana, Texas, by a baker who brought his recipe for fruitcake from Wiesbaden, Germany, in 1896, the bakery got into the mail-order business in 1914 when John Ringling's circus troupe, after tasting the cake, asked to have cakes sent to family and friends throughout Europe.

WILLIAMS-SONOMA

–1.12–

Williams-Sonoma

During a visit to Paris in 1953, building contractor Chuck Williams noticed the wonderful cooking equipment and decided to import sauté pans, stockpots, fish poachers, and French bakeware for American home cooks. He bought an old hardware store in Sonoma, California, and remodeled it to display his new merchandise. The timing was perfect. At just around this time, Julia Child took to the American airwaves and took housewives by storm. Stopping by the store, customer and copywriter Jackie Mallorca said to Williams, "You need a catalog and I can create one for you." After Williams consulted with his friend, mail-order guru Edward Marcus, he decided she was right. Williams mailed his first "catalog" (some black-and-white sheets in a #10 enve-

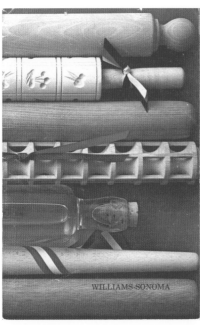

lope) in 1971. Items that Williams introduced to the United States included garlic presses, lemon zesters, ice-cream makers, Kitchen-Aid mixers, and balsamic vinegar. Today, his multibillion-dollar empire includes Williams-Sonoma, Pottery Barn, and West Elm.

The Horchow Collection

Neiman Marcus alumnus Roger Horchow founded his catalog in 1971 to sell luxury items from around the world. Horchow is credited with pioneering the use of the toll-free number for placing catalog orders. Neiman Marcus welcomed Horchow back into the fold when it acquired his company in 1988.

Bloomingdales

New York's first department store came late to the world of mail order, launching their first catalog in 1976 though the store had been around since 1872. But when their lingerie catalog, Sighs and Whispers, with sexy photographs by French *Vogue* photographer Guy Bourdin came out, it was a smash. Today, the original catalog fetches between $700 and $1,000 at auction.

Banana Republic

The company was founded in 1978 by Mel and Patricia Ziegler when Mel couldn't find a replacement for his beloved yet threadbare safari jacket. After locating one in a second-hand store in Sydney, Australia, the Zieglers started their own store to provide quality safari-esque attire. Their catalog was the first to combine wit and whimsy, with Mel, a former journalist, writing quirky copy and Patricia, an artist, drawing the sketches. J. Peterman called it his inspiration.

J.Crew

In 1983, the company started offering preppy clothing with a contemporary twist. While their clothes are bright and appealing, J.Crew's major contribution to mail order was to take the art of "color naming" to a new level. Today's colors range from Pebble, Dark Mineral, and Twig, to Chili Pepper, Espresso, and Cognac. The following recipes were developed using only J.Crew "colors" as ingredients:

Blend Soft Butter and Chili Pepper with Juicy Orange and Sour Lemon juices in a bowl. Add Shrimp to coat and grill. Transfer to plate. Drizzle with Honey Glaze and garnish with Lime Zest. Serve with salad of Ripe Avocado, Yellow Corn, and Roasted Peppers. For desert, top Strawberry Ice with Bright Guava and Fresh Tangerine; sprinkle with Toasted Almond and Raisin. Finish with a Light Latte.

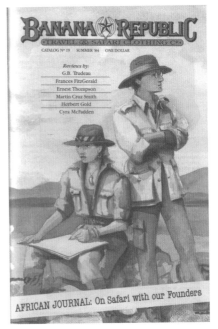

–1.15–

J. Peterman

Starting in 1987, John Peterman built a $75 million business from a western coat before becoming a pop-culture icon as Elaine's boss on *Seinfeld*. Peterman's entertaining prose revived the art of catalog copy: "As my boat sank into the Zambezi I watched my luggage float downstream over Victoria Falls. But the day wasn't a total loss." After expanding too rapidly into retail stores, the company was forced to declare bankruptcy in 1999. In early 2005, Peterman relaunched the catalog. Peterman ended up becoming good friends with actor John Hurley, who portrayed him on *Seinfeld*, and Hurley now sits on the board of the new company.

1.16

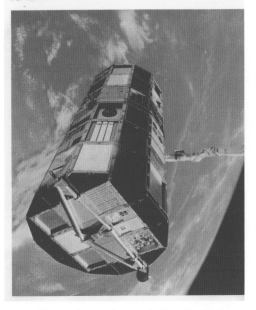

Park Seed

In 1984, Park Seed became the first catalog company to ship products to space when their tomato seeds were shipped on board the Challenger. The seeds were returned to Earth and when Park attempted to germinate them, they found that they germinated thirty percent faster than tomato seeds that had not flown in space. This tomato-seed experiment was turned into a worldwide student outreach program, which has distributed more than sixty thousand tomato seed kits.

–1.17– NASA's Long Duration Exposure Facility orbited Earth from 1984–1990, Park Seed.

Sundance Catalog

After Robert Redford founded Sundance Village, he opened a general store where visitors could purchase unique handcrafted Western items. The catalog was started in 1989 (with four employees working in the old village firehouse) to make those items available to a wider audience. Uncertain about the catalog's prospects, Redford said, "If for any reason this catalog should fail, I plan to change my name and move to Bolivia." Suffice it to say that Redford doesn't live in La Paz.

–1.18– Scientists check their payload, Park Seed.

Fashion
and
Beauty

2

Fashion and Beauty

Nothing documents the history of American fashion and beauty better than mail-order catalogs. They showed the sometimes questionable progress of clothing from corsets, bustles, men's (bibbed) fancy bosom shirts, and Clara Bow hats, through leisure suits, tunics, and bell bottoms, to more contemporary fashions like baby doll dresses and Uggs. Natural fabrics gave way to synthetics that sounded eerily like science projects (Orlon acrylic, Estron acetate, Avril viscose, and Fortrel polyester).

Fashions following the Civil War reflected the country's growth and increasing wealth. Women, in their tightly laced corsets and full skirts, were voluptuous and elegant. Children dressed like little adults. Young girls wore crinolines and petticoats. Young boys also wore dresses, while older boys often appeared in military-style uniforms.

The Gay Nineties and prewar Belle Époque reveled in clothing that was ostentatious and luxurious. Women wore wide-brimmed hats and tight corsets. The growing popularity of the automobile required "traveling clothes" to protect elegant fashions from the grime that was an inevitable part of open-air motoring. Both men and women wore long, loose-fitted coats that kept them clean and made it easy to get in and out of vehicles. The summer coats were called dusters because they shielded passengers from the dust kicked up on the unpaved roads. To protect their eyes, men wore goggles and ladies wore scarves. A glove compartment was added to hold driving gloves. To keep warm in the winter, lap robes were popular. Hemlines inched above the ankle.

During WWI, men went off to war and women took their places in the factory. They required clothing that was more tailored, relaxed, and utilitarian, and there was no turning back. WWI made the world safe for democracy and women's pants. The formality that had characterized fashion since the Victorian era was gone. An interest in sports and the outdoors led to a rise in sportswear.

The Roaring Twenties featured women in straight dresses with flat chests, short bobs, and cloche hats. The rising interest in athletic activities led to a further relaxing of daytime wear. Louise Brooks was the fashion icon. The twenties culminated in the Great Depression and the slow drift toward another war. In 1941, the War Production Board regulated all manufacturing. Neiman Marcus president Stanley Marcus, in his role as apparel consultant to the board, told designers it was their patriotic duty to make clothes that would remain fashionable for several seasons and use a minimum amount of fabric. Men's suits were sold without vests and trousers were sewn without pleats or cuffs. Marcus encouraged men to wear droopy socks so the rubber used to hold them up could be redirected to the war effort. Items that required a surplus of fabric like long skirts, full sleeves, wide belts, and patch pockets were prohibited. Hemlines rose to conserve fabric. According to Marcus, the board's restrictions "froze the fashion silhouette," effectively preventing the introduction of dramatically new styles

NEATNIKS MAKE GREAT PLAYMATES

Sears, children's apparel, 1969

that might have encouraged women to get rid of their existing clothes.

DuPont introduced nylon (then known as Fiber 66) in 1939 and caused a fashion revolution when "stronger than steel" and "run-proof" nylon stockings were introduced at the World's Fair and exhibited at the Golden Gate Exposition in San Francisco. At the DuPont pavilion, the chemist who invented nylon introduced Miss Chemistry, a long-legged beauty in nylon stockings who emerged from a giant test tube. Nylon was considered a miracle of modern science. In 1941, Neiman Marcus first offered nylon stockings for $2.95; silk stockings were $1.35. A prescient editorial read, "While our collections now are bounteous and you're sure to find the stockings you want for gifts, we cannot make promises for the future."

The love affair with nylon hosiery was cut short when the United States entered WWII and the War Production Board declared that nylon was to be strictly for military use. Nylon was used for items such as parachutes, tow ropes, and mosquito netting. Max Factor introduced a stocking cream to simulate stockings. Women would also draw lines down their legs to replicate stocking seams. In August 1945, eight days after Japan's surrender, DuPont announced it would resume production of nylon hosiery, and the following month, stockings went on sale at major department stores. Massive crowds showed up, but the stockings quickly sold out, and fights known as the "Nylon Riots" broke out. Angry mobs of women rioted outside department stores until March 1946 when the nation's hosiery supply caught up with demand.

Western-inspired clothing was popular during times of war; Sears offered Roy Rogers and Dale Evans Western Wear throughout the forties. The 1947 introduction of Christian Dior's New Look, with its soft curves and cinched waist, ushered in a new era of femininity in dress. Dior's couture clothing was democratized into the popular shirtdress.

When Frederick Mellinger returned from the war, women's underwear was white, utilitarian, and unflattering. Seeking to provide American women with the sensuous lingerie made popular by the WWII pinups, the former GI set up a shop called Mellinger's on Fifth Avenue in Manhattan. While he was beloved by Broadway showgirls, he thought he could do better on the West Coast, believing that Hollywood stars and wannabes would embrace his sexy attire. He moved to California in 1946 and opened the legendary Frederick's of Hollywood where he sold "California Originals Styled for the Stars" to American housewives who wanted to "please their man."

The fifties witnessed the rise of the "Career Woman," although she was only expected to stay in the workforce until a suitable husband was found. To that end, Frederick's of Hollywood introduced the padded bra and the first push-up bra, which it called "the rising sun." Thanks to the fine engineers at DuPont, acrylic and polyester (known by their nifty sobriquets, Orlon and Dacron) made irons less important. "Wash and Wear," a nonwrinkling cotton-polyester blend, was invented by Ruth Rogan Benerito, a scientist with the United States Department of Agriculture. Benerito figured out how to chemically treat the surface of cotton so that it would resist wrinkles, thus freeing housewives from hours of weekly ironing. Her process is credited with saving America's cotton industry, which had been losing sales to synthetic, nonwrinkling fabrics as well as to foreign imports. Benerito's patented process also led to the creation of stain- and flame-resistant cotton. Although society was swinging, fashion remained conservative until the mid-sixties. Jackie Kennedy was the fashion icon.

The late sixties and seventies were groovy and psychedelic. Colors were loud; patterns were louder. Miniskirts were all the rage (made possible by the invention of pantyhose), and pants were widely accepted for women. Catalogs offered a wide selection of athletic clothes, like track suits with matching tops and bottoms (making trans-continental flight comfortable for generations to come). Twiggy was the physical ideal. In the seventies, newly liberated women could choose from an array of hemlines: from miniskirts and hot pants to midiskirts and maxidresses. Caftans and ethnic clothing were popular leisure wear for women; men, horrified in hindsight, embraced the leisure suit. Disco reigned; platform shoes were worn by both men and women, putting the ankles of both sexes at risk.

In the eighties, women wore shoulder pads and floppy silk ties. Men returned to conventional business suits; yellow ties were popular. Youth culture, so dominant over the past two decades, lost influence. The nineties was the era of dressing (and stripping) down. Stirrup pants, stonewashed denim, and camouflage were popular. The Gap, The Banana Republic, and J.Crew ruled. Women could cherry-pick their fashion favorites from past decades. Bell bottoms and baby doll dresses from the sixties and seventies staged returns. In 1997, Abercrombie & Fitch relaunched its catalog as the *A&F Quarterly* with the racy photography of Bruce Weber. Weber, who is well known for his erotic black-and-white photos, caused consternation, contention, and confusion with his titillating images of scantily clad, beautiful young men and women. Weber knew A&F Creative Director Sam Shahid from their collaboration on Brooke Shields's controversial "Nothing comes between me and my Calvins" ads for Calvin Klein. Weber preferred jocks to professional male models. To be considered, students were asked to submit Polaroid pictures, because they weren't as slick as professional photos. Successful A&F models were uninhibited young men who had no qualms about getting naked at the drop of a hat. In 2001, Abercrombie & Fitch was prohibited from selling the catalog to minors. The quarterly was discontinued in 2003 after parents and the American Decency Association protested its graphic content and called for a boycott of its store. It was replaced by the less controversial *A&F Magazine*. In 2008, the company announced it would bring back the *A&F Quarterly* in the less puritanical city of London.

The dot-com boom of the late nineties churned out young millionaires overnight; business casual was the order of the day. Heroin chic was both revered and reviled; waif Kate Moss was the most sought-after model. Actress Camryn Manheim took a stand for plus-sized women, accepting her Emmy Award saying, "This is for all the fat girls." The aforementioned bubble burst and the economic landscape had changed. Corporate layoffs were rampant; early-twenty-first-century fashion embraced a bit of everything—trends came and went at lightening speed. America continued to broaden its standard of beauty to include plus sizes and nonwhite ethnicities. Jennifer Lopez and Queen Latifah appeared alongside conventional skinny white beauties on *People* magazine's 50 Most Beautiful People List.

BEAUTY

Catalogs have offered beauty enhancers like hairpieces and cosmetics from almost the beginning. At the turn of the twentieth century, society went from viewing cosmetically enhanced women as "painted ladies" of questionable virtue to those who simply wanted to look good (and, in 1910,

Sears cautioned: "Because You Are Married is No Excuse for Neglecting Your Personal Appearance").

Ivory Soap was accidentally invented in 1879 when a soap-maker at Procter & Gamble forgot to turn off the soap mixer when he went to lunch. Extra air was pumped into the soap and rather than admit his mistake, the soap-maker packaged and shipped the air-filled soap. Soon buyers were clamoring for the "soap that floats."

Even then, the French were held in high esteem (recognizing French toilet preparations as the standard and in many cases far superior), so Sears devoted pages to French lines like Coty, Houbigant, and Bourjois. Sears offered Rouge de Theatre that gave (presumably living) women a "natural and lifelike glow."

In 1913, T. L. Williams invented mascara and named it after his sister Mabel, who wanted to be more alluring to Chet, who was interested in another woman. The darker lashes worked. Chet and Mabel were married in 1914. By combining Mabel with Vaseline, Williams named his mascara, and subsequently his company, Maybelline.

Even though the use of makeup was encouraged, the Victorian association of makeup with prostitution held sway until the 1920s. Makeup was used to make women look healthy and pure, not sexy and alluring. When the twenties hit, women got the right to vote and celebrated with bold red lipstick. Not everyone was enthusiastic however, and in 1924 the New York Board of Health considered banning lipstick, because they feared it would poison men who kissed a woman wearing it. Fifty million American women were using lipstick at the time. The board decided not to move forward with the ban. Also during the twenties, Coco Chanel popularized the idea of the suntan when she accidentally got sunburned on a cruise from Paris to Cannes. Prior to Chanel, suntans

had been reserved for low-class outdoor laborers. Tanning would also be all the rage in the seventies and eighties when self-tanners were popular despite their distinctive orange tint. In 1979, the FDA declared the importance of sunscreen in preventing skin cancer. By the 1990s, the awareness of skin cancer prompted most manufacturers to produce skin products with SPF protection.

The rise of Hollywood cemented women's right to bear compacts, and no one did more to make them beautiful than Polish émigré Max Factor. Factor got his start at the age of eight apprenticing for a dentist-pharmacist where he learned how to mix potions. He moved to Russia and opened up a shop in Moscow selling handmade cosmetics and wigs. A traveling theater troupe wore his products while performing for the Russian nobles, who were so impressed that they appointed him official makeup supplier to the royal family and the Imperial Russian Grand Opera. In 1904, Factor moved to St. Louis and sold his cosmetics at the World's Fair. Sensing that St. Louis was not a hotbed of celebrity and glamour, he set off to Los Angeles and in 1914 scored his first hit with greasepaint that would not cake or crack on film like theatrical makeup. In 1928, he created the first makeup for use in color motion pictures and was awarded an Oscar. He created the glamorous looks of Hollywood stars like Rita Hayworth and Jean Harlow in the twenties and thirties. He is credited with Clara Bow's Cupid's bow lips, Joan Crawford's mouth "smear" and Betty Davis's eyes. In the twenties, Factor started selling his cosmetics directly to women believing they should be able to look as good as the stars. In 1935, he revolutionized the cosmetics world with his invention of Pancake Makeup, the first powder makeup in solid form. During the thirties, Factor himself was featured in the Sears catalog, applying makeup to Claudette Colbert.

Between 1939 and 1945, three million women entered the civilian workforce, and their employers encouraged them to look good. Martin Aircraft offered beauty tips and Lockheed had beauty salons installed in its factories. Relieved of the war shortages, women in the fifties caused a dramatic rise in the sale of face powders, tanning oils, and fragrances. In the sixties, hippies went au naturel (except for the ever-present painted butterflies). For other women, foundation and lip color were pale and austere. Mascara and false eyelashes were redundantly augmented with black kohl eyeliner. Elizabeth Taylor's *Cleopatra* is partly to blame.

The "natural look" was the face of the feminist movement and the seventies. Foundation was light and subtly tinted lip gloss was all the rage. Women had no intention of painting their face to please their men. In the eighties, the cosmetics industry embraced diversity, tailoring products for a wide range of ethnic skin and hair. Power dressing required power makeup: big shoulders, bright lipstick. A heightened awareness that animals were being used to test cosmetics caused an extreme backlash against the inhumane use of animals. Since the nineties, cosmetics have become increasingly sophisticated, using scientific methods and ingredients to try to stem the tide of age.

Today, the classic beauty products of bygone days can be found in the Vermont Country Store catalog. Items include Tabu, the original smear-proof lipstick; and Tangee, an orange lipstick that changes color to accentuate your own skin tone; as well as long-lost perfumes like spicy Tigress from the seventies ("Are you wild enough to wear it?"), and Evening in Paris (touted as "the fragrance more women wear than any other in the world") from the twenties.

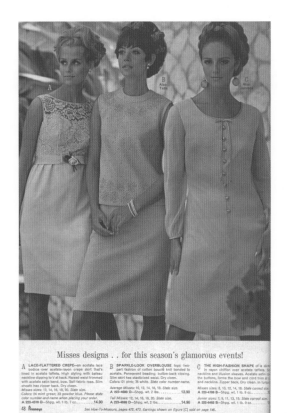

–2.1– J. C. Penney, 1967

English Lavender Smelling Salts.

REFRESHING AND INVIGORATING.

For faintness, headache, etc. In pretty, glass stoppered bottles, a useful and handsome ornament for the dressing table.

No. 8C1104　Price, per bottle, 18c
If by mail, postage and tube extra, 10 cents.

Malaga Almond Meal.

This is the genuine Oriental meal; it is more emollient than the meal usually sold in this country. We import it direct in original bags and put it up in nice packages. It is splendid for the skin and can be used in place of soap. Malaga Almond Meal is highly recommended to ladies who have a very sensitive skin, one that is easily affected even by the slightest presence of acid in a toilet preparation.

No. 8C1107　¼-lb. size. Price...15c
½-lb. size. Price...25c

By mail, postage extra, small size, 8 cents; large size, 12 cents.

Milk of Roses for the Complexion.

A great beautifier used by the most fashionable ladies in Europe, and prepared from fresh white and pale colored roses by a simple process, which, however, secures and obtains by a separate extraction, the finest odor and other portions which always have a pleasant and softening effect on the skin when used for the treatment of same, especially when the same is not entirely free from blemishes. The process for preparing this toilet article has been secured from the French manufacturer and chemist for our exclusive control in the United States.

No. 8C1110　Price........................32c
Unmailable on account of weight.

Genuine Juice of Lily Bulbs.

After many futile efforts we finally succeeded in obtaining the genuine pure juice of the fresh bulbs of the lilies, so that our customers are in a position to obtain from us the genuine article of this toilet preparation, recognized as one of the best in the world. When used for a short time only this preparation also assures a clear complexion, soft and transparent, giving at the same time an extremely healthy color.

No. 8C1113　Price...............36c
Unmailable on account of weight.

Creme de Marshmallow.

A very fine, fragrant, dainty toilet lotion, bland and soothing, for preserving the complexion. Especially recommended for an inflamed and irritated condition of the skin. Ladies doing domestic work will find it a perfect lotion for the skin. May be applied at any time. Quickly absorbed by the skin. Unmailable.

No. 8C1116　Price...............26c

Milk of Cucumber.

An astringent wash, scientifically prepared from the fresh juice of green cucumbers. Cannot be equaled for the treatment of coarse pores and oily skin. Always gives a freshness to the skin, so much desired. Purely vegetable and perfectly harmless. This toilet article has been in great favor for the past few years, and is highly recommended by ladies having used the same constantly, and always with the best results. Unmailable.

No. 8C1119　Price...............35c

Orange Flower Skin Food

QUI VIVE.

This celebrated preparation has quickly grown into popular favor, and is today, by ladies of fashion, considered an indispensable toilet article. It acts as a skin nourisher and wrinkle remover, smooths roughness and fills out hollow cheeks, giving the natural healthy glow and beauty to the skin. Orange Flower Skin Food is today often preferred and used instead of preparations that would cost three and four times the price at which we furnish same to our lady customers.

No. 8C1122　Regular sized jar. Price........21c
2-ounce size. Price.....(Not mailable).....35c
By mail, postage extra, regular size, 15 cents.

Creme Marquise.

QUI VIVE.

This cream is equally as popular as the Orange Flower Skin Food, and while it can be used successfully alone, most society ladies employ it together with the Orange Flower Skin Food. It is especially effective for whitening, softening and preserving the skin. When Orange Flower Skin Food and Creme Marquise are used together, they should be alternated by changing every other night.

No. 8C1125　Regular sized jar. Price.......20c
4-ounce jars. Price.......(Not mailable)......37c
If by mail, postage extra, regular size, 15 cents.

Mme. Qui Vive Complexion Powder.

This is an equally well known toilet article, prepared from the famous Qui Vive formulas, is non-irritating, contains no mineral poisons and may be applied without danger to the most delicate skin. Three shades, flesh, brunette and white.

No. 8C1129　Price, per box........18c
If by mail, postage extra, per box, 3 cents. Always state which color is wanted.

Floral Complexion Powder.

Floral Complexion Powder is one of the very best powders the market affords, is delicately perfumed, fragrant with natural flower odors, and is composed of carefully selected ingredients of the purest kind, and cannot under any conditions whatever cause inflammation or the slightest irritation of the skin as many other complexion powders often do.

No. 8C1131　Price, per box...............25c
If by mail, postage extra, per box, 7 cents.

La Dore's Powder de Riz.

Made from fine rice flour and exquisitely perfumed. This powder is very popular and preferred by many to any other complexion powder used for the purpose for which it is intended. Furnished in three shades, white, cream and flesh.

No. 8C1134
Price, per box...........15c
If by mail, postage extra, per box, 3 cents.

Rouge de Theatre.

This is positively the best, giving a natural and lifelike glow, never injures the skin, is today considered by the theatrical profession the only safe and satisfactory rouge, and used by them almost exclusively owing to the fine distributive qualities which it possess so that it can never be noticed or detected.

No. 8C1137　Price, per box...........12c
If by mail, postage extra, per box, 6 cents.

Liquid Rouge.

A harmless liquid preparation for giving color to the cheeks and lips, making them a perfectly natural, pretty color.

No. 8C1140　Price, per bottle......25c
If by mail, postage extra, per bottle, 10c

Le Maire's Rubyline.

Rubyline is a refined and harmless rouge prepared in the form of a cream for tinting the cheeks, lips and fingers, leaves a perfectly natural tint or glow and can never be detected. The majority of ladies prefer rouge in this form, as it is put up in a very convenient manner and easily applied.

No. 8C1141　Price per box...............18c
If by mail, postage extra, 5 cents.

Camphor Cold Cream.

Retail price...........................25c
Our price, each.................$0.16
Our price, per dozen...............1.50

A SALVE OF REMARKABLE HEALING QUALITIES. Of great value when the skin is chapped from cold; it will heal up the cracks and make the skin soft and smooth again, also it cannot be excelled as a soothing and healing application to burns, and dressing for abrasions of the skin, pimples, boils, etc.

No. 8C1145　Price, per dozen, $1.50; each...............16c
If by mail, postage extra, per box, 6 cents.

HAIR PREPARATIONS.

Danderof.

The Great Scalp Cleaner and Tonic. Permanently cures dandruff, eczema, itching, hair falling out, humors, and all troubles of the scalp and hair. Will positively clear the scalp from dandruff and render it healthy, promoting the growth of the hair. It is recommended to ladies who desire long, glossy hair. It keeps the hair soft and glossy; prevents baldness; makes the hair grow stronger.

Price, No. 8C1150 per bottle.....42c
Unmailable on account weight.

Hair Elixir.

A beautiful dressing for the hair, making it soft and glossy; prevents it from splitting and falling out. Cures dandruff and makes the hair grow. Our Hair Elixir is used and recommended by every professional hair dresser in large cities. It is the only safe hair preserver known, and should be used especially for protecting and promoting a fine growth of hair.

No. 8C1151　Price, per bottle.....45c
Unmailable on account of weight.

Eau De Quinine Hair Tonic.

Excellent preparation for strengthening and dressing the hair; much used in Europe by the ladies of the best society. We have the genuine, imported by the ladies from France, where it has gained a much deserved reputation as a valuable hair dressing and tonic. The genuine Eau de Quinine is recognized the world over as a stimulant to the hair nerves and roots, a strengthener and builder where the natural strength and growth of the hair has become impaired.

No. 8C1152　Price, 8-ounce bottles, 35c; 4-ounce bottles...............22c
If by mail, postage and tube extra, small, 16 cents; large, unmailable on account of weight.

Barbers' Egg Shampoo.

This shampoo is the highest grade of shampoo preparations used by the first class barbers in the large cities, and is very popular in every part of the country. As a gentleman's shampoo it is unequaled, makes clean and healthy hair, removes itching of the scalp, and is guaranteed not to contain, like most other egg shampoos, any alkali, which leaves the hair harsh and dry. Our barbers' hair shampoo renders the hair soft, smooth and glossy.

No. 8C1156　Price, 8-oz. round shampoo bottle...............25c
Unmailable on account of weight.

Imperial Shampoo.

A preparation put up especially for ladies' use, thoroughly antiseptic, and supplied in liquid form, making a soft and copious lather, free from alkalies and any injurious substances whatever. It stimulates the scalp and leaves the hair soft and luxuriant, and should be used once or twice a month freely. The Imperial Shampoo represents the highest art of shampoo preparations and is put up in handsome eight-ounce sprinkler top bottles, making it very convenient for use. The genuine Imperial Shampoo is never sold for less than $1.00 per bottle.

No. 8C1159　Price, 8-ounce sprinkler top bottle.....(Unmailable.).....32c

-2.2- Sears, 1905.　　　　　-2.3- Early-twentieth-century hats from Sears; note the "Stunning Charlotte Corday," oddly named after the young woman who murdered French revolutionary Jean-Paul Marat.

the Prevailing Shapes for Season, Very Becoming.

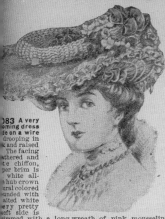

083 A very coming dress de on a wire drooping in and raised The facing athered and chiffon, per brim is white all alted white ery pretty left side is rimmed with a long wreath of pink mousseline iliage, buds and rosettes, made of loops of white satin l around bandeau, trimmed with folds and bows of bbon, completes the trimming of this hat. Very ribed in white, but can also be ordered in black and t blue and white or pink and white.............$3.10

ng and Original Style, $3.15.

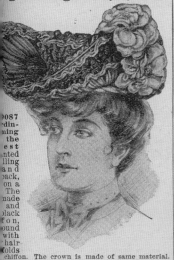

9087 din- ning the est nted lling and ack, on a The made and lack of on, und with hair olds chiffon. The crown is made of same material. ner brim and the outer crown is a fold of gathered on. On the left side are three extra large very best ted pink silk roses with contrasting centers. The im, which fits closely to the hair, is very effectively loops of pink satin taffeta ribbon. A fold of the ged on the left side of the all around bandeau. ptionally pretty turban in the color as described, d with pink, but can also be ordered in white, t blue and white with any color flowers desired.$3.15

ul Dress Hat with Uprolling and Drooping Back, $3.25.

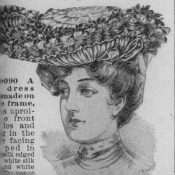

090 A dress made on frame, s uproll- e front les and g in the facing ped in ilk edged and white

This Large Dress Hat Developed in White and Pink, Very Beautiful, $3.28.

$3.28

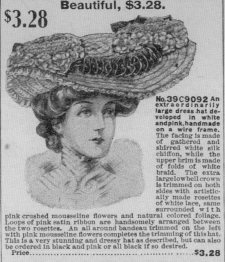

No.39C9092 An extraordinarily large dress hat de- veloped in white and pink, handmade on a wire frame. The facing is made of gathered and shirred white silk chiffon, while the upper brim is made of folds of white braid. The extra largelowbell crown is trimmed on both sides with artistic- ally made rosettes of white lace, same surrounded with pink crushed mousseline flowers and natural colored foliage. Loops of pink satin ribbon are handsomely arranged between the two rosettes. An all around bandeau trimmed on the left with pink mousseline flowers completes the trimming of this hat. This is a very stunning and dressy hat as described, but can also be ordered in black and pink or all black if so desired. Price...............................$3.28

A Design by Madame Rentau, $3.30.

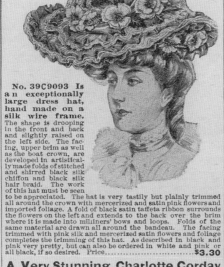

No. 39C9093 Is an exceptionally large dress hat, hand made on a silk wire frame. The shape is drooping in the front and back and slightly raised on the left side. The fac- ing, upper brim as well as the boat crown, are developed in artistical- ly made folds of stitched and shirred black silk chiffon and black silk hair braid. The work of this hat must be seen to be appreciated. The hat is very tastily but plainly trimmed all around the crown with mercerized and satin pink flowers and imported foliage. A fold of black satin taffeta ribbon surrounds the flowers on the left and extends to the back over the brim where it is made into milliners' bows and loops. Folds of the same material are drawn all around the bandeau. The facing trimmed with pink silk and mercerized satin flowers and foliage completes the trimming of this hat. As described in black and pink very pretty, but can also be ordered in white and pink or all black, if so desired. Price...............................$3.30

A Very Stunning Charlotte Corday in Lace, $3.35.

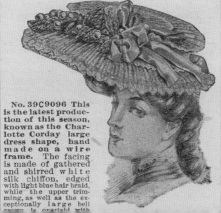

No. 39C9096 This is the latest produc- tion of this season, known as the Char- lotte Corday large dress hat shape, hand made on a wire frame. The facing is made of gathered and shirred white silk chiffon, edged with light blue hair braid, while the upper trimming, as well as the ex- ceptionally large bell

This Nobby Dress Hat is An Elegant Design, $3.50.

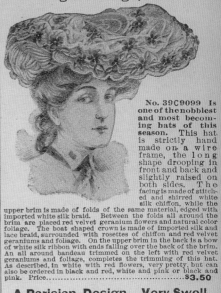

No. 39C9099 Is one of the nobblest and most becom- ing hats of this season. This hat is strictly hand made on a wire frame, the long shape drooping in front and back and slightly raised on both sides. The facing is made of stitch- ed and shirred white silk chiffon, while the upper brim is made of folds of the same material, edged with imported white silk braid. Between the folds all around the brim are placed red velvet geranium flowers and natural color foliage. The boat shaped crown is made of imported silk and lace braid, surrounded with rosettes of chiffon and red velvet geraniums and foliage. On the upper brim in the back is a bow of white silk ribbon with ends falling over the back of the brim. An all around bandeau trimmed on the left with red velvet geraniums and foliage, completes the trimming of this hat. As described, in white with red flowers, very pretty, but can also be ordered in black and red, white and pink or black and pink. Price...............................$3.50

A Parisian Design. Very Swell, $3.55.

$3.55

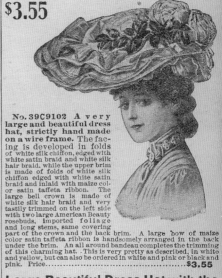

No. 39C9102 A very large and beautiful dress hat, strictly hand made on a wire frame. The fac- ing is developed in folds of white silk chiffon, edged with white satin braid and white silk hair braid, while the upper brim is made of folds of white silk chiffon edged with white satin braid and inlaid with maize col- or satin taffeta ribbon. The large bell crown is made of white silk hair braid and very tastily trimmed on the left side with two large American Beauty rosebuds, imported foliage and long stems, same covering part of the crown and the back brim. A large bow of maize color satin taffeta ribbon is handsomely arranged in the back under the brim. An all around bandeau completes the trimming of this charming hat. This is very pretty as described, in white and yellow, but can also be ordered in white and pink or black and pink. Price...............................$3.55

Large Beautiful Dress Hat with the New Hub Crown, $3.65.

$3.65

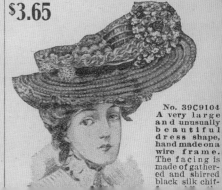

No. 39C9104 A very large and unusually beautiful dress shape, hand made on a wire frame. The facing is made of gather- ed and shirred black silk chif-

OUR 60-CENT PRINCESS TONIC HAIR R

A WONDERFUL NEW HAIR TONIC AND PROD

No. 8C1101

Per Bottle, 60c.

Restores the Natural Color, Preserves and Strengthens the Hair for Years, Promotes the Growth, Arrests Falling Hair, Feeds and Nourishes the Roots, Cures Dandruff and Scurf, and Allays all Scalp Irritations.

THE ONLY ABSOLUTELY EFFECTIV
CESSFUL, PERFECTLY HARML
NO-DYE PREPARATION ON

that restores gray hair to its natural and youthf
and dandruff, soothes irritating, itching surface
supplies the roots with energy and nourishmen
soft, and makes the hair grow.

EVERY SINGLE BOTTLE OF PRINCESS TONIC HAIR RESTORER

is compounded especially in our own laboratory by our own skilled chemists, and according to the prescription of one who has made the hair and scalp, its diseases and cure, a life study.

PRINCESS TONIC HAIR RESTORER IS NOT AN EXPERIMENT,

not an untried, unknown remedy, depending on enormous, glittering advertisements for sales, but it is a preparation of the very finest and most expensive ingredients, that will positively cure any case of falling hair, stimulate the growth of new hair on bald heads, cure dandruff and other diseases of the scalp.

Regular R
Our Price
Our Price,
Unmar

ARE YOU BALD?

Is your hair thin or falling out?

Does your hair come out easily and gather on the comb and brush when you brush it?

Does your head itch?

Do you have dandruff or scurf and do white, dust-like particles settle on your coat collar?

Is your hair stiff and coarse and hard to brush?

Is your hair fading or has it turned prematurely gray?

IF YOUR HAIR SUFFERS in any one or more of these particulars, we would urge you by all means to order a bottle of Princess Tonic Hair Restorer as a trial, for speedy relief. Use it according to directions and you will be surprised and delighted at the wonderful results. It acts direct on the tiny roots of the hair, giving them required fresh nourishment, starts quick, energetic circulation in every hair cell, tones up the scalp, freshens the pores, stops falling and sickly hair, changes thin hair to a fine heavy growth, puts new life in dormant, sluggish hair cells on bald heads, producing in a short time an absolutely new growth of hair. If your hair is fading or turning gray, one bottle of Princess Tonic Hair Restorer will give it healthy life, renew its original color and restore it to youthful profusion and beauty.

Princess T

PRINCESS TONIC HAIR RESTORER IS GOOD FOR BOTH MEN AND WOMEN. IS EQUALLY EFFECTIVE ON MEN'S, WOMEN'S AND CHILDREN'S HAIR.

USE IT ALWAYS IF YOU WANT A HEAD OF FINE, SILKY, GLOSSY HAIR, THE PRIDE OF EVERY WOMAN.

AS A CURE FOR DANDRUFF, as a tonic for thin and scanty

hair, Princess Tonic Hair Re-storer acts with quick and wonderful success. It removes crusts and scales, keeps the scalp clean and healthy, the roots at once respond to its vigorous action, dandruff is banished and a thick and healthy growth of hair is assured.

FOR A TOILET ARTICLE, as a fine hair dressing, no one who takes any pride in a nice head of hair can afford to be without a bottle always on the dresser. Princess Tonic Hair Restorer is delicately perfumed, and one light application imparts a delightful, refined fragrance. Neither oils, pomades, vaseline or other greases are required with our preparation.

DON'T SEND AWAY TO A CHEAP SPECIALIST and pay $1.00, $1.50 or $2.00 a bottle for a worth-less and perhaps injurious preparation. Don't be misled by catchy adver-tisements with baits of free trial sample bottle and fake examination offers—such people will draw you in, make you believe something awful is the matter and scare you into paying enormous prices for alleged remedies, when you can get the genuine, tried, tested Princess Tonic Hair Restorer at 60 cents a bottle, the actual cost of the ingredients and labor of bottling, with our one small profit added.

PRINCESS TONIC HAIR RESTORER IS ABSOLUTE
not injure the most delicate hair, it will not sta
Princess Tonic Hair Restorer works wonders with
from people telling how much good it has done fo
for you. You can sell a dozen bottles at a profit t
neighborhood to people who see the good it has done
your hair.

ORDER A BOTTLE AT (

which you can easily sell at $1.00, and if yo
than we claim for it, if you do not find it is just th
ulating the growth, cleansing the scalp, stopping ha
natural color, curing dandruff or promoting a r
head, return it to us at once AND WE WILL
YOUR MONEY.

SEROCO

Guarantee of Highest Quality

This Label is your Protection

EVERY BOTTLE OF OUR GENUINE PRINCESS TONIC HAIR RESTORER IS S
LABEL AS SHOWN IN THE ILLUSTRATION,

OUR GUARANTEE OF HIGHEST OU

YOU WILL FIND VARIOUS SO CALLED HAIR TONICS and hair restorers widely advertis

Those that possess merit are sold for two and three times the price we ask for the genuine Princess Toni
equal to the preparation we put out under our binding guarantee for quality. If you have any doubt as
Tonic Hair Restorer as against the preparations advertised and offered by others we would be willing

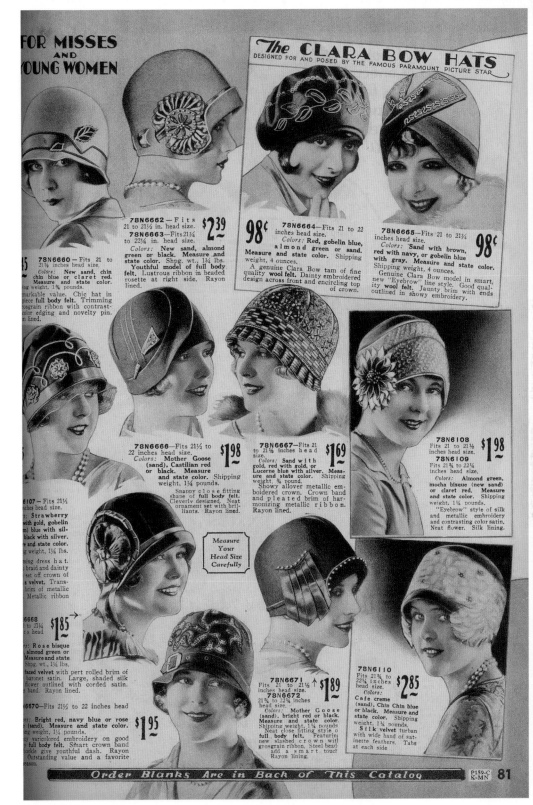

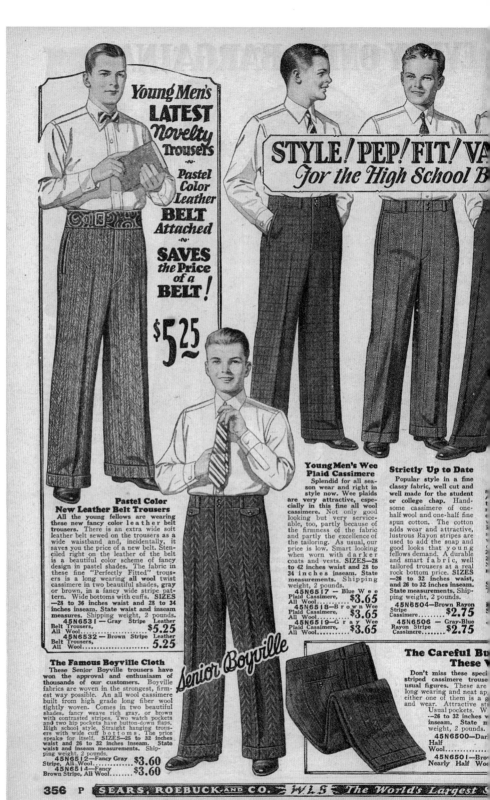

Young Men's LATEST *Novelty Trousers*

Pastel Color Leather **BELT** Attached

SAVES the Price of a **BELT!**

$5.25

STYLE! PEP! FIT! VA
for the High School B

Pastel Color New Leather Belt Trousers

All the young fellows are wearing these new fancy color l e a t h e r belt trousers. There is an extra wide soft leather belt sewed on the trousers as a wide waistband and, incidentally, it saves you the price of a new belt. Stenciled right on the leather of the belt is a beautiful color scheme of fancy design in pastel shades. The fabric in these fine "Perfectly Fitted" trousers is a long wearing all wool twist cassimere in two beautiful shades, gray or brown, in a fancy wide stripe pattern. Wide bottoms with cuffs. SIZES —28 to 36 inches waist and 28 to 34 inches inseam. State waist and inseam measures. Shipping weight, 2 pounds.

45N6531 — Gray Stripe Leather Belt Trousers, All Wool.................. **$5.25**
45N6532 — Brown Stripe Leather Belt Trousers, All Wool.................. **5.25**

The Famous Boyville Cloth

These Senior Boyville trousers have won the approval and enthusiasm of thousands of our customers. Boyville fabrics are woven in the strongest, firmest way possible. An all wool cassimere built from high grade long fiber wool tightly woven. Comes in two beautiful shades, fancy weave rich gray, or brown with contrasted stripes. Two watch pockets and two hip pockets have button-down flaps. High school style. Straight hanging trousers with wide cuff b o t t o m s. The price speaks for itself. SIZES—25 to 32 inches waist and 26 to 32 inches inseam. State waist and inseam measurements. Shipping weight, 2 pounds.

45N6512—Fancy Gray Stripe, All Wool.................. **$3.60**
45N6514—Fancy Brown Stripe, All Wool.................. **$3.60**

Senior Boyville

Young Men's Wee Plaid Cassimere

Splendid for all season wear and right in style now. Wee plaids are very attractive, especially in this fine all wool cassimere. Not only good looking but very serviceable, too, partly because of the firmness of the fabric and partly the excellence of the tailoring. As usual, our price is low. Smart looking when worn with d a r k e r coats and vests. SIZES—28 to 42 inches waist and 28 to 34 inches inseam. State measurements. Shipping weight, 2 pounds.

45N6517 — Blue Wee Plaid Cassimere, All Wool.................. **$3.65**
45N6518—Brown Wee Plaid Cassimere, All Wool.................. **$3.65**
45N6519—G r a y Wee Plaid Cassimere, All Wool.................. **$3.65**

Strictly Up to Date

Popular style in a fine classy fabric, well cut and well made for the student or college chap. Handsome cassimere of one-half wool and one-half fine spun cotton. The cotton adds wear and attractive, lustrous Rayon stripes are used to add the snap and good looks that y o u n g fellows demand. A durable and smart f a b r i c, well tailored trousers at a real rock bottom price. SIZES —26 to 32 inches waist, and 26 to 32 inches inseam. State measurements. Shipping weight, 2 pounds.

45N6504—Brown Rayon Stripe Cassimere.................. **$2.75**
45N6506—Gray-Blue Rayon Stripe Cassimere.................. **$2.75**

The Careful Bu **These V**

Don't miss these speci striped cassimere trouse usual figures. These are long wearing and neat ap either one of them is a g and wear. Attractive st Usual pockets. W —26 to 32 inches w inseam. State in weight, 2 pounds.

45N6500—Dar Half Wool..................
45N6501—Bro Nearly Half Woo

−2.6− Sears, mens fashions, 1928

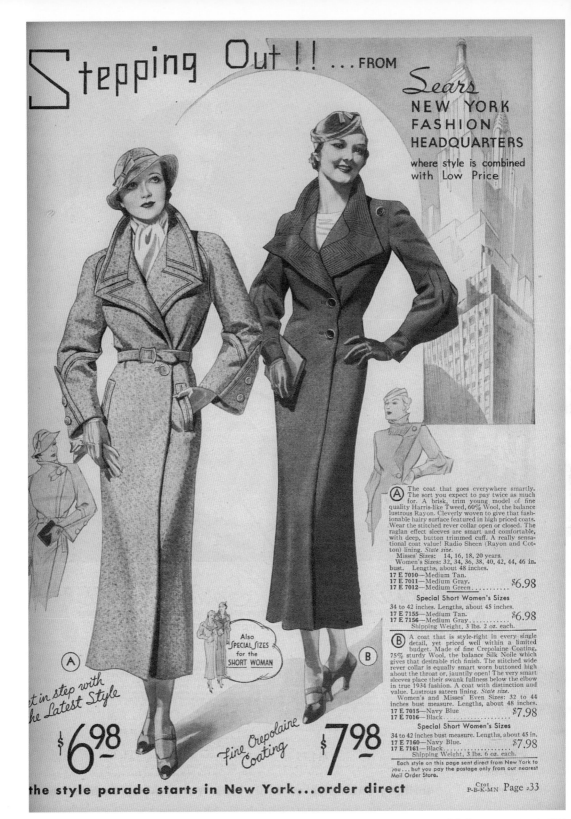

Stepping Out!! ...FROM

Sears
NEW YORK FASHION HEADQUARTERS

where style is combined with Low Price

Also *SPECIAL SIZES* for the SHORT WOMAN

Ⓐ

et in step with the Latest Style

$6⁹⁸

Ⓑ

Fine Crepolaine Coating

$7⁹⁸

Ⓐ The coat that goes everywhere smartly. The sort you expect to pay twice as much for. A brisk, trim young model of fine quality Harris-like Tweed, 60% Wool, the balance lustrous Rayon. Cleverly woven to give that fashionable hairy surface featured in high priced coats. Wear the stitched rever collar open or closed. The raglan effect sleeves are smart and comfortable, with deep, button trimmed cuff. A really sensational coat value! Radio Sheen (Rayon and Cotton) lining. *State size.*
Misses' Sizes: 14, 16, 18, 20 years.
Women's Sizes: 32, 34, 36, 38, 40, 42, 44, 46 in. bust. Lengths, about 48 inches.
17 E 7010—Medium Tan.
17 E 7011—Medium Gray.
17 E 7012—Medium Green........... $6.98

Special Short Women's Sizes
34 to 42 inches. Lengths, about 45 inches.
17 E 7155—Medium Tan.
17 E 7156—Medium Gray $6.98
 Shipping Weight, 3 lbs. 2 oz. each.

Ⓑ A coat that is style-right in every single detail, yet priced well within a limited budget. Made of fine Crepolaine Coating, 75% sturdy Wool, the balance Silk Noile which gives that desirable rich finish. The stitched wide rever collar is equally smart worn buttoned high about the throat or, jauntily open! The very smart sleeves place their swank fullness below the elbow in true 1934 fashion. A coat with distinction and value. Lustrous sateen lining. *State size.*
Women's and Misses' Even Sizes: 32 to 44 inches bust measure. Lengths, about 48 inches.
17 E 7015—Navy Blue.
17 E 7016—Black.................. $7.98

Special Short Women's Sizes
34 to 42 inches bust measure. Lengths, about 45 in.
17 E 7160—Navy Blue.
17 E 7161—Black.................. $7.98
 Shipping Weight, 3 lbs. 6 oz. each.

Each style on this page sent direct from New York to you ... but you pay the postage only from our nearest Mail Order Store.

the style parade starts in New York ...order direct

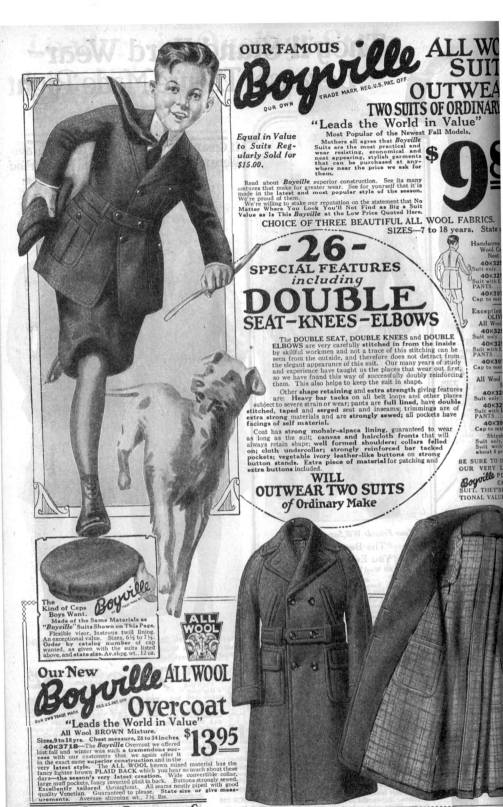

OUR FAMOUS *Boyville* ALL WOOL SUITS OUTWEAR TWO SUITS OF ORDINARY

TRADE MARK REG. U.S. PAT. OFF.
OUR OWN

"Leads the World in Value"

Most Popular of the Newest Fall Models.

Equal in Value to Suits Regularly Sold for $15.00.

Mothers all agree that *Boyville* Suits are the most practical and wear resisting, economical and neat appearing, stylish garments that can be purchased at anywhere near the price we ask for them.

Read about *Boyville* superior construction. See its many features that make for greater wear. See for yourself that it is made in the latest and most popular style of the season. We're proud of them.

We're willing to stake our reputation on the statement that No Matter Where You Look You'll Not Find as Big a Suit Value as Is This *Boyville* at the Low Price Quoted Here.

$9

CHOICE OF THREE BEAUTIFUL ALL WOOL FABRICS. SIZES—7 to 18 years. State

-26-
SPECIAL FEATURES
including
DOUBLE
SEAT—KNEES—ELBOWS

The DOUBLE SEAT, DOUBLE KNEES and DOUBLE ELBOWS are very carefully stitched in from the inside by skillful workmen and not a trace of this stitching can be seen from the outside, and therefore does not detract from the elegant appearance of this suit. Our many years of study and experience have taught us the places that wear out first, so we have found this way of successfully doubly reinforcing them. This also helps to keep the suit in shape.

Other shape retaining and extra strength giving features are: Heavy bar tacks on all belt loops and other places subject to severe strain or wear; pants are full lined, have double stitched, taped and serged seat and inseams; trimmings are of extra strong materials and are strongly sewed; all pockets have facings of self material.

Coat has strong mohair-alpaca lining, guaranteed to wear as long as the suit; canvas and haircloth fronts that will always retain shape; well formed shoulders; collars felled on; cloth undercollar; strongly reinforced bar tacked pockets; vegetable ivory leather-like buttons on strong button stands. Extra piece of material for patching and extra buttons included.

WILL
OUTWEAR TWO SUITS
of Ordinary Make

Handsome
Wool C
Neat
40K325
Suit only.
40K325
Suit with
PANTS..
40K397
Cap to mat

Exception
OLIVE
All Wool
40K325
Suit only.
40K325
Suit with
PANTS...
40K397
All Wool
40K32
Suit only.
40K32
Suit with
PANTS...
40K39
Cap to ma

Shipp
Suit only,
Suit with
about 5 po

BE SURE TO O
OUR VERY L
Boyville PL
CA
SUIT. THEY'R
TIONAL VALUE

The Kind of Caps Boys Want.

Made of the Same Materials as "*Boyville*" Suits Shown on This Page. Flexible visor, lustrous twill lining. An exceptional value. Sizes, 6½ to 7½. Order by catalog number of cap wanted, as given with the suits listed above, and state size. Av.shpg.wt., 12 oz.

ALL WOOL

Our New *Boyville* ALL WOOL Overcoat

REG. U.S. PAT. OFF.
OUR OWN TRADE MARK

"Leads the World in Value"

All Wool BROWN Mixture.

Sizes, 9 to 18 yrs. Chest measure, 28 to 34 inches.

$13.95

40K3718—The *Boyville* Overcoat we offered last fall and winter was such a tremendous success with our customers that we again offer it in the exact same superior construction and in the very latest style. The ALL WOOL brown mixed material has the fancy lighter brown PLAID BACK which you hear so much about these days—the season's very latest creation. Wide convertible collar, large muff pockets, fancy inverted plait in back. Buttons strongly sewed. Excellently tailored throughout. All seams neatly piped with good quality Venetian. Guaranteed to please. State size or give measurements. Average shipping wt., 7½ lbs.

234. 39K SEARS ROEBUCK AND Co

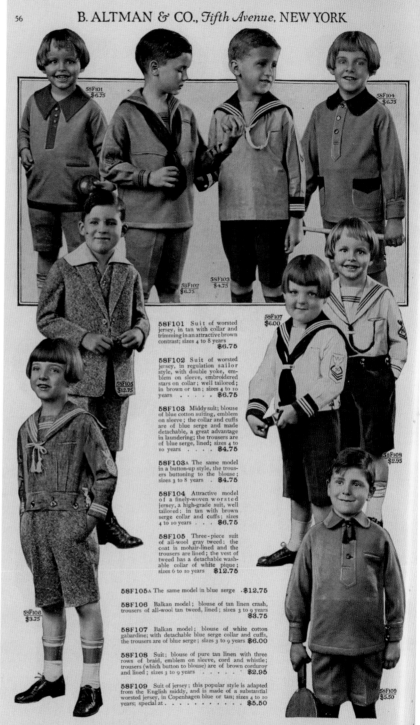

58F101 Suit of worsted jersey, in tan with collar and trimming in an attractive brown contrast; sizes 4 to 8 years **$6.75**

58F102 Suit of worsted jersey, in regulation sailor style, with double yoke, emblem on sleeve, embroidered stars on collar; well tailored; in brown or tan; sizes 4 to 10 years **$6.75**

58F103 Middy suit; blouse of blue cotton suiting, emblem on sleeve; the collar and cuffs are of blue serge and made detachable, a great advantage in laundering; the trousers are of blue serge, lined; sizes 4 to 10 years **$4.75**

58F103A The same model in a button-up style, the trousers buttoning to the blouse; sizes 3 to 8 years . **$4.75**

58F104 Attractive model of a finely-woven worsted jersey, a high-grade suit, well tailored; in tan with brown serge collar and cuffs; sizes 4 to 10 years . . . **$6.75**

58F105 Three-piece suit of all-wool gray tweed; the coat is mohair-lined and the trousers are lined; the vest of tweed has a detachable washable collar of white piqué; sizes 6 to 10 years **$12.75**

58F105A The same model in blue serge . **$12.75**

58F106 Balkan model; blouse of tan linen crash, trousers of all-wool tan tweed, lined; sizes 3 to 9 years **$3.75**

58F107 Balkan model; blouse of white cotton gabardine; with detachable blue serge collar and cuffs, the trousers are of blue serge; sizes 3 to 9 years **$6.00**

58F108 Suit; blouse of pure tan linen with three rows of braid, emblem on sleeve) cord and whistle; trousers (which button to blouse) are of brown corduroy and lined; sizes 3 to 9 years **$2.95**

58F109 Suit of jersey; this popular style is adapted from the English middy, and is made of a substantial worsted jersey, in Copenhagen blue or tan; sizes 4 to 10 years; special at **$5.50**

To facilitate the prompt and correct filling of orders, it is suggested that the order blank be used in every instance possible. Additional order blanks will be sent on request

YUKON Prices Reduced

NEW! Elastic Waist Pajamas
AMOSKEAG FLANNELETTE
$1.48

IMPROVED SET-IN SEAT

35 C 967—Fancy assorted patterns $1.48 EVEN SIZES: 34 to 52-inch chest. State size. Ship. wt. 1 lb. 3 oz.

The very newest in every respect. Colors and patterns are up to the minute. There's a new comfortable set-in seat and the elastic waist is a great improvement. Amoskeag Flannelette. Compare with $1.95 Pajamas.

Famous AMOSKEAG TEAZLE DOWN FLANNELETTES

OUR FINEST Nightshirt $1.39

35 C 956—Assorted fancy stripes. SIZES: 15 to 20-inch neck. State size. Ship. wt. 1 lb. 4 oz.

New YUKON Nightshirt, warm and comfortable. Everybody knows that Teazle Down is one of the very best Flannelettes manufactured. Rayon frog trim. Length about 54 in.

Pajamas for Warmth $1.65

35 C 932—Assorted fancy stripes. EVEN SIZES: 34 to 48-inch chest. State size. Ship. wt. 1 lb. 8 oz.

Our most popular YUKON Pajamas at $1.95—now the price is cut. This fine heavy weight, soft Flannelette Pajama is excellently finished and full cut. Rayon frogs, drawtape at waist.

Middy Style Nightshirt $1.29

35 C 935—Assorted Fancy Stripes. EVEN SIZES: 15 to 20-inch neck. State size. Ship. wt. 1 lb. 3 oz.

Excellently tailored YUKON Slipover. Quick to put on, no buttons to come off. Full 54 inches long and a new low price. Very warm—exceptionally comfortable.

OUR FINEST PAJAMA

Flannelette Nightshirts

Medium Weight

35 C 944—Assorted Stripes. SIZES: 15 to 20-inch neck. State size. Ship. wt. 1 lb.

Serviceable YUKON Nightshirt generously made in comfortable roomy sizes. About 52 inches long. A big value at our former price of 89¢.

Heavy Amoskeag

35 C 951—Plain white...$1.09
35 C 952—Assorted Stripes. SIZES: 15 to 20-inch neck. State size. Ship. wt. 1 lb. 2 oz. Heavy weight. Length about 54 in.

35 C 945—HOTEL SIZES: Assorted stripes. Length about 60 inches....$1.29

Flannelette Pajamas.. GREAT VALUES

Heavy Weight Flannelette $1.29

35 C 950 — Assorted Fancy Stripes. EVEN SIZES: 34 to 48-inch chest. State size. Ship. wt. 1 lb. 8 oz.

The New YUKON, of quality heavy weight, unusually warm. Trousers with elastic at waist. The new middy type jacket.

Medium Weight Flannelette 89¢

35 C 941—Assorted Fancy Striped. EVEN SIZES: 34 to 48-inch chest. State size. Ship. wt. 1 lb. 3 oz.

Medium weight, soft comfortable Flannelette. Rayon frog trim and military collar. Full cut and roomy; well and neatly made. New low price. Draw tape at waist.

Elastic Waist $1.89

35 C 960 — Fancy Assorted Stripes. EVEN SIZES: 34 to 48-inch chest. State size. Ship. wt. 1 lb. 8 oz.

A better Pajama than we have ever sold at any price. The remarkably fine quality Flannelette is extra heavy, extra warm and extra soft. YUKON.

YOU SAVE THE POSTAGE
IF YOUR ORDER TOTALS $2 OR MORE See Page 20

FINE MUSLIN NIGHTSHIRT 79¢

Muslin Nightshirt 79¢

35 C 966—White only. SIZES: 15 to 20-inch neck. State size. Ship. wt. 14 ounces.

The muslin is a surprisingly sturdy quality, far superior to the usual grade found in Nightshirts anywhere near this price. And we've cut the price again. About 52 inches long.

ELASTIC WAIST APPROVED SET-IN SEAT

GENUINE Finnshrunk BROADCLOTH

Distinctive BROADCLOTH Pajamas

(A) $1.65 **Cord Trim Plain Colors**

35 C 954—COLORS: White, tan or blue. EVEN SIZES: 34 to 48-inch chest. State size and color. Ship. wt. 15 oz.

Exactly the same quality Cotton Broadcloth Pajamas sold in other stores for $2 or more. Very latest style yet conservative and attractive. Cord Trim, excellently made throughout with every latest feature including the improved set-in seat and elastic waist.

(B) $1.35 **Fast Color Fancy Stripes**

35 C 955—Coat Style.
35 C 946—Middy Style.
Fancy colored Stripes. EVEN SIZES: 34 to 48-inch chest. State size. Ship. wt. 14 ounces.

You'll find this same fine quality Cotton Broadcloth Pajamas at $1.95 in the average store. Well made, full cut throughout in every detail. Trousers have drawstring at waist. Fast color. Very pleasing patterns.

(C) 95¢ **Plain or Fancy Fast Colors**

35 C 933—Assorted Fancy Striped Patterns. SIZES: 34 to 48-inch chest. State size. Ship. wt. 14 ounces.

Only 95¢ yet full cut and well made in every detail. Newest patterns; fast colors. Cotton Broadcloth.

35 C 964—Plain white, tan or blue. Sizes and weight as above. Pajama cloth. State size and color. Each............95¢

(D) $1.48 **Elastic Waist Plain Colors**

35 C 938—COLORS: Plain white, tan, blue. EVEN SIZES: 34 to 48-inch chest. State size and color. Ship. wt. 15 oz.

New! We are offering for the first time fully shrunk good quality Cotton Broadcloth Pajamas. They are guaranteed for permanent fit by Ward's and by the manufacturer. The elastic waist feature assures utmost comfort. Well tailored and full cut.

Fine Lounging and Bath Robes Shown on Pages 191 and 210

Afraid to be
Weighed?
It's a joy to watch
your weight go
down with the
Rubber Reducer!
Makes larger figures
look and grow...
slimmer!

Sears, 1934

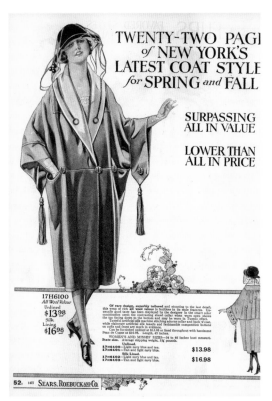

TWENTY-TWO PAGES
of NEW YORK'S
LATEST COAT STYLES
for SPRING and FALL

SURPASSING
ALL IN VALUE

LOWER THAN
ALL IN PRICE

17H6100
All Wool Velour
Unlined
$13.98
Silk
Lining
$16.98

Of rare design, superbly tailored and stunning to the last detail, this wrap of rich all wool velour is faultless in its style features. Unusually good taste has been displayed by the designer in the smart color combination used; the contrasting shawl collar when worn open shows the tan facing down to the bottom and may be worn in Tuxedo effect.
Tasteful artificial silk machine stitching adorns collar and back of coat, while elaborate artificial silk tassels and fashionable composition buttons on cuffs and front are much in evidence.
Can be furnished unlined at $13.98 or lined throughout with handsome Peau de Cygne at $16.98. Length, 45 inches.
WOMEN'S AND MISSES' SIZES—34 to 46 inches bust measure.
State sizes. Average shipping weight, 3¼ pounds.

Unlined
17H6100—Light navy blue and tan.
17H6101—Tan and light navy blue. $13.98
Silk Lined
17H6102—Light navy blue and tan.
17H6103—Tan and light navy blue. $16.98

52

−2.11− Sears, 1922

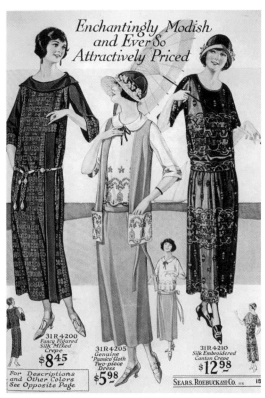

Enchantingly Modish
and Ever So
Attractively Priced

31R4200
Fancy Figured
Silk Mixed
Crepe
$8.45

31R4205
Genuine
'Pazico' Cloth
Two-piece
Dress
$5.98

31R4210
Silk Embroidered
Canton Crepe
$12.98

For Descriptions
and Other Colors
See Opposite Page

SEARS, ROEBUCK AND CO.

−2.12− Sears, 1924

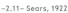
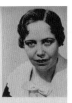

IN all my experience in the world of f... have had nothing thrill me quite as mu... feting to you this beautiful style prese... This season the styles seem to be more s... than ever before, and it was a considera... City, orders for items listed as "Seti... although a pleasant one, to select from t... oney, the cream of the crop for our custo... season materials are simply gorgeous, ... colors are most striking; and the styles ... to wear. And best of all the prices are v... So many more thousands of women profi... Sears service last season. Join them an... the thrill of wearing clothes direct from N...

Anne Willia...
Fashionist

How to Order Fashio...
You can order from our nearest Mail ... House with other goods, or you can ... directly to Sears, Roebuck and Co., "Sett... City," orders for items listed as "Seti... New York." In either case, you pay the po... only from our nearest Mail Order House ... we rush delivery direct from New Yo...

SPECIAL PRICE FOR
LOVELY SMOCKED DR...

$3.98

Your heart will beat faster when y... this dress out of its New York box! It's ... packed full of brand new style and ... pensive-looking! Hand smocked in ... color contrast with gleaming Rayo... Full, graceful sleeves! Flattering hip... and gay button trim. Pleats back an... of skirt give the new slightly flared sil... Made of that much preferred fabric, ... rich Celanese Pebble Crepe, and th... are divine. And it's a fashion in the w... of that exquisite Hollywood star, A... Ames. Each dress bears her autog... label. You'll be charmed with the value ... delighted with the value at this price!
Misses' Sizes: 14-16-18-20 years.
Women's Sizes: 33-34-36-38 inch bust.
Length, about 49 inches. State actual bust...
31 K 2100—Duck Brown with Rust.
31 K 2101—Navy Blue with Red.
31 K 2102—French Violet (purple) with Lilac...
Shipping weight, 1 lb. 6 oz.

AN AUTOGRAPHED FASHION
from Hollywood by
Adrienne Ames

−2.13− Sears, Anne Williams, 1935

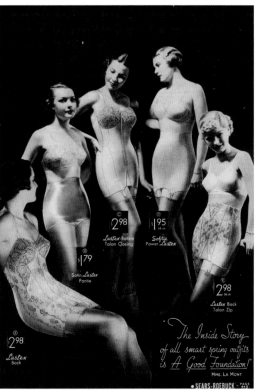

$1.79
Satin *Lastex*
Pantie

$2.98
Lastex-Batiste
Talon Closing

$1.95
Softie
Power *Lastex*

$2.98
Lastex Back
Talon Zip

$2.98
Lastex
Back

"The Inside Story
of all smart spring outfits
is A Good Foundation!"
MME. LA MONT

SEARS-ROEBUCK
PAGE 113

−2.14− Sears, lingerie, 1936

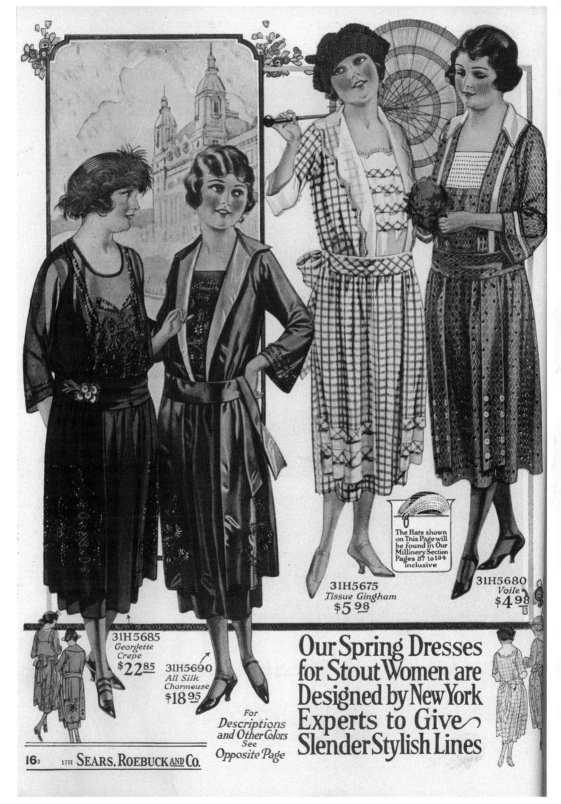

31H5675
Tissue Gingham
$5.98

31H5680
Voile
$4.98

The Hats shown on This Page will be found in Our Millinery Section Pages 87 to 104 inclusive

31H5685
Georgette Crepe
$22.85

31H5690
All Silk Charmeuse
$18.95

For Descriptions and Other Colors See Opposite Page

Our Spring Dresses for Stout Women are Designed by New York Experts to Give Slender Stylish Lines

−2.15− Sears, stout dresses, 1922

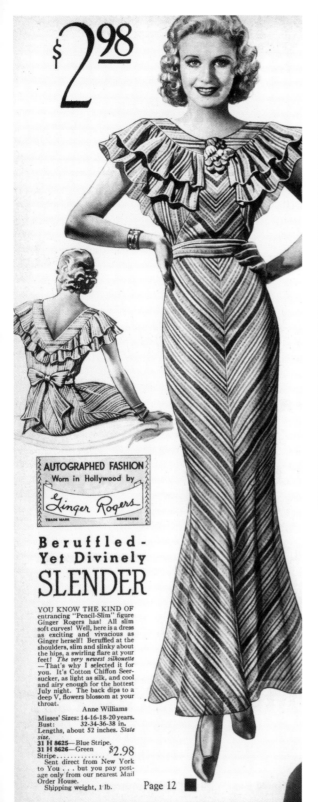

$2⁹⁸

AUTOGRAPHED FASHION
Worn in Hollywood by

Ginger Rogers

TRADE MARK REGISTERED

Beruffled-
Yet Divinely
SLENDER

YOU KNOW THE KIND OF
entrancing "Pencil-Slim" figure
Ginger Rogers has! All slim
soft curves! Well, here is a dress
as exciting and vivacious as
Ginger herself! Beruffled at the
shoulders, slim and slinky about
the hips, a swirling flare at your
feet! *The very newest silhouette*
—That's why I selected it for
you. It's Cotton Chiffon Seer-
sucker, as light as silk, and cool
and airy enough for the hottest
July night. The back dips to a
deep V, flowers blossom at your
throat.

Anne Williams

Misses' Sizes: 14-16-18-20 years.
Bust: 32-34-36-38 in.
Lengths, about 52 inches. *State
size.*
31 H 8625—Blue Stripe.
31 H 8626—Green
Stripe............ $2.98
 Sent direct from New York
to You . . . but you pay post-
age only from our nearest Mail
Order House.
 Shipping weight, 1 lb.

Page 12 ■

FIGURES ... FEMALE?

Looking, as all men must, at the increasing array of
photographs of girls in our magazines, I am led to the
inescapable conclusion that something terribly wrong,
and perhaps dangerous, is afoot. And I don't mean
dangerous to me or other men . . . I mean dangerous
to the girls themselves.

Other and more learned writers have commented
upon the American mania for sex and its growing use
to sell everything from lipstick to Diesel engines . . .
none of which I object to . . . that is, if it *were* sex!

But the notion, as exemplified by editors and pho-
tographers in these magazines as to what constitutes
sex and gives forth as a girl, or even an attractive
female has, I submit, gone completely haywire. Indeed,
in a manner of speaking, the employment of these
creatures as symbols of sex has reached the point of
diminishing returns!

No one, I think, or at least no man old enough to
remember women who looked like females, can accuse
the editors and photographers of using sex when the
symbols they display are emaciated, scrawny, fusiform,
spiny sticks, instead of standard animated females! The
girls selected for models today are a disgrace to the
female race. Not only do they look like shrunken un-
healthy Dead End boys, who have just crawled through
a fence, and a very tight fence . . . but the bored,
blase, supercilious, and sneering look on their faces, in-
dicates that the models too have forsworn and abjured
sex and have entered a curious land of neuter gender
from which there is no return.

I haven't a daughter, unfortunately for me . . . but
if I did have one, the last ambition I should want her
to seize upon would be to become a model. I know
men who do have daughters and some of these girls
had such ambitions and realized the same. My friends
tell me that when they see their daughters, they hardly
recognize them. Furthermore they are worried about
them . . . and not the way fathers are usually worried
about daughters. They are worried for fear the poor
girls will starve to death.

No woman wants to be fat I am sure, but there is
a reasonable point beyond which they cease to be
women . . . or what is commonly recognized by us old-
timers as women . . . and become travesties of women.

I don't know if there are any men interested any
longer . . . this thing has gone so far . . . but I am
willing to start a new Society for Saving Spindly Girls.
Now men, don't laugh . . . because the poor incapa-
cious creatures are dying . . . of starvation.

−2.17− Vermont Country Store's Vrest Orten was ahead of his time.
Here he calls for the creation of a "Society for Saving Spindly Girls"

Sturdy Ranchwear for Boys

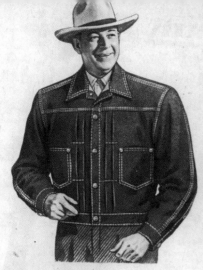

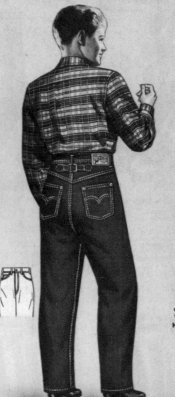

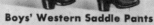

Strong 8-Oz. Denim Cowboy Jacket

A mighty low price to pay for the finest 8-ounce indigo blue denim, in a roomy, strongly-tailored work jacket you can wear day in and day out for months and months! **San-forized-Shrunk** for permanent good fit. Maximum fabric shrinkage 1%. **Main seams triple-stitched**—guaranteed not to rip. **Copper rivets at pocket corners**—won't pull out. Panel pleats in front and back for easy action. Adjustable back strap. Average length, 22 inches. Union Made in the West.

Sizes: Even chest sizes 34 to 44 inches. **State chest measurement.** Shipping weight, 2 pounds.
51 K 742—8-Ounce Denim Cowboy Jacket...... **$1.39**

$1.39

Handy Zip Bottoms

Double Seat Double Knees

Boys' Western Saddle Pants

Super heavy 9-oz. coarse weave blue denim. Sanforized-Shrunk (fabric shrinkage 1%). Western made ... famous Circle S Ranch quality throughout, with a big leather label. Twenty tough copper rivets and bartacks at all strain points. Heavy drill pocketing. Western style yoke back with adjustable back strap.

Even sizes: 6 to 18. **State size.** See Page 366.
50 K 9107—Shpg. wt., 1 lb.............. $1.00

$1.00

Sanforized Breeches for Boys

Extra heavy 8-oz. cotton whipcord. Sanforized (maximum fabric shrinkage 1%). Five pockets of wear-resisting boat sail drill—two are polo pockets to button. Handy zip legs. Lace them to fit the first time. After that use the zipper!

All sizes: 6 to 18. **State size.** See Page 393C.
40 K 4406—Dark Gray. Shpg. wt., 1 lb. 2 oz.$1.79
40 K 4409—Med. Brown. Shpg. wt., 1 lb. 2 oz. 1.79

$1.79

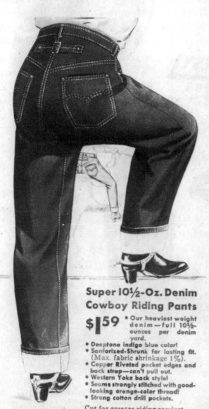

Super 10½-Oz. Denim Cowboy Riding Pants

$1.59

• Our heaviest weight denim—full 10½-ounces per denim yard.
• Deeptone indigo blue color!
• Sanforized-Shrunk for lasting fit. (Max. fabric shrinkage 1%).
• Copper Riveted pocket edges and back strap—can't pull out.
• Western Yoke back style!
• Seams strongly stitched with good-looking orange-color thread!
• Strong cotton drill pockets.

Cut for greater riding comfort ... with snug seat and comfortable thighs tapering down to trim narrow bottoms. Made with all the reinforcements needed to give wear second to none! Convenient slash pockets in front with extra watch pocket.

Sizes: Even waist sizes 30 to 44-in.; even inseam sizes 30 to 36-in. **State waist and inseam measurements.** See How to Measure on Page 447. Shipping weight, 2 pounds 12 ounces.
51 K 730—Indigo Blue 10½-Oz. Denim Riders .. $1.59

Outfit Him Like a Real Cowboy!

In Genuine Leather Vest and Chaps

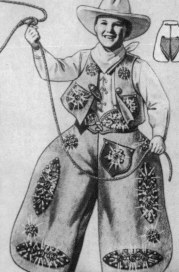

THE VEST ... Made in the West of Genuine Fawn Color Suede Leather

$1.59 For Vest

Add style to your outfit with this smart looking vest—and save at Sears low price. Made in the West—of genuine fawn color suede leather to match the chaps described below.

Two cherry red leather pockets decorated with leather flower cutouts, flashing glass "jewels," and nickel plated studs. Cherry red leather cross strap with two large nickel plated buttons; nickel plated stud decorations on chest.

Sizes: 4, 6, 8, 10, 12, 14. **State size**; see Page 367.
40 K 4350—Vest only. Shpg. wt., 1 lb........$1.59

THE CHAPS ... Match Above Vest Western Made—Fawn Color Suede

$2.98 For Chaps

Genuine fawn color suede leather fronts, heavy weight brown cotton twill back. Cherry red leather belt has leather flower cut-outs, mirror-like chromium underlay, sparkling glass "jewels," and nickel plated studs. Adjustable buckle in back.

Cherry red leather pocket has leather flower cut-outs, nickel plated studs, and "jewel" stones. Decorated at sides and bottom with cherry red leather flower cut-outs with chromium underlay, glass "jewels," and nickel plated studs.

Sizes: 4, 6, 8, 10, 12, 14. **State size;** see Page 366.
40 K 4351—Chaps only. Shpg. wt., 2 lbs....$2.98

⊗ PAGE 546J RANCHWEAR

Helena Rubinstein

offers solutions for eleven of your beauty problems!

"If I could talk with you personally, I would tell you there is an answer to every one of your beauty problems .. answers that will help you to become more radiant, prettier once you have learned them. For years I have worked with doctors and scientists to perfect the correctives below. I am proud to assure you that you can rely on every product from my world-wide laboratories. They have been scientifically compounded, tested and proved effective. I am so sure of their results when used as directed that I guarantee them or you will get a full refund."—HELENA RUBINSTEIN

Dry Skin?

"PASTEURIZED" FACE CREAM SPECIAL. Thorough cleanser for dry, taut skin or "over-30" skin. Super-fine emollients lubricate, soothe, and leave skin velvety soft. Cream gently, but thoroughly, removes make-up and dirt .. creates finer textured, more translucent look. Trust Helena Rubinstein to aid you to softer looking skin beauty. 3-oz. jar.
8 K 5900E—Postpaid. (Wt. 12 oz.) **$1.65**

Dirty Pores?

DEEP CLEANSER. Creamy liquid with foaming action reaches deep into pore openings, helps whisk out make-up, grime, counteract dryness. Wonder antiseptic R-51 helps prevent externally-caused blemishes by destroying bacteria that commonly cause them. Plastic "squeeze" bottle won't break. 160 cleansings in 6-oz. bottle.
8 K 5904E—Postpaid. (Wt. 12 oz.) **$1.65**

Blackheads?

BEAUTY WASHING GRAINS do a wonderful clean-up job on your pores. These granules and water make an invigorating friction wash that helps rout out stubborn blackheads, other clogging impurities. Gently rids you of flaky, dead skin. Skin beauty begins with scrupulous cleansing . . . the kind that beauty washing grains can give you. 7-oz. box.
8 K 5902E—Postpaid. (Wt. 12 oz.) **$1.49**

Pimple

MEDICATED CREAM—cated formula for skin. Actually helps the skin boon to young people plagued by surface ski press on erupted su overnight. Don't negle ishes . . help them safely. 1-oz. jar.
8 K 5903E—Postpaid.

Lines, Flaky Skin?

"PASTEURIZED" NIGHT CREAM—a luxurious overnight cream that gives deep-down lubrication to dry, taut skin. This extra-rich blend of emollients helps smooth out fine lines as well as roughened areas resulting from winter weather. "Pasteurized" Night Cream works while you sleep . . helps give skin a younger look! 2 ounce jar.
8 K 5933E—Postpaid. (Wt. 12 oz.) . . **$1.93**

Coarse Pores?

PLUS CLEANSER is a miracle for the many women who are embarrassed by coarse pores. This remarkable cream foams and lathers like soap, yet soothes like a cream. Its penetrating lather loosens pore-clogging dirt, helps give skin a finer-textured look . . a glow that comes from skin that is really clean. 4¾-oz. jar.
8 K 5901—Postpaid. (Wt. 1 lb.) **$1.50**

Crow's Feet?

EYE CREAM SPECIAL. You need special care for the dry, delicate area around eyes and on eyelids. This rich, easily absorbed cream helps check age-betraying squint lines, crow's feet, dryness. Smooth on lightly for overnight action. You'll be pleased at how much softer and smoother your skin will look .. how lovely your eyes will look. ⅓-oz. jar.
8 K 5924E—Postpaid. (Wt. 4 oz.) . . **$2.20**

Sagging C

CONTOUR-LIFT FILM. helps "lift," firm and t tours. Sagging chin line Skin is toned, uplifted youthful freshness. U night. An invisible make-up. Choose from ping weights 12 oz.: 5
8 K 5908E—Postpaid. .
8 K 5914E—Postpaid. .

Facial Hair?

2-OZ. NUDIT FOR THE FACE AND ½-OZ. SUPER-FINISH. Only facial hair remover which gives you protection of Super-finish from redness, rash. Apply Nudit, wash off in minutes. Skin feels satin-smooth, fuzz free. Follow with Super-finish. Your skin is protected against bacteria which cause surface blemishes.
8 K 5920E—Postpaid. (Wt. 6 oz.) . . **$2.48**

Overweight?

Diet book with 4 practical plans .. choose the one that best suits you plus handy pill box

REDUCE-AID TABLETS contain exclusive ingredients which help curb appetite.
Vitamin enriched. Four a day provide adults with normal daily need for Vitamins B₁, B₂, C, D; 15% of calcium and 8% of phosphorus, contain Calcium Pantothenate, Niacin Amide and Vitamin B₆. 4-Plan Reduce Book . . . *Ten-day diet* with exchangeable int menus, *Family plan diet* allows dieting while you cook for a family. *Professional woman's diet* gives convenient eating-out food. *Handy diet guide*—lists permissible and non-permissible foods. Plastic pill box for purse use. State candy or coffee flavor. Postpaid. (Wts. 2 lbs.; 4 lbs.)
8 K 5934—140 tablets **$2.95**
8 K 5935—280 tablets 5.00

Wrinkle

ESTROGENIC HORMONE natural hormones—th fective beauty help to ing moisture. Helps n appear, make skin looking. Aids in plump smoothing outer skin look firm and fresh, to
8 K 5921E—Postpaid. (

NOTE: Catalog Numbers ending in "E" include 10% Federal Excise Tax. Order regularly; get Sears Catalo

–2.19– Sears, Helena Rubenstein, 1957

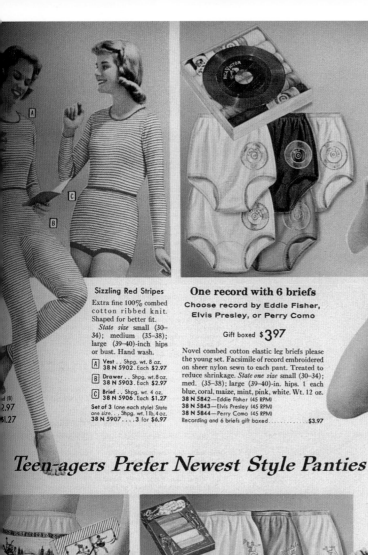

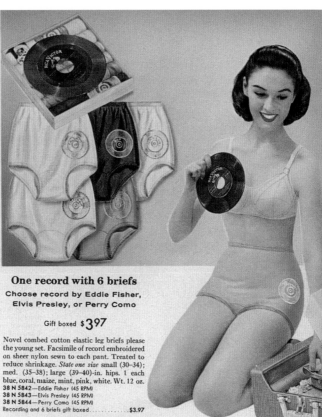

Sizzling Red Stripes

Extra fine 100% combed cotton ribbed knit. Shaped for better fit.
State size small (30–34); medium (35–38); large (39–40)-inch hips or bust. Hand wash.

[A] Vest . . Shpg. wt. 8 oz.
38 N 5902. Each **$2.97**

[B] Drawer . . Shpg. wt. 8 oz.
38 N 5903. Each **$2.97**

[C] Brief . . Shpg. wt. 4 oz.
38 N 5906. Each **$1.27**

Set of 3 (one each style) *State one size.* . Shpg. wt. 1 lb. 4 oz.
38 N 5907 3 for **$6.97**

One record with 6 briefs

Choose record by Eddie Fisher, Elvis Presley, or Perry Como

Gift boxed **$3.97**

Novel combed cotton elastic leg briefs please the young set. Facsimile of record embroidered on sheer nylon sewn to each pant. Treated to reduce shrinkage. *State one size* small (30–34); med. (35–38); large (39–40)-in. hips. 1 each blue, coral, maize, mint, pink, white. Wt. 12 oz.
38 N 5842—Eddie Fisher (45 RPM)
38 N 5843—Elvis Presley (45 RPM)
38 N 5844—Perry Como (45 RPM)
Recording and 6 briefs gift boxed**$3.97**

Teen-agers Prefer Newest Style Panties

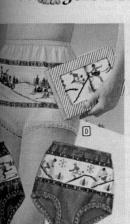

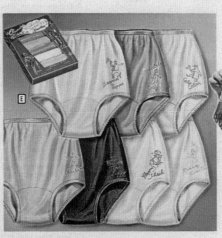

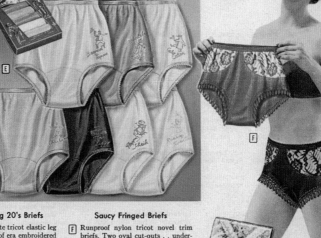

ry Scene Sport Briefs

[D] tricot elastic leg briefs. Leg
gs edged with narrow lace.
ape frames winter scenes on
d. One each black, red,
te one size small (30–34);
(35–38); large (39–40)-inch
g. wt. 12 oz.
—3 briefs gift boxed**$3.27**

Clever Roaring 20's Briefs

[E] Runproof acetate tricot elastic leg briefs. Phrases of era embroidered on sheer nylon sewn to brief. Seven assorted colors 1 each black, blue, green, pink, yellow, 2 white. *State one size* 30–34; 35–38; 39–40-inch hips.
Shipping weight 12 oz.
38 N 5161—7 briefs gift boxed**$3.77**

Saucy Fringed Briefs

[F] Runproof nylon tricot novel trim briefs. Two oval cut-outs . . underlays of white nylon . . overlays of lace. Matching looped fringe edges legs. Package of two . . 1 black, 1 red. *State one size* small (30–34); medium (35–38); large (39–40)-inch hips. Shpg. wt. 4 oz.
38 N 5172—2 briefs in reusable package.**$2.07**

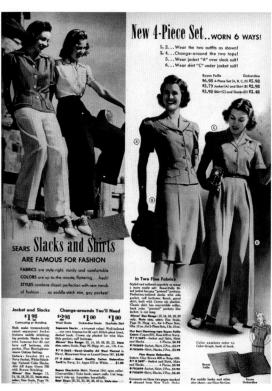

-2.21- Sears, women in pants, 1941

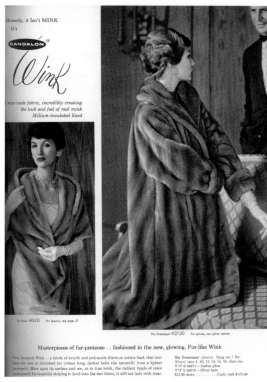

-2.22- It isn't mink, it's Candalon Wink! Sears, 1958

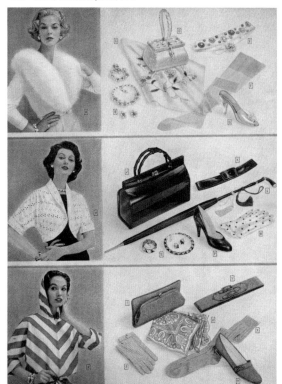

-2.23- Sears, 1957

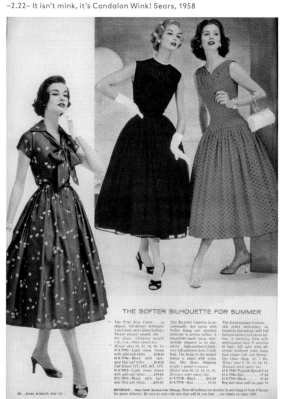

-2.24 -Sears, 1957

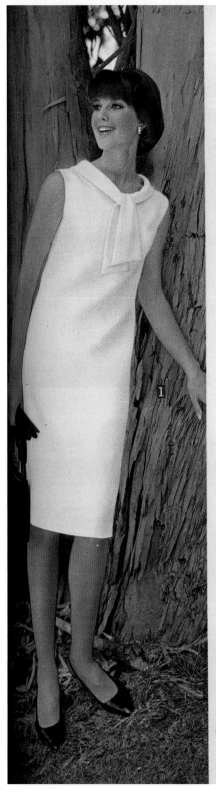

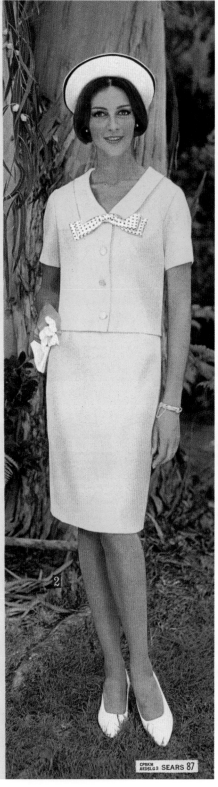

Bright ideas in

PURE
LINEN

from Belgium. Tebelized®
for crease-resistance.

$8.00

1 **Slender dress.** Becoming roll-collar and tie top the gently shaped bodice. Long back zipper. Hand washable separately.

PETITE MISSES' SIZES 8P, 10P, 12P, 14P, 16P. *Please state size.*
V31 K 3368F—Yellow
V31 K 3369F—Lt. copen blue
Shipping weight 1 pound...$8.00

MISSES' SIZES 10, 12, 14, 16, 18.
V31 K 3354F—Yellow
V31 K 3355F—Lt. copen blue
State size. Shpg. wt. 1 lb....$8.00

TALL MISSES' SIZES 10T, 12T, 14T, 16T, 18T. *Please state size.*
V31 K 3358F—Yellow
V31 K 3359F—Lt. copen blue
Shipping weight 1 pound...$8.00

SHORTER WOMEN'S SIZES 14½, 16½, 18½, 20½, 22½.
V31 K 3356F—Yellow
V31 K 3357F—Lt. copen blue
State size. Shpg. wt. 1 lb....$8.00

2 **Two-piece dress.** Chelsea-collared top with perky polka-dot bow in navy on white. Back zipped skirt. Hand wash separately. Bracelet sold on page 36.

PETITE MISSES' SIZES 6P, 8P, 10P, 12P, 14P. *Please state size.*
V31 K 3300F—Yellow
V31 K 3301F—Geranium red
Shipping wt. 1 lb. 2 oz....$8.00

MISSES' SIZES 10, 12, 14, 16, 18.
V31 K 3294F—Yellow
V31 K 3295F—Geranium red
State size. Wt. 1 lb. 2 oz....$8.00

TALL MISSES' SIZES 10T, 12T, 14T, 16T, 18T. *Please state size.*
V31 K 3298F—Yellow
V31 K 3299F—Geranium red
Shipping wt. 1 lb. 2 oz....$8.00

SHORTER WOMEN'S SIZES 14½, 16½, 18½, 20½, 22½.
V31 K 3296F—Yellow
V31 K 3297F—Geranium red
State size. Wt. 1 lb. 2 oz....$8.00

Be sure to use
**SEARS NEW
MEASUREMENT CHARTS**
for proper fit
.. see pages 654, 655

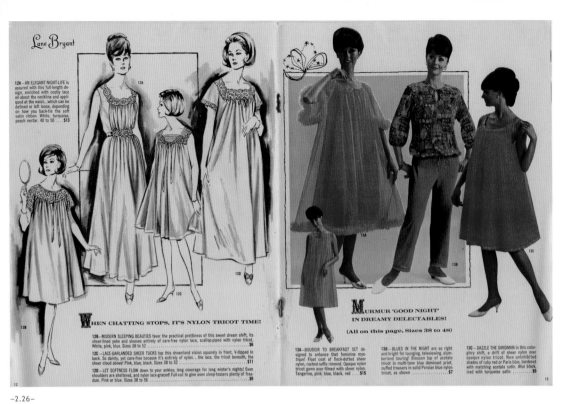

12A—AN ELEGANT NIGHT-LIFE is assured with this full-length design, enriched with costly lace all-about the neckline and appliqued at the waist...which can be defined or left loose, depending on how you back-tie the soft satin ribbon. White, turquoise, peach nectar. 40 to 50 $13

WHEN CHATTING STOPS, IT'S NYLON TRICOT TIME!

12B—MODERN SLEEPING BEAUTIES favor the practical prettiness of this sweet dream shift, its sheer-lined yoke and sleeves entirely of care-free nylon tricot, scallop-piped with nylon tricot. White, pink, blue. Sizes 38 to 52 . $6

12C—LACE-GARLANDED SHEER TUCKS top this dreamland vision squarely in front, V-dipped in back. So dainty, yet care-free because it's entirely of nylon...the lace, the tricot beneath, the sheer cloud above! Pink, blue, black. Sizes 38 to 52 . $11

12D—LET SOFTNESS FLOW down to your ankles; long coverage for long winter's nights! Even shoulders are sheltered, and nylon lace-graced! Full-cut to give even sleep-tossers plenty of freedom. Pink or blue. Sizes 38 to 56 . $6

MURMUR 'GOOD NIGHT' IN DREAMY DELECTABLES!

(All on this page, Sizes 38 to 48)

13A—BOUDOIR TO BREAKFAST SET designed to enhance that feminine mystique! Float coat of flock-dotted sheer nylon, ruched-ruffle rimmed. Opaque nylon tricot gown over-filmed with sheer nylon. Tangerine, pink, blue, black, red $15

13B—BLUES IN THE NIGHT are so right and bright for lounging, televiewing, slumberland touring! Biouson top of acetate tricot in multi-tone blue dominant print, cuffed trousers in solid Persian blue nylon tricot, as shown $7

13C—DAZZLE THE SANDMAN in this colorglory shift, a drift of sheer nylon over opaque nylon tricot. New uninhibited shades of ruby red or Paris blue, bordered with matching acetate satin. Also black, iced with turquoise satin $9

—2.26—

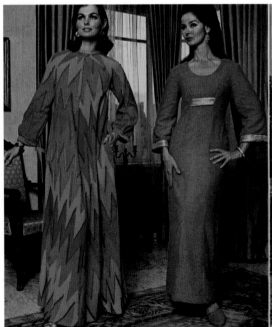

For gold leather mules pictured above, see page 55, style 141.

761 • ZigZag
Capturing excitement and beauty in a marvelous zigzag blend of color, our flowing robe is for hostessing in the grand manner. Starkly simple lines with raglan sleeves gathered into circle cuffs. Side pockets. Back zipped. Screen print terry as shown. Sm(8-10), Med(12-14), Lg(16-18). $22.95
page 56

For grass-green mules pictured above, see page 55, style 150.

765 • Camelot
Loveliness itself! A reed-slim length of terry—gently curved with a paneled front to make it look even slimmer. Just a hint of a high waistline, but with what dramatic effect. Back zipped. In grass-green with gold trim. Washable, of course. Sm(8-10), Med(12-14), Lg(16-18). $17.95

For grass-green mules as pictured, see page 55, style 150.

753 • Chinese Culotte
Our floor-length culotte looks ravishing with wide, wide pants that fall in folds like a skirt. We love the Chinese look of the mandarin collar and the long slim sleeves. Zips neatly up the front. Terry print as shown. Small(8-10), Medium(12-14), Large(16-18). $17.95

For white mules as pictured, see page 55, style 150.

766 • Romantic Rose
Roses and romance in a softly flowing robe of unusual beauty. The front falls smoothly from a rolled collar. The back is slightly V-d, zippered and finished with a bow and streamers of pink ribbon. Hidden side pockets. Print terry as shown. Sm(8-10), Med(12-14), Lg(16-18). $18.95
page 57

—2.27— Catalogs offered sleepwear with scrumptious-sounding names like Nylon tricot, Dreamy Delectables, Camelot, and Romatic Rose; Montgomery Ward.

Long, Flowing Knits that You Can Machine Wash

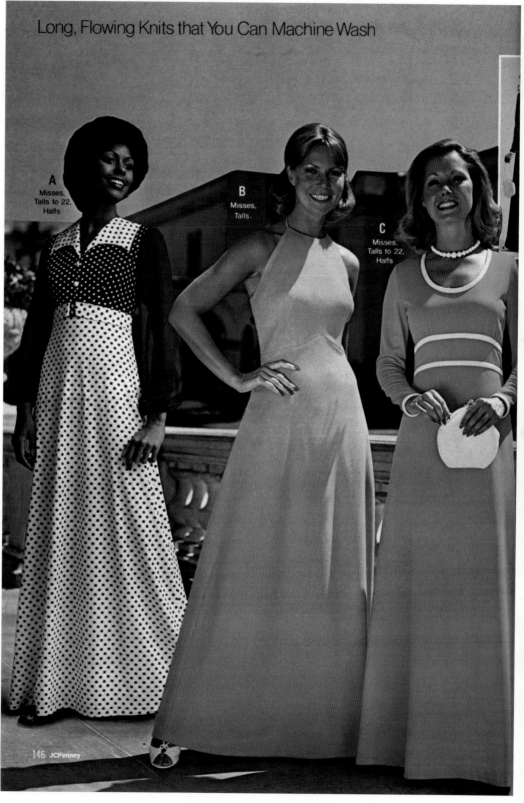

A
Misses,
Talls to 22,
Halfs

B
Misses,
Talls.

C
Misses,
Talls to 22,
Halfs

146 JCPenney

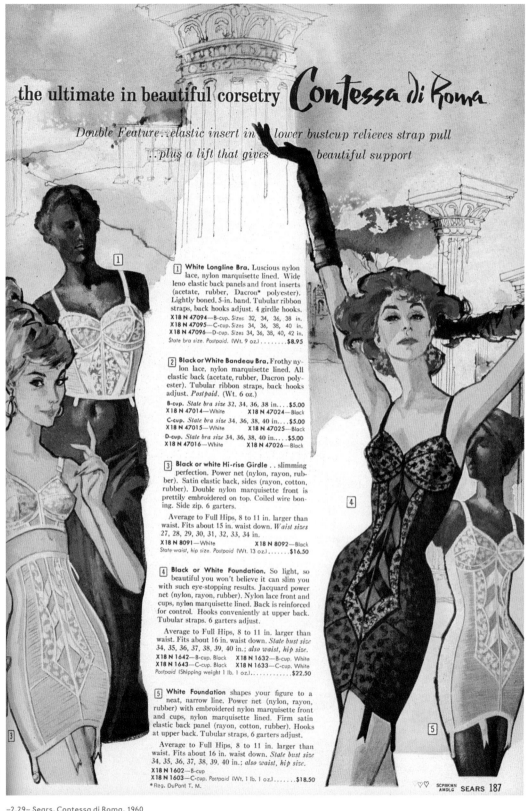

the ultimate in beautiful corsetry *Contessa di Roma*

Double Feature..elastic insert in lower bustcup relieves strap pull
..plus a lift that gives beautiful support

[1] **White Longline Bra.** Luscious nylon lace, nylon marquisette lined. Wide leno elastic back panels and front inserts (acetate, rubber, Dacron* polyester). Lightly boned. 5-in. band. Tubular ribbon straps, back hooks adjust. 4 girdle hooks.
X18 N 47094—B-cup. Sizes 32, 34, 36, 38 in.
X18 N 47095—C-cup. Sizes 34, 36, 38, 40 in.
X18 N 47096—D-cup. Sizes 34, 36, 38, 40, 42 in.
State bra size. Postpaid. (Wt. 9 oz.)**$8.95**

[2] **Black or White Bandeau Bra.** Frothy nylon lace, nylon marquisette lined. All elastic back (acetate, rubber, Dacron polyester). Tubular ribbon straps, back hooks adjust. *Postpaid.* (Wt. 6 oz.)
B-cup. *State bra size* 32, 34, 36, 38 in....**$5.00**
X18 N 47014—White X18 N 47024—Black
C-cup. *State bra size* 34, 36, 38, 40 in....**$5.00**
X18 N 47015—White X18 N 47025—Black
D-cup. *State bra size* 34, 36, 38, 40 in.....**$5.00**
X18 N 47016—White X18 N 47026—Black

[3] **Black or white Hi-rise Girdle** . . slimming perfection. Power net (nylon, rayon, rubber). Satin elastic back, sides (rayon, cotton, rubber). Double nylon marquisette front is prettily embroidered on top. Coiled wire boning. Side zip. 6 garters.
Average to Full Hips, 8 to 11 in. larger than waist. Fits about 15 in. waist down. *Waist sizes* 27, 28, 29, 30, 31, 32, 33, 34 in.
X18 N 8091—White X18 N 8092—Black
State waist, hip size. Postpaid (Wt. 13 oz.)**$16.50**

[4] **Black or White Foundation.** So light, so beautiful you won't believe it can slim you with such eye-stopping results. Jacquard power net (nylon, rayon, rubber). Nylon lace front and cups, nylon marquisette lined. Back is reinforced for control. Hooks conveniently at upper back. Tubular straps. 6 garters adjust.
Average to Full Hips, 8 to 11 in. larger than waist. Fits about 16 in. waist down. *State bust size* 34, 35, 36, 37, 38, 39, 40 in.; *also waist, hip size.*
X18 N 1642—B-cup. Black X18 N 1632—B-cup. White
X18 N 1643—C-cup. Black X18 N 1633—C-cup. White
Postpaid (Shipping weight 1 lb. 1 oz.)**$22.50**

[5] **White Foundation** shapes your figure to a neat, narrow line. Power net (nylon, rayon, rubber) with embroidered nylon marquisette front and cups, nylon marquisette lined. Firm satin elastic back panel (rayon, cotton, rubber). Hooks at upper back. Tubular straps, 6 garters adjust.
Average to Full Hips, 8 to 11 in. larger than waist. Fits about 16 in. waist down. *State bust size* 34, 35, 36, 37, 38, 39, 40 in.; *also waist, hip size.*
X18 N 1602—B-cup
X18 N 1603—C-cup. *Postpaid* (Wt. 1 lb. 1 oz.)**$18.50**
* Reg. DuPont T. M.

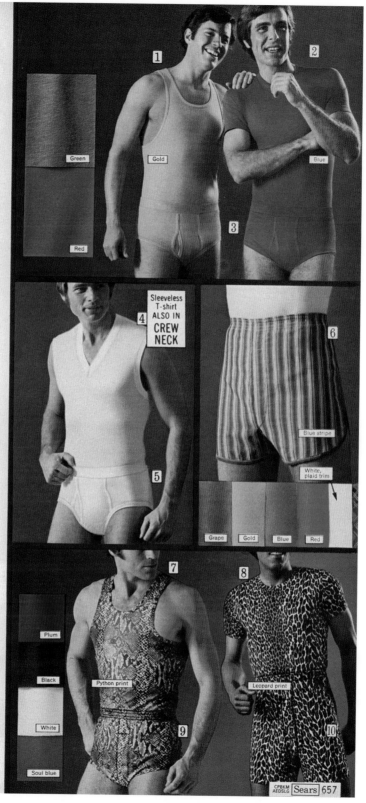

–2.30– Nothing warms a woman's heart like a man in python print underwear, Sears, 1971

NEATNIKS MAKE GREAT PLAYMATES

Girls who wear these darling new Perma-Prest® coordinates are ready for all kinds of fun. Without a worry in the world about making too much work for mother!

Because their Neatnik® stretch-knit tops and double-knit pants are Perma-Prest, they need no ironing. Just tumble dry. No wilting. And they won't bag or shrink out of shape.

What's more, this Fortrel® polyester and cotton knit is tough on the outside, so it resists abrasion—yet cuddly soft on the inside to pamper a girl's skin. In pastel pink, blue, green or yellow. Girls' sizes 7-14; chubby sizes, too. At Sears, Roebuck and Co. now.

Note to Neatniks—Only Sears has the Perma-Prest clothes girls love.

Sears

–2.31– Sears, children's apparel, 1969

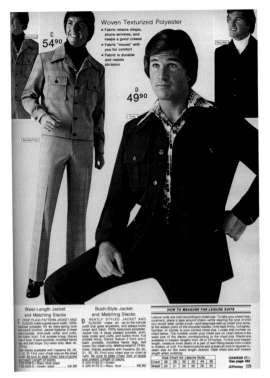

Woven Texturized Polyester

- Fabric retains shape, shuns wrinkles, and keeps a good crease
- Fabric "moves" with you for comfort
- Fabric is durable and resists abrasion

C **54.90**

D **49.90**

Waist-Length Jacket and Matching Slacks

Bush-Style Jacket and Matching Slacks

–2.32– JC Penney, leisure suits, 1974

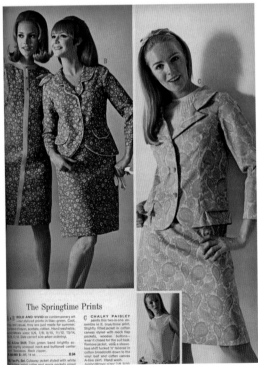

The Springtime Prints

–2.33– JC Penney, 1967

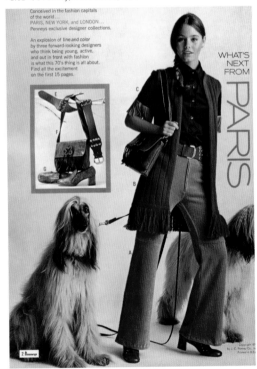

Conceived in the fashion capitals of the world...
PARIS, NEW YORK, and LONDON...
Penneys exclusive designer collections.

An explosion of line and color by three forward-looking designers who think being young, active, and out in front with fashion is what this 70's thing is all about. Find all the excitement on the first 15 pages.

WHAT'S NEXT FROM PARIS

–2.34– JC Penney, Susan Dey, 1970

THE IMPORTANT LOOKS IN NIGHTWEAR

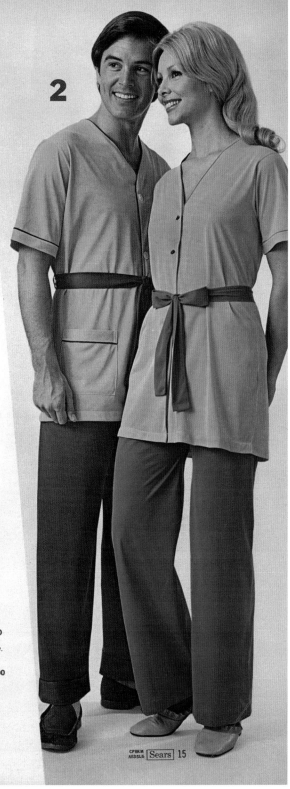

2

1.. in Kimonos done for the first time in soft, warm, luxurious Wincama® fleece

The cozy kimono .. to wrap and lounge in all year 'round. The elegant knit fabric is 80% Arnel® triacetate, 20% brushed nylon .. so richly blended it actually takes on the look of velour. Knee length. Roomy ¾ length sleeves. Two patch pockets. Self-tie belt (men's has Gripper® snaps to anchor sash to belt loops). Wonderfully machine washable at warm temperature .. PERMA-PREST® fabric never needs ironing when you tumble dry.

HIS: *One size fits all.*
33 G 80357—Blue
33 G 80353—Copper
Shipping weight 1 pound 8 ounces **$18.00**

HERS: Misses' sizes S(10-12); M(14-16); and L(18).
Please state size letter S, M, or L.
38 G 88619F—Blue
38 G 88618F—Copper
Shipping weight 1 pound 3 ounces **$15.00**

2.. in nylon tricot Pajamas that coordinate beautifully with the Wincama® kimonos

Soft, smooth nylon tricot in vibrant two-tones that look great with kimonos . . or alone. Lightly colored tunic tops have a contrasting, dark tie sash. There's dark piping, too, on the 3-button front, short sleeve cuffs, and V-neck. Men's top has pocket with dark piping. Straight-leg pants match up to the piping and sash, have comfortable boxer-style waistbands. Buttons are pearlized plastic. Best of all, the fine PERMA-PREST® fabric keeps its good looks with minimum care. Just machine wash, medium; tumble dry.

HIS: Chest sizes S(34 to 36 inches); M(38-40 inches); L(42-44 inches); XL(46-48 inches).
Please state size letter S, M, L or XL.
33 G 11781F—Light blue and medium blue
33 G 11784F—Amber and brown
Shipping weight 1 pound 5 ounces **$9.00**

HERS: Bust sizes 32, 34, 36, 38, 40. *Please state size.*
38 G 17372F—Light blue and medium blue
38 G 17373F—Amber and brown
Shipping weight 14 ounces **$7.00**

ORDER YOUR USUAL SIZE ..
if in doubt, see pages 748 and 749

CPBKM
AEDSLG Sears 15

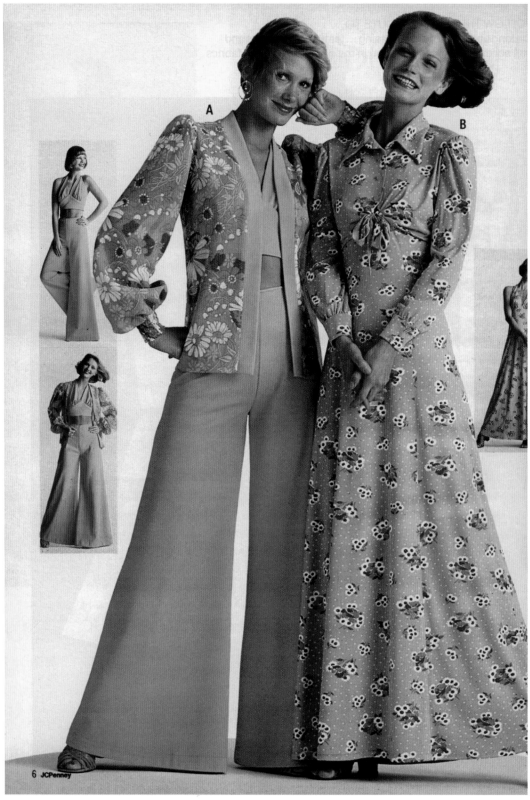

A

B

6 JCPenney

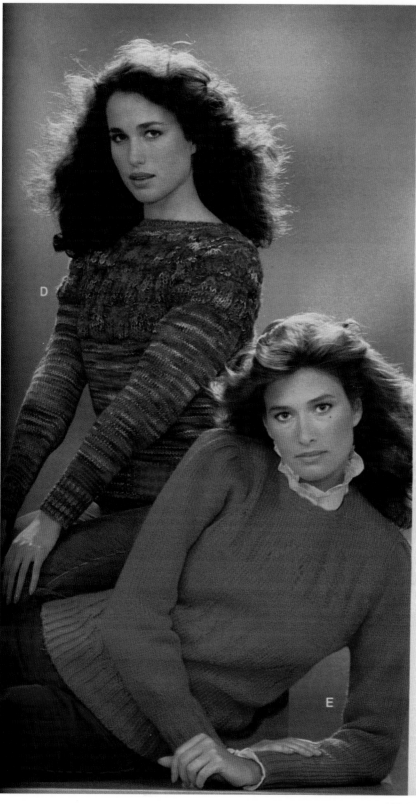

D. Color, shape, texture work together in new ways. Pullover of acrylic knit. Bubble-stitch front yoke and shoulders. Rib-knit boat neckline, cuffs, and bottom. Multicolor tweedy yarn. Machine wash warm, dry flat. Imported from Taiwan. Del. wt. 0.90 lb.
Misses Sizes: S(8-10), M(12-14), L(16-18). State S, M, or L.
State color number-and-name: 01 pink; 49 rust.
R 281-3400 D............ 23.00

E. A pretty pair— the sweater with pointelle-and-cable-stitch front over a ruffled blouse. Pullover sweater of acrylic knit. Scallop-edged neckline. Rib-knit cuffs and bottom. Blouse of woven polyester. Ruffled collar and cuffs. Button front. Machine wash warm, tumble dry—low heat. Imported from Korea. Del. wt. 0.90 lb.
Misses Sizes: S(8-10), M(12-14), L(16-18). State S, M, or L.
State color number-and-name: 02 rose; 35 blue; 52 beige.
R 281-3129 D............ 28.00

–2.37– J. C. Penney, Andie MacDowell, 1982

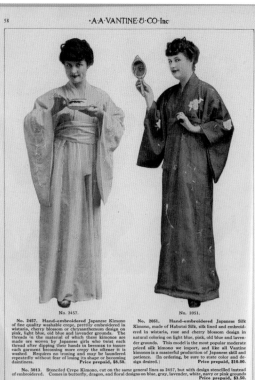
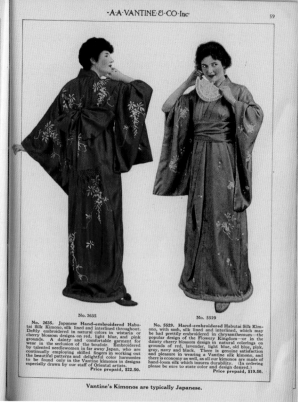

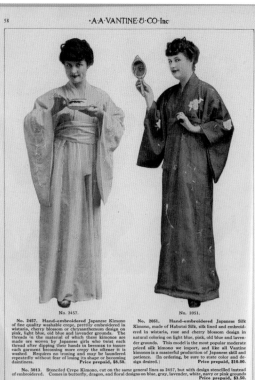
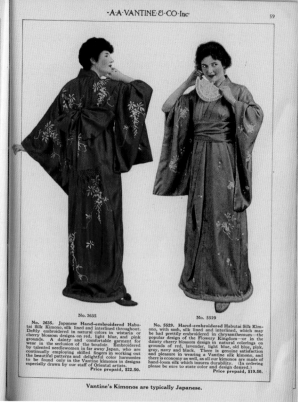

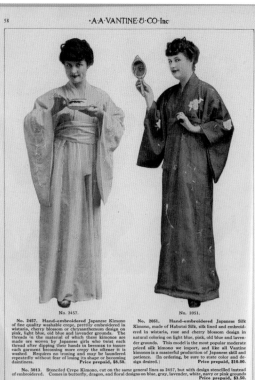

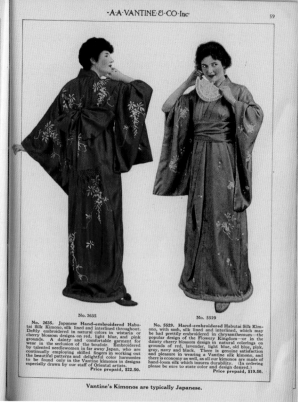

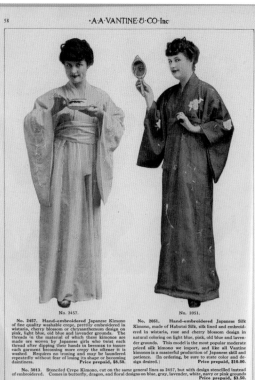

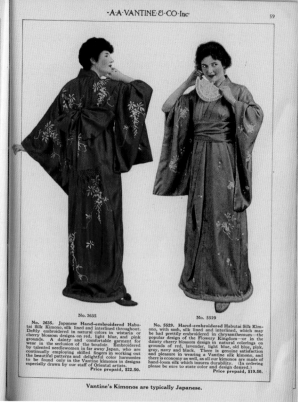

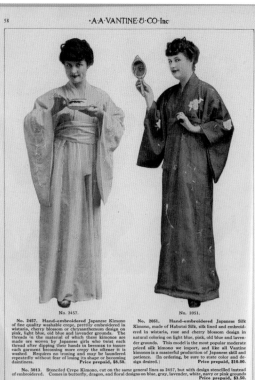

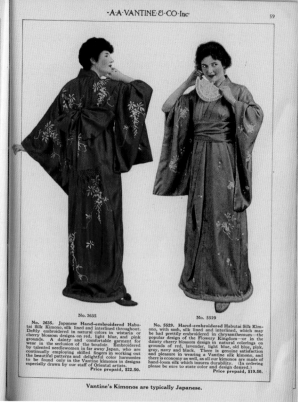

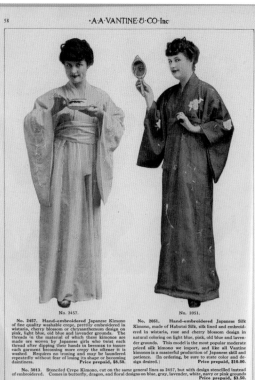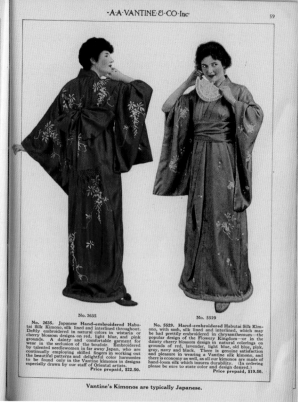

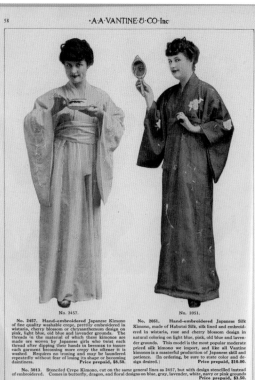

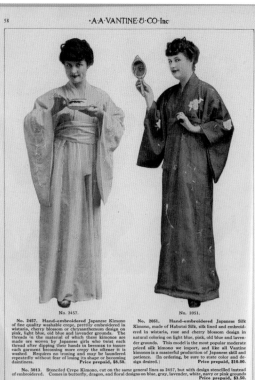
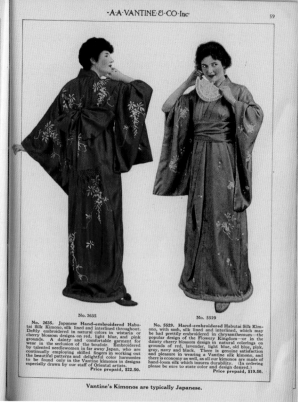

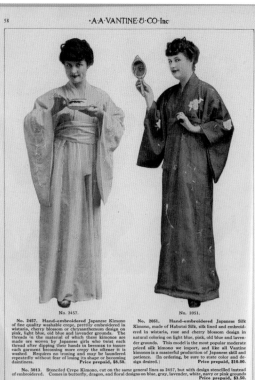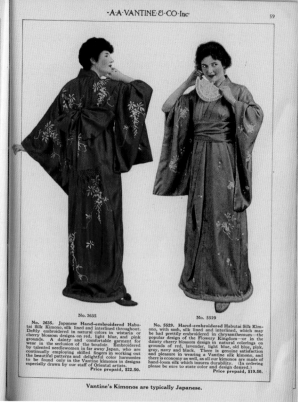

Top double-page catalog spread:

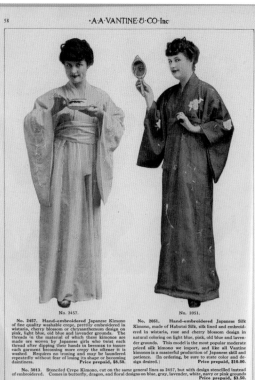

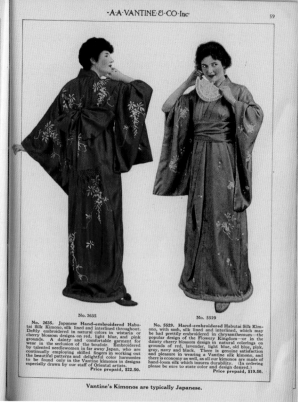

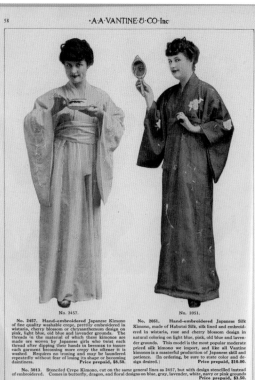

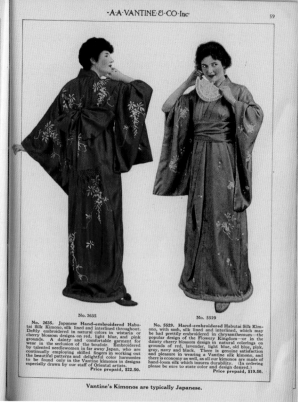

Page 58 / 59 — ·A·A·VANTINE·&·CO·Inc·

No. 2457.

No. 2051.

No. 2635

No. 5529

No. 2457. Hand-embroidered Japanese Kimono of fine quality washable crepe, prettily embroidered in wistaria, cherry blossom or chrysanthemum design on pink, light blue, old blue and lavender grounds. The threads in the material of which these kimonos are made are woven by Japanese girls who twist each thread after dipping their hands in beeswax to insure each garment becoming more crepy the oftener it is washed. Requires no ironing and may be laundered repeatedly without fear of losing its shape or becoming daintiness. **Price prepaid, $8.50.**

No. 3013. Stenciled Crepe Kimono, cut on the same general lines as 2457, but with design stenciled instead of embroidered. Comes in butterfly, dragon, and floral designs on blue, gray, lavender, white, navy or pink grounds. **Price prepaid, $3.50.**

No. 2051. Hand-embroidered Japanese Silk Kimono, made of Habutai Silk, silk lined and embroidered in wistaria, rose and cherry blossom design in natural coloring on light blue, pink, old blue and lavender grounds. This model is the most popular priced silk kimono we import, and like all Vantine kimonos is a masterful production of Japanese skill and patience. (In ordering, be sure to state color and design desired.) **Price prepaid, $10.00.**

No. 2635. Japanese Hand-embroidered Habutai Silk Kimono, silk lined and interlined throughout. Deftly embroidered in natural colors in wistaria or cherry blossom designs on red, light blue, and pink grounds. A dainty and comfortable garment for wear in the seclusion of the boudoir. Embroidered by talented needlewomen in far away Japan, who are continually employing skilled fingers in working out the beautiful patterns and delightful color harmonies to be found only in the Vantine kimonos in designs especially drawn by our staff of Oriental artists. **Price prepaid, $22.50.**

No. 5529. Hand-embroidered Habutai Silk Kimono, with sash, silk lined and interlined, which may be had prettily embroidered in chrysanthemum—the popular design of the Flowery Kingdom—or in the dainty cherry blossom design in natural colorings on grounds of red, lavender, light blue, old blue, pink, gray, navy and black. There is genuine satisfaction and pleasure in wearing a Vantine silk kimono, and there is economy as well, as all our kimonos are made of hand-loom silk which insures durability. (In ordering please be sure to state color and design desired.) **Price prepaid, $19.50.**

Dainty boudoir garments that are practical and pretty.

Vantine's Kimonos are typically Japanese.

–2.38– A A Vantine & Co., Inc., Japanese kimonos, 1917

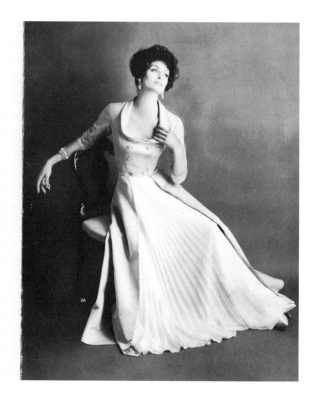

2A. Clear vinyl veils a glow of rayon satin. Bag by Patricia of Miami in black, white, champagne beige. 8½" high, 7½" top, 11½" bottom. $18.95
2B. Koret bag in silky-soft non-crockable Koretolope (suede) with mock tortoise handle. Black, brown, navy. 11" wide, 8" high. $55.95

Rich-as-tapestry rayon broade purse accessories, the floral motif sparked with hand beaded "pretend" gems. Our exclusives, by Wand Arts.

2C. Compact $8.50
2D. Clutch purse $10
2E. Cigarette case $12.50
2F. Evans lighter $8.50
Not shown: 2G. Petite French purse $8.50. 2H. Comb $5.50
2J. Eyeglass case $9.50
All prices on this page plus 10% Federal Tax

(Opposite page)
3A. Our exclusive hostess gown of silk peau d'ange is beautiful to watch in motion, with its pleated panel of silk chiffon. Pale pink or blue; 10-16. $150
Also in purple, green, or porcelain blue velveteen with contrasting panel; 10-16. $125

2A

2B

2C

2F

2E

2D

3A

–2.39– Bergdorf Goodman, hostess gown, 1958

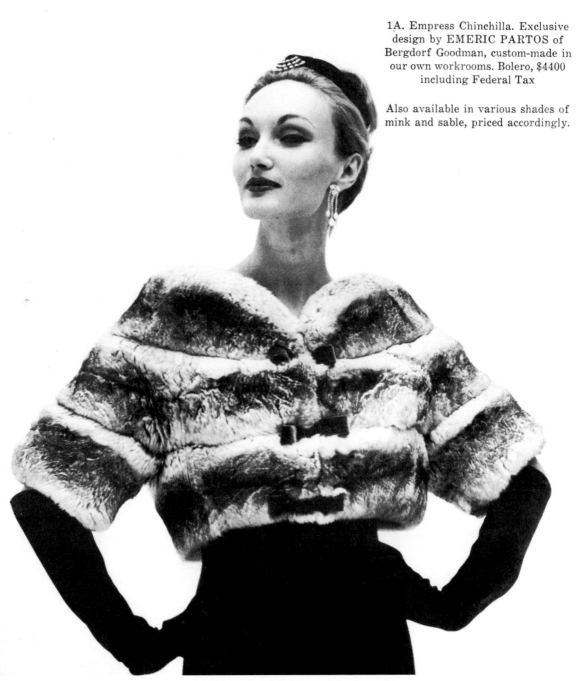

1A. Empress Chinchilla. Exclusive design by EMERIC PARTOS of Bergdorf Goodman, custom-made in our own workrooms. Bolero, $4400 including Federal Tax

Also available in various shades of mink and sable, priced accordingly.

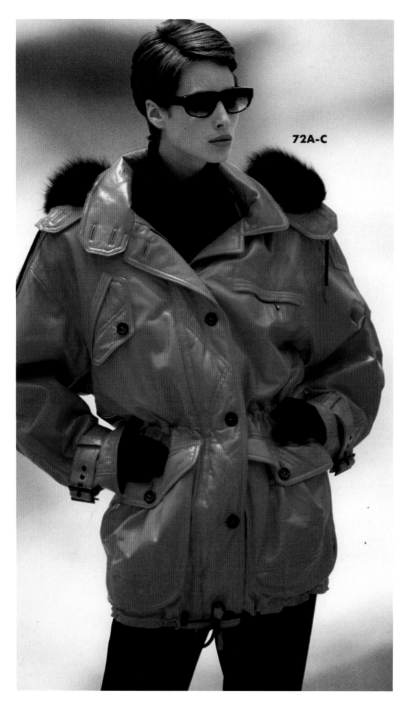

72A-C

−2.41− Neiman Marcus, Christy Turlington

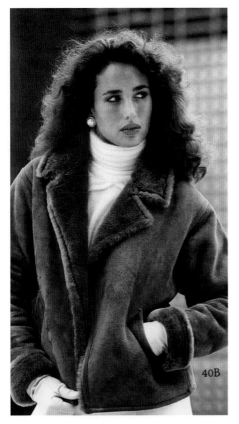

40B

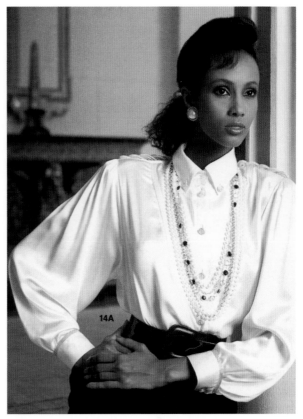

14A

-2.42- Neiman Marcus, Andie MacDowell

-2.43- Neiman Marcus, Iman

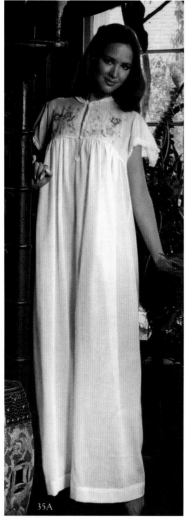

−2.44− Neiman Marcus, Morgan Fairchild

−2.45− Neiman Marcus, Janine Turner

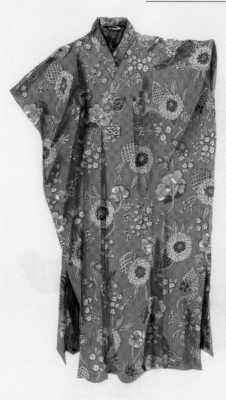

Hanami Caftan.

The cherry trees will blossom soon. Time for another hanami, a flower viewing, on the banks of the Hozu River.

Noble Mt. Arashiyama in the distance. Soft tolling of bells from an ancient Shinto shrine. Sip fragrant tea, discuss nuances of pink.

By evening, you will all be in a hot tub, drinking Suntory whisky and singing old geisha songs filled with double-entendres. It is an honorable tradition.

Hanami Caftan (№. 1845), in a gorgeous Déco Japanese floral pattern. Comfortable cotton poplin. Flowing, ankle-length cut. 2" wide crossover V-neck. Deep side-seam pockets and side vents.

As the poet Basho said, "The moon is brighter since the barn burned."

Size: one size fits most.
Color: shades of Pink, with Green, Blue, Orange, and Red.
Reg price: $88.
Sale: $55.

Colt in Clover. The sight of a young American Saddlebred frisking over a Lexington hillside is a glorious thing...those long legs really do almost seem to unfold in slow motion.

Later, it gets even better. The limestone water here encourages more length of bone. And years of training perfect the high-stepping gait.

I'm not surprised that women in Bluegrass Country, the ones who spend time around horses, often favor pants like these.

Thoroughbred Twill Pants (№. 1902), in fine-line cotton blend with stretch for comfort and fit. Clean Hollywood waistband. Buttoning back pockets.

The precise seams, high fly, vertical side pockets, and straight-cut legs create a long, graceful look.

See you at the Kentucky Horse Park Classic.

Women's sizes: 4 through 16.
Colors: Stone, Tan.
Reg. price: $78.
Sale: $59.

−2.46− J. Peterman

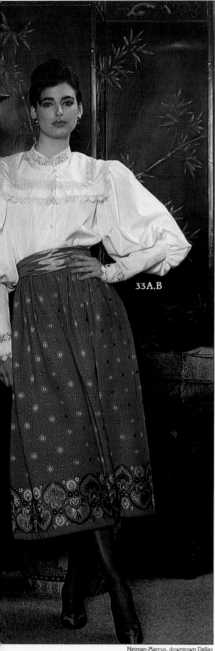

33A,B

Neiman-Marcus, downtown Dallas

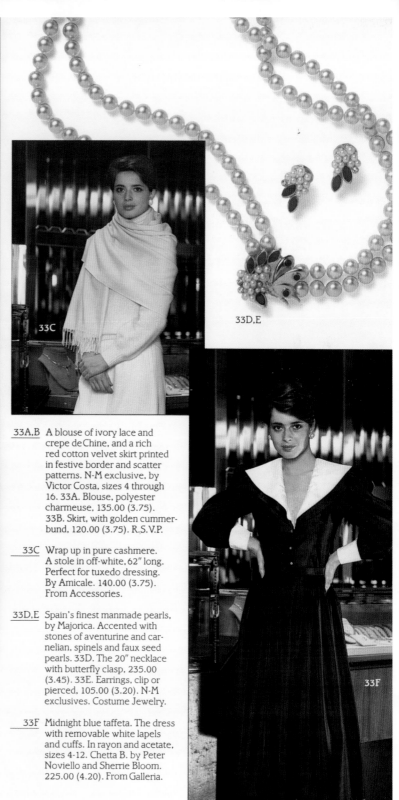

33C

33D,E

33F

33A,B A blouse of ivory lace and
crepe de Chine, and a rich
red cotton velvet skirt printed
in festive border and scatter
patterns. N-M exclusive, by
Victor Costa, sizes 4 through
16. 33A. Blouse, polyester
charmeuse, 135.00 (3.75).
33B. Skirt, with golden cummer-
bund, 120.00 (3.75). R.S.V.P.

33C Wrap up in pure cashmere.
A stole in off-white, 62" long.
Perfect for tuxedo dressing.
By Amicale. 140.00 (3.75).
From Accessories.

33D,E Spain's finest manmade pearls,
by Majorica. Accented with
stones of aventurine and car-
nelian, spinels and faux seed
pearls. 33D. The 20" necklace
with butterfly clasp, 235.00
(3.45). 33E. Earrings, clip or
pierced, 105.00 (3.20). N-M
exclusives. Costume Jewelry.

33F Midnight blue taffeta. The dress
with removable white lapels
and cuffs. In rayon and acetate,
sizes 4-12. Chetta B. by Peter
Noviello and Sherrie Bloom.
225.00 (4.20). From Galleria.

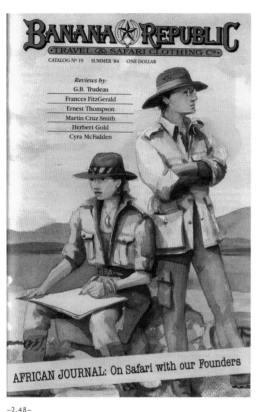

Reviews by:
G.B. Trudeau
Frances FitzGerald
Ernest Thompson
Martin Cruz Smith
Herbert Gold
Cyra McFadden

AFRICAN JOURNAL: On Safari with our Founders

–2.48–

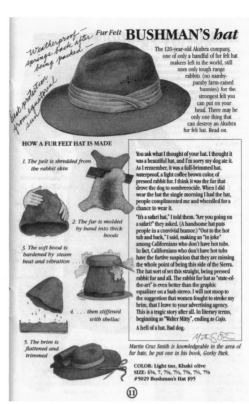

Weatherproof springs back after being packed

best protection from equatorial sun

Fur Felt BUSHMAN'S *hat*

The 120-year-old Akubra company, one of only a handful of fur felt hat makers left in the world, still uses only tough range rabbits (no namby-pamby farm-raised bunnies) for the strongest felt you can put on your head. There may be only one thing that can destroy an Akubra fur felt hat. Read on.

HOW A FUR FELT HAT IS MADE

1. *The pelt is shredded from the rabbit skin*

2. *The fur is molded by hand into thick hoods*

3. *The soft hood is hardened by steam heat and vibration . . .*

4. *. . . then stiffened with shellac*

5. *The brim is flattened and trimmed*

You ask what I thought of your hat. I thought it was a beautiful hat, and I'm sorry my dog ate it. As I remember, it was a full-brimmed hat, waterproof, a light coffee brown color, of pressed rabbit fur. I think it was the fur that drove the dog to sombrericide. When I did wear the hat the single morning I had the hat, people complimented me and wheedled for a chance to wear it.

"It's a safari hat," I told them. "Are you going on a safari?" they asked. (A handsome hat puts people in a convivial humor.) "Out to the hot tub and back," I said, making an "in joke" among Californians who don't have hot tubs. In fact, Californians who don't have hot tubs have the furtive suspicion that they are missing the whole point of being this side of the Sierra. The hat sort of set this straight, being pressed rabbit fur and all. The rabbit fur hat as "state-of-the-art" is even better than the graphic equalizer on a Saab stereo. I will not stoop to the suggestion that women fought to stroke my brim, that I leave to your advertising agency. This is a tragic story after all. In literary terms, beginning as "Walter Mitty", ending as *Cujo*.

A hell of a hat. Bad dog.

Martin Cruz Smith is knowledgeable in the area of fur hats; he put one in his book, Gorky Park.

COLOR: Light tan, Khaki olive
SIZE: 6⅞, 7, 7⅛, 7¼, 7⅜, 7½, 7⅝
#5029 Bushman's Hat $95

⑪

–2.49–

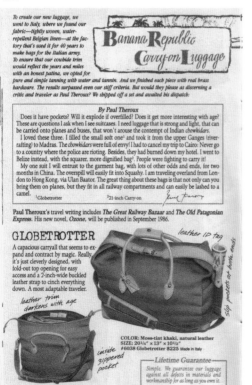

To create our new luggage, we went to Italy, where we found our fabric—tightly woven, water-repellent Belgian linen—at the factory that's used it for 40 years to make bags for the Italian army. To ensure that our cowhide trim would acquire the years and miles with an honest patina, we opted for pure and simple tanning with water and tannin. And we finished each piece with real brass hardware. The results surpassed even our stiff criteria. But would they please as discerning a critic and traveler as Paul Theroux? We shipped off a set and awaited his dispatch:

Banana Republic Carry-on Luggage

By Paul Theroux

Does it have pockets? Will it explode if overfilled? Does it get more interesting with age? These are questions I ask when I see suitcases. I need luggage that is strong and light, that can be carried onto planes and buses, that won't arouse the contempt of Indian *chowkidars*.

I loved these three. I filled the small soft one[1] and took it from the upper Ganges (river-rafting) to Madras. The *chowkidars* were full of envy! I had to cancel my trip to Cairo: Never go to a country where the police are rioting. Besides, they had burned down my hotel. I went to Belize instead, with the squarer, more dignified bag[2]. People were fighting to carry it!

My one suit I will entrust to the garment bag, with lots of other odds and ends, for two months in China. The overspill will easily fit into Squashy. I am traveling overland from London to Hong Kong, via Ulan Baator. The great thing about these bags is that not only can you bring them on planes, but they fit in all railway compartments and can easily be lashed to a camel.

[1]Globetrotter [2]21-inch Carry-on

Paul Theroux's travel writing includes *The Great Railway Bazaar* and *The Old Patagonian Express*. His new novel, *Ozone*, will be published in September 1986.

GLOBETROTTER

A capacious carryall that seems to expand and contract by magic. Really, it's just cleverly designed, with fold-out top opening for easy access and a 2-inch-wide buckled leather strap to cinch everything down. A most adaptable traveler.

leather ID tag

slip pockets at both ends

leather trim darkens with age

inside zippered pocket

COLOR: Moss-tint khaki, natural leather
SIZE: 20¼" × 13" × 10½"
#6038 Globetrotter $225 Made in Italy

—Lifetime Guarantee—
Simple. We guarantee our luggage against all defects in materials and workmanship for as long as you own it.

20

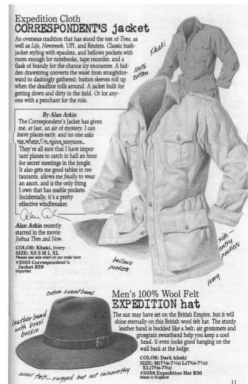

Expedition Cloth
CORRESPONDENT'S *jacket*

An overseas tradition that has stood the test of *Time*, as well as *Life, Newsweek*, UPI, and Reuters. Classic bush-jacket styling with epaulets, and bellows pockets with room enough for notebooks, tape recorder, and a flask of brandy for the chance icy encounter. A hidden drawstring converts the waist from straightforward to dashingly gathered; button sleeves roll up when the deadline rolls around. A jacket built for getting down and dirty in the field. Or for anyone with a penchant for the role.

By Alan Arkin

The Correspondent's Jacket has given me, at last, an air of mystery. I can leave places early, and no one asks me where I'm going anymore. They're all sure that I have important planes to catch in half an hour for secret meetings in the jungle. It also gets me good tables in restaurants, allows me *finally* to wear an ascot, and is the only thing I own that has usable pockets. Incidentally, it's a pretty effective windbreaker.

Alan Arkin recently starred in the movie Joshua Then and Now.

COLOR: Khaki, ivory
SIZE: XS S M L XL
Please see size chart on our order form
#3163 Correspondent's Jacket $59
Imported

Khaki

100% cotton

side entry pockets

bellows pockets

ivory

cotton sweatband

Men's 100% Wool Felt
EXPEDITION *hat*

The sun may have set on the British Empire, but it will shine eternally on this British wool felt hat. The sturdy leather band is buckled like a belt; air grommets and grosgrain sweatband help you keep a cool head. It even looks good hanging on the wall back at the lodge.

leather band with brass buckle

wool felt—rugged but not rainworthy

COLOR: Dark khaki
SIZE: M(7⅛–7¼) L(7⅜–7½)
XL(7⅝–7¾)
#5058 Expedition Hat $36
Made in England

11

–2.48, 2.49, 2.50, 2.51– In its initial travel gear incarnation, Banana Republic's founders invited reviews by commentators like writers Paul Theroux and Martin Cruz Smith, and actor Alan Arkin. Banana Republic, 1984

M(39-41), L(42-44), XL(45-47). State S, M, L, or XL.
R 508-0635 D ...225.00
Tall Sizes (for men 6' to 6'3½" tall): MT(fits 39-41 in. chest),
LT(42-44), XLT(45-47). State MT, LT, or XLT.
R 508-0643 D ...245.00

State chest size when ordering.
R 508-0288 D ...195.00
Tall Sizes (for men 6' to 6'3½" tall): Chests 40, 42, 44, 46.
State chest size when ordering.
R 508-0296 D ...215.00

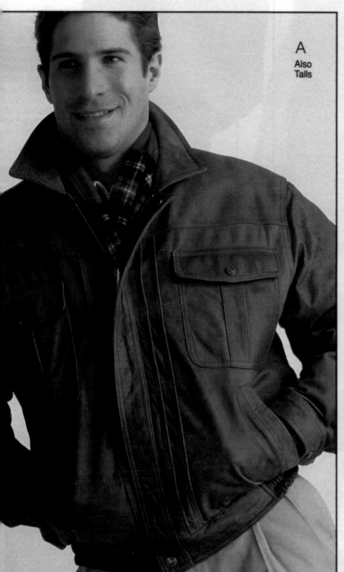

A
Also
Talls

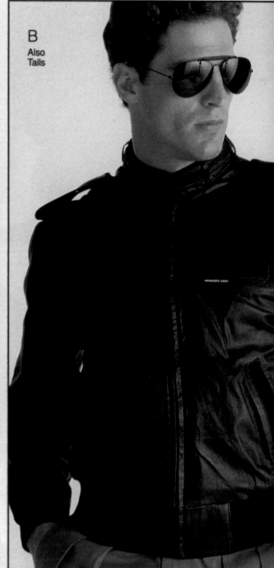

B
Also
Talls

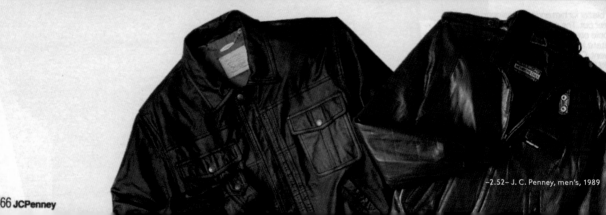

−2.52− J. C. Penney, men's, 1989

–2.53– Neiman Marcus, Rene Russo

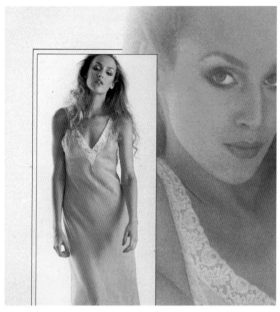

–2.54– Neiman Marcus, Jerry Hall

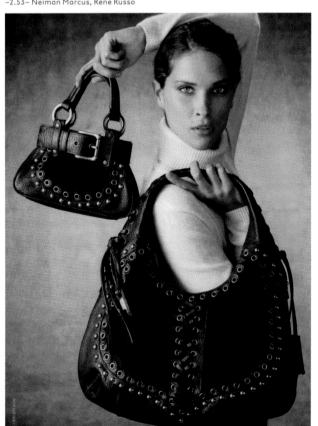

–2.55– Neiman Marcus

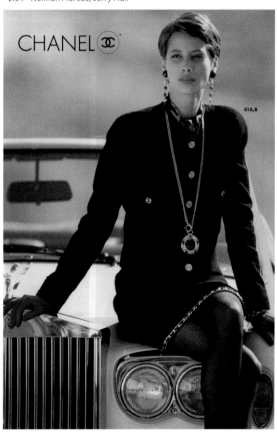

CHANEL

61A,B

–2.56– Neiman Marcus, Christy Turlington, 1990

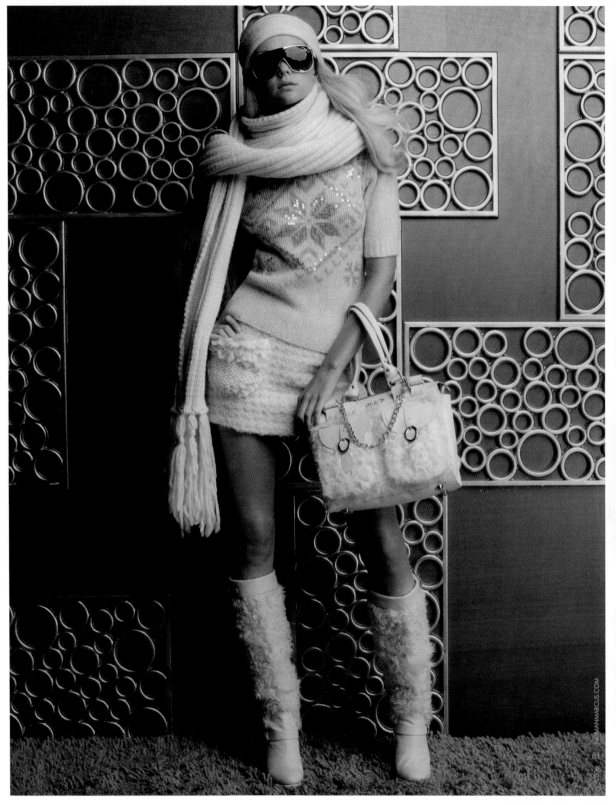

-2.57- Neiman Marcus, 2006

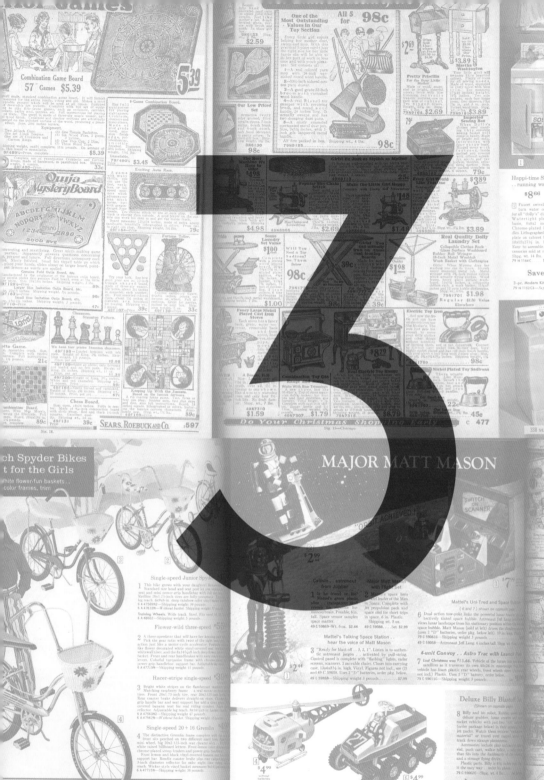

Toys, Dolls, and Sporting Goods

3

Toys, Dolls, and Sporting Goods

From Noah's Ark to the Man on the Moon, toys and dolls reflect the times. Female dolls evolved from housewives to "Presidential Candidate" Barbie. Dolls also reflect society's attitudes toward race, from the racially offensive depictions of black mammies to more true-to-life dolls resembling children of every race and color.

Early catalogs featured parlor games like jigsaw puzzles, magic and coin tricks, and board and card games. Comic dialogues that could be read as entertainment and Ouija boards, which Sears said, "purported to enable people to communicate with the afterworld," were also popular.

Until the early twentieth century, most toys were homemade, often of wood, straw, and stone. After the industrial revolution, modern materials like iron and tin were used. The first toy-grade plastic, polystyrene, was invented in 1927.

Until the women's liberation movement of the seventies attempted to advocate gender neutrality, toys were largely gender-specific. Girls learned to sew by making clothes for their dolls. Boys loved electric trains and construction. In 1900, Joshua Lionel Cowen

came up with a gimmick to liven up a New York City toy manufacturer's window displays. He put a small electrical motor under a cheese box and had it ride around a track advertising specials and displaying small items. The trains proved to be more popular than the products they were designed to promote. The entrepreneurial Cowen decided to market his Electric Express and Lionel trains was born. As the company expanded, trains grew more streamlined and realistic, and additional components like Pullman cars, cabooses, and freight cars were added. These were first offered in the early twentieth century catalogs, and Cowen also published his own catalog. Sears gave Lionel trains their "Sears Best" label.

During WWI, the company produced compasses, binoculars, and navigation equipment for the United States Navy, as well as a model war train. The postwar years were good, but while the core business suffered during the depression, a Mickey Mouse handcar offered for $1 was a major hit. During WWII, train production was suspended, and Lionel again made nautical items for the navy. The late forties and early fifties were the heyday for train sets. During the fifties, Lionel published the third most popular catalog in the country, its distribution exceeded only by Sears and Montgomery Ward. Alas, the popularity of television and a diminished interest in train travel caused the company's fortunes to sag in the late fifties, and the Cowen family sold the company. The Lionel Corporation declared bankruptcy in 1967, the same year the legendary Twentieth Century Limited made its final run. Lionel has had many owners since then and today is owned by a consortium that includes train enthusiast and rock star Neil Young.

The early-twentieth-century construction boom led to the invention of several classic building toys that were offered by both Sears and Montgomery Ward. The

Erector Set was invented in 1913 by A. C. Gilbert, a Yale-trained physician and former Olympic Gold Medal winning pole-vaulter. The multitalented Gilbert was also a gifted magician who paid his way through medical school doing magic tricks. In 1907, he founded a company to sell magic kits to children. Although he graduated from medical school in 1909, he decided to pursue his interests in magic and business. Gilbert claims he was inspired by construction workers erecting steel girders to electrify the train lines while taking the train from New Haven to New York. In 1913, with a $5,000 loan from his father, Gilbert produced a collection of steel beams, gears, and bolts and marketed them as the Mysto Erector Structural Steel Builder. With new skyscrapers, planes, and cars captivating the popular imagination, the Erector Set was a smash and went on to become the best selling educational toy of all time.

Gilbert also played an important role in the lives of children during WWI. In 1918, the United States Council of National Defense considered banning the sale of toys to support the war effort. As president of the Toy Manufacturers of America, Gilbert lobbied against the ban, arguing that toys were critical to the education and development of children. The council agreed. Toys were declared "essential," prompting the *Boston Post* to call Gilbert "the man who saved christmas." Alas the 1958 introduction of the lighter, more colorful, and easier to use LEGO sounded the death knell for the Erector Set. The company folded in 1968. *The Man Who Saved Christmas*, a movie based on Gilbert's story, aired on CBS in 2002, starring Jason Alexander as Gilbert.

Charles Pajeau invented Tinker Toys for younger children (after seeing toddlers play with thread spools and pencils) in 1914. Lincoln Logs were invented by Frank Lloyd Wright's son, John, in 1916, after he watched builders lay the foundation for his father's Imperial Hotel in Tokyo.

Toys for girls sought to prepare them for lives as happy homemakers. Catalog pages touted items "for the little housekeeper" and included toy sewing machines, dresser sets, sewing boxes, ironing boards, and laundry sets for the doll's laundry. Sears offered a Bissell toy carpet sweeper as early as 1897. Toy kitchen sets, often in pink, included ranges, stoves, ovens, pots, pans, utensils, and dishes. Little girls had mini wicker baby buggies. Tea sets for tea parties (initially tin and enamel, and later china) were popular until long after their mothers had given their last tea party. Miniature typewriters were seen as appropriate for little girls since full-size typewriters were often many women's entrée into the business world. The snazzy turquoise Easy Bake Oven (a real oven with a fake stovetop) was introduced in 1963; over 500,000 were sold in the first year.

One doll that enchanted both boys and girls was the teddy bear. In 1902, after President Theodore Roosevelt refused to shoot a captured bear, toy maker Roy Michoum decided to rechristen his toy bears "Teddy's bears" in his honor. Michoum went on to found the Ideal Toy Company, which would become one of the country's preeminent toy companies. Teddy bears were used as table decorations at the wedding of Roosevelt's daughter.

In the twenties and thirties, toys glorified the future. Italian immigrant, Antonio Pasin, originally named his company Liberty Coast, in honor of the Statue of Liberty. When he introduced his new wagon at the 1933 World's Fair, he wanted it to have a name that evoked the future. He named it Radio Flyer, combining infatuation with the new wireless radios (invented by another Italian) with the exciting concept of flight.

The post-war period was prosperous; a record number of children were born.

Educational toys like the shape-sorting blue mailbox from Playskool and the Chatter Telephone from Fisher-Price were popular as parents hoped they would keep their children entertained (and get them into the Ivy League).

As America embraced fitness and the outdoors, active toys gained in popularity. Wham-O was founded to sell slingshots; it was named for the sound projectiles made when they hit their targets. In 1956, they branched out with flying disks that they christened Pluto Platters, inspired by the country's infatuation with UFOs. The name was later changed to Frisbee, after the baking company whose pie plates were originally used. Wham-O also scored a hit with another classic: the Hula Hoop.

Dolls were made of rags, straw, and wood until manufactured dolls, made of composition (sawdust and glue) and bisque (unglazed porcelain) were introduced. Celluloid, an early plastic, was used from the mid-nineteenth century until the fifties when it fell out of favor because it faded and was highly flammable. Horsman, which manufactured dolls for both Sears and Montgomery Ward, introduced "soft, realistic, washable vinyl dolls that were guaranteed not to rot, crack, or mildew" in 1947. They later introduced a more flexible vinyl that they trademarked Fairy Skin. Real hair was used until the fifties when United States health regulations banned it. After that, dolls' wigs and hair were made of Saran, later used in the eponymous wrap. Barbie, who would go on to become an American icon, was invented in 1959. Retailers were not initially taken with the new doll, which retailed for $3, but consumers went wild; Barbie sold out completely. In 1963, Sears devoted eight pages of their Christmas catalog to Barbie and her accessories. Barbie enhancements (her bust required none) included the Twist 'n Turn Waist, Talking, Live Action, and sun-kissed Malibu. Barbie got a boyfriend, Ken, in 1961; black friends, Christie and Brad, in 1969; and a bellybutton in 2000.

The influx of immigrants (and the anxiety it caused the Anglo-American majority) was accompanied by a large number of toys featuring derogatory stereotypes of African-Americans, Native Americans, Asians, and immigrants. Dolls, mechanical toys, and board games represented African-Americans as either lazy and subservient or strong and menacing. Africans were savages and witch doctors; Native Americans were the ferocious nemeses of the virtuous white cowboys; and Chinese merchants were portrayed as wily and deceptive. Over time, through assimilation and legislation like the Civil Rights Act, these disgraceful toys fell dramatically (and thankfully) out of favor.

Today, little girls flock to American Girl, a store that offers girls dolls in every skin, eye, and hair color and an array of hairstyles (including with or without highlights). American Girl dolls come with a book to help bring the doll's backstory to life. Historical dolls include Depression era Kit Kittredge who "as a girl growing up in 1934, sees her dad lose his business overnight. Her days are filled with worry about whether her family can save their house. Kit pitches in at home all she can, struggling with an endless list of chores that keeps her constantly busy." Girls are invited to experience Kit's whole world.

Space toys go back to the twenties; Buck Rogers, the twenty-fifth-century space explorer, was introduced in 1928. Buck Rogers (and his competitor, Flash Gordon) ignited the fantasy of space travel and helped to launch a rash of toy rocket ships, ray guns, and robots. His existence five hundred years in the future made him less relevant when, in 1957, the Soviets launched Sputnik, the first man-made satellite to orbit earth. Sputnik's launch may have shocked lawmakers, but American toymakers knew the golden rocket

had landed. As an executive at Ideal Toy Company put it, "This may be a propaganda blow to the U.S., but for us, boy, oh, boy." Children clamored for robots, rockets, and spaceships. The toys children wanted were more practical than those of the twenties and thirties—they replicated objects that we could really imagine in use. Montgomery Ward offered a telescope, Spiegel offered a "Super Satellite Station," and Sears offered the "Radar Rocket Cannon." In 1975, Neiman Marcus offered "The Moon Walk," an inflatable trampoline with a plastic roof that made it safe for all children. Billionaire J. Paul Getty ordered one but refused to pay the transportation charges. After repeated attempts to collect, Stanley Marcus filled his car up at a Getty gas station and refused to pay the tax, telling the attendant to refer the matter to Mr. Getty. Science kits were also popular as children looked toward the future.

In 1974, Montgomery Ward was the exclusive seller of Mego's line of Secret Identity outfits, which featured the civilian clothes of Clark Kent (Superman), Peter Parker (Spiderman), Bruce Wayne (Batman), and Dick Grayson (Robin). Since buyers of the outfits presumably had the doll, the Secret Identity set came with an (unmasked) head and the outfit. They are extremely rare and eagerly sought by legions of Mego collectors.

Today, even religion is fair game. The Jewish Source catalog offers toys based on traditional favorites like Candy Land and Chutes and Ladders. In Kosherland, players spin their way to the Kosher Home; along the way they meet the Little Latke Men, sail the Kiddush Wine Ocean, and visit Hamentashen House—but they mustn't get stuck mixing milk and meat. In Passover Slides & Ladders, players try to be the first to reach Square Ten—Jerusalem. It shouldn't, they promised, take forty years of wandering.

Sears was also at the forefront of the video game phenomenon. When Atari ushered in the era of video games with PONG, Sears, under its TeleGames brand, was its exclusive retailer. Although Magnavox's Odyssey was the first video game, it wasn't until Sears offered the home version of Atari's PONG that video games took off. Because of the failure of Odyssey, most of the buyers at the 1975 Consumer Electronics Show passed on PONG. When Sears's sporting goods buyer was told that Atari could make 75,000 consoles, he told them he needed 150,000 and would pay for the increased cost of production. Introduced under Sears's TeleGames brand, PONG was the most successful toy of the year, and Sears sold out completely.

JOY BUZZER

(Hand Shaker and Tickler)

FUNNIEST JOKER'S NOVELTY EVER INVENTED!

☞ Use the ring as a key to wind it.

Wear it as a ring —the Buzzer in the palm. ☞

☞ It "shocks" them when they shake hands.

It makes them jump if they are ticklish. ☞

☞ They will hit the ceiling if they sit on it.

Under a sheet it feels like a mouse. ☞

With one of these little contrivances you may have no end of fun. Attached to one end of the Joy Buzzer is a brass ring that slips over the second finger, allowing the Buzzer itself to be concealed unobserved in the palm of the hand. Inside the Buzzer is a clock-work mechanism that is wound up. Projecting from the center of the Buzzer is a brass point, and a little pressure upon this point releases the mechanism. Shake hands with someone and see the shock the person receives when he unconsciously releases the mechanism of the Buzzer. If he is ticklish, watch him jump. Place it on a chair and watch the commotion when someone sits upon it. Place it under a pillow—under a sheet it feels like a mouse. You can use it as an ordinary "tic-tac" on a door or window—use it to awaken a sleeper by holding it on the foot or just behind the ear—try it on the window of an automobile just as the gears are shifted; they will think the engine is "busted." Dozens of other uses will suggest themselves to you. It is well and strongly made, entirely of metal, and it is certain you will get more than your money's worth of fun out of this little contraption.

No. 2955. JOY BUZZER. Price Postpaid...50c

270 *JOHNSON SMITH & CO.* RACINE, WIS.

–3.1– Johnson Smith & Co.

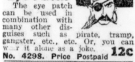

–3.2– Hitler, Mussolini, and Stalin masks, Johnson Smith & Co., 1940s

CONSTRUCTION TOYS

Erector

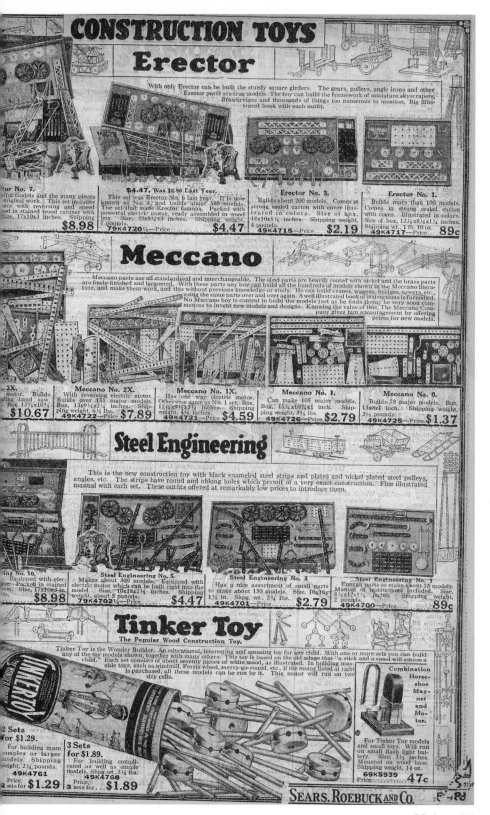

With only Erector can be built the sturdy square girders. The gears, pulleys, angle irons and other Erector parts are true models. The boy can build the framework of miniature skyscrapers, drawbridges and thousands of things too numerous to mention. Big illustrated book with each outfit.

Erector No. 7.
...riful models and the many pieces ...original work. This set includes ...otor with reversing and speed ...ed in stained wood cabinet with ...Size, 17x10x3 inches. Shipping weight, ... pounds.
$8.98

$4.47, Was $8.98 Last Year.
This set was Erector No. 6 last year. It is now known as No. 4, and builds about 380 models. The set that made Erector famous. Packed with powerful electric motor, ready assembled in wood box. Size, 22x8¼x3 inches. Shipping weight, 7 pounds.
79K4720¼—Price. **$4.47**

Erector No. 3.
Builds about 200 models. Comes in strong sealed carton with cover illustrated in colors. Size of box, 18x10x1¼ inches. Shipping weight, 4 pounds.
49K4715—Price. **$2.19**

Erector No. 1.
Builds more than 100 models. Comes in strong sealed carton with cover. Illustrated in colors. Size of box, 12¼x8½x1¼ inches. Shipping wt. 1 lb. 10 oz.
49K4717—Price. **89c**

Meccano

Meccano parts are all standardized and interchangeable. The steel parts are heavily coated with nickel and the brass parts are finely finished and lacquered. With these parts any boy can build all the hundreds of models shown in the Meccano literature, and make them work, and this without previous knowledge or study. He can build cranes, wagons, bridges, towers, etc., using the same parts over and over again. A well illustrated book of instructions is furnished. No Meccano boy is content to build the models just as he finds them; he very soon commences to invent new models and designs. Knowing the value of this, The Meccano Company gives him encouragement by offering prizes for new models.

...3X.
...motor. Builds ...ting band saw. ...Box, 13⅝x10¾ ...
$10.67

Meccano No. 2X.
With reversing electric motor. Builds over 151 major models. Box, 13x9½x2¼ inches. Shipping weight, 6½ lbs.
49K4722—Price. **$7.89**

Meccano No. 1X.
Has one way electric motor. Otherwise same as No. 1 set. Box, 12⅝x8⅞x2½ inches. Shipping weight, 4½ inches.
49K4721—Price. **$4.59**

Meccano No. 1.
Can make 105 major models. Box, 15¼x10¾x1 inch. Shipping weight, 3½ lbs.
49K4726—Price. **$2.79**

Meccano No. 0.
Builds 78 major models. Box, 13x8x1 inch. Shipping weight, 2½ pounds.
49K4725—Price. **$1.37**

Steel Engineering

This is the new construction toy with black enameled steel strips and plates and nickel plated steel pulleys, angles, etc. The strips have round and oblong holes which permit of a very exact construction. Fine illustrated manual with each set. These outfits offered at remarkably low prices to introduce them.

...ing No. 10.
Equipped with elec... ...Packed in stained ...ver. Size, 17x10x3 in.
$8.98

Steel Engineering No. 5.
Makes about 300 models. Equipped with electric motor which can be built right into the model. Size, 10x18x2½ inches. Shipping weight, about 5 pounds.
79K4702¼—Price. **$4.47**

Steel Engineering No. 3.
Has a nice assortment of small parts to make about 150 models. Size, 10x18x1½ in. Shpg. wt., 2¼ lbs.
49K4701—Price. **$2.79**

Steel Engineering No. 1.
Enough parts to make about 75 models. Manual of instructions included. Size, 8½x12x1½ inches. Shipping weight, 2 pounds.
49K4700—Price. **89c**

Tinker Toy
The Popular Wood Construction Toy.

Tinker Toy is the Wonder Builder. An educational, interesting and amusing toy for any child. With one or more sets you can build any of the toy models shown, together with many others. This toy is based on the old adage that "a stick and a spool will amuse a child." Each set consists of about seventy pieces of white wood, as illustrated. In building movable toys, such as windmill, Ferris wheel, merry-go-round, etc., if the motor listed at right is purchased, all these models can be run by it. This motor will run on two dry cells.

2 Sets for $1.29.
For building more complex or larger models. Shipping weight, 2¼ pounds.
49K4761 Price, 2 sets for **$1.29**

3 Sets for $1.89.
For building complicated as well as simple models. Shpg. wt., 3¼ lbs.
49K4768 Price, 3 sets for. **$1.89**

Combination Horseshoe Magnet and Motor.
For Tinker Toy models and small toys. Will run on small flash light battery. Size, 3½ inches. Mounted on wood base. Shipping weight, 14 oz.
69K5939 Price. **47c**

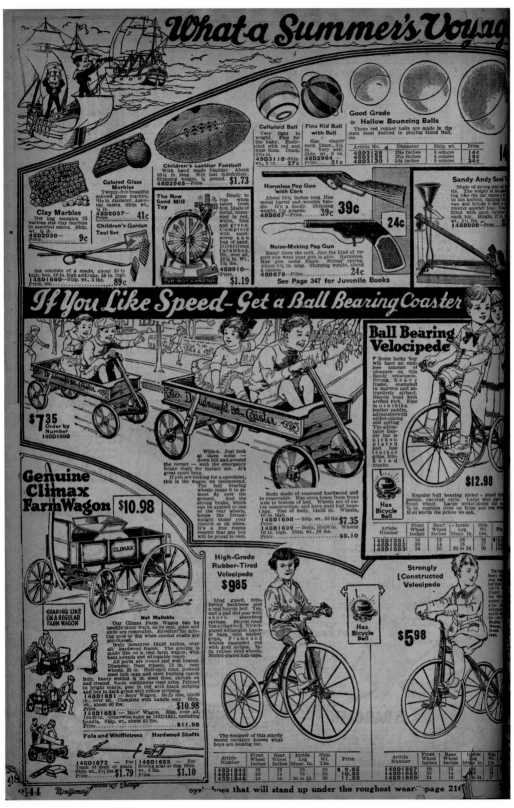

What a Summer's Voyage

Good Grade Hollow Bouncing Balls
These red rubber balls are made in the sizes most desired in playing Hand Ball, etc.

Article No.	Diameter	Ship. wt.	Price
48D3128	2⅝ Inches	3 ounces	14c
48D3129	2¾ Inches	4 ounces	19c
48D3130	3¼ Inches	5 ounces	34c

Celluloid Ball Very light in weight. Fine for the baby. Encircled with red and blue lines. Diam, 2⅞ in. Ship. wt., 8 oz. **49D3118**—Price... **27c**

Fine Kid Ball with Bell Has elastic cord. Diam., 3½ in. Very soft. Ship. wt., 6 oz. **48D2964**—Price... **21c**

Children's Leather Football With hand made bladder. About 10½ in. long. Will last indefinitely. Shipping weight, ¾ pound. **48D2965**—Price... **$1.73**

Colored Glass Marbles Twenty-five beautiful colored glass marbles, 1¼ in. diameter. Assorted colors. Ship. wt., ¾ lb. **48D2037**—Price... **41c**

Children's Garden Tool Set Set consists of a spade, about 32 in. high; hoe, 36 in. high and rake, 36 in. high. **148D1660**—Ship. wt., 3 lbs. Price, set... **89c**

Clay Marbles Net bag contains 75 various size clay marbles in assorted colors. Ship. wt. ¾ lb. **48D2038**—Price... **9c**

The New Sand Mill Toy Ready to run when taken from box. Made of metal, enameled in red, white, blue and green. Complete with sand-scoop and bag of sand. Directions furnished. Ht., over all, 10½ in. Wt., 1¾ lbs. **48D910**—Price... **$1.19**

Harmless Pop Gun with Cork About 16¼ inches long. Has metal barrel and wooden handle. It's a dandy. Shipping weight, 1½ pounds. **48D867**—Price... **39c**

Noise-Making Pop Gun Bang! Goes the cork. Just the kind of report you want your gun to give. Harmless. Has gun metal finish. Strong spring. About 6¾ in. long. Shipping weight, about 4 ounces. **48D878**—Price... **24c**

Sandy Andy Sand Made of strong steel and tin. The weight of the sand going into the car causes it to go to the bottom, dumps the sand, can and brings it back to receive another load. Steel filled with sand. Start each toy. Height, 17 in. wt., 2¼ lbs. **148D808**—Price...

See Page 347 for Juvenile Books

If You Like Speed— Get a Ball Bearing Coaster

$7.35 Order by Number 148D1698

Whiz-s. Just look at them come — down hill and around the corner — with the emergency brake ready for instant use. It's great sport boys.
If you are looking for a speedster, this is the wagon we recommend. The ball bearing wheels cause it to almost fly over the ground. And the strong brake, which can be applied to one of the rear wheels, keeps the Dreadnaught under your control at all times. It's a fine roomy coaster that any boy will be proud to own. Body made of seasoned hardwood and is removable. Has extra brace from front axle to bottom of bed. Wheels are of extra construction, and have steel ball bearings. Size of body, 14x32 in. Wheels, 10 in. high.
148D1698—Ship. wt., 35 lbs. Price... **$7.35**
148D1699—Body, 16x36 in. Wheels 10 in. high. Ship. wt., 38 lbs. Price... **$8.10**

Ball Bearing Velocipede
Some lucky boy will have an endless amount of pleasure on this dandy velocipede. Strong, heavy frame, enameled in maroon and attractively striped. Bicycle head with arched fork. Fine motorbike leather saddle, adjustable with nickel-plated coil spring. The adjustable handle bar is nickel-plated and has leather grips. Nickeled cranks.

$12.98

Has Bicycle Bell

Regular ball bearing nickel - plated hub pedals, rat-trap style. Large mud guard, front wheel. Large nickel-plated hub and ¾-in. cushion tires on front and rear wheels. Well worth the price we ask.

Article Number	Front Wheel Inches	Rear Wheel Inches	Inside Leg Meas. In.	Ship. Wt. Lbs.	Price
48D1981	16	12		24	
48D1982	20	14		27	
48D1983	24	16	20 to 24	30	

Genuine Climax Farm Wagon **$10.98**

GEARING LIKE ON A REGULAR FARM WAGON

Not Malleable
Our Climax Farm Wagon can be used in many ways, as its seat, sides and ends are removable. Excellent for driving goat or dog when special shafts are purchased.
Body measures 18x36 inches, over all: hardwood frame. The gearing is made like on a real farm wagon, with bent hounds and adjustable reach.
All parts are ironed and well braced. Diameter, front wheels, 13 in.; rear wheels, 20 in. Half-inch rims, pressed steel hub caps and steel bushing inside hub; heavy welded ⅝ in. steel tires, shrunk on and riveted. ¾x¼-in. continuous steel axles. Painted in bright colors, gear in red with black striping and box in dark green with yellow striping.
148D1651—Boys' Wagon. Body size, 18x36 in., over all. Complete with handle only. Ship. wt., about 60 lbs. Price... **$10.98**
148D1653—Boys' Wagon. Size, over all, 18x40 in. Otherwise same as 148D1651, including handle. Ship. wt., about 65 lbs. Price... **$11.98**

Pole and Whiffletrees **Hardwood Shafts**

148D1672—For Team of dogs or goats. Ship. wt., 3½ lbs. Price... **$1.79**
148D1655—For driving goat or dog. Ship. wt., 1½ lbs. Price... **$1.10**

High-Grade Rubber-Tired Velocipede **$9.85**
Mud guard, reinforced backbone and a real bicycle bell. Yes, and a pad bed seat with shock absorbing springs. Bicycle head has arched fork. Nickel-plated adjustable handle bars, with leather grips. Frame and wheels enameled red with gold stripes. ¾-in. rubber steel wheels. Nickel-plated hub caps.

Has Bicycle Bell

Strongly Constructed Velocipede **$5.98**
The designer of this sturdy model certainly knows what boys are looking for.

Article Number	Front Wheel Inches	Rear Wheel Inches	Inside Leg Meas. In.	Ship. Wt. Lbs.	Price
48D1844	16	12		25	$9.85
48D1845	20	14		28	10.95
48D1846	24	16	18 to 24	30	11.95

Article Number	Front Wheel Inches	Rear Wheel Inches	Inside Leg Meas. In.	Ship. Wt. Lbs.	
48D1867	16	12			
48D1868	20	14			
48D1869	24	16	18 to 24		

Boys' shoes that will stand up under the roughest wear. page 216

Girl's Sewing Cabinets

...sser Sets

Our Best Set
Beautifully hand decorated, pearl color on amber color filled pyralin. Just like mother's set, 8-inch beveled glass, mirror with brush and comb. In plain gift box.
8N6133 Shpg. wt., 2 lbs.
$2.59

Our Low Priced Set
Attractive ivory color grained, filled pyralin pieces. 7-inch mirror, 6-inch brush and 6-inch comb, each hand decorated in pretty colors, in plain gift box. Shipping weight, 1½ lbs.
8N6130
98c

One of the Most Outstanding Values in Our Toy Section

Every little girl enjoys helping her mother dust, sweep and mop. With this practical 5-piece outfit just the right size for her little hands she will be able to do her part of work in less time and with much pleasure. Set consists of:

1—A real colored yarn mop with 24-inch varnished round wood handle.

2—10½-inch colored cotton yarn duster.

3—A good grade 32-inch broom with varnished wood handle.

4—A real Bissel toy sweeper with revolving brush, and round wood handle, 24 inches long. It actually sweeps and has two dumping dust pans.

5—A nicely enameled corrugated metal dust pan. Size, 9x5⅞ inches, with 3-inch gilt lacquered metal handle.

All five packed in box. Shipping wt., 4 lbs.
79N9185

All 5 for 98c

98c

$2.69
Often Sold Elsewhere at From $3.50 to $4.00

Pretty Priscilla
For the Busy Little Mother
Made of wood, enameled in bright, cheerful colors; ivory with blue trimming, two pretty transfer pictures, one on each side of cabinet. Two hinged covers. Height, 23¾ in. Shpg. wt., 6 lbs.
79N9164 **$2.69**

$3.89
Sold up to $5.00 Elsewhere Our Price,

Martha Washington
Your little girl will treasure this beautiful cabinet. Plenty of room for all sewing needs. Made of wood, enameled in ivory color with blue trim. Top measures 17½x9 inches; height, 19¾ inches. Two side pockets, each has hinge cover, two drawers, 7⅝x 7½ in. and 3 in. deep. Turned wood legs. Shpg. wt., 9 lbs.
79N9191 **$3.89**

79c

Imported Sewing Box
When Dolly's clothes need mending this complete sewing basket will come in handy. Made of bright red rafia, interwoven with fancy straw braid. Hinged cover with fastener. Inside padded and covered with colored sateen. Six spools and two balls of colored thread, bodkin, thimble, celluloid tatting shuttle and three needles. Size, 5¼x3⅝x2 inches. Neatly packed complete in box. Shipping weight, 8 ounces.
49N9163 **79c**

The Best Machine We Have to Offer
$4.98
Has many attachments. Can be used for many practical purposes. All metal construction. Drop foot, shuttle, nickel plated tension and heavy base, black with gilt ...x8¼ inches.
49N5805 **$4.98**

Girls! Be Just as Stylish as Mother
It looks so real—studded with ten pretty sparkling imitation diamonds and colored stone in stationary crown. Heavy glass crystal; adjustable grosgrain ribbon wristlet with clasp. Shipping weight, 3 ounces.
49N9113 **25c**

Popular Size Chain Stitch
Very solid and substantial. Made of pressed steel. Thread tension and raising foot. Makes fine stitches. Enameled back with gilt decorations. All moving parts nickeled. Size, 7⅝x 4¾x7¼ inches. Shipping weight, 3 lbs.
Has Clamp and Screwdriver
Right Size for Little Girls
49N5805 **$2.69**

Make the Little Girl Happy
Complete with Clamp and Screwdriver
$1.48
Black enameled steel. All moving parts nickeled. A little machine that sews chain stitches exceptionally well. Size, 6⅝x 4⅛x6½ inches. Each packed complete in box. Shpg. wt., 2 lbs.
49N5804 **$1.48**

Every Girl Would Like This One
$3.89
Sews easily and well. Made of heavy metal. Fancy gilt decorations on black enamel; nickel plated wheel and trimmings. Makes four chain stitches at each turn of the driving wheel. Size, 7⅝x5¾x7¼ in. Shpg. wt., 8¼ lbs.
49N5800 **$3.89**

Some Laundry Set Value
$1.00
Complete with a strong wood ironing board, 20½x 5⅞x13⅜ in.; a nickel plated sadiron, 4½x 2½ inches, a basket, 11½x 7¼ inches, 12 feet of clothesline, 2 iron pulleys, 6 tiny clothespins and 6⅞x3⅜-inch metal washboard. Shipping weight, 7 lbs.
$1.00

Will You Need a Toy Sadiron? See Them Below
98c
Large Size. The One We Recommend
79N1775—For important business of ironing doll clothes, handkerchiefs and lots of other things. Top, 35x10¾ inches. Height adjustable from 20 to 25 inches. Shipping weight, 7 pounds. **98c**

Girls! You can actually iron on these real ironing boards
Made by same workmen who build ironing boards for grown-ups. Nice smooth lumber, no nasty splinters, easy to set up.
39c
For the Tiny Tot
49N1777—Very little; just like Mother's. Size, top, 20½x5½ inches. About 13½ inches high. Shipping wt., 1¾ lbs. **39c**

Real Quality Dolly Laundry Set
Collapsible Clothes Rack
Glass Surface Washboard
Rubber Roll Wringer
10-Inch Metal Washtub
Wash Basket with Clothespins
Girls! When Mamma does her washing you can do yours. 10-inch nicely enameled metal tub. Metal wringer with 3⅜-inch rubber rollers which actually wring clothes. Wood frame, heavy glass surface washboard, 11x5½ inches, a collapsible clothes rack, a wash basket, 11½x7 inches and 12 cute kiddie clothespins. Shpg. wt., 6 lbs.
79N1701 **$1.98**
Regular $2.50 Value Elsewhere
Complete Outfit $1.98

Fancy Large Nickel Plated Cast Iron Stoves
Each stove has a fancy back, grate, water reservoir, removable back and front apron, lined oven, stovepipe, removable lids, hinged doors, dinner pot, skillet, coal scuttle, shovel and lid lifter.

A Beauty, $1.59
Size: Length over all, 11⅜ in.; height, 10¼ in.; depth, over all, 5½ in. Similar to one shown at ...mming. Has a dummy warming oven and only four 2½-inch lids. No draft damper. Shpg. wt., 7 lbs.
49N7310 **$1.59**

Combination Toy Gas Range and Stove
White With Blue Trimmings
A new stove, just like Mother's. Top of stove measures 8x5¼ inches; has four imitation gas burners. Total height, 9 in. Complete with cast iron skillet, dinner kettle and lid lifter. Shipping weight, 6½ pounds.
49N7307....**$1.79**

$8.79

Real Electric Toy Range
What fun the little housekeeper will have with this Range. Delicious meals can be prepared; bread and pastry baked and candy made. Made of sheet steel, enameled gray with nickel plated burner top, legs and trimmings. Has 5½x4-inch oven and hot closet, each with hinge door. Width of stove, 14 inches; depth, 6¾ inches. Total height, 11⅝ inches. Two burners. Complete with four aluminum utensils, double boiler, teakettle, etc., also 6-foot cord and plug to attach to 110-volt house lighting system. Shipping weight, 11 pounds.
79N7315....**$8.79**

Electric Toy Iron
And now the little girl can have an electric iron just like Mother's. The iron just gets hot enough to press your dolly clothes and other things without scorching or burning them, and is not dangerous. Connect to 110-volt light socket like Mother does. Very highly nickel plated and has red duco finish handle, silk cord about 6 feet long with 2-piece plug. Size, over all, 3⅞x3¼x2⅝ inches. Shipping weight, 1½ pounds.
49N1799.........**98c**

Nickel Plated Toy Sadirons
These actually iron. Like Mamma's. Detach the bottom, heat and when hot attach handle and iron away. Polished wood handles. Two sizes.
Our Small Iron
4⅝x2¼ in. Shipping weight, 1¼ pounds.
49N1797.....**22c**
Our Large Iron
5x3½ inches. Shipping wt., 2¾ lbs.
49N1798.........**45c**

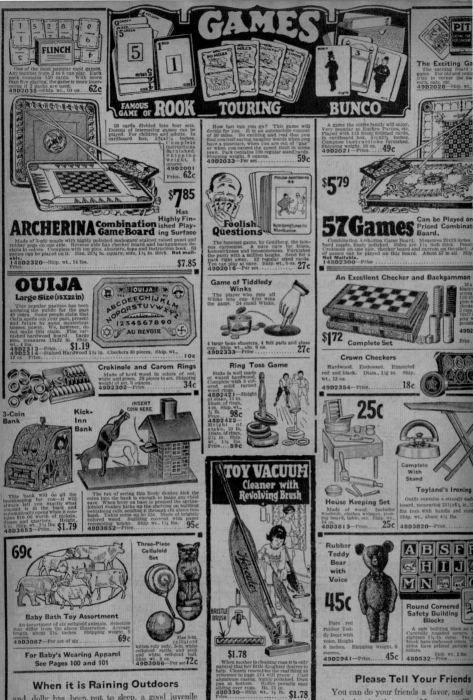
–3.6–Montgomery Ward, 1921

−3.7− Sears, Tinker Toys, 1922

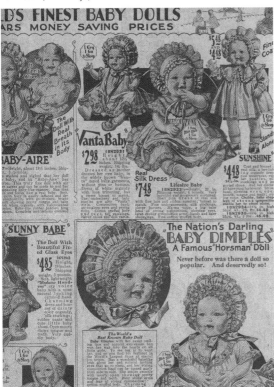

−3.8− Sears, strong composition dolls, 1921

−3.9− Sears, baby dolls, 1928.

−3.10− Sears, Erector Sets, 1928

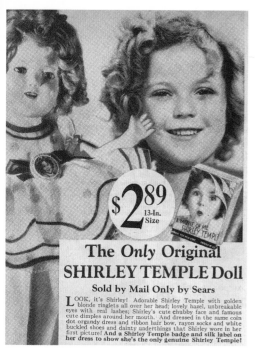

The *Only* Original
SHIRLEY TEMPLE Doll
Sold by Mail Only by Sears

LOOK, it's Shirley! Adorable Shirley Temple with golden blonde ringlets all over her head; lovely hazel, unbreakable eyes with real lashes; Shirley's cute chubby face and famous cute dimples around her mouth. And dressed in the same coin dot organdy dress and ribbon hair bow, rayon socks and white buckled shoes and dainty underthings that Shirley wore in her first picture! And a Shirley Temple badge and silk label on her dress to show she's the only genuine Shirley Temple!

$2⁸⁹ 13-In. Size

–3.11– Sears, Shirley Temple Doll, 1936

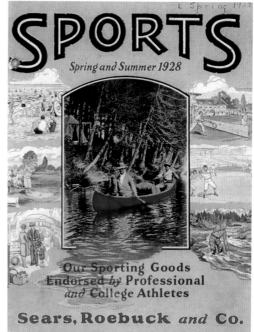

SPORTS
Spring and Summer 1928

Our Sporting Goods
Endorsed *by* Professional
and College Athletes

Sears, Roebuck *and* Co.

–3.12– Sears, sports catalog, 1928

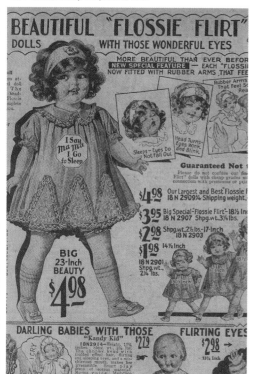

BEAUTIFUL "FLOSSIE FLIRT"
DOLLS WITH THOSE WONDERFUL EYES

MORE BEAUTIFUL THAN EVER BEFORE
NEW SPECIAL FEATURE — EACH "FLOSSIE"
NOW FITTED WITH RUBBER ARMS THAT FEE

I Say mama I Go to Sleep

Sleeps—Eyes Do Not Fall Out

Rubber Arms That Feel So Rea

Head Turns—Eyes Wink and Blink

Guaranteed Not

Please do not confuse our fine "Flossie" dolls with cheap grades so connection with premiums or pu

$4⁹⁸ Our Largest and Best Flossie In 18 N 2909¼ Shipping weight.

$3⁹⁵ Big Special-"Flossie Flirt"-18½ Inc 18 N 2907 Shpg.wt.3¾lbs.

$2⁹⁸ Shpg.wt.2½lbs.-17-Inch 18 N 2903

$1⁹⁸ 14½ Inch 18 N 2901 Shpg.wt.— 2¼ lbs.

BIG 23-Inch BEAUTY $4⁹⁸

DARLING BABIES WITH THOSE FLIRTING EYES
"Kandy Kid" $2⁷⁹
18N2914—Height, 13½ inches... shpg. wt., 2¾ lbs. The chubby head with tousled effect hair, darting and sleeping eyes, and a mischievous mouth, makes her irresistible. Smart pink dress of sateen material... Mama voice. Medallion trimmed. Unbreakable head.

$2⁹⁸ 13½ Inch

–3.13– Sears, Flossie Flirt, 1928

49 K 3299 $4.79 49 K 3296 $5.79

$2⁹⁸

$2⁸⁹ 15½ In. PHOTOGRAPH

Pretty as a Princess
Big as a Baby
28 Inches Tall

Easily worth from $1.50 to $2.00 more than we ask. She simply gorgeous! Big as a really truly little sister and so pretty she'll steal your heart away! Big blue eyes with real lashes and long curls of lustrous brown rea hair that comes down to he shoulders! Tiny pearly teeth and a little pink tongue peep ou through her smile. And she dressed like a little princess!

Pleated pink organdy, ribbon and lace trimmed, with two-ton rayon socks, buckled shoes, and dainty undies. Her head, arm and legs are hard-to-break composition. Her arms are in side jointed, (the better kind) and her legs are the new slim style Shpg. wt., 6 lbs.
79 K 3041......$2.98

Tall 20-In. Tall
lbs. 9 oz. Shpg. wt., 3 lbs. 7 oz.
192 49 K 3193
79 $4.79

shopping from *Sears* catalogs

–3.14– Sears, 1936

Never get over seeing Hitler in per-son, looking in on the party

Johnson Smith & Co.;
Hitler, Mussolini, and Stalin
masks, 1940s

We're 10½-inch Miniatures..Just Right to Dress

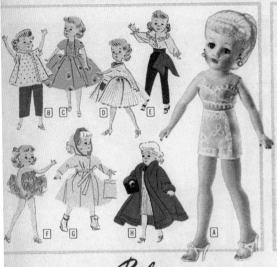

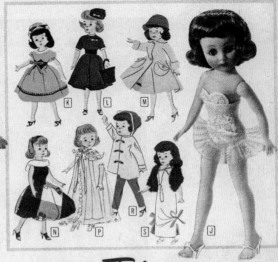

Little Miss *Revlon* $2.82 — 10½-inch Doll only

[A] Shapely grownup, as pretty as the models in fashion magazines. She has jointed legs and turning waist so she can sit alone and pose. It's fun to comb, brush, and set her rooted Saran hair. Vinyl plastic head and arms. "Magic-touch" body of firm vinyl feels like real skin. Painted fingernails, toenails. *Please state pony tail or bobbed hair style.*
49 N 3076—Doll with bra, panty girdle, shoes, earrings. Shpg. wt. 1 lb............$2.82

Clothing for Miss Revlon. High-style, nicely made. Shpg. wt. each 8 oz.
(B) 49 N 3973—2-piece Pajamas. Cotton with lace trim, snap closure..............88c
(C) 49 N 3974—Print Dress. Cotton pique with jacket-effect. Snaps................88c
(D) 49 N 3975—Striped Dress. Cotton, full skirt lace-trimmed panties.......... 1.37
(E) 49 N 3979—Toreador Outfit. Cotton blouse, velvet pants, sash, shoes......... 2.29
 49 N 3264—Accessories (not shown). 2 pair hose, 2 pair high heel shoes.........88c
(F) 49 N 3978—Ballerina Outfit. Rayon taffeta trimmed with metallic thread and net. Shoes, and flower spray for hair. Snap closure...................... 1.79
(G) 49 N 3976—Rain Outfit. Water-repellent plastic coat and hood, corduroy lined. Matching handbag and belt. Clear plastic boots.......................... 1.37
(H) 49 N 3977—Evening Coat. Full cut. Fluffy cotton and rayon fleece........... 1.79

Glamorous *Toni* Doll $2.82 — 10½ inch Doll only

[J] Full-figured vinyl doll with soft, bisque finish. Jointed arms, legs, turning head. Lashed moving eyes. Rooted Saran hair . . you can comb, brush, set it. In fashionable undies, high-heel shoes. For play wave set, see below.
49 N 3912—Shipping weight 1 pound...$2.82
49 N 3913—Play Wave Kit (not shown). Includes solution, squeeze bottle, applicator, curlers, comb, brush and make-up cape. Shpg. wt. 8 oz...........................89c

Clothing for 10½-inch Toni Doll. Exquisite detail. Shpg. wt. each 8 oz.
(K) 49 N 3958—Tea Time. Rayon taffeta dress, straw hat, long hose, shoes......$1.87
(L) 49 N 3959—Stewardess. Blue cotton tailored uniform, hat. Hand bag, shoes... 1.87
(M) 49 N 3960—Coat and Hat. Felt coat, straw hat, kerchief, long hose, shoes... 2.37
(N) 49 N 3961—High Society. Taffeta bell-shaped harem skirt dress, posy hair-band, long hose, high-heel shoes. High-style for Toni's partying................. 2.37
(P) 49 N 3962—Bon Soir. Glamorous nylon ensemble: sheer nighty, lace-trimmed negligee, "jewelled" slippers................................... 2.83
(R) 49 N 3963—Suburbanite. Plastic car-coat, corduroy hood, slack suit, shoes.. 2.83
(S) 49 N 3964—Romance. Satin formal dress in the new chemise style. Lined with taffeta. Genuine Ranch Mink stole. Rope of "pearls," long hose, shoes....... 3.79

I'm SHIRLEY TEMPLE..12-inches tall

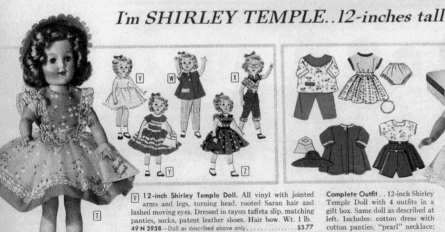

[V] 12-inch Shirley Temple Doll. All vinyl with jointed arms and legs, turning head, rooted Saran hair and lashed moving eyes. Dressed in rayon taffeta slip, matching panties, socks, patent leather shoes. Hair bow. Wt. 1 lb.
49 N 3938—Doll as described above only................$3.77

Buy Shirley's wardrobe below. Shipping weight each 8 oz.
(T) 49 N 3969—Nylon Party Dress. Attached slip, panties. "Straw" hat (2 hat pins), pocketbook. Doll not included. See 49N3938 above.$2.87
(W) 49 N 3965—2-piece cotton pajamas, ribbon for hair... 1.37
(X) 49 N 3968—Pedal Pushers, shirt, belt, sunglasses, ribbon 2.39
(Y) 49 N 3966—Cotton pique dress. Attached slip, panties. Shirley Temple pocketbook. Matching hair ribbon..................$1.79
(Z) 49 N 3967—Jumper Dress, attached cotton blouse, slip, panties, hair ribbon. Shirley Temple pocketbook..................$1.79

Complete Outfit . . 12-inch Shirley Temple Doll with 4 outfits in a gift box. Same doll as described at left. Includes: cotton dress with cotton panties, "pearl" necklace; soft fleecy coat, "straw" hat; 2-pc. cotton pajama set; 3-pc. blouse, shorts and skirt ensemble of cotton. All outfits highly styled with careful detailing, snap closures. Buy extra outfits at left.
49 N 3950—Doll outfit. Shipping weight 2 pounds 12 ounces............$9.97

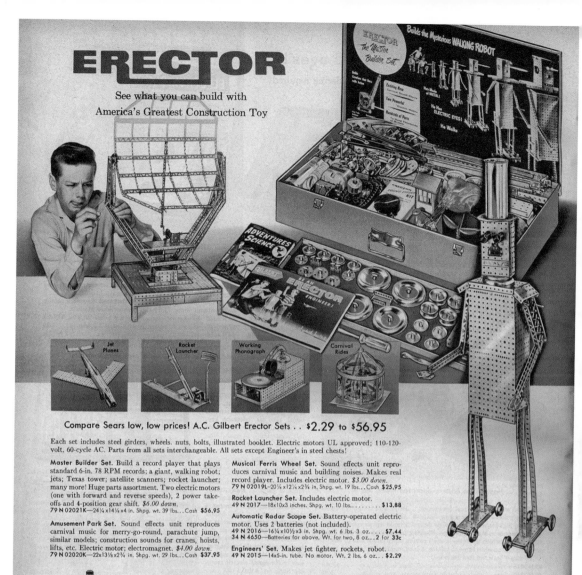

ERECTOR

See what you can build with
America's Greatest Construction Toy

Builds the Mysterious WALKING ROBOT

ERECTOR The Master Builder Set

Jet Planes · **Rocket Launcher** · **Working Phonograph** · **Carnival Rides**

Compare Sears low, low prices! A.C. Gilbert Erector Sets .. $2.29 to $56.95

Each set includes steel girders, wheels, nuts, bolts, illustrated booklet. Electric motors UL approved; 110-120-volt, 60-cycle AC. Parts from all sets interchangeable. All sets except Engineer's in steel chests!

Master Builder Set. Build a record player that plays standard 6-in. 78 RPM records; a giant, walking robot; jets; Texas tower; satellite scanners; rocket launcher; many more! Huge parts assortment. Two electric motors (one with forward and reverse speeds), 2 power take-offs and 4-position gear shift. *$6.00 down.*
79 N 02021K—24¼ x14¼ x4 in. Shpg. wt. 39 lbs...Cash **$56.95**

Amusement Park Set. Sound effects unit reproduces carnival music for merry-go-round, parachute jump, similar models; construction sounds for cranes, hoists, lifts, etc. Electric motor; electromagnet. *$4.00 down.*
79 N 02020K—22x13⅛x2¾ in. Shpg. wt. 29 lbs...Cash **$37.95**

Musical Ferris Wheel Set. Sound effects unit reproduces carnival music and building noises. Makes real record player. Includes electric motor. *$3.00 down.*
79 N 02019L—20¼ x12¼ x2¾ in. Shpg. wt. 19 lbs...Cash **$25.95**

Rocket Launcher Set. Includes electric motor.
49 N 2017—18x10x3 inches. Shpg. wt. 10 lbs.......... **$13.88**

Automatic Radar Scope Set. Battery-operated electric motor. Uses 2 batteries (not included).
49 N 2016—16¼ x10½ x3 in. Shpg. wt. 6 lbs. 3 oz.... **$7.44**
34 N 4650—Batteries for above. Wt. for two, 8 oz...2 for 33c

Engineers' Set. Makes jet fighter, rockets, robot.
49 N 2015—14x5-in. tube. No motor. Wt. 2 lbs. 6 oz... **$2.29**

Real Steam Engines, Atomic Power Plant change heat into energy

[1] Low-priced Steam Engine. *Oscillating* brass cylinder engine. Safety valve, real dome whistle. Water heats in nickel-plated 3½-in. brass boiler with copper-plated, embossed, brick-type walls. Steam operates piston, turns separate flywheel with grooved pulley. To be heated with solid alcohol. Finely varnished metal base 5x8 inches. German import.
49 N 2144—8 in. high overall. Shpg. wt. 3 lbs.............. **$6.98**

[2] Our Standard Steam Engine. 3-in. flywheel. Throttle valve controls speed .. engine runs fast or slow. Double-acting, *oscillating* brass cylinder, slide valve. Positive-acting safety valve, large water gauge, real whistle. Electric unit heats water in 6-in. brass boiler; develops steam to operate piston and turn flywheel. 6-ft. cord. UL approved. 4½x9-inch wood base.
49 N 2321—8 inches high overall. Shpg. wt. 4 lbs.......... **$12.98**

[3] Operating Atomic Power Plant Steam Engine. Power plant actually uses the principles of nuclear energy production to create mechanical power. 110-volt house current substitutes for uranium pile in heat generation. Authentic-looking Graphite Moderator, Heat Exchange Tower, etc. UL approved. All metal. German import. 9x11-inch base.
49 N 2145—9 in. high overall. Shpg. wt. 5 lbs. $2 dn.....Cash **$19.95**

384 PGR KMN

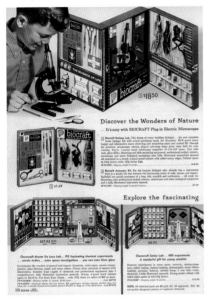

–3.17– Sears, toy chemistry set, 1960

–3.18– Sears, toy catalog, 1960

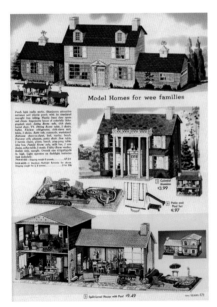

–3.19– Sears, doll houses, 1960

–3.20– Sears, toy dinnerware, 1961

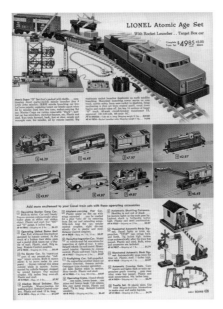

–3.21– Sears, atomic train, 1960

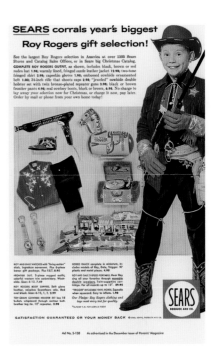

–3.22– Sears, children's apparel, 1959

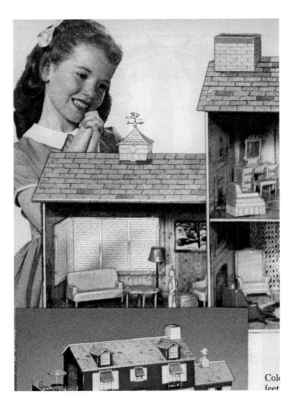

–3.23– Sears, doll house, 1961

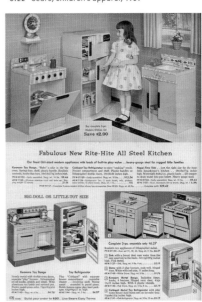

–3.24– Sears, toy kitchen appliances, 1960

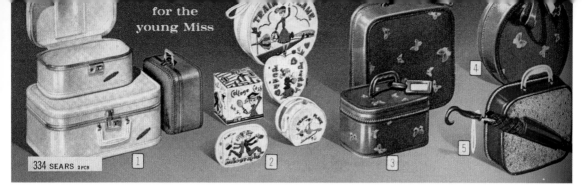

for the young Miss

334 SEARS 2PCB

1 2 3 4 5

−3.25− Sears, 1961

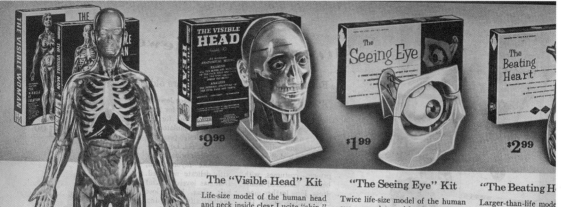

THE VISIBLE WOMAN

THE VISIBLE MAN

THE VISIBLE HEAD $9.99

The Seeing Eye $1.99

The Beating Heart $2.99

THE VISIBLE MAN

$3.99

The "Visible Head" Kit

Life-size model of the human head and neck inside clear Lucite "skin." Fine detail will interest doctors and students . . amuse teen-agers.

All components can easily be removed for analysis. Includes all neck and head parts. Made of plastic molded in 4 colors . . requires little painting. Easy to assemble. Instruction booklet is included.

8 N 9279—Wt. 5 lbs. 8 oz...... $9.99

"The Seeing Eye" Kit

Twice life-size model of the human eye, complete with skull section orbit which serves as a stand. Features an unusual life-like motion which is achieved by pulling on wires which represent actual muscles in the eye.

Fully detailed. Easy to assemble. Made of polystyrene plastic. Instructions, anatomy chart incl.

8 N 9292—Shpg. wt. 12 oz......$1.99

"The Beating H

Larger-than-life mode
man heart with displa
movable sections ma
the interior chambers
detailed construction.

So life-like you can
it beat. Polystyrene
includes a full-color
chart, assembling an
instructions.

8 N 9301—Wt. 1 lb. 4 c

Easy way to discover the wonders of the human body

The "Visible Man" Kit. A valuable teaching-learning aid that makes studying the human body interesting and fun. Marvelous do-it-yourself project. Instead of just reading about the parts of the body, you see them, actually put them where they belong inside a plastic skeleton of the bone structure. Clear Lucite "skin" houses the circulatory system. So life-like that it's startling. Anatomy chart, study guide and instructions included. ⅙ scale model . . 16 inches tall on base.

8 N 9282—Shpg. wt. 3 lbs...........$3.99

The "Visible Woman" Kit. Model of a woman with same material features as above.

8 N 9283—Shipping weight 3 pounds. $3.99

For the Teen-age

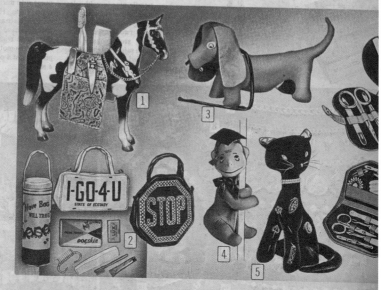

1 2 3 4 5

I-GO-4-U STATE OF ECSTASY

STOP

Tissue Box and Waste-basket

1 Pinto Groomer Set for your cowboy or cowgirl.

5 Sleek-looking Cat is 14 inches tall. Th

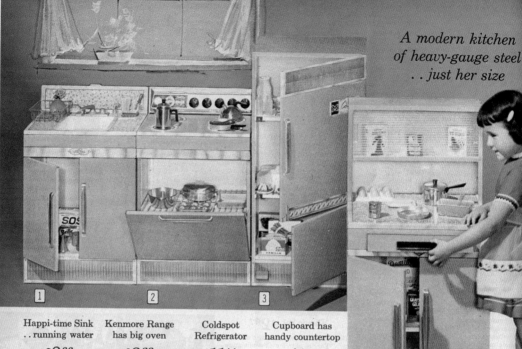

*A modern kitchen
of heavy-gauge steel
.. just her size*

| ① | ② | ③ |

Happi-time Sink .. running water
$8⁶⁶

Kenmore Range has big oven
$8⁶⁶

Coldspot Refrigerator
$11⁴⁴

Cupboard has handy countertop
$10⁶⁶

① Faucet swivels to turn water on-off for all "dolly's" dishes. Watertight plastic basin, 8x8x2 inches. Chrome-plated handles. Lithographed kick plate on cabinet base. 18x15x27½ in. high. Easy to assemble. Accessories sold at right. Shpg. wt. 14 lbs.
79 N 1164C..... $8.66

② So realistic with controls and knobs that really turn and click. Big oven for "baking" her cakes. Spring door, shelf. Chrome-plated handle. Lithographed kick plate. 18x15x27½ in. high. Easy to assemble. Accessories sold at right. Shpg. wt. 15 lbs.
79 N 1162C..... $8.66

③ Stores her "cooking" needs. Large freezer compartment and shelf. Foot door lever, magnetic catch. Chrome-plated handle. Lithographed double doors and kick plate. 18x15x36 inches high. Easy to assemble. Accessories sold at right. Shpg. wt. 18 lbs.
79 N 1163C.... $11.44

④ Gives ample work surface and storage space for play food and utensils. Sliding overhead doors of translucent plastic. Cutlery drawer. Chrome-plated handles, lithographed kick plate on base. 15x18x36 in. high. Easy to assemble. No groceries, utensils. Wt. 19 lbs.
79 N 1161C..... $10.66

Save $3.88 to $4.54 on Complete Kitchen Ensembles

3-pc. Modern Kitchen. Range, refrigerator, sink.
79 N 1152C3—*Separately $28.76.* Wt. 46 lbs. **$24.88**

4-pc. Kitchen. Range, refrigerator, sink, cupboard.
79 N 1167C4—*Separately $39.42.* Wt. 65 lbs. **$34.88**

| ④ |

Kitchen Accessories for items at left

49 N 1126—18-piece Plastic Refrigerator Set of bowls, bottles and make-believe food. Shpg. wt. 1 lb....... $1.44

49 N 1132—22-piece Plastic "Play Food" Set. Wt. 8 oz. 1.90

49 N 1122—17-piece Cook and Bake Set. Assorted aluminum utensils. Shpg. wt. 1 lb. 2 oz............ 1.99

49 N 1125—12-piece Plastic Sink Set. Shpg. wt. 1 lb... 97¢

Kenmore Laundry Set

5-piece Set **$19⁹⁴**

Specially chosen as a Sears Jubilee Value

◆ *Because* lab tests prove everything *really works* .. just like mommy's

◆ *Because* we've never seen a laundry set of this quality selling for under $20

Combination washer-dryer actually washes and spin dries. Just set switch to spin or wash dolly's playsuits and pinafores. Then turn the crank and watch fin-type agitator get out all the dirt. Top load, see-thru plastic lid. Heavy gauge steel. Drain hose for easy emptying.

After laundry's done—hang it up on revolving straightline dryer. 6 plastic clothespins. Press out the wrinkles with real electric iron with light. Folding steel ironing table has heat-resistant Tufflex® (wood fiber) pad and silicone cover.

Washer-dryer is 23½ inches high to work surface, 18x 15x27½ inches high over-all. Electric iron UL listed for 110–120-volt, 60-cycle AC. 5-piece set is shipped by freight (rail or truck) or express.
79 N 1004N—5-piece Set. Shpg. wt. 24 lbs........ $19.94
79 N 1060L—Washer-dryer only. Shpg. wt. 19 lbs... 14.C8

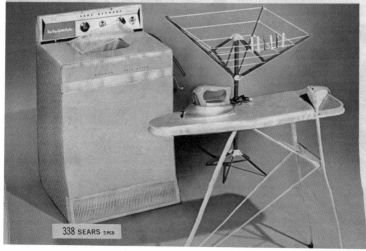

338 SEARS ₂PCB

mini-martians

From up above the
sky so high came the
MINI-MARTIANS
"pinky" high

Professor Pook Marti Mini

Bonnie Meri Teenie

Mini-Martians $1.49 each

Futuristic sprites a mere 4½ inches tall. They'll take
you to their world above where make-believe is so much
fun. Made of soft vinyl, their arms and head move. Comb
and wash their rooted hair. Remove boots for barefoot
space walks. Dressed in supersonic styles. From Japan.
Collect all 6 and have your own Mini-Martian community.
49N3246—**Prof. Pook**. Painted glasses. Wt. 3 oz. $1.49
49N3247—**Marti**. Space lad. Shpg. wt. 3 oz. 1.49
49N3248—**Mini**. In silver-color cape. Wt. 3 oz. . . . 1.49
49N3249—**Bonnie**. In lunar sarong. Wt. 3 oz. . . . 1.49
49N3250—**Meri**. In solar shift. Shpg. wt. 3 oz. . . 1.49
49N3251—**Teenie**. In cosmic tent dress. Wt. 3 oz. 1.49

Martian Star House

Far beyond earth's bustling pace
Mini-Martians dwell at ease

Zooming around in "outer space", Mini-
Martians live and play. Nestled among the
stars and comets . . a home so streamlined,
all their own. Brightly colored outside and
in. Space car parks on terrace platform.

Offered nowhere in the universe
but at Sears

$3.99

Two elevated bunks for sleeping
scanner to check on pals. All fur
vacuum formed. Vinyl house cl
visits to "other planets" . . 15½x5
49 N 9203—Shpg. wt. 2 lbs. 14 o
Mini-Martians not included with Star House

"Carnaby Comet" Clothes for Mini-Martians

Two outfits in each space-age

1 Star Time Togs. For all th
Martian girls. Bright colored
. . one tent dress and hostess p
49 N 3296—Shpg. wt. 3 oz. . .

2 Zoom Suits. Just the thin
the girls take the scooter fo
Each dress has matching helm
49 N 3297—Shpg. wt. 3 oz. . .

3 Stellar Shifts. Just meant
cial parties. Gold-color dr
gold-color headband. Blue d
star trimmed headpiece.
49 N 3298—Shpg. wt. 3 oz. . .

4 Lunar Leisure Wear. Fo
ing, games of star tag. Yel
jumper, headband. Blue, white
49 N 3299—Shpg. wt. 3 oz. . .

5 Galaxy Garb. For Marti or
Pook. Full cape for cold
short jacket and helmet for scoo
49 N 3292—Shpg. wt. 3 oz. . .

6 Jet Jumpers. Professor Poo
them, Marti can too. Silve
ever so dashing for Martian
49 N 3293—Shpg. wt. 3 oz. . .

Dolls not included with above o

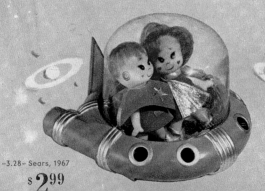

$2.99

Sporty Space Scooter for errands on t

$1.99 One Mini-Martian dri

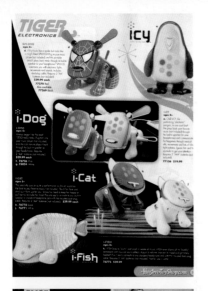

RIDE 'EM, COWBOY

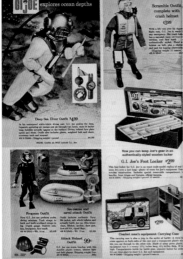

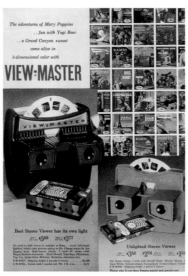

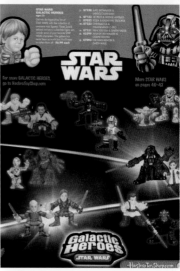

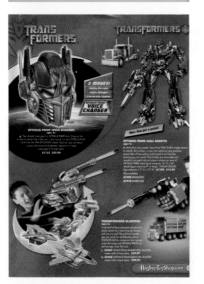

-3.29- Hasbro, Tiger Electronics (top left)
-3.30- Neiman Marcus, mechanical bull, 1996 (top right)
-3.31- Sears, GI Joe, 1966 (middle left)
-3.32- Sears, View-master, 1966 (above)
-3.33- Hasbro, Galactic Heroes (middle right)
-3.34- Hasbro, Transformers (left)
-3.35- Sears, James Bond toys, 1966 (right)

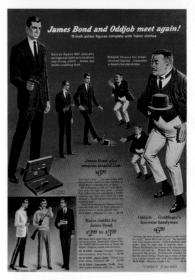

MAJOR MATT MASON

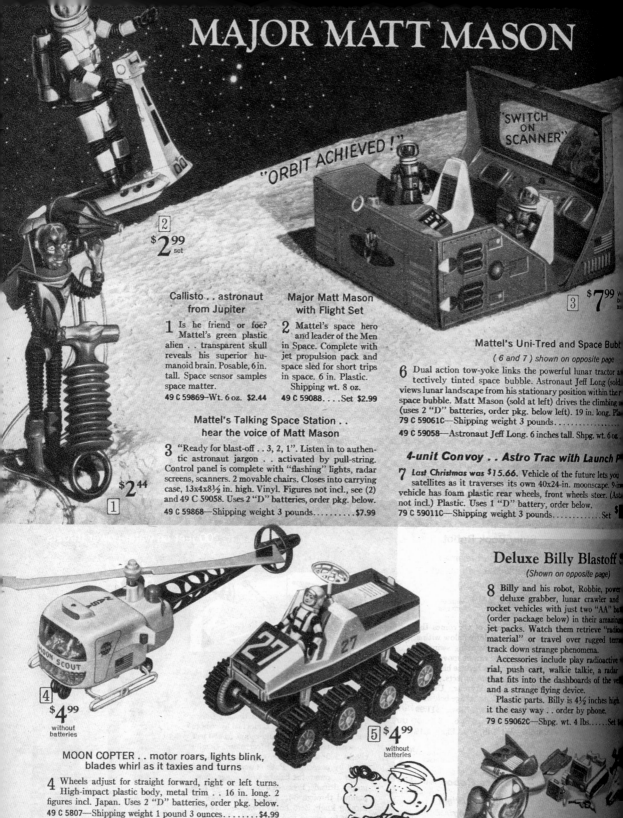

"ORBIT ACHIEVED!"

"SWITCH ON SCANNER"

[2] $2.99 set

[3] $7.99

Callisto . . astronaut from Jupiter

1 Is he friend or foe? Mattel's green plastic alien . . transparent skull reveals his superior humanoid brain. Posable, 6 in. tall. Space sensor samples space matter.
49 C 59869—Wt. 6 oz. **$2.44**

Major Matt Mason with Flight Set

2 Mattel's space hero and leader of the Men in Space. Complete with jet propulsion pack and space sled for short trips in space. 6 in. Plastic. Shipping wt. 8 oz.
49 C 59088. . . . Set **$2.99**

Mattel's Talking Space Station . . hear the voice of Matt Mason

3 "Ready for blast-off . . 3, 2, 1". Listen in to authentic astronaut jargon . . activated by pull-string. Control panel is complete with "flashing" lights, radar screens, scanners. 2 movable chairs. Closes into carrying case, 13x4x8½ in. high. Vinyl. Figures not incl., see (2) and 49 C 59058. Uses 2 "D" batteries, order pkg. below.
49 C 59868—Shipping weight 3 pounds. **$7.99**

Mattel's Uni-Tred and Space Bubb
(6 and 7) shown on opposite page

6 Dual action tow-yoke links the powerful lunar tractor a tectively tinted space bubble. Astronaut Jeff Long (sold views lunar landscape from his stationary position within the r space bubble. Matt Mason (sold at left) drives the climbing (uses 2 "D" batteries, order pkg. below left). 19 in. long. P
79 C 59061C—Shipping weight 3 pounds.
49 C 59058—Astronaut Jeff Long. 6 inches tall. Shpg. wt. 6 oz.

4-unit Convoy . . Astro Trac with Launch P

7 *Last Christmas was* $15.66. Vehicle of the future lets yo satellites as it traverses its own 40x24-in. moonscape. 9-in vehicle has foam plastic rear wheels, front wheels steer. (Ast not incl.) Plastic. Uses 1 "D" battery, order below.
79 C 59011C—Shipping weight 3 pounds. Set

Deluxe Billy Blastoff
(Shown on opposite page)

8 Billy and his robot, Robbie, powe deluxe grabber, lunar crawler a rocket vehicles with just two "AA" ba (order package below) in their amazing jet packs. Watch them retrieve "radi material" or travel over rugged terr track down strange phenomena.

Accessories include play radioactive rial, push cart, walkie talkie, a radar that fits into the dashboards of the ve and a strange flying device.

Plastic parts. Billy is 4½ inches high it the easy way . . order by phone.
79 C 59062C—Shpg. wt. 4 lbs.Set

[4] $4.99 without batteries

MOON SCOUT

27

[5] $4.99 without batteries

MOON COPTER . . motor roars, lights blink, blades whirl as it taxies and turns

4 Wheels adjust for straight forward, right or left turns. High-impact plastic body, metal trim . . 16 in. long. 2 figures incl. Japan. Uses 2 "D" batteries, order pkg. below.
49 C 5807—Shipping weight 1 pound 3 ounces. **$4.99**

SPACE MOBILE climbs over obstacles

5 Runs forward or reverse. 8 wheel drive lets wheels

Basic Billy Blastoff

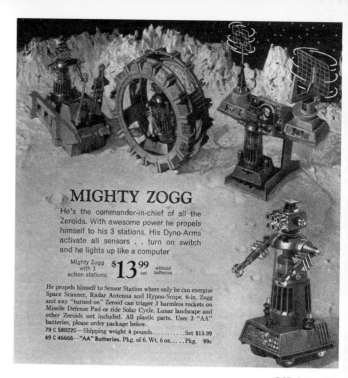

MIGHTY ZOGG

He's the commander-in-chief of all the Zeroids. With awesome power he propels himself to his 3 stations. His Dyno-Arms activate all sensors . . turn on switch and he lights up like a computer

Mighty Zogg
with 3
action stations **$13⁹⁹** set without batteries

He propels himself to Sensor Station where only he can energize Space Scanner, Radar Antenna and Hypno-Scope. 6-in. Zogg and any "turned on" Zeroid can trigger 3 harmless rockets on Missile Defense Pad or ride Solar Cycle. Lunar landscape and other Zeroids not included. All plastic parts. Uses 2 "AA" batteries, please order package below.
79 C 58022C—Shipping weight 4 pounds..........Set $13.99
49 C 46666—"AA" Batteries. Pkg. of 6. Wt. 6 oz.....Pkg. 99c

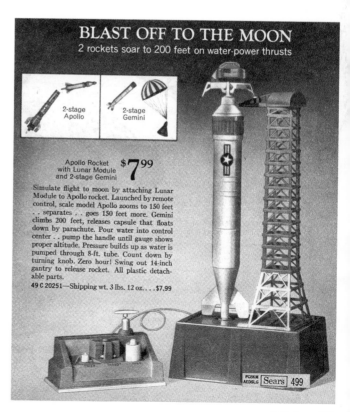

BLAST OFF TO THE MOON
2 rockets soar to 200 feet on water-power thrusts

2-stage Apollo

2-stage Gemini

Apollo Rocket
with Lunar Module
and 2-stage Gemini **$7⁹⁹**

Simulate flight to moon by attaching Lunar Module to Apollo rocket. Launched by remote control, scale model Apollo zooms to 150 feet . . separates . . goes 150 feet more. Gemini climbs 200 feet, releases capsule that floats down by parachute. Pour water into control center . . pump the handle until gauge shows proper altitude. Pressure builds up as water is pumped through 8-ft. tube. Count down by turning knob. Zero hour! Swing out 14-inch gantry to release rocket. All plastic detachable parts.
49 C 20251—Shipping wt. 3 lbs. 12 oz....$7.99

Sears 499

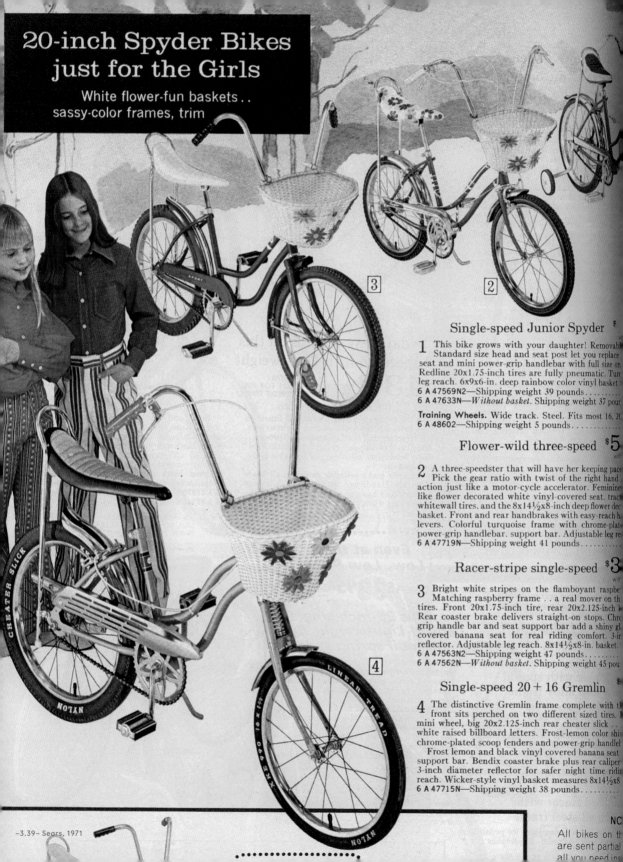

ABIN TENTS

9x12-foot tent
...ps a family of 8 $78.99

...y family-size cabin tent accommodates four
...t or double-decker cots. Outside aluminum
...itches quickly, protects against contact
...Two 18x33-inch nylon screened windows
...mfortable ventilation . . outside tie-down
...wn-in floor helps keep out bugs and moisture.
...he door has nylon screened window . . opens
...th sturdy zipper and double pull sliders.
...pellent finish.
...made of sturdy 6.0-oz. cotton drill. 6.74-oz.
...ill roof. 4.0-oz. gray cotton drill floor. Eave
...feet 10 inches. Center height 6 feet 10 inches.
...cluded. Handsome brown and yellow color.
...nt case, frame case, ground cloth below.
...AL—Shipping weight 40 pounds......$78.99

...my 8x10-foot tent
...ps a family of 6 $54.99

...s three single or double-decker cots. Outside
...num frame sets up in minutes. Two 20x36-
...lon screen windows with outside tie-down
...er comfortable cross ventilation. Sewn-in
...to keep out bugs and moisture. Dutch-style
...a nylon screen window . . full zipper closure.
...pellent finish.
...ails made of strong 6-ounce cotton drill. 6.74-
...tton drill roof. 4.0-ounce cotton sheeting
...ve height 5 feet. Center height 7 feet. Stakes
...d. Handsome green color with yellow trim.
...nt case, frame case and ground cloth below.
...67L—Shipping weight 42 pounds......$54.99

Cabin Tent Accessories

...t Case, 13.13-oz. cotton duck. 10x28-in.
...7031—Shipping weight 2 pounds......$9.49

...me Case. Made of 13.13-ounce cotton duck.
...ches long, 8-inch diameter.
...33—Shipping weight 2 pounds........$6.99

...Ground Cloth. (Not shown.) 10x12 feet.
...68—Shipping weight 3 lbs. 5 oz........$3.98

Sturdy 5x7-foot Pup Tent
with sewn-in floor $18.49

...oor gives ventilation . . zips down center. Water repellent finish.
...n and top made of 6-oz. cotton drill. 4-oz. cotton sheeting floor.
...ith yellow door panels. Center height 3 ft. 6 in. Stakes, ropes included.
...—Shipping weight 12 pounds.............................$18.49
...09—Tent Case. 7.68-oz. cotton duck. 18x46 in. Wt. 14 oz..... 3.98

...ps from Sir Edmund Hillary. 20 pages of sound advice from the
...me explorer who conquered Mt. Everest. Includes tips on planning,
...t, tent care, campsites and cooking. Use postcard on page 662A.

Ted Williams 2-man Pack Tent
with inside-zip storm flaps $59.50

Really lightweight and easy to carry . . weighs just 15½ pounds. Pitches in
minutes with outside aluminum frame. Vinyl-coated nylon floor has sealed
seams to keep water out. 20x32-inch nylon screen window. Nylon screen door.
Water repellent finish. Made of rugged 7.68-ounce cotton drill. Base 6 feet x 7
feet 10 inches long. Center height 4 feet 2 inches. Tent and frame fit in 7x27-in.
zippered case (included). Stakes included. Blue and orange color.
6 A 78017C—Shipping weight 17 pounds.........................$59.50

CPBKM
AEDSLG Sears 815

-3.40 – Sears, Ted Williams tents, 1971

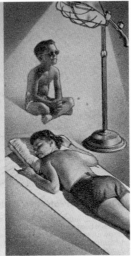

Row, Row your way to a more streamlined
e, to better muscle tone, increased activity

NG MACHINE.
frame is silver
mfortable con-
n rubber wheels
th rowing. 3
ted steel springs
justs spring ten-
tour foot rest ..
ards. Polished
handle grips.
gs with rubber
bber bumpers.
wing exercise at
pping wt. 18 lbs.
in.
.....$12.95

B DE LUXE ROWING MACHINE.
Nickel-plated seat, foot rest,
standing platform are extra durable
.. won't chip. Silver gray frame of
strong steel. Comfortable contour
seat mounted on rubber wheels for
smooth rowing exercise. 3 nickel-
plated steel springs plus 2 extra
springs for more tension in exercises.
Contour foot rest .. steel guards
protect feet. Highly polished hard-
wood handle grips. Steel legs, rub-
ber feet. Rubber bumpers. Provides
wonderful exercise! 48x13½x8
inches. Shipping weight 18 pounds.
8 K 02521L–$2.50 down. Cash $22.95

Sun and Heat Lamp . . .
Sun-bathe indoors

Sperti professional type. Pro-
vides effective therapeutic heat
rays and full-bodied sun bathing
in the privacy of your own home
in any weather. Works three
ways: emits ultra-violet and
infra-red simultaneously or sep-
arately. Adjusts from 51 inches
to 69 inches.
Built-in timer for ultra violet
use turns off lamp automatically,
helps prevent overexposure.
110-120-volt AC, DC. 600 watts.
Shipped freight, express or
truck. Shpg. wt. 33 lbs.
8KM2599–$7.50 dn. Cash $72.95

-Red Massager

d Heat Oscillating
. Massage action stim-
rculation in muscles,
eep, penetrating heat
oothing. Helps relieve
es, pains due to sprains,
over-exertion, every
ns. Stimulates healthy
in facial muscles,
calp. Durable plastic,
late. UL listed. 110-
60-cycle AC.
—Shpg. wt. 12 oz. $5.49

Chest Exerciser

Spring-Pulley Chest Exerciser.
For body-building effects.
Adaptable for men, women,
children. Helps improve pos-
ture, limbers and tones the
muscles. Helps strengthen and
firm chest and bust muscles.
Comes ready for installation
to any wall or door. Easy
to install . . . directions in-
cluded.Spring tension adjusts
easily. Shpg. wt. 9 lbs.
8 K 2504 $13.95

Exercise Suit

Fitted elastic wrist and ankle
cuffs, help create perspiration.
Easy to use. Just wear suit
while you garden, clean house,
participate in sports, exercise.
Suit is made of heavy vinyl
plastic with a 30-in. zipper, elas-
ticized neck, wrists and anklets.
Medium size fits persons up to
6 feet tall. Large fits those over
6 feet. *State size* medium or
large.
8 K 2506—Shpg. wt. 8 oz. .. $3.29

–3.41– Sears, health aids, 1957

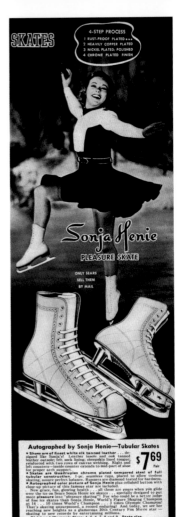

–3.42– Sears, Sonja Henie, 1939

–3.43– Sears, Radio Flyer, 1956

–3.45– Sears, Ted Williams Fielder's Glove, 1971
(opposite)

..SIZED JUST FOR YOUR CHILD

These gold-color appliances run on the best kind of energy . . your child's imagination. Heavy-gauge steel sections have smooth, rolled edges to help protect floors and fingers. Assembly instructions. Ages 4 and up.

New at Sears . .
Washing Machine with $**13**^{99}
hand-crank agitator

3 Your dolls can have clean clothes, too. Just fill the plastic tub with water, put in the clothes and "set" the dial on wash. Simply turn the hand crank to operate agitator for wash or spin dry action. Includes hose for emptying water. Measures 18x15x28 inches high. Buy it the easy way—order by phone.
79 N 1172C—Shipping weight 15 pounds$13.99

Refrigerator-Freezer with
"ice-maker" and 5 shelf areas
$**15**^{99} without food

4 A double-door refrigerator that even has a real-looking "ice-maker" in the freezer compartment. Get plastic cubes when you push a button. Refrigerator compartment has a vegetable crisper with sliding door. Side-by-side doors show pictures of food on shelves. Measures 18x15x36 inches high. Food is not included, order below.
79 N 1173C—Shipping weight 23 pounds.$15.99

men's Mitt. Laced split h big-sized grease-set ans better fielding. Flex-ge hugs the ball. Made ne cowhide with horse-ng. Rawhide lacing t. Adjustable wrist strap h loop for a real fit. right-handed throwers or left-handed throwers 1 lb. 8 oz.$9.99

dded Catcher's Mitt. e trap and large grease-et can handle tricky ucklers and sliders. Dou-ction hinge. Made of rktone cowhide with foam d rubber padding. Raw-g. Adjustable wrist strap. op thumb adjusters. For led throwers only. —Wt. 1 lb. 13 oz. . .$9.99

Sears
SPORTS CENTER ..where you'll find a Ted Williams Fielder's Glove that feels like it's already broken in the first time you step on the diamond. Special heat treatment shapes glove so it fits naturally, comfortably. Deep natural pocket helps snare anything you can get hold of. Flex-action hinge snaps over ball and holds tight. Another nice part of our story: the price. Just $**10.75**

Ted hit a hard one at Sears. And Sears made the play.
Ted wanted a baseball glove that felt broken in the very first time a youngster put it on. "After all," *said Ted*, "a youngster has a tough enough time making the plays—and a stiff new glove just makes it tougher."
So Sears went to bat for Ted.

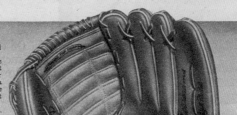

-3.46- Sears, 1975

Mini-Martians

From up above the sky so high come the MINI-MARTIANS "pinky" high

Sears, 1967

–3.47– Eddie Bauer

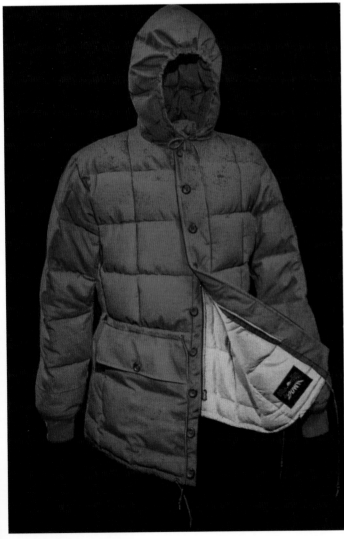

–3.48– Eddie Bauer, Kara Koram, 1954

be a real trip, with the help of this Her Gift for Christmas 1982.

e best inducement to exercise since ery of the mirror (and considerably ting), the LaserTour™ by Perceptronics e modern magic of microelectronics to tally new concept of surrogate travel ercise. The LaserTour, created for arcus, is a unique microcomputer at amalgamates a superior, industrial erDisc™ player with a video disc, a 45″ n video projector, and the Lifecycle® bicycle/aerobic trainer.

dal off on the bicycle, you're plunged ety of locations and situations —

projected from the laser video disc onto the large screen, eye level projector. The faster you pedal, the faster you whirl through the landscape. At intervals, road signs give you a choice of destinations at the push of a button on your cycle's handle. You can vary the same tour as the day's mood dictates. Glide down the beach bikeways, cruise through elegant Beverly Hills, range the Southern California canyons and hills (you'll feel the ups and downs). Or Mitty-like, choose the multi-segment fantasy tour for some surprises.

To ice the cake, any part of the LaserTour System may be used on its own — the entertainment components separately to enjoy your favorite TV programs or video disc movies, or the Lifecycle alone for simply the finest precision mechanical

exercise. As a complete unit the combination of elements directed by the microcomputer gives you startlingly natural control over your tours — movement speed, route, sensations of change in grade over the terrain.

Sign up for LaserTour — you'll want to travel this way often for your health, and for pure fun.

23A. LaserTour System with Lifecycle, rear screen projector, LaserDisc player, and an especially produced video disc with approximately two hours of tours, 20,000.00.*

*For full information, including delivery fees to your area, call Neiman-Marcus, Area code 214/573-5780.

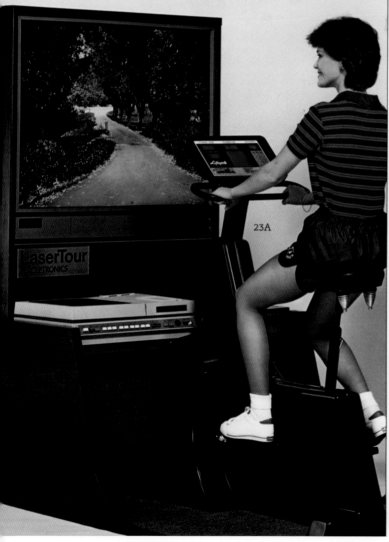

23A

-3.49- Neiman Marcus, His and Hers interactive bike, 1982

POLO TRAINING FOR THE NEW AGE

128A Since polo's introduction to England in 1869, determined polo players have known the advantage of constant training. Britain's Lord Mountbatten once built a wooden horse on shipboard, and trained sailors for a match with Malta. Now there is the Polo Tech Trainer from England, computerized and mechanized to simulate the actual conditions and feel of playing on the field. With this high-tech trainer, the player can develop correct timing and striking of the ball while at full gallop, be-fore ever going or the field. Ideal for beginner, invaluab the experienced pl The trainer slow ca canters, and gallo ahead; a light on head signals wher much pressure is c reins. With the sp ly developed rubb ball, play in a rest ed area can feel l the game at full g lop. Best of all: no chukkers! Allow 8 weeks. Green woo base not included. Catalog order onl

128A. Pit Polo Ltd Polo Tech Trainer, 12,000.00 (X).*

*gift wrap not availa

128A

HIS & HERS. Maybe he sent bonbons after the first date. Certainly, untold chocolate has been exchanged over the years. To celebrate that entertaining, exasperating, enduring thing you call love, try our His & Hers portrait by Vik Muniz. The brilliant Brazilian lives and works in New York, crafting internationally famous art out of literally anything: caviar, dirt, diamonds, toys even! Here, he will capture your likenesses in a double helping of Bosco® chocolate syrup. You come away with a framed 60" x 48" museum-quality photographic work of art, a limited edition of one, thank you. To grow the good karma you've started, Vik is donating his proceeds to Centro Espacial Rio de Janeiro, the charity he created to bring social and art projects to life for underprivileged young people in Brazil. Call 1.877.9NM.GIFT for the delicious details.
96 Double Portrait in Chocolate 110,000.00

Art by Vik Muniz © Vik Muniz/Licensed by VAGA, New York, NY

TREETENT. What exactly is going on in there? A totally new way to experience nature. A limited-edition dollop of sci-fi futurism. A 13-foot-tall cred-building choice that silences that, "We hate camping!" whining once and for all. Dutch sculptor and designer Dré Wapenaar has earned international fame for making the world's coolest architectural tents. Nestled among the branches, up off the ground, there's a nine-foot-diameter hardwood floor and groovy round mattress inside. It sleeps two adults comfortably and also makes the world's coolest tree fort/spaceship (with adjustable planetary landing steps). Send the kids to granny's every once in a while and let the rising sun wake just the two of you. We'll promise not to disturb you too early, if you promise to call 1.877.9NM.GIFT for more details.
97 Treetent by Dré Wapenaar 50,000.00

98A "Blading" is an exciting new way to roller skate, creates a great off-season workout for ice skaters or skiers. With the wheels set in line, the motion is not linear, but side to side — working both upper and lower body. As a low-impact sport it's easier on the joints than running. In sizes 3-13. For women, size down 1½ sizes. By Rollerblade® Mail Order only.

98A. Macroblade® skates, as shown, 265.00.

98B Surf in the winter with the Snowboard. A fast-rising winter sport. Flexible fiberglass with foam core, urethane tip and tail, UV coating. 170cm long, it weighs 8 lbs. Colors and pattern as shown. Adjustable bindings fit most boot sizes. From Mail Order only.

98B. K2 Snowboard with bindings, 554.00.

99A-F David Upton, Ph.D., researched and selected stellar equipment for us to compile the Ultimate Fitness Room.

The Polar Accurex® Heart Rate Monitor is used by world class athletes to improve performance by increasing aerobic capacity, maximize recovery, avoid injuries or over-training. It's the single most important aid to anyone's workout program. ECG accuracy eliminates guess work.

Hoggan dumbbells and rack are professional quality. Dumbbells have anatomically contoured handles. The 10 pairs are made of chrome and solid steel, weighing 4 to 45 lbs. The rack is made of solid steel and polished chrome. Rests are coated with PVC for protection.

The Hoggan Adjustable Bench (not shown) is made of chrome and solid steel. Measuring 18 x 48", it accommodates a wide variety of exercises. The bench back easily adjusts from a flat to a full upright position.

The LifeFitness Lifestep 1000® is engineered to give the maximum benefits with the least stress to the body. Fingertip control determines intensity of workout. Digital readouts display energy output vs. goal, calories burned. Operating dimensions of the unit are 36" wide and 49" long.

The Challenger Mach 5® walking/jogging treadmill has a speed range of 0-10 mph, an 18 x 51" surface. It can be self-programmed, and stores 9 programs up to 40 stages each. The unit is equipped with 5 pre-existing programs.

The 21st Century Workout Orbotron® is a non-repetitive, no-impact workout as much fun as it is beneficial. A safe and easy cardiovascular unit for all levels of ability, and a thrill to ride! Can be set up indoors or out. Requires an 11' square area.

99A. Heart rate monitor, 249.00 (X).
99B. Dumbbells, rack, 3730.00 (X).*
99C. Adjustable bench, 715.00 (X).*
99D. Lifestep 1000, 3495.00 (X).*
99E. The Challenger, 4100.00 (X).*
99F. Orbotron, 6895.00 (X).*

All items on page 98 and 99 are available from Mail Order only. For more information, call toll free, 1-800-NEIMANS.

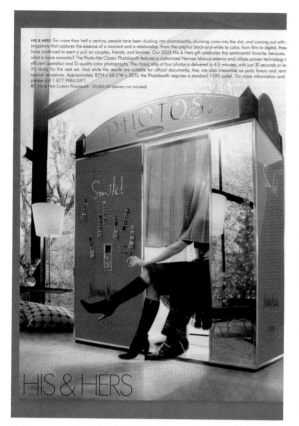

HIS & HERS

–3.53– Neiman Marcus, photobooth, 2005

–3.54– Neiman Marcus, underwater BOB, 1994

–3.55– Neiman Marcus, robots, 2003

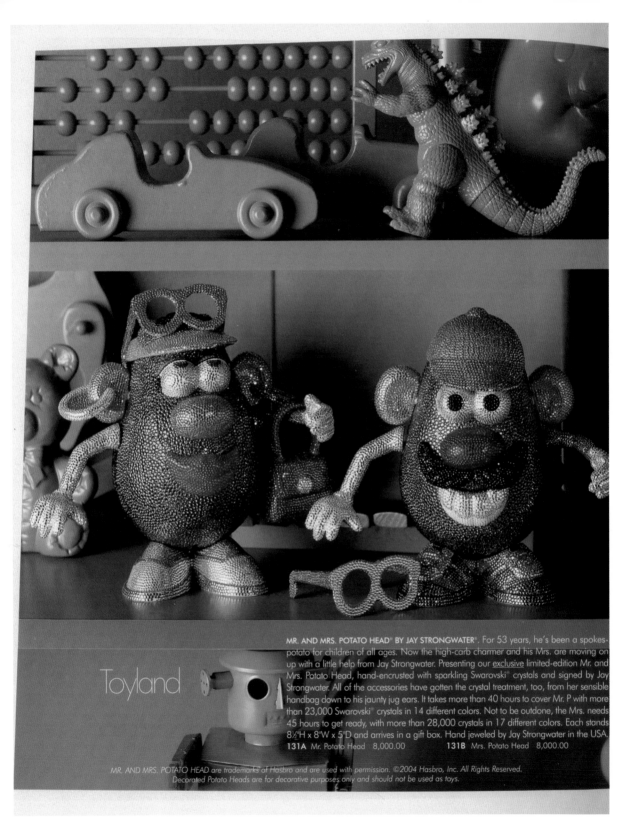

MR. AND MRS. POTATO HEAD® BY JAY STRONGWATER®. For 53 years, he's been a spokes-potato for children of all ages. Now the high-carb charmer and his Mrs. are moving on up with a little help from Jay Strongwater. Presenting our <u>exclusive</u> limited-edition Mr. and Mrs. Potato Head, hand-encrusted with sparkling Swarovski® crystals and signed by Jay Strongwater. All of the accessories have gotten the crystal treatment, too, from her sensible handbag down to his jaunty jug ears. It takes more than 40 hours to cover Mr. P with more than 23,000 Swarovski® crystals in 14 different colors. Not to be outdone, the Mrs. needs 45 hours to get ready, with more than 28,000 crystals in 17 different colors. Each stands 8½"H x 8"W x 5"D and arrives in a gift box. Hand jeweled by Jay Strongwater in the USA.
131A Mr. Potato Head 8,000.00 **131B** Mrs. Potato Head 8,000.00

Toyland

-3.57- Neiman Marcus, 2007

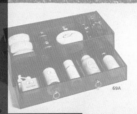

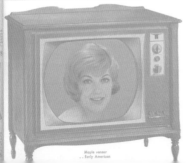

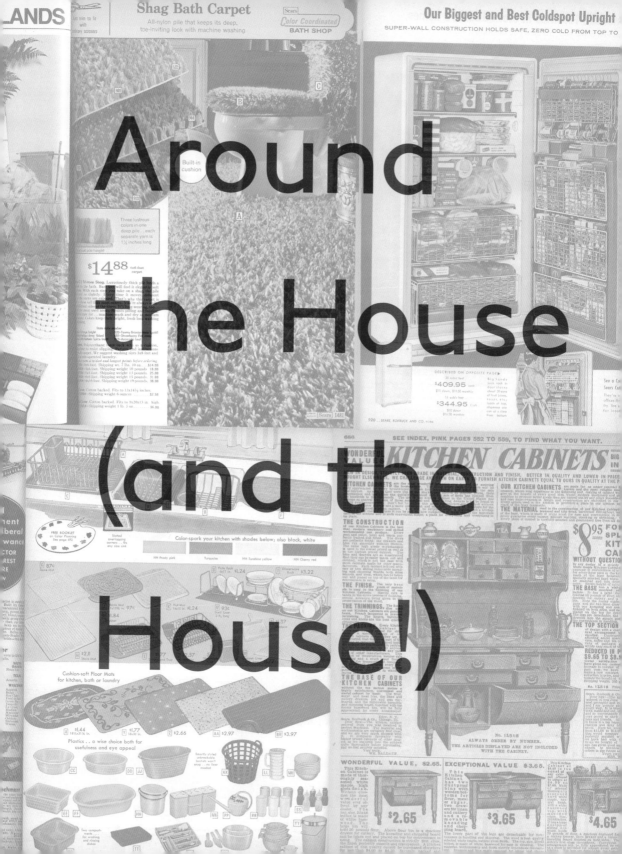

Around the House (and the House!)

4

Around the House (and the House!)

Not only could you buy everything you needed around the house, from appliances and furniture to bedspreads and carpets, Sears and other mail-order outfits would also sell you the materials to make your own house.

When mail order started, 65 percent of the United States population lived in rural areas. But during the early twentieth century's industrialization and immigration, veterans returned from war eager to start families, which created a pressing need for houses in both urban and suburban areas. 1920 was the first time that the number of people living in cities outnumbered those living in rural areas.

In 1906, Aladdin Homes of Bay City, Michigan, was the first company to offer prefabricated homes by mail. Sears launched their Modern Homes Catalog two years later, though initially they just sold house plans. Sears started selling the home kits in 1915 and in 1916, started their own mortgage business. A number of other manufacturers also offered mortgages—a very profitable sideline, until the Depression when the number of defaulters skyrocketed. Montgomery Ward

started selling house plans in 1911. In 1921, Ward partnered with Gordon-Van Tine to sell plans and materials; they stopped selling houses in 1931. Though they were marketed under the Wardway brand, they contracted all of the manufacturing from other mills. The Lewis Manufacturing Company (later Lewis-Liberty) were the other prominent house kit purveyors.

Sears's initial catalog offered forty-four different models ranging in price from $495 to $4,115. A typical home filled two boxcars and came with up to 30,000 different pieces. The homes came with a seventy-five-page leather-bound instruction manual plan with the new homeowner's name embossed in gold. In addition to precut lumber, 750 pounds of nails, glue, plaster, paint, windows, doors, plumbing, and electrical fixtures and bathroom tile floors set in mortar, Sears included floor plans suggesting optimum placement of Sears furnishings (sofas, chairs, beds, dinettes, etc.) as well as two trees for planting in the front yard.

While these new homes helped to spread modern innovations like central heating, electric lighting, and indoor plumbing, not all communities had electricity and water systems; Sears continued to offer a $23 outhouse well into the 1920s.

In 1918, Standard Oil had just opened a new coal mine in Carlinsville, Illinois. The miners and their families needed places to live so the company wrote out a check for $1 million to Sears. That money bought 192 precut Sears houses; 156 of which were built in a twelve-block area of Carlinsville that became known as the "Standard Addition." (When the mine closed and the town fell on hard times, it became known as the "Substandard Addition.")

The Depression foretold the end of the house kit market. Montgomery Ward stopped selling house kits in 1931; Sears stopped in 1940. Between 1908 and 1940, it is believed

that 500,000 mail-order houses were sold; roughly one-quarter of them by Sears. Of the major prefabricated house manufacturers, only Sears is still in business. Kit homes continued to be of interest; a 1925 Lewis home in Chevy Chase, Maryland, which would have cost less than $5,000, sold for $550,000 in 2001. Also in Chevy Chase, a Sears home recently sold for $816,000.

In 2005, the fishing/hunting catalog Orvis introduced its own log cabins that can be shipped to the owner's favorite fishing spot. They offer six different models, which they are quick to mention are "premilled, not prefabricated." Each is named after a river or lake—so The Rogue is named after Oregon's river, not the village cad. Turnkey prices start at $500,000 including walls, doors, windows, beams, roofing, and hardware. All models include a "Sportsmen's Room."

Catalogs also reflect the changes in the utility and design of the domestic environment. Initially, labor, from canning and baking to water heating and laundry, was done at home and by hand. Catalogs provided the requisite Mason jars, cream separators, and washtubs. After WWII, when appliances were designed to make housekeeping more efficient and less labor-intensive, the mass production of appliances flourished. Sears made the world safe for the avocado-colored appliances of the seventies when they introduced the Kenmore Harmony House appliances in Sunshine Yellow, Malibu Coral, and Aquamarine, in addition to the standard white of 1940.

Catalogs sold iceboxes well into the twentieth century; the mechanical refrigerator wasn't invented until 1913. Boxy refrigerators were introduced in 1916; freezer compartments were added in the thirties. Sears's Coldspot electric refrigerator was the toast of Paris when it was introduced at the Paris International Exposition in 1929. In 1937, a streamlined Coldspot, designed by acclaimed industrial designer Raymond Loewy, won first prize for design at that year's Paris exposition.

For washing, metal tubs replaced wooden ones in 1900. Early washing machines were hand-powered. In 1929, Sears offered the motor-operated "Gyrorator" for $79.50. The first one to wash, rinse, and extract water from clothes was Sears's Toperator, introduced in 1933. In 1947, Sears introduced a top-loading automatic washing machine for $239.95.

The first portable vacuum cleaner was introduced in 1901. Unfortunately, it weighed ninety pounds and wasn't a big hit. James Spangler invented the "suction sweeper" out of a box, a fan, and a pillow case. He incorporated a rotating brush to lift up dirt. He sold his invention to his friend, "Boss" Hoover. Hoover introduced the first vacuum with a cloth filter and cleaning attachments in 1908. Sears offered its first vacuum cleaner in 1932 for $24.50.

Early stoves were powered with wood, charcoal, and coal. Gas stoves gained popularity at the end of the nineteenth century and were offered by both Sears and Montgomery Ward; the electric stove was invented in 1906 but didn't catch on until the thirties when most American residences were electrified.

The microwave oven was the accidental invention of an engineer at Raytheon who noticed a candy bar in his pocket melted when he walked past a bank of radar tubs. Christened the "Radarange," the first microwave ovens cost $2,000–$3,000 and were originally marketed for commercial use. It wasn't until Raytheon acquired Amana in 1965 that the microwave took off in American households. The microwave oven first appeared in the Sears and Montgomery Ward catalogs in 1971. By 1975, sales of microwaves had surpassed those of gas ranges. By 1976, more Americans owned microwaves than dishwashers.

For years, Americans had heard that television was just around the corner. A 1938 article in *Radio News* asked, "Is Television Here?" "Yes" said the vice president of the American Television Institute; "No" said the president of Zenith Radio Corporation. RCA introduced television at the 1939 World's Fair as RCA President David Sarnoff proclaimed, "Now we add sight to sound." NBC began regularly televised broadcasting at the fair. In the early days, Sears invited customers to attend television demonstrations, while RCA offered salespeople seminars on how to sell the new technology. By 1955 when catalogs and manufacturers introduced color televisions, there were roughly 40 million black-and-white televisions in American households. Sears's and Montgomery Ward's color televisions were advertised for less than $500. In 2002, Sears Kenmore was the "official home appliance" supplier for the Winter Olympics in Salt Lake City.

The rise of the suburb also spurred America's love of growing plants, and gardening catalogs flourished, introducing many foreign plant varietals to American gardeners. Plant developers were protected from imitators when President Hoover signed a law allowing new plant varietals to be patented like inventions. The garden catalogs were known for their optimistic, almost over-the-top language, touting fruits, vegetables, and flowers of previously unimaginable grandeur. Wayside Gardens offered the Amaryllis Hercules and the Rose Double Knock Out; Burpee offered the Tomato Mortgage Lifter developed in the 1930s by a gardener who paid off his mortgage by selling the plants, which yielded immense, flavorful tomatoes. One of the more peculiar innovations was Kelly Nurseries' Fruit Cocktail Tree, an "amazing one-tree orchard" that grew nectarines, peaches, plums, and apricots on the same tree. Kelly Nurseries also offered the Apple 5-on-1 Dwarf, which is actually a small fruit tree with five different apple varieties grafted on one tree. A Pear 5-on-1 Dwarf was also available.

To avoid disappointment, garden writer Ken Druse offered home gardeners the following advice:

1. Read the catalog.
2. Mark those plants you believe you cannot live without.
3. Fill out the form.
4. Tear up the form and throw it away.

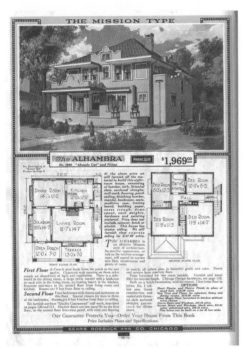

−4.1− Sears Kit House, 1918

−4.2− At the end of the nineteenth century, Simplex made inexpensive "Index" typewriters. They did not have keyboards, and the acts of selecting a letter and printing it were separate.

MODERN-OF COURSE SEARS HAVE IT

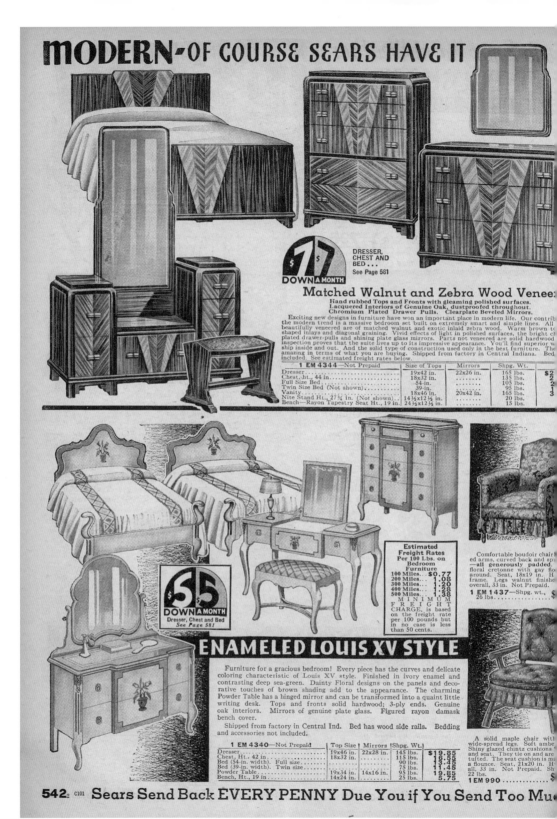

$7 7 $ DOWN A MONTH

DRESSER, CHEST AND BED... See Page 581

Matched Walnut and Zebra Wood Veneer

Hand rubbed Tops and Fronts with gleaming polished surfaces. Lacquered Interiors of Genuine Oak, dustproofed throughout. Chromium Plated Drawer Pulls. Clearplate Beveled Mirrors.

Exciting new designs in furniture have won an important place in modern life. Our contrib the modern trend is a massive bedroom set built on extremely smart and simple lines. All beautifully veneered are of matched walnut and exotic inlaid zebra wood. Warm brown re shaped inlays and diagonal graining. Vivid effects of light in polished surfaces, the bright ch plated drawer-pulls and shining plate glass mirrors. Parts not veneered are solid hardwood inspection proves that the suite lives up to its impressive appearance. You'll find superior w ship inside and out. And the solid type of construction used only in the best furniture. Th amazing in terms of what you are buying. Shipped from factory in Central Indiana. Bed included. See estimated freight rates below.

1 EM 4344—Not Prepaid	Size of Tops	Mirrors	Shpg. Wt.	
Dresser	19x42 in.	22x26 in.	165 lbs.	$2
Chest, ht., 44 in.	18x32 in.	135 lbs.	2
Full Size Bed	54-in.	105 lbs.	1
Twin Size Bed (Not shown)	39-in.	95 lbs.	3
Vanity	19x34 in.	20x42 in.	165 lbs.	
Nite Stand Ht., 27¾ in. (Not shown)	14½x12½ in.	20 lbs.	
Bench—Rayon Tapestry Seat Ht. 19 in.	24½x12½ in.	15 lbs.	

$5 5 $ DOWN A MONTH

Dresser, Chest and Bed See Page 581

Estimated Freight Rates Per 100 Lbs. on Bedroom Furniture

100 Miles	$0.77
200 Miles	1.08
300 Miles	1.20
400 Miles	1.28
500 Miles	1.38

MINIMUM FREIGHT CHARGE, is based on the freight rate per 100 pounds but in no case is less than 50 cents.

Comfortable boudoir chair ed arms, curved back and sp —all generously padded floral cretonne with gay flo around. Seat, 18x19 in. H frame. Legs walnut finishe overall, 33 in. Not Prepaid.
1 EM 1437—Shpg. wt., 26 lbs.

ENAMELED LOUIS XV STYLE

Furniture for a gracious bedroom! Every piece has the curves and delicate coloring characteristic of Louis XV style. Finished in ivory enamel and contrasting deep sea-green. Dainty Floral designs on the panels and decorative touches of brown shading add to the appearance. The charming Powder Table has a hinged mirror and can be transformed into a quaint little writing desk. Tops and fronts solid hardwood; 3-ply ends. Genuine oak interiors. Mirrors of genuine plate glass. Figured rayon damask bench cover.

Shipped from factory in Central Ind. Bed has wood side rails. Bedding and accessories not included.

1 EM 4340—Not Prepaid	Top Size	Mirrors	Shpg. Wt.	
Dresser	19x46 in.	22x28 in.	145 lbs.	$19.85
Chest, Ht., 42 in.	18x32 in.	115 lbs.	18.55
Bed (54-in. width). Full size	90 lbs.	11.49
Bed (39-in. width). Twin size	75 lbs.	11.45
Powder Table	19x34 in.	14x16 in.	95 lbs.	19.85
Bench, Ht., 19 in.	14x24 in.	25 lbs.	5.75

A solid maple chair with wide-spread legs. Soft ambe Shiny glazed chintz cushions and seat. They tie on and are tufted. The seat cushion is ma a flounce. Seat, 21x20 in. H all, 31 in. Not Prepaid. Sh 22 lbs.
1 EM 990 $

542 C101 **Sears Send Back EVERY PENNY Due You if You Send Too Muc**

special attention being given to the preservation of the wood.

THE TRIMMINGS. The handles used on our Kitchen Cabinets are genuine brass, French lacquered to prevent tarnishing. The hinges, fasteners, locks and knobs are the best quality obtainable.

THE PACKING. Every Kitchen Cabinet is firmly and securely crated for shipment. A special feature of our kitchen cabinets is that they are so constructed that the lower part of the legs can be removed and placed inside the cabinet for convenience in packing and can be easily put on by anyone. This feature is not found in any cabinets of other manufacturers. This method of construction insures safe handling and a much lower freight rate by the transportation company. We absolutely guarantee every cabinet to arrive at your home in the same perfect condition in which it leaves the factory.

THE BASE OF OUR KITCHEN CABINETS without the top section makes a highly satisfactory, convenient and useful cabinet by itself. The flour, sugar and meal bins, the linen and cutlery drawers, pot and pan cupboards, and the removable kneading and chopping board, together with the roomy basswood top, will be fully appreciated by every housekeeper.

Sears, Roebuck & Co., Chicago, Ill.
Dear Sirs:—The kitchen cabinet ordered from you was received in perfect condition. The material and workmanship are certainly first class. I am very much pleased with it. It compares favorably with higher priced cabinets of other dealers, as we inquired into the subject quite thoroughly before purchasing, and we feel entirely satisfied.
Very truly,
WM. BALDAUF.

No. 1L51
ALWAYS ORDER BY
THE ARTICLES DISPLAYED A
WITH THE CAB

HARDWARE - CUTLERY
ELECTRICAL GOODS
POWER TOOLS · MOTORS · VACUUM CLEANERS
KITCHEN WARE · ALUMINUM WARE

SEARS, ROEBUCK AND CO.
The World's Largest Store ... A National Institution CHICAGO

–4.5– Sears, hardware, 1932

WONDERFUL VALUE, $2.65.

This Kitchen Cabinet is made of thoroughly seasoned white maple, high gloss finish. Without question the most wonderful value ever offered by any dealer. The top, size, 25x44 inches, is made of white basswood. The large bin will

$2.65

EXCEPTIONAL VALU

This Kitchen Cabinet has two dustproof bins with wooden bottoms for flour, meal or sugar, two drawers for linen and cutlery and a removable kneading and chop-

$3.65

–4.4– Sears, kitchen, 1908

ALREADY CUT AND FITTED PRICE $569.00 AND UP

A Modern General Purpose Barn, Braced Rafter Type, With Drop Siding, "Already Cut" and Fitted.

LIGHT, air and comfort for a mixed stock are the special features of this General Purpose Barn. The construction is of the braced rafter type shown on page 4.

Ground floor height, 8 feet 6 inches.

Framing lumber is of No. 1 yellow pine.

The outside walls are covered with drop siding of Cypress, "The Wood Eternal." This secures a strong and weather resisting combination.

To make the roof good and strong we furnish tight fitting tongued and grooved sheathing boards to be laid on the rafters and covered with Fire-Chief Shingle Roll Roofing. Fire-Chief Roofing is guaranteed by us for fifteen years. It resembles painted shingles.

Doors are made of Clear Cypress, "The Wood Eternal." Ground floor doors and the double hay door slide on Roll Rite Hangers, the highest priced hangers we handle. A smaller hinged door on the mow floor level is convenient for many purposes. All doors are "ready made," ready to hang in place and are superior to those produced by hand carpentry.

Large windows, 1⅜ inches thick, with nine lights, are liberally provided for the ground floor. Opening size of windows is 2 feet 8 inches by 3 feet 6 inches. Ventilation shields are furnished. A quick change of air can be made by lifting the windows back into the shields. The practical construction of the shields protects your stock from direct drafts.

Gable arrangement of barn, 24 feet wide, is shown in the small illustration. This size has different door and window arrangement on ground floor and a drop hay door.

Hardware, such as latches, bolts, screws, nails, etc., is included in the price, also sufficient paint for two coats, oxide red for the body and white for the trim. You may select other combinations from our paint page (see page 47). Ventilating systems, cupolas, barn equipment, silos, foundation material, etc., are not included in the price.

Floor Plans. See pages 40 to 42 for sample floor plan arrangements. Be sure to specify number of the floor plan that best suits your requirements. Use the enclosed sketch sheet to outline your needs when changes are necessary and return for quotation on equipment.

Our "already cut" feature, together with "ready made" doors, sash, etc., furnished at the prices quoted, make it possible for you to erect this modern general purpose barn at a remarkable saving of time and labor. Free building plans, which are easy to understand, are furnished with every order. They show exactly where every piece fits. You will appreciate the value, economy and convenience in this strong and sanitary modern general purpose barn.

QUALITY GUARANTEED

Prices of "Ideal" Modern General Purpose Barn No. 2060 "Already Cut" and Fitted.

SIZE OF BARN				PRICE OF BARN		HAY MOW Capacity in Tons	SIZE OF BARN				PRICE OF BARN		HAY MOW Capacity in Tons
Width, Feet	Lgth, Feet	Height, From Sill to Eaves, Feet	No.	With 1 Common Siding	With Select Cypress Siding		Width, Feet	Lgth, Feet	Height, From Sill to Eaves, Feet	No.	With 1 Common Cypress Siding	With Select Cypress Siding	
24	26	12		$ 569.00	$ 595.00	17	34	44	16		$1,144.00	$1,199.00	63
24	32	12		644.00	673.00	21	34	56	16		1,397.00	1,420.00	80
24	38	12		719.00	751.00	25	34	68	16		1,570.00	1,640.00	97
28	32	12		794.00	829.00	29	34	74	16		1,676.00	1,751.00	106
28	44	12		806.00	859.00	34	34	86	16		1,889.00	1,973.00	123
28	50	12		859.00	897.00	34	34	98	16		1,999.00	2,291.00	140
28	56	12		947.00	988.00	39	36	38	16		1,081.00	1,136.00	61
30	32	12		1,123.00	1,169.00	49	36	44	16		1,192.00	1,250.00	71
30	38	12		843.00	881.00	29	36	50	16		1,412.00	1,478.00	90
30	44	12		936.00	978.00	34	36	56	16		1,633.00	1,706.00	109
30	50	12		1,031.00	1,076.00	43	36	74	16		1,743.00	1,820.00	118
30	62	12		1,125.00	1,173.00	57	36	86	16		1,963.00	2,048.00	138
30	74	12		1,312.00	1,367.00	68	36	98	16		2,184.00	2,276.00	157
32	32	14		1,499.00	1,563.00	72	36	110	16		2,404.00	2,504.00	176
32	38	14		873.00	917.00	56	40	44	16		1,554.00	1,626.00	104
32	44	14		970.00	1,017.00	45	40	56	16		1,877.00	1,626.00	125
32	50	14		1,067.00	1,117.00	51	40	68	16		2,386.00	2,485.00	150
32	56	14		1,261.00	1,318.00	60	40	98	16		2,623.00	2,731.00	202
32	74	14		1,418.00	1,418.00	73	40	110	16		3,099.00	3,225.00	247
34	44	16		1,038.00	1,089.00	87	40	152	16		3,455.00	3,595.00	280

–13–

SEARS, ROEBUCK AND CO., CHICAGO.

–4.6– Sears, barn, 1918

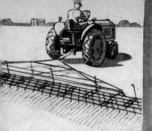

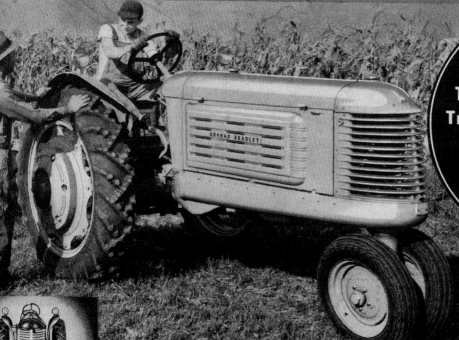

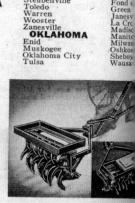

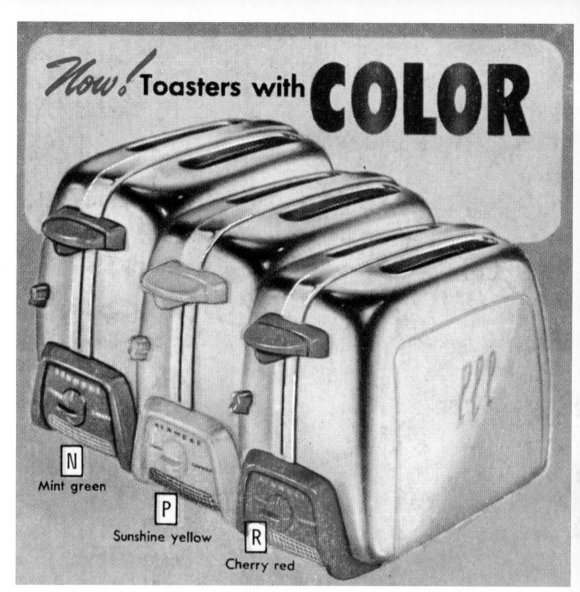

Now! Toasters with COLOR

N Mint green

P Sunshine yellow

R Cherry red

-4.7- Sears, 1939

-4.8- Sears, 1952

Our Biggest and Best Coldspot Upright Freezers..

SUPER-WALL CONSTRUCTION HOLDS SAFE, ZERO COLD FROM TOP TO BOTTOM

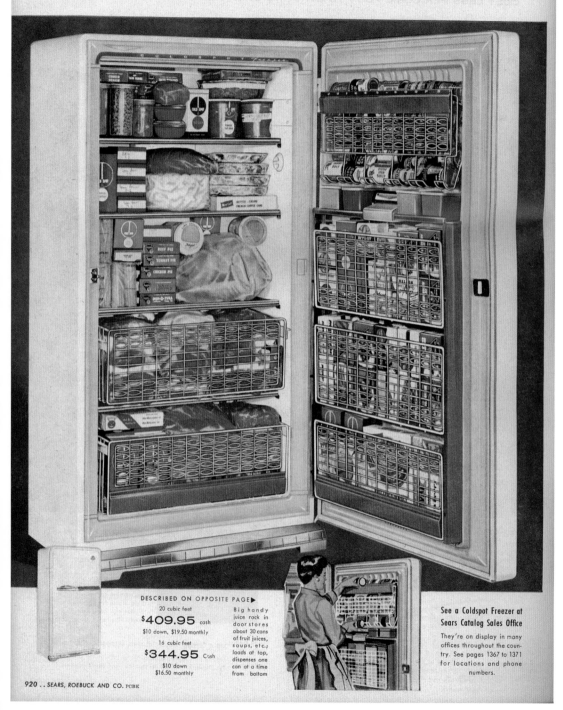

DESCRIBED ON OPPOSITE PAGE▶

20 cubic feet

$409.95 cash

$10 down, $19.50 monthly

16 cubic feet

$344.95 Cash

$10 down
$16.50 monthly

Big handy juice rack in door stores about 30 cans of fruit juices, soups, etc., loads at top, dispenses one can at a time from bottom

See a Coldspot Freezer at Sears Catalog Sales Office

They're on display in many offices throughout the country. See pages 1367 to 1371 for locations and phone numbers.

920 .. SEARS, ROEBUCK AND CO. PGBK

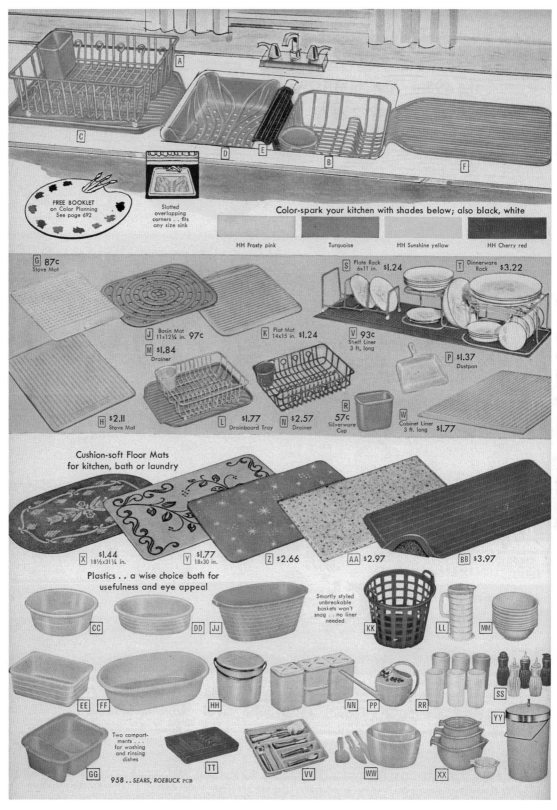

FREE BOOKLET
on Color Planning
See page 692

Slotted
overlapping
corners . . fits
any size sink

Color-spark your kitchen with shades below; also black, white

HH Frosty pink Turquoise HH Sunshine yellow HH Cherry red

G 87c
Stove Mat

S Plate Rack
6x11 in. $1.24

T Dinnerware
Rack $3.22

J Basin Mat
11x12¾ in. 97c

K Flat Mat
14x15 in. $1.24

M $1.84
Drainer

V 93c
Shelf Liner
3 ft. long

P $1.37
Dustpan

H $2.11
Stove Mat

L $1.77
Drainboard Tray

N $2.57
Drainer

R 57c
Silverware
Cup

W Cabinet Liner
3 ft. long $1.77

**Cushion-soft Floor Mats
for kitchen, bath or laundry**

X $1.44
18½x31¼ in.

Y $1.77
18x30 in.

Z $2.66

AA $2.97

BB $3.97

**Plastics . . a wise choice both for
usefulness and eye appeal**

CC **DD** **JJ**

Smartly styled
unbreakable
baskets won't
snag . . no liner
needed

KK **LL** **MM**

EE **FF** **HH** **NN** **PP** **RR** **SS** **YY**

Two compart-
ments . . .
for washing
and rinsing
dishes

GG **TT** **VV** **WW** **XX**

958 .. SEARS, ROEBUCK PCB

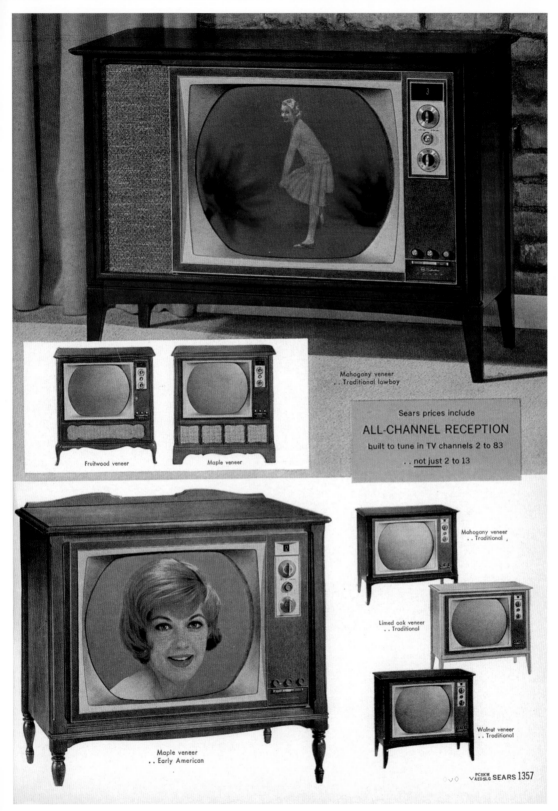

Mahogany veneer
. . Traditional lowboy

Sears prices include
ALL-CHANNEL RECEPTION
built to tune in TV channels 2 to 83
. . not just 2 to 13

Fruitwood veneer

Maple veneer

Mahogany veneer
. . Traditional

Limed oak veneer
. . Traditional

Walnut veneer
. . Traditional

Maple veneer
. . Early American

PCBKM
V AED SLG SEARS 1357

−4.11− Sears, first color televisions, 1963

Our brightest picture ever.. and now, a _wireless_ remote control

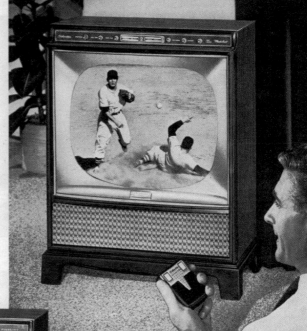

Selectra Remote Control turns VHF set on and off, changes channels, adjusts volume from your easy chair. Works up to 40 feet away—without wires!

Memory Power Tuning. Fine-tune just once—then touch a button to change channels

Our Most Powerful Chassis. Action springs to life with 20,000 volts of picture power. Picture's clear and steady, locked in by advanced automatic controls

Realistic Sound. You almost feel you're in the theater. Music and speech pour from six hi-fi speakers—two 6-in. woofers, four tweeters. Use them for stereo . . built-in input jack

Automatic Power Monitor protects tubes and circuits from damaging overloads. Removable tinted safety shield

24-inch Lowboy . . Enjoy 26% more picture than 21-in. lowboys for only $20 more
(Over-all diagonal measure. 331-sq. in. viewing area)

As low as $287.95
without remote control
$10 down

All the thrilling performance of our finest TV—plus a lifelike BIG picture—in a slim lowboy console styled to go with any surroundings. It's fine furniture you'll be proud to have in your home. Powerful far-fringe chassis in richly finished, hardwood-framed hardboard cabinetry. About 37x15 inches deep, 32 inches high.

With Selectra wireless remote control. Available on VHF sets only.
57 K 181N—Mahogany. VHF. Shpg. wt. 124 lbs. *$16 monthly*........$337.95
57 K 183N—Blonde. VHF. Shpg. wt. 124 lbs. *$16 monthly*............ 347.95

Without Selectra control. See our wired remote control at right.
57 K 180N—Mahogany. VHF. Shpg. wt. 120 lbs. *$13.50 monthly*......$287.95
57 K 182N—Blonde. VHF. Shpg. wt. 120 lbs. *$14 monthly*............ 297.95
57 K 18050N—Mahogany. All-Channel. Shpg. wt. 120 lbs. *$15 monthly* 317.95
57 K 18250N—Blonde. All-Channel. Shpg. wt. 120 lbs. *$15 monthly*.... 327.95

Get a service contract at no increase in down payment . . see facing page

Traditional Upright Consoles, superbly styled to blend in any decor — only $10 down

Our finest TV in our slimmest cabinets ever. Powerful far-fringe chassis brings far stations near. Rolls where you want it on hidden casters. Fine furniture finishes on hardwood-framed hardboard cabinets.

21-INCH SCREEN As low as $277.95
without remote control
(Over-all diagonal measure. 261-sq. in. viewng area)

Cabinet about 27x15 inches deep, 34 inches high.
With Selectra wireless remote control. On VHF set only.
57 K 165N—Mahogany. VHF. Shpg. wt. 102 lbs. *$15 monthly*.....$327.95
Without Selectra control. See our wired remote control below.
57 K 164N—Mahogany. VHF. Shpg. wt. 97 lbs. *$13.50 monthly*....$277.95
57 K 16450N—Mahogany. All-Channel. Wt. 98 lbs. *$14 monthly*... 307.95

24-INCH SCREEN As low as $297.95
without remote control
(Over-all diagonal measure. 331-sq. in. viewing area)

Get 26% more picture area than our 21-inch sets at no increase in down payment. Cabinet about 28x16 inches deep, 36 inches high.
With Selectra wireless remote control. On VHF sets only.
57 K 185N—Mahogany. VHF. Shpg. wt. 125 lbs. *$16 monthly*.....$347.95
57 K 187N—Fruitwood. VHF. Shpg. wt. 125 lbs. *$17 monthly*...... 357.95
Without Selectra control. See our wired remote control below.
57 K 184N—Mahogany. VHF. Shpg. wt. 120 lbs. *$14 monthly*.....$297.95
57 K 186N—Fruitwood. VHF. Shpg. wt. 120 lbs. *$14 monthly*...... 307.95
57 K 18450N—Mahogany. All-Channel. Wt. 121 lbs. *$15 monthly*... 327.95
57 K 18650N—Fruitwood. All-Channel. Wt. 121 lbs. *$16 monthly*... 337.95

Wired Remote Control

Turn set on and off and change channels from your easy chair. 25-ft. cable. Order *only* for Medalist TV on these two pages without Selectra control.
57 K 7776—Order with TV. *not sold separately*... $9.50

NOTE FOR BOTH PAGES: *All TV UL listed.*
110-120-volt, 60-cycle AC. VHF sets for channels 2-13; All-Channel sets for channels 2-83

PCBMNG **SEARS** 915

—4.12— Sears, first wireless remote, 1960

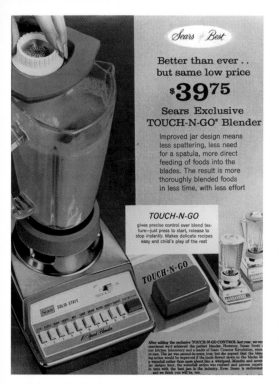

Sears Best

Better than ever .. but same low price

$39.75

Sears Exclusive
TOUCH-N-GO® Blender

Improved jar design means less spattering, less need for a spatula, more direct feeding of foods into the blades. The result is more thoroughly blended foods in less time, with less effort

TOUCH-N-GO

gives precise control over blend texture—just press to start, release to stop *instantly*. Makes delicate recipes easy and child's play of the rest

−4.13− Sears, blender, 1970

A Immensely practical stainless steel WIRE MESH COLANDERS are strengthened with wire cross supports, steel rims and ring bases. The fine mesh of these colanders allows you to wash and drain even small items such as rice, bean sprouts or berries. Dishwasher proof.
1½ qt., 7½" diam. #21-43018, $5.00
3 qt., 9½" diam., #21-43026, $7.50
6 qt., 11" diam., #21-43034, $10.00
Set of three WIRE MESH COLANDERS (one of each size) #21-49320, Regularly $22.50 **Special Price $19.25**

B Four-sided professional STAINLESS STEEL GRATER & SHREDDER grates, shreds and slices quickly and easily. The cutting edges stay aggressively sharp, and neither a dishwasher nor acidic foods will harm it. 4" sq. x 9" H., made in USA. #21-43893, $9.50

C We feel that the best quiche has lots of filling, so this DEEP QUICHE PAN with 2" sides is our favorite. Heavy tinned steel ensures even browning and the separate bottom facilitates removal of baked quiche. Use for deep dish tarts or plain butter cakes with pretty fluted sides. Chuck Williams's quiche recipes incl. 9¾" diam., from France. #21-00018, Regularly $7.50, **Special Price $6.00**

NOTE: When we say "recipe included" we will enclose with your order a complimentary 3" x 5" printed recipe card, tested by — and in fact often originated by — Chuck Williams. We have started publishing our recipes in this form in response to requests from customers.

−4.14− Williams-Sonoma

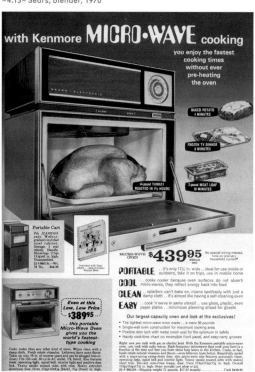

with Kenmore MICRO·WAVE cooking

you enjoy the fastest cooking times without ever pre-heating the oven

BAKED POTATO 4 MINUTES

FROZEN TV DINNER 8 MINUTES

14-pound TURKEY ROASTED IN 1¾ HOURS

2-pound MEAT LOAF 10 MINUTES

Portable Cart
Fits 22A992103 only. Walnut-grained vinyl clad steel cabinet. Storage. 2 rear wheels. Handle. Metal legs. 17⅝x 15⅝x41 in. high. Unassembled. 22A96013 — Wt. 34 lbs.$44.95

Even at this Low, Low Price $389.95

.. this portable Micro-Wave Oven gives you the world's fastest-type cooking

MICRO-WAVE OVEN $439.95 No special wiring needed, runs on ordinary household current

PORTABLE .. It's only 17¾ in. wide .. ideal for use inside or outdoors, take it on trips, use in mobile home

COOL .. cooks cooler because oven surfaces do not absorb micro-waves, they reflect energy back into food

CLEAN .. splatters can't bake on, cleans spotlessly with just a damp cloth .. it's almost like having a self-cleaning oven

EASY .. cook 'n serve in same utensil .. use glass, plastic, even paper plates .. minimizes planning ahead for guests

Our largest-capacity oven and look at the exclusives!
• The lightest micro-wave oven made .. a mere 59 pounds
• Single-wall oven construction for maximum cooking area
• Positive door lock with metal mesh seal for the optimum in safety
• Handy cook-time chart on reversible front panel, and easy-carry grooves

−4.15− Sears, first microwave, 1971

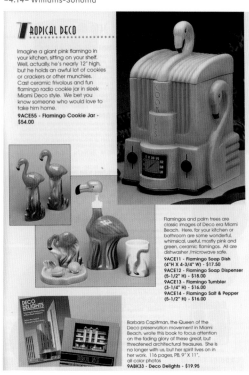

TROPICAL DECO

Imagine a giant pink flamingo in your kitchen, sitting on your shelf. Well, actually, he's nearly 12" high, but he holds an awful lot of cookies or crackers or other munchies. Cast ceramic frivolous and fun flamingo radio cookie jar in sleek Miami Deco style. We bet you know someone who would love to take him home.
9ACE55 - Flamingo Cookie Jar - $54.00

Flamingos and palm trees are classic images of Deco era Miami Beach. Here, for your kitchen or bathroom are some wonderful, whimsical, useful, mostly pink and green, ceramic flamingos. All are dishwasher /microwave safe.
9ACE11 - Flamingo Soap Dish (4"H X 4-3/4" W) - $17.50
9ACE12 - Flamingo Soap Dispenser (5-1/2" H) - $18.00
9ACE13 - Flamingo Tumbler (3-1/4" H) - $16.00
9ACE14 - Flamingo Salt & Pepper (5-1/2" H) - $16.00

Barbara Capitman, the Queen of the Deco preservation movement in Miami Beach, wrote this book to focus attention on the fading glory of these great, but threatened architectural treasures. She is no longer with us, but her spirit lives on in her work. 116 pages. PB. 9" X 11", all color photos
9ABK33 - Deco Delights - $19.95

−4.16− Montgomery Ward, tropical decor

Looks like a Million and just as good as it looks....

Sears, tractor, 1939

OUR FINEST 19-INCH PORTABLE COLOR TV GIVES YOU AN EXTRA LARGE PICTURE BECAUSE IT HAS A SPECIAL WIDE-ANGLE SCREEN

.. but Sears wouldn't settle for just that

▶ THIS TV ALSO HAS A TINTED, BONDED-ETCHED PICTURE TUBE FOR BRIGHT, RICH COLORS; CLEAR, DEFINED CONTRAST .. UP FRONT IS A LIGHT DIFFUSER SCREEN THAT <u>MINIMIZES GLARE</u>

▶ IT ALSO HAS EVERY AUTOMATIC PICTURE CONTROL THAT WE OFFER .. GIVES YOU <u>EXCELLENT</u> COLOR QUALITY

Sears ✱ Best

MEDALIST II
$389⁹⁵

19 INCH diagonal measure picture

1 Instant sound, brilliant 185-sq. in. picture in seconds. Automatic tint-lock lets you make grass greener, skies bluer without ever losing the proper flesh tones. Automatic color purifier holds color vivid, even if set is moved a lot. Adjust picture tone with Chromix® control. Color intensity is maintained from channel to channel by automatic chroma color.

You get the strongest picture and sound signals electronically selected by automatic fine tuning. Interference is minimized by keyed automatic gain control, giving you steady reception. Tint, color, and volume controls are slide-bar type .. responsive to a touch of your finger. Picture sharpness control, too. Medalist II chassis packs 25,000 volts of picture-bright power. Rich-sounding 5-in. oval speaker. For private listening, earphone and pillow speaker on 12-ft. cords. VHF, UHF antennas. Exacting slide-rule UHF tuning. Lighted channel indicator. Walnut-grained plastic cabinet; 22³/₄x17⁵/₈x19⁹/₁₆-in. deep. UL listed. **W57 K 4188N**—Shipping wt. 80 lbs. . **$389.95**

2 Wood Rollabout Cart. For sets up to 24⁷/₈-in. wide. 26x28x20-in. deep. *Unassembled.* **57 K 4554C**—Shipping weight 17 lbs... **$19.95**

9 INCH diagonal measure picture

For real "tote-ability". . this Solid State Portable Color TV weighs only 25½ pounds

- Completely solid state for travel durability, long set life
- Immediate sound <u>and</u> picture . . absolutely no delay

$269⁹⁵

A real companion TV, and no matter how often it's moved the colors remain vivid because of automatic color purifier. Automatic frequency control "homes in" on the strongest picture and sound signals. Automatic keyed gain control guards against picture flutter. Automatic chroma-control maintains color intensity.

"Pull-push" on-off control means set-and-forget volume. Crisp 4-in. oval speaker. Earphone on 12-ft. cord. Tinted sun-shield fits over 38-sq. in. screen . . remove for night-time viewing. Chassis is small, but powerful . . packs a full 19,000 volts. Built-in VHF antenna, clip-on UHF antenna. Built-in handle. Black molded plastic cabinet. Silver-color trim. 10¹/₈x15⁷/₈x14¹/₂-in. deep. Japan. **W57 K 4005N**—Shipping weight 29 pounds **$269.95**

SIMULATED RECEPTION ON BOTH SCREENS

1220 [Sears] c

-4.17– Sears, 1972

Shag Bath Carpet

All-nylon pile that keeps its deep, toe-inviting look with machine washing

rim to fit
with
y scissors

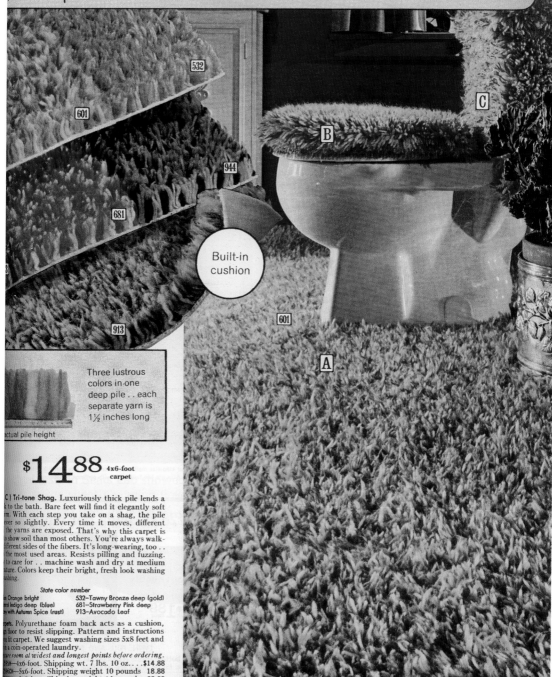

Built-in cushion

Three lustrous colors in-one deep pile . . each separate yarn is 1½ inches long

actual pile height

$**14**^{88} 4x6-foot carpet

C) **Tri-tone Shag.** Luxuriously thick pile lends a
k to the bath. Bare feet will find it elegantly soft
rm. With each step you take on a shag, the pile
ver so slightly. Every time it moves, different
the yarns are exposed. That's why this carpet is
o show soil than most others. You're always walk-
ifferent sides of the fibers. It's long-wearing, too . .
the most used areas. Resists pilling and fuzzing.
to care for . . machine wash and dry at medium
ature. Colors keep their bright, fresh look washing
ashing.

State color number

n Orange bright	532—Tawny Bronze deep (gold)
sol Indigo deep (blue)	681—Strawberry Pink deep
ay with Autumn Spice (rust)	913—Avocado Leaf

pets. Polyurethane foam back acts as a cushion,
floor to resist slipping. Pattern and instructions
p fit carpet. We suggest washing sizes 5x8 feet and
a coin-operated laundry.

ure room at widest and longest points before ordering.
254—4x6-foot. Shipping wt. 7 lbs. 10 oz. . . .$14.88
CH—5x6-foot. Shipping weight 10 pounds 18.88
TCH—5x8-foot. Shipping weight 13 pounds 25.88

Irish Tapestries

Irish Tapestries has become one of the major woven bedspread manufacturers in Europe. In the past eight years it has successfully brought bedspreads into the fashion world of home furnishings with acceptance of its design and quality on a world wide basis. 100% pure new wool.

A. THE SLANE DESIGN: Bedspread: Colour (code 2) as illustrated with 2 inch binding and 8 inch fringe.

Size (inc. fringe)	Description	Cat. No.	Approx. weight	Price	Surface	Airmail
82 x 110"	Twin	61352	7 lbs	$64.00	$5.75	$17.00
96 x 110"	Full	61360	8½ lbs.	$75.00	$6.30	$18.70
104 x 120"	Queen	61379	9½ lbs.	$90.00	$6.75	$19.50
120 x 120"	Dual King	61387	10½ lbs.	$102.00	$7.50	$21.50

FLOOR PILLOW
Slane design. Size, including fringe 27 x 27 ins. Approx. 24 ozs. **Colour** (2) as illustrated. Stuffing not included.
Cat. No. 61395 **Price each $14.50**
Airmail $3.25 Surface $1.75

PILLOW SHAM
Slane design. Size, including fringe 21 x 27 ins. Approx. 17 ozs. **Colour** (2) as illustrated. Stuffing not included.
Cat. No. 61409 **Price each $12.75**
Airmail $3.25 Surface $1.75

−4.19− Shannon catalog, 1971

We are the First to Offer by Mail Schoonmaker's Wine Glasses

As everyone knows who knows anything about wine, Frank Schoonmaker, member "Diplome de l'Academie du Vin de France," is the world's leading authority on wines of the world. Nothing like fine wine to console us when faced by the problems and anxieties of modern living, he declares. But to enjoy fine wines, one simply must drink them from proper glasses. Part of the enjoyment comes with knowing what glass to use with each breed of wine. Now, at long last, Frank has designed, and one of the oldest American glass companies has made, authentic glasses so your table can be set with distinction and grace. You will now know, not guess, what glass to serve wine to your guests.

These graceful, impeccably correct glasses are handblown of the very highest quality paper thin lead crystal, so fine and brilliant that wine in them is really enhanced. Schoonmaker glasses take the mystery and uncertainty out of serving wine.

From left to right, in the picture above.

1. CHAMPAGNE TULIP: 8 oz., for champagnes and sparkling wines.

2. THE CABERNET: 9 oz., for red wines.

3. THE JOHANNISBERG: 6 oz., for German Rhine, Moselle or Riesling wines.

4. THE CHATEAU: 7 oz., for white wines, other than German.

5. THE SOLERA: 5 oz., Sherry, Port, and fortified wines.

6. THE V.S.O.P.: a 7 oz. snifter for Cognac and other liqueurs.

Since most lead crystal glasses sell for $5 to $8 each, these are most reasonable in price. But because of packing costs, we can sell no less than FOUR GLASSES of any one shape. **No. 11036** 4 glasses for **$10.00.** Weight 4 lbs.

–4.20– Vermont Country Store, Schoonmaker's glasses

–4.21– Neiman Marcus, mummy cases

–4.22– Williams-Sonoma

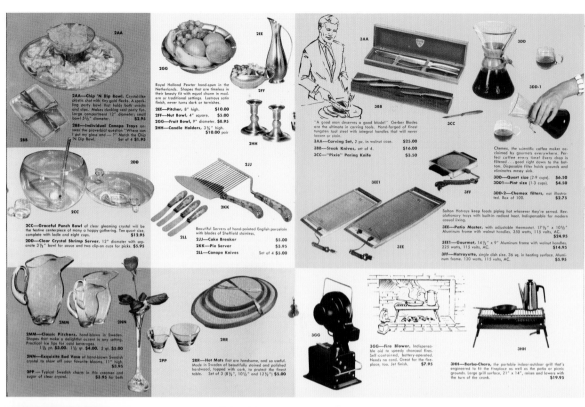

2AA—Chip 'N Dip Bowl. Crystal-like plastic that with tiny gold flecks. A sparkling party bowl that holds both snacks and dips. Makes dunking real party fun. Large compartment 12" diameter; small bowl 5½" diameter. **$2.95**

2BB—Individual Canapé Trays answer the proverbial question "Where can I put my glass and—?" Match the Chip 'N Dip Bowl. Set of 4 **$1.95**

2CC—Graceful Punch Bowl of clear gleaming crystal will be the festive centerpiece of many a happy gathering. Ten quart size, complete with ladle and eight cups. **$12.95**

2DD—Clear Crystal Shrimp Server. 12" diameter with separate 3½" bowl for sauce and two clip-on cups for picks. **$5.95**

Royal Holland Pewter hand-spun in the Netherlands. Shapes that are timeless in their beauty fit with equal charm in modern or traditional settings. Lustrous satin finish, never turns dark or tarnishes.
2EE—Pitcher, 8" high. **$10.00**
2FF—Nut Bowl, 4" square. **$5.00**
2GG—Fruit Bowl, 9" diameter. **$8.95**
2HH—Candle Holders, 3½" high. **$10.00** pair

Beautiful Servers of hand-painted English porcelain with blades of Sheffield stainless.
2JJ—Cake Breaker **$5.00**
2KK—Pie Server **$3.95**
2LL—Canape Knives Set of 4 **$5.00**

2MM—Classic Pitchers, hand-blown in Sweden. Shapes that make a delightful accent in any setting. Practical ice lips for cold beverages.
1½ pt. **$3.00.** 1½ qt. **$4.00.** 2 qt. **$5.00**

2NN—Exquisite Bud Vase of hand-blown Swedish crystal to show off your favorite blooms. 11" high. **$3.95**

2PP— Typical Swedish charm in this creamer and sugar of clear crystal. **$3.95** for both

2RR—Hot Mats that are handsome, and so useful. Made in Sweden of beautifully stained and polished hardwood, topped with cork, to protect the finest table. Set of 3 (8½", 10½" and 12½") **$5.00**

"A good man deserves a good blade!" Gerber Blades are the ultimate in carving tools. Hand-forged of finest tungsten tool steel with integral handles that will never loosen or stain.
3AA—Carving Set, 2 pc. in walnut case. **$25.00**
3BB—Steak Knives, set of 4. **$16.00**
3CC—"Pixie" Paring Knife **$3.50**

Chemex, the scientific coffee maker acclaimed by gourmets everywhere. Perfect coffee every time! Every drop is filtered ... good right down to the bottom. Disposable filter holds grounds and eliminates messy sink.
3DD—Quart size (2-9 cups). **$6.50**
3DD1—Pint size (1-3 cups). **$4.50**
3DD-2—Chemex filters, not illustrated. Box of 100. **$2.75**

Salton Hotrays keep foods piping hot wherever they're served. Revolutionary trays with built-in radiant heat. Indispensable for modern casual living.
3EE—Patio Master, with adjustable thermostat. 17½" x 10½" Aluminum frame with walnut handles. 350 watts, 115 volts, AC. **$24.95**
3EE1—Gourmet, 14½" x 9" Aluminum frame with walnut handles. 225 watts, 115 volts, AC. **$14.95**
3FF—Hotrayette, single dish size. 36 sq. in heating surface. Aluminum frame. 120 watts, 115 volts, AC. **$5.95**

3GG—Fire Blower. Indispensable aid to speedy charcoal fires. Self-contained, battery-operated. Needs no cord. Great for the fireplace, too. Jet finish. **$7.95**

3HH—Barba-Charo, the portable indoor-outdoor grill that's engineered to fit the fireplace as well as the patio or picnic grounds. Large grill surface, 21" x 14", raises and lowers with the turn of the crank. **$19.95**

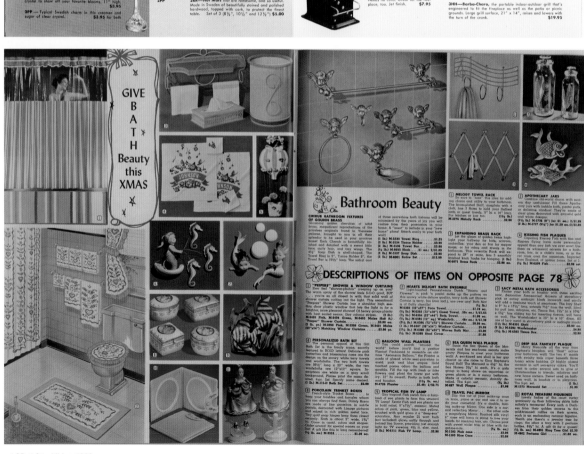

GIVE BATH Beauty this XMAS

Bathroom Beauty

CHERUB BATHROOM FIXTURES OF GOLDEN BRASS
Gleaming golden cherubim of solid brass, magnificent reproductions of the priceless originals found in Viennese pictures, brought to you in all their splendor to be used in your precious home! Bath Cherub is beautifully tailored and detailed with a sweet little face, curly hair, and tiny wings. The 4½" Soap Dish is shell-shaped. The Towel Ring is 5", Tissue Holder 8", the Towel Bar is 19½" long. The initial cost of these marvelous bath fixtures will be minimized by the years of joy you will realize from their possession in your home. A "must" to include in your "new home" plans! Attach easily to your bath wall!
(1 lb.) M-5335 Towel Ring$1.25
(1 lb.) M-5334 Tissue Holder$1.75
(1 lb.) M-5336 Towel Bar$2.96
(1 lb.) M-6055 Hook$1.65, 2/$3.29
(1 lb.) M-5587 Soap Dish$2.95
(1 lb.) M-6001 Entire Set$12.00

DESCRIPTIONS OF ITEMS ON OPPOSITE PAGE 78

[1] "PEEPERS" SHOWER & WINDOW CURTAINS
Ever feel "shower-phobic" creeping up on you? The warm spray of the shower feels SOO good, BUT ... you're so all closed in with that solid wall of shower curtain cutting out the light. This sensational "Peepers" Shower Curtain has a shoulder high see-thru clear plastic window that lets the light in for a brighter, more pleasant shower! Of heavy opaque plastic with twin scaled seams. Gay cotton stripes. (2 lb.)
M-3460 Pink, M-3404 Green, M-3403 Maize (Red B.).
(2 lb. pr.) M-3596 Peepers Shower Curtain $3.95 ea.
(2 lb. pr.) M-3594 Matching Window Curtains $1.96 pr.

[2] HEARTS DELIGHT BATH ENSEMBLE
Light-hearted Pennsylvania Dutch "Hearts and Flowers" in pink 'n pastel make up the pattern on this snowy white shower quality, terry bath set (Shower Curtain is terry, too; liner incl.); use over any) Bath Mat is of fluffy chenille!
M-6382 (18"x27") Face Towel $1.19 ea.
(1 lb.) M-6383 (12"x49") Guest Towel - 50c. 3/$1.45
(1 lb.) M-6384 (22"x44") Bath Towel $1.95 ea.
(1 lb.) M-6385 (12"x12") Washcloth 45c ea.; 3/$1.30
(2½ lb.) M-6386 (19"x27") Shower Curtain $5.95 ea.
(2 lb.) M-6387 (36"x54") Window Curtain $3.95
(1½ lb.) M-6388 (22"x36") Worm Bath Mat $3.95

[3] LACY METAL BATH ACCESSORIES
Fashion your bath or boudoir with these exciting new, decorative Accessories! Accents of strawberry pink or antiqui midnight black brownish and swirls will add a feminine touch of charm! The Itty Shelf is 9" h. x 17½" long; extends 5½" from the wall. Good for pull bars, ashtrays, etc. These 8xc. 5½" h. x 10½" x 5½" bye shining for Insuctory timed, will hang in wall. The Washbasket is 13" h. x 10" deep. All one of lacy metal in strawberry pink or midnight black!
(1½ lb.) M-6381 Shelf $3.95
(1½ lb.) M-6382 Washbasket $2.95
(1½ lb.) M-6383 Three Box $2.95

[4] PERSONALIZED BATH SET
The personal appeal of this Gift Bath Set is the trendy tones, exactly lettered in BOLD letters! Delicate pink tourettes and blossoming tones are the design on the snowy white terry towels and washcloths. The two bath towels are 19½" long x 27" wide, the two washcloths are 12"x12" square. Inscriptions one white on a gray satin background. Please print the name desired. Set. Specify name desired.
(1 lb.) M-112 Bath Set $7.95

[5] BALLOON WALL PLANTERS
Glorious the world before you'd find a prettier Planter! Fashioned in ceramic at one time "Aeronauts Balloon," the Planter is made of glazed white semi-gardeners in pastel pink and blue stripes. Gold touched peace adorn the balloon and gondola. Fill the top with fresh or blue flowers and plant the lower part with ivy. 12" h. overall. Pretty in both bath and boudoir.
(1½ lb.)
M-4726 Planter $2.96

[6] PORCELAIN TRINKET BOXES
French-style Trinket Boxes ... to keep your baubles and bangles where you can always find them. Dainty Boxes are made of fine porcelain in subtle pastels, decorated with Limoge pictures and edged in rich golden metal lace. They gold snap hinges keep them closed securely. Each is about 3" wide, 2½" hi. Come in varied colors and shapes. Order several for several names on your hair. A gift like this is long remembered!
(½ lb. ea.) M-5319 $1.29 ea.

[7] TROPICAL FISH TV LAMP
Gay tropical Fish swish thru a fairyland of sea plants to form this unusual TV Lamp! Exotic Fish and sea plants are in bold relief. 8"x7½", ceramic. Metal colors of pink, green, blue and yellow, brushed with gold gives it a "deep-sea" coloration. Any regular 25 watt bulb (not included) allows softly through and behind Sea Scene, providing just enough light for TV viewing. 8½ lb.
(2 lb. M-5318 $5.29 ea.

[8] SEA QUEEN WALL PLAQUE
Susie the Sea Queen of the Mermaids and her sea-horse escorts make pretty Plaques to crest your bathroom wall! A sea-toned sea shell is her gay chariot as she rares to King Neptune's Royal Ball! The Mermaid is 6½" hi, the Sea Horses 3½" hi. each. It's a cute group to hang above an aquarium or green plants or in a young bathroom. Made of colorful ceramic, daintily detailed. The 6-pc. set. (1½ lb.)
M-697 Wall Plaque $1.39

[9] TRAVEL PAC MIRROR
Slip this out of your make-up case in train, plane or car and use it to apply your cosmetics! 8"x4" including make-up Mirror. One side is a normal reflecting Mirror ... the other side a magnifying Mirror. Brushed silk vinyl 6" case will hang or stand to free your hands for cosmetic hair, etc. Comes with sweet velvet blue or blush with pastel pink-striped interiors.
(½ lb.) M-1375 Mermaid Set

[1] MELODY TOWEL RACK
Be sure to "note" this idea to add-ing charm and utility to your bathroom. The three-pleated Staff, complete with a cleft, has 3 Notes to hold your fluffiest bath, or guest towels. 9" hi x 14" long. For kitchen or bar too.
(1½ lb.) M-2276 Melody Rack $2.95

[2] APOTHECARY JARS
Combine old-world charm with mid-day unfussiness! Fill these Apothecary Jars with bubble bath, pastel putts, or delicious candies! They're made of clear glass decorated with graceful gold and white designs.
(1½ lb.) M-5726 (8") for $1 ea.; 2/$1.39
(2 lb.) M-5727 (5½") for $1.59 ea.; 2/$1.59

[3] KISSING FISH PLAQUES
Courting Kissing Fish with fins and flippers flying from more personality appeal than any fish we ever saw! Use them as whimsical accents for a bathroom, bar, in a child's room, or in the rec room over the aquarium. Imported from England, of golden brass. Set of 2.
(1 lb. pr.) M-6381 Fish $2.95

[10] DEEP SEA FANTASY PLAQUE
Merry Mermaids all the way from Neptune's domain will "float" across your bathroom wall! The two 4" motifs with swishy tails crisper beneath three foamy white bubbles Of highly glazed ceramic in soft sea-spray colors. You'll want to order several sets to give at Christmastime to friends, relatives and new home owners. Sweet used on bathroom wall, in boudoir or as playroom. The 5-pc. set.
(1½ lb. ea.) M-4991 Ring Tree Set $1.50
(½ lb.) M-4902 Perfume Girl $1.50 ea.

[11] ROYAL TREASURE FIGURINES
Lovely ladies of the court curtsy graciously as their billowing skirts hide milady's treasures! Every such a Duchess from their golden crowns to the goldtouched ruffles on their gowns, each is an enchanting ceramic figurine. Needs one there's a proper box for rings, the other a tray with 3 partitions for cuffs. 6½" hi. A gift fit for a queen!
(½ lb. ea.) M-4891 Ring Tree Set $1.50
(½ lb.) M-4902 Perfume Girl $1.50 ea.

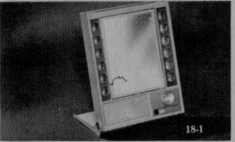

18-1

18-2

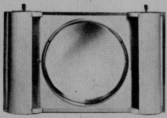

18-3

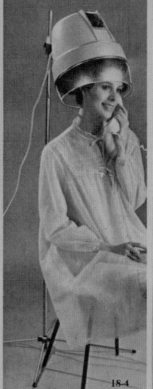

18-4

18-5

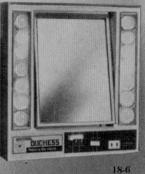

18-6

Clairol true-to-light make-up mirror,
Macy⋆s Low Discount Price, 19.77

18-1. Dial daylight, office light or evening light. Reverses from regular to super magnification. Cool, glare-free illumination. Swivels, adjusts to any angle. #LM1.

Hitachi hair dryer
fits your hand, 14.95

18-2. Gives you cool or hot air instantly. Whisper-quiet motor does not interfere with TV or radio. Dries your hair in minutes. Slips into suitcase for travel. #HD5000.

First at Macy⋆s, Brytone® lighted
make-up mirror, 12.99

18-3. Has three settings for daylight, office light or evening light. 8″ diameter mirror swivels to any angle... Tru Image or magnified. Glare-free illumination. For school, travel, vanity. #E825.

Norelco® thermostatically controlled
stand hair dryer, 19.99

18-4. Sure, even, fast-drying finger-tip temperature settings from cool to hot. Thermostat control means it won't overheat. Has an attractive double-insulated hood. Folds for storage. #HP4606.

"Swinger" illuminated make-up mirror,
by Rialto, regularly 8.99, Sale 7.88

18-5. 'Swinger" tilts to any angle, reverses easily from true reflection to magnifying image. Mirror is a big 7¾″ in diameter, with 4 complexion-toned bulbs. Lightweight; carrying handle. Ivory, pink, blue.

"Duchess" vanity and travel make-up mirror,
regularly 19.99, Sale 17.99

18-6. By Universal Lamp. Variable light for day, office or evening. Hi-lo intensity switch. Compact, easy to take with you. #UC-601.

Mail and phone orders filled, see instructions on page 111. Sorry, no C.O.D.'s. Add $1 handling charge within

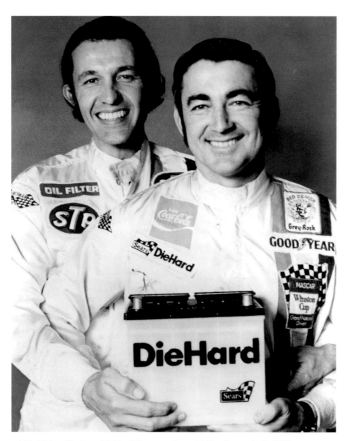

−4.26− Richard Petty and Bobby Allison tout Sears DieHard batteries in 1973.

Shag Bath Carpet

All-nylon pile that keeps its deep toe-inviting look.

Sears, 1971

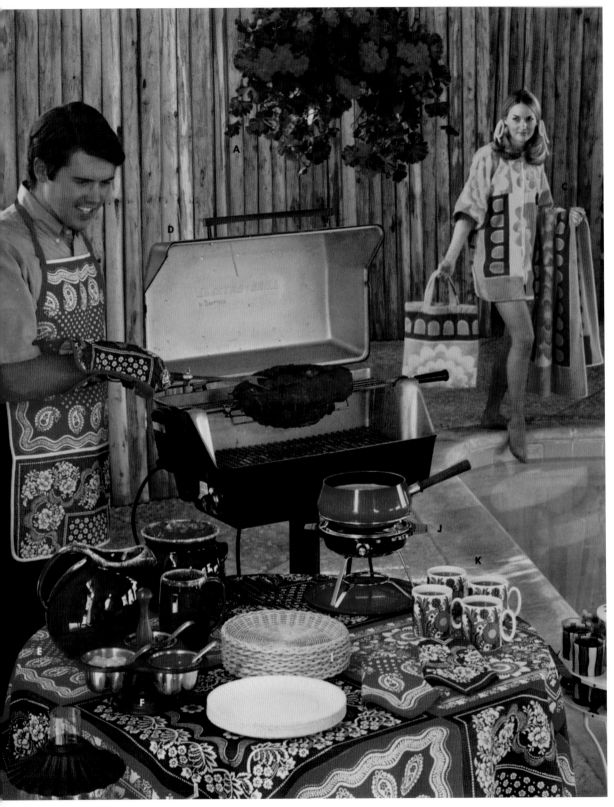

-4.27- Marshall Field, 1972

15

-4.29- Marshall Field, 1972

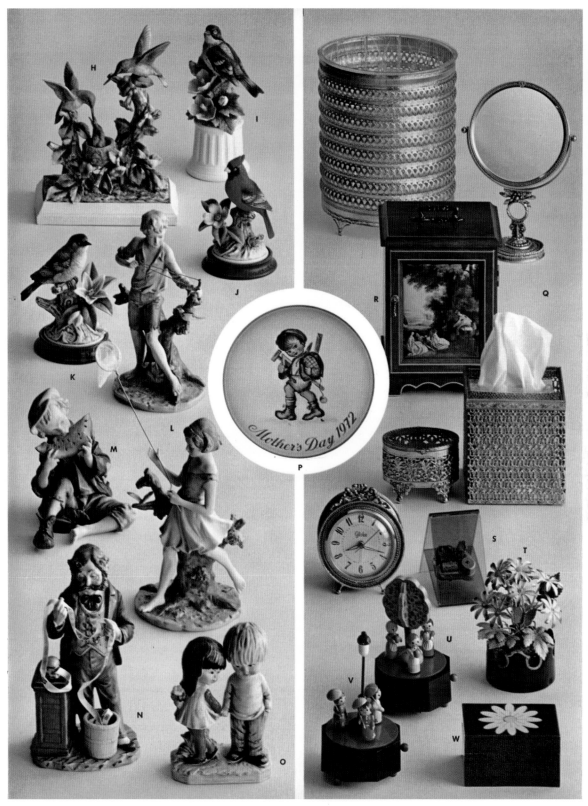

H

I

J

K

L

M

N

O

P

Mother's Day 1972

Q

R

S

T

U

V

W

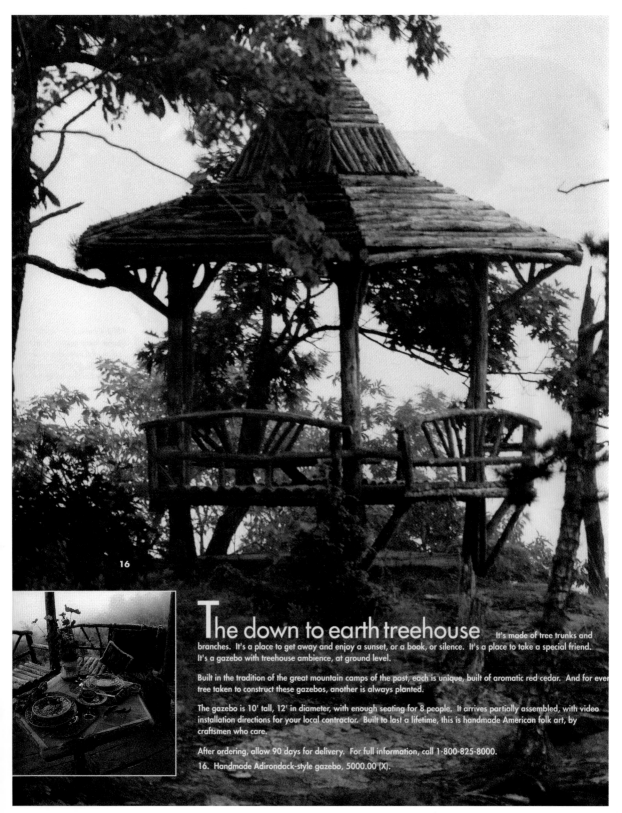

The down to earth treehouse

It's made of tree trunks and branches. It's a place to get away and enjoy a sunset, or a book, or silence. It's a place to take a special friend. It's a gazebo with treehouse ambience, at ground level.

Built in the tradition of the great mountain camps of the past, each is unique, built of aromatic red cedar. And for every tree taken to construct these gazebos, another is always planted.

The gazebo is 10' tall, 12' in diameter, with enough seating for 8 people. It arrives partially assembled, with video installation directions for your local contractor. Built to last a lifetime, this is handmade American folk art, by craftsmen who care.

After ordering, allow 90 days for delivery. For full information, call 1·800·825·8000.

16. Handmade Adirondack-style gazebo, 5000.00 (X).

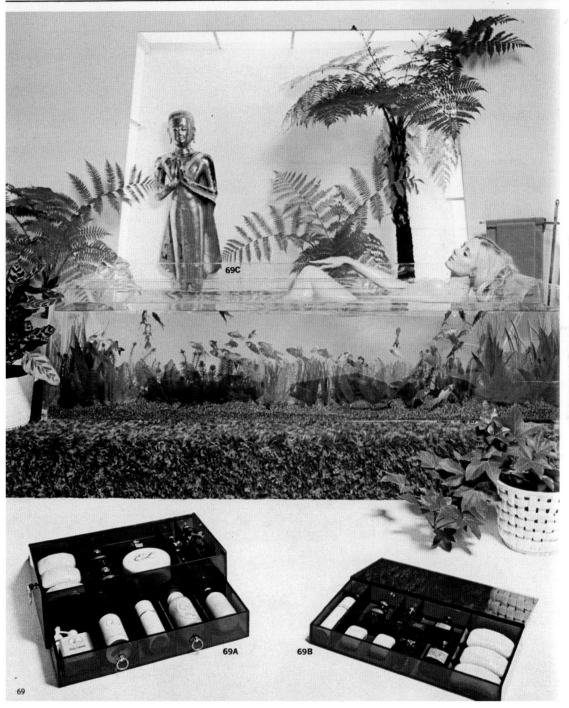

−4.32− Neiman Marcus, aquarium tub, 1970

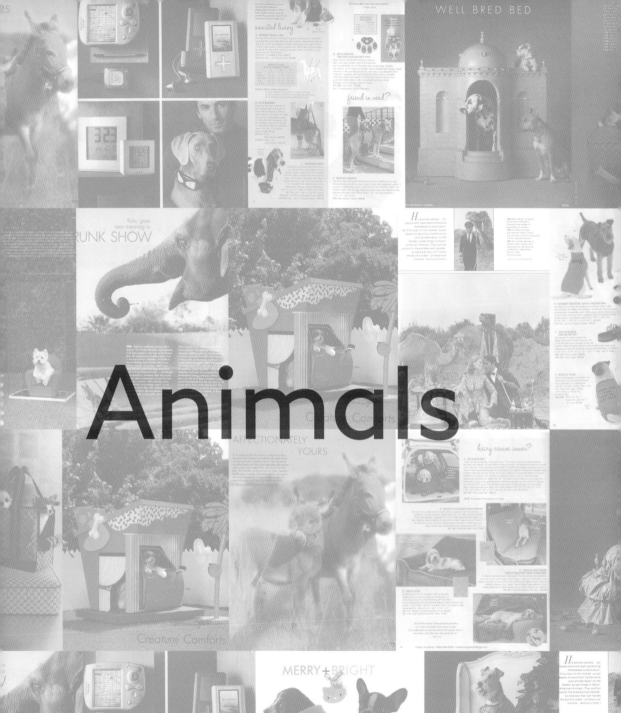

Animals

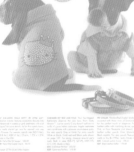

5

Animals

The decades saw animals evolve (or devolve) from workers to pampered pets. Through the years, catalogs offered animal paraphernalia, as well as a surprising range of pets, among them, a Mexican burro ($69.95, Spiegel, 1955); a Shetland pony ($299.95, Spiegel, 1956); and a miniature donkey ($1,300–$9,000 depending on gender and pedigree, Neiman Marcus, 2002).

Since catalogs were founded to serve rural communities, it's not surprising that early catalogs featured harnesses, plows, and wagons that converted horses, dogs, sheep, and goats into farm machinery and modes of transport. Teams of animals plowed fields; dogs and goats powered everything from butter churns to cream separators. Horses dragged buggies, carriages, and wagons. With the advent of the tractor and the automobile, dogs and horses were transformed from motors to man's best friend (dog) and little girl's best friend (horse). Chicks were, and continue to be, a popular mail-order staple but, as mail-order genius Max Sackheim learned, when dealing with living things, accurate projections are essential. Sackheim, who helped to found Book-of-the-Month Club, discovered that he could expand his farm supply business by offering the chicks to the farmers' wives, so they could start their own businesses. The response was so strong that he sold more chicks than he had on hand. His staff had to scour the entire Midwest for chicks and, according to his old friend, Book-of-the-Month Club president Harry Scherman, "completely upset the market on baby chicks with one circular."

Orvis's "Dog Nest," one of the company's best-selling products, owes its inspiration to a goat. Owner Leigh Perkins's son (and Orvis's current CEO) received a pet goat as a college graduation gift. A Harris Tweed salesman visiting from England got such a kick out of the goat that he sent it a homemade "nest" when he got home. The family dogs loved the nest so much that they decided to offer them to customers. Today, customers can order "Dog Nests" customized to their dogs' dimensions and desires. The "Dog Nest" appeals to people who want to pamper their pets as well as those who want to keep them off the furniture.

Roy Rogers was one of Sears's most prolific pitchmen. In 1949, he bought a gold and silver saddle studded with rubies for $50,000. Rogers traveled around the country with the saddle, making stops at rodeos, a world's fair, and Sears stores. In 2002, the saddle fetched $412,500 at auction.

The ever-outrageous Neiman Marcus didn't disappoint on the animal front. In 1950, Neiman Marcus offered gloves made of baby ostrich so fine they could be (and were) packed in walnut shells. Ostriches fared better thirty years later, when they offered a live pair of baby ostriches for $1,500. In 1969, customers could choose between a baby girl elephant ($5,000), a Galapagos turtle ($2,200), an entire petting zoo (burros, rabbits, goats, Shetland ponies, and ducks—$1,750), or a pair of gerbils ($35—and a flop). In 1976, in honor of the Bicentennial, Neiman Marcus decided to offer bison ("bicen"). The bison

on offer included a roll of uncirculated 1938 buffalo nickels (the animal's coin swansong) for $450, a stuffed bison for $700, or a pair of his-and-hers live bison ($11,750 for the duo). Gift wrapping was described as "optional and difficult." In 1961, Stanley Marcus overruled his staff, who thought his idea of His and Hers camels was silly. Someone from Fort Worth asked if they could purchase just the female camel. The camel was shipped from the camel breeder in California to Texas in the cargo hold of American Airlines. The camel's Christmas Eve disembarkation was covered on the ten o'clock news. A woman in Fort Worth who was watching the news with her daughter turned to her and said, "I wonder who's the darn fool getting that?" The next day, she found out. The woman actually came to love the camel and built a special house for it on her estate. In 1971, after the success of the camel, the same daughter gave her mother another Neiman Marcus animal gift, the $1,750 petting zoo. A man from Hawaii called to order a Shetland pony for his grandson in Oregon. The item was not in the catalog, but the man said, "If anyone in the country could help me out, it would be Neiman Marcus." Undaunted they located the pony and had it air shipped to the lucky boy.

In 1956, Edward Marcus came up with the idea of decorating a Stieff plush tiger with precious jewels and offered it for $1 million. It was featured in *Life* magazine and attracted the attention of a seven-year-old boy who wrote the following letter: "Dear Mr. Neiman Marcus, How much is your *Life* tiger? Not the diamonds. I am a tiger collector, not diamonds. I am seven, and I have five tigers. Nor real, just play. I love tigers, especially yours. Please send the letter and how much it costs without the diamonds right away. Also, can you charge it or do you have to pay right away? I have my garden money, so please send the letter right away before I lose it."

In 1969, a man claiming to be a Middle Eastern sheikh called to order twenty-four baby elephants for a giant chess game to be played in a valley between two mountains. The elephants would be dressed as chess pieces and the players would be on the opposing mountains and would communicate their moves to riders mounted on the elephants. When the mail-order director called to check his bank references, it was found to be a prank, later revealed to have been played by a Los Angeles disc jockey. The mail-order director thought of delivering an elephant to the radio station with information that the other twenty-three were on the way with a bill for $120,000 but, fearing it would encourage others to top the prank, was dissuaded from doing so.

Neiman Marcus presaged the craze for animal outfits when it offered a "10-gallon hat for dogs" in 1963. It also offered a wastebasket made from an elephant foot for $350. The following year, a fox-covered wastebasket was a steal at $30.

In 1999, Susan Bing, a former art director for Tiffany & Company, started Trixie + Peanut, named for her two rescued boxers, to offer high-end products in a sleekly designed mail-order catalog. Today, the catalog is online, and she has a boutique and website where she offers "designer collars and leashes, chic pet beds and cozy blankets, stylish pet apparel, unique toys and treats, sleek pet carriers, fabulous feeding bowls, and grooming accessories, as well as heartwarming gifts for all animal lovers." Her client list includes everyone from Britney Spears and Jessica Simpson to presidents George W. Bush and Bill Clinton. Bing offers such items as the Chewy Vuitton Purse Dog Bed, the Sniff Army Watch, Hairy Balls, Sniffany & Company bed, a Furrari Bed, a Grand Lotus Bed, and sparkling tiaras. Costumes include the Afro Doggie Wig, the Penguin Hoodie, the Pirate, and Superdog. For the holidays, there

are Christmas outfits galore, but Jewish pet owners will appreciate Chewish dog toys (a Star of David, a dreidel, and a bagel) and cat toys (a fish labeled lox and some Hanukkah gelt).

Some of today's premier pet designers are Little Lily, Susan Lanci, and even famed photographer William Wegman, who designed a line of dog beds. Lara Alameddine and Daniel Dubjecki founded Little Lily after Alameddine's Yorkie, Lily, injured her paw and when they set out to find protective shoes, "Lily did not approve of the shoes they found." Today, Little Lily offers fashionable canine boots and other apparel, including a line of dresses inspired by the Red Carpet dresses (and tuxedos) of the stars. Little Lily outfitted Reese Witherspoon's gay dog, Bruiser, in *Legally Blonde*. The company also does lines with Hello Kitty, the Care Bears, and Tinkerbell's mom, Paris Hilton.

G.W. Little, a specialty catalog devoted to "The Great World of Little Dogs," has an over-the-top collection of cocktail dresses, coats, tuxedos, costumes, and toys. "For the most special night on earth," you could buy Susan Lanci's limited edition, red silk dress studded with over three hundred and fifty Swarovski crystals. At $375, you'll be tempted to see if you could wear it yourself.

Today, the Pampered Pets catalog offers fashions including wedding dresses and veils for dogs and cats, as well as couture creations like the Dragonfly Kimono Jacket that it calls "an Asian-Inspired Masterpiece," made of genuine silk with satin frog accents. New on the market and a must for all fashion-conscious pets are scrunchies that come "complete with a scrunchie hanger for easy keeping."

In a more serious vein, veterinarians Rory Foster and Marty Smith operated four animal clinics in Wisconsin before starting their catalog, Drs. Foster and Smith in 1983. After twenty-five years of selling supplies for dogs, cats, fish, birds, reptiles, and small pets, the company responded to customer's requests to offer supplies for ferrets.

In a less serious vein, rapper Snoop Dogg has his own line of pet toys and clothes available exclusively from Amazon.com. And while there are no plans for a mail-order catalog, it would be a shame to exclude the boom box chew toy with a sound chip of Mr. Dogg himself saying "Bow wow wow, yippee yo, yippee yay" or the Doggfather hoodie. Your dog can be ghetto chic in no time.

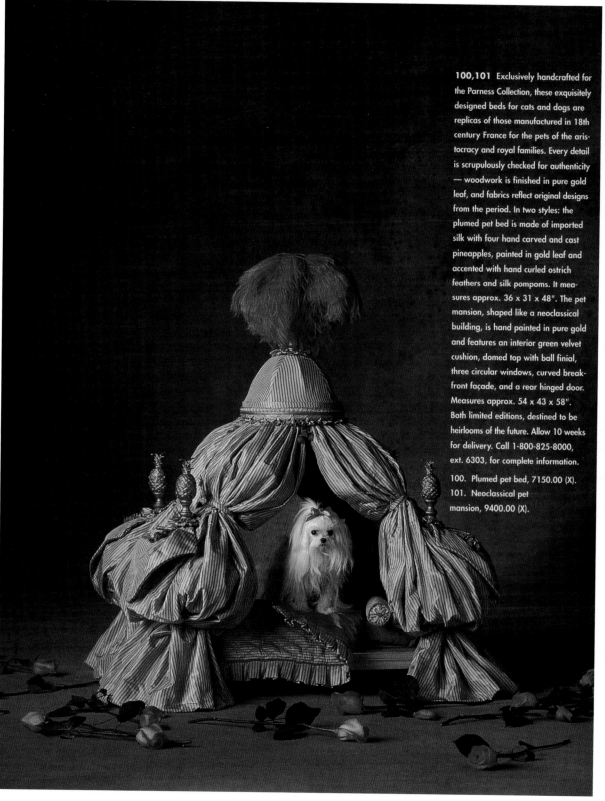

100,101 Exclusively handcrafted for the Parness Collection, these exquisitely designed beds for cats and dogs are replicas of those manufactured in 18th century France for the pets of the aristocracy and royal families. Every detail is scrupulously checked for authenticity — woodwork is finished in pure gold leaf, and fabrics reflect original designs from the period. In two styles: the plumed pet bed is made of imported silk with four hand carved and cast pineapples, painted in gold leaf and accented with hand curled ostrich feathers and silk pompoms. It measures approx. 36 x 31 x 48". The pet mansion, shaped like a neoclassical building, is hand painted in pure gold and features an interior green velvet cushion, domed top with ball finial, three circular windows, curved breakfront façade, and a rear hinged door. Measures approx. 54 x 43 x 58". Both limited editions, destined to be heirlooms of the future. Allow 10 weeks for delivery. Call 1-800-825-8000, ext. 6303, for complete information.

100. Plumed pet bed, 7150.00 (X).
101. Neoclassical pet mansion, 9400.00 (X).

–5.1– Neiman Marcus, 1996

–5.2– Trixie + Peanut, Afro Doggie Diva Wig

-5.3- Trixie + Peanut, Chewish toys

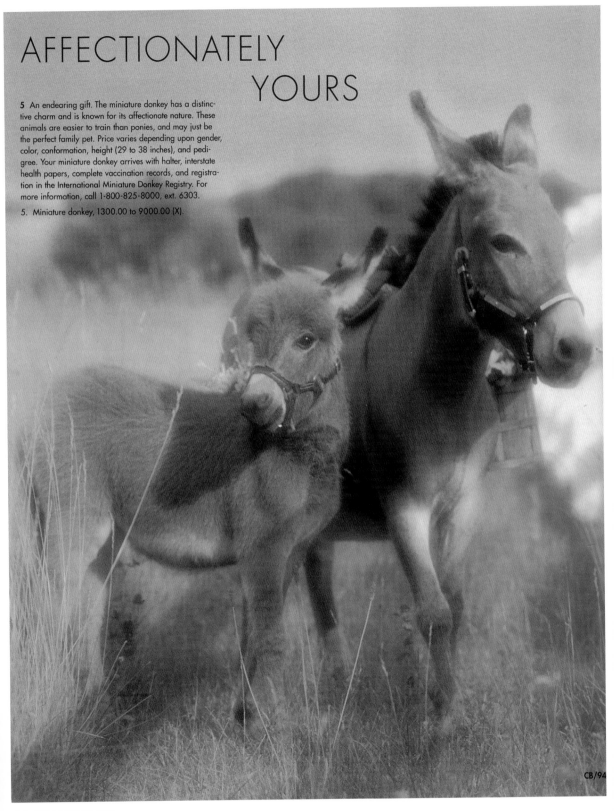

AFFECTIONATELY
YOURS

5 An endearing gift. The miniature donkey has a distinctive charm and is known for its affectionate nature. These animals are easier to train than ponies, and may just be the perfect family pet. Price varies depending upon gender, color, conformation, height (29 to 38 inches), and pedigree. Your miniature donkey arrives with halter, interstate health papers, complete vaccination records, and registration in the International Miniature Donkey Registry. For more information, call 1-800-825-8000, ext. 6303.

5. Miniature donkey, 1300.00 to 9000.00 (X).

CB/94

Does this shirt make me look fat?

Company of Dogs

*"Dogs have given us their absolute all.
We are the center of their universe.
We are the focus of their love and faith and trust.
They serve us in return for scraps. It is without a doubt
the best deal man has ever made."*
—Roger Caras

**PAW PADS™
SIZE CHART**

	Pad Width
Small	½"–¾"
Medium	¾"–1"
Large	1"–1½"
X-Large	1½"–2½"

For the perfect fit, measure width of metatarsal pad.

D

D. SELF-ADHESIVE
TRACTION PADS PROTECT PAWS
Help prevent injuries from sliding on slippery
floors and stairs, protect paws from abrasions
and provide better traction for older and arthritic dogs. Ultrathin,
lightweight, comfortable and durable, they're backed with medical-grade
adhesive to stay put indoors and out. Non-toxic, hypoallergenic black
Toughtek® neoprene with perforations that allow paws to breathe.
Individual cutouts are shaped to fit each pad. Easy to put on; lasts
up to two weeks. *Sizes:* S, M, L, XL; please see chart, above.
Package includes enough pads for 8 paws.
D71-087 Paw Pads™ **$19.95**

–5.5– Company of Dogs

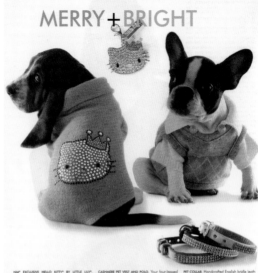

MERRY + BRIGHT

N™ EXCLUSIVE HELLO KITTY® BY LITTLE LILY®. Adorable sweater features everyone's favorite kitty emblazoned in crystals on pink cashmere, with a bit of Lycra® for some stretch. As for the crystal charm, you really should get one for yourself and one for Princess. For sweater, specify size XS(2-5 lbs.), S(5-8 lbs.), M(8-12 lbs.). Charm, 1.2"H x 1.5"W. Made in the USA.
82A Hello Kitty Pet Sweater 100.00
82B Hello Kitty Crystal Charm 48.00

See page 127 for our pet clothes hangers.

CASHMERE PET VEST AND POLO. Your four-legged fashionistas deserve the very best, from Hedy Manon™. Just be careful Coby doesn't spill on his outfit; it's pure Italian cashmere. Argyle cashmere vest coordinates with cashmere short-sleeve polo. For vest, specify Grey or Gold. For polo, specify White or Black. Gold vest and black polo shown on page 127. For sizing, measure around pet's neck. Both in sizes XS(5-7"), S(7-9"), M(9-11"), L(11-13"). Made in Italy.
82C Cashmere Pet Vest 245.00
82D Cashmere Pet Polo 175.00

PET COLLAR. Handcrafted English bridle leath accented with three rows of Swarovski® cry for the perfect touch of elegance. For col leather collar with matching stones, specify Pink, or Faux Tanzanite (not shown). For leather collar; specify Clear (shown). Re Black crystals. For size, specify Teacup (7-neck) or Toy (8-10"Dia. neck). Made in En
82E Colored Leather Collar 195.00
82F Black Leather Collar 175.00

–5.6– Neiman Marcus, rhinestone dog accessories, 2006

B

"Simone"
Parson Russell
Terrier

r

"D
Irish

B. HANDKNIT SIGNATURE ALPACA SWEATER
Our Signature Running Dog design is knit into this classic rolled-

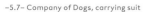

–5.7– Company of Dogs, carrying suit

"Gelato"
& "Peddlar"
Golden
Retrievers

A

B. QUILTED COVER KEE

–5.8– Company of Dogs, sweaters

WELL BRED BED

*H*is and her camels...for people who have been promising themselves to slow down. We'll fly a pair of the slowest, surest beasts on land from California to your private oasis* on the fastest, surest wings in the air, American Airlines. (They built an airline for the professional traveller, so naturally they can handle the world's oldest "professional traveller" without a hitch.)

13A Matched pair of desert plutocrats, 4,125.00 (x) (Delivery time subject to availability of camels.)
13B His abba of striped Siamese silk lined in Indian silk with wool braid. By Cleopatra 170.00 (.80) Man's Store
13C Her nomad pajamas, a jeweled feast of plum and turquoise silk. By Oscar de La Renta for Jane Derby 575.00 (1.00) Couture Shop

*Within the continental U.S.A.

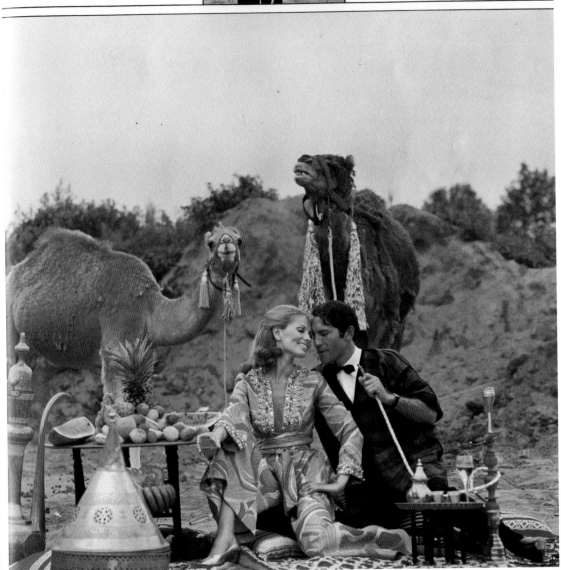

58A

A Rare Gift
His and Hers, 1983

Neiman-Marcus specializes in the rare and the be
Without doubt, the Chinese Shar-Pei dog is rare ... and
after all, in the eye of the beholder. With a heritage tha
traced back at least as far as the Han Dynasty in China
220 AD), the Shar-Pei was down to a mere 12 in the 195
recently as 1979 was listed by Guiness as the world's ra
breed. Though the first known Shar-Pei (Jones Faigoo)
the U.S. in 1966, it was not until Matgo Law of Hong Ko
an urgent, world-wide plea to save these loving and ou
ingly intelligent dogs that the incipient loss of the bree
altogether was fully realized. Now there are 2,495 regist
the Chinese Shar-Pei Club of America as of the last (198
— still rare because of the strictness in breeding and a
edgement. The adults "grow into" the oversize skin — \
puppy defense mechanism. And Shar-Peis are innately
tidy — often housebreaking themselves within a month
give a real bundle of love — a Shar-Pei puppy.

-5.11– Neiman Marcus, His and Hers wrinkle

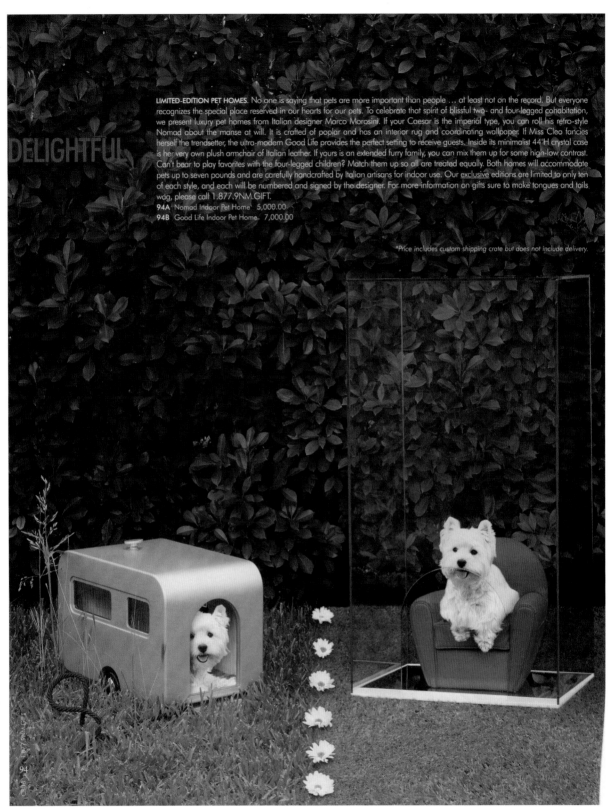

DELIGHTFUL

LIMITED-EDITION PET HOMES. No one is saying that pets are more important than people … at least not on the record. But everyone recognizes the special place reserved in our hearts for our pets. To celebrate that spirit of blissful two- and four-legged cohabitation, we present luxury pet homes from Italian designer Marco Morosini. If your Caesar is the imperial type, you can roll his retro-style Nomad about the manse at will. It is crafted of poplar and has an interior rug and coordinating wallpaper. If Miss Cleo fancies herself the trendsetter, the ultra-modern Good Life provides the perfect setting to receive guests. Inside its minimalist 44"H crystal case is her very own plush armchair of Italian leather. If yours is an extended furry family, you can mix them up for some high-low contrast. Can't bear to play favorites with the four-legged children? Match them up so all are treated equally. Both homes will accommodate pets up to seven pounds and are carefully handcrafted by Italian artisans for indoor use. Our exclusive editions are limited to only ten of each style, and each will be numbered and signed by the designer. For more information on gifts sure to make tongues and tails wag, please call 1.877.9NM.GIFT.

94A Nomad Indoor Pet Home* 5,000.00
94B Good Life Indoor Pet Home* 7,000.00

*Price includes custom shipping crate but does not include delivery.

94

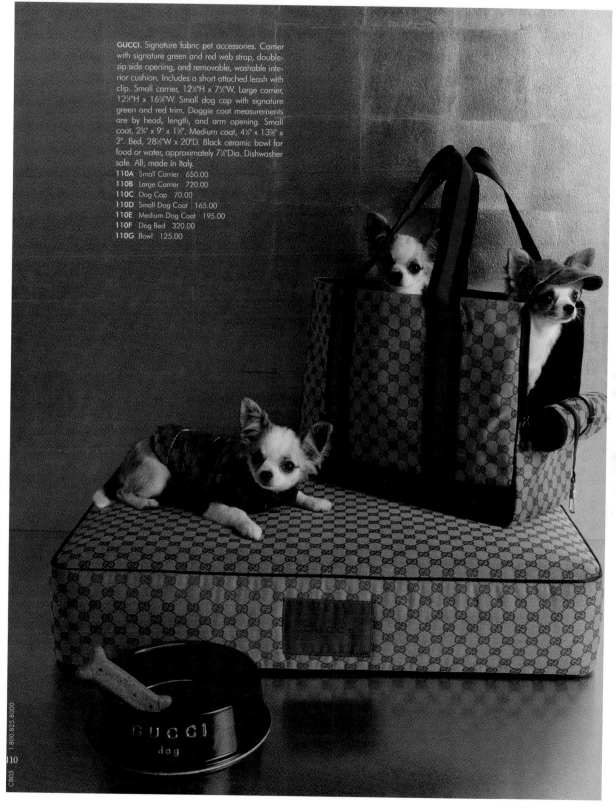

GUCCI. Signature fabric pet accessories. Carrier with signature green and red web strap, double-zip side opening, and removable, washable interior cushion. Includes a short attached leash with clip. Small carrier, 12½"H x 7½"W. Large carrier, 12½"H x 16⅝"W. Small dog cap with signature green and red trim. Doggie coat measurements are by head, length, and arm opening. Small coat, 2⅜" x 9" x 1⅜". Medium coat, 4½" x 13⅜" x 2". Bed, 28½"W x 20"D. Black ceramic bowl for food or water, approximately 7⅛"Dia. Dishwasher safe. All, made in Italy.

110A Small Carrier 650.00
110B Large Carrier 720.00
110C Dog Cap 70.00
110D Small Dog Coat 165.00
110E Medium Dog Coat 195.00
110F Dog Bed 320.00
110G Bowl 125.00

Creature Comforts

21A

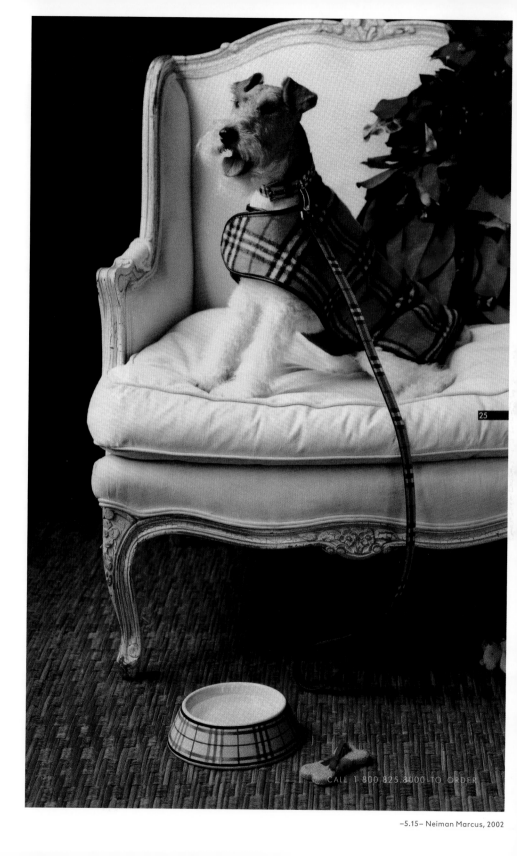

CALL 1.800.825.8000 TO ORDER

–5.15– Neiman Marcus, 2002

−5.16− Neiman Marcus, pet GPS, 2005

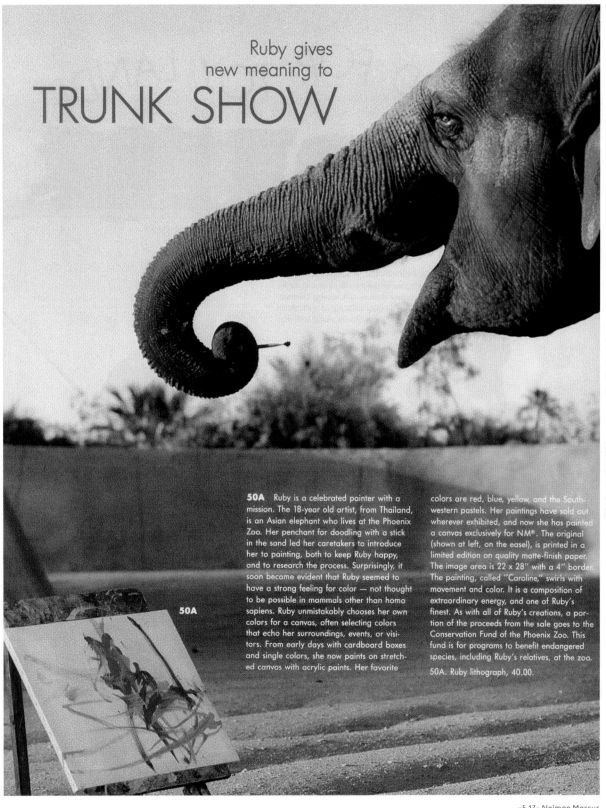

Ruby gives
new meaning to

TRUNK SHOW

50A Ruby is a celebrated painter with a mission. The 18-year old artist, from Thailand, is an Asian elephant who lives at the Phoenix Zoo. Her penchant for doodling with a stick in the sand led her caretakers to introduce her to painting, both to keep Ruby happy, and to research the process. Surprisingly, it soon became evident that Ruby seemed to have a strong feeling for color — not thought to be possible in mammals other than homo sapiens. Ruby unmistakably chooses her own colors for a canvas, often selecting colors that echo her surroundings, events, or visitors. From early days with cardboard boxes and single colors, she now paints on stretched canvas with acrylic paints. Her favorite colors are red, blue, yellow, and the Southwestern pastels. Her paintings have sold out wherever exhibited, and now she has painted a canvas exclusively for NM®. The original (shown at left, on the easel), is printed in a limited edition on quality matte-finish paper. The image area is 22 x 28" with a 4" border. The painting, called "Caroline," swirls with movement and color. It is a composition of extraordinary energy, and one of Ruby's finest. As with all of Ruby's creations, a portion of the proceeds from the sale goes to the Conservation Fund of the Phoenix Zoo. This fund is for programs to benefit endangered species, including Ruby's relatives, at the zoo.

50A. Ruby lithograph, 40.00.

50A

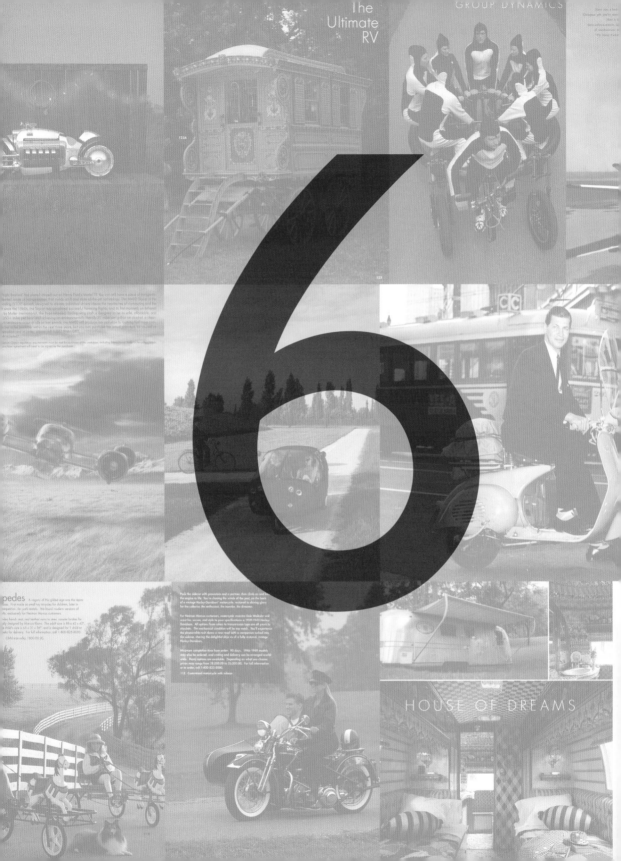

GROUP DYNAMICS

6

pedes

HOUSE OF DREAMS

Transpor-tation

This year, rise above it

Putting Around the Greens

Our Acme King
The Highest Grade Reduced from $35.00 to $23.75

$23.75

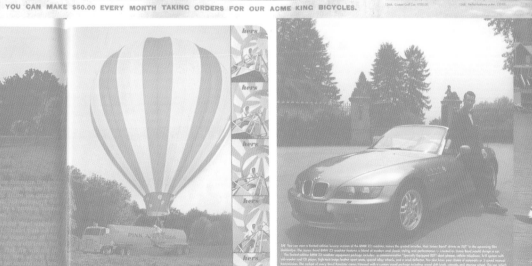

6

Transportation

Catalogs illustrate the progression of American transportation from horses, carriages, wagons, and buggies, to bicycles, motorcycles, cars, and airplanes. To attract attention, catalogers also offered less conventional modes of transport, like hot air balloons, zeppelins, submarines, and spaceships.

In 1893, Montgomery Ward sent out a "Special Buggy Catalog" that offered only non-motorized buggies, wagons, and sleighs. Accessories included lap robes decorated with animals to keep passengers warm during the winter. Both Montgomery Ward and Sears did a brisk buggy business until 1923, when motorized transportation prevailed.

In 1899, American companies produced one million bicycles; by 1909 the advent of the car and the motorcycle brought bicycle production to a standstill. Bicycles would come back in favor in the seventies as an antidote to smoggy cities and due to the renewed interest in physical fitness. Bike design changed little until the late sixties when BMX (bicycle motocross) enabled kids to imitate their free-spirited, motorcycle-riding idols. In the sixties and seventies, the Spyder, with its curved handlebars and groovy banana seat, was the bicycle of choice for hip and happening ten-somethings. The Spyder was available in boys and girls models as well as in a "Chopper Style." All had a sissy bar, the U-shaped metal piece that held up the back of the seat. As the space race heated up, Sears also offered the streamlined Spaceliner, designed by renowned industrial designer Viktor Schreckengost, who designed over one hundred bikes for Sears.

At the beginning of the twentieth century, cars were novel and not always welcome, as this editorial in the *New York Times* indicates: "The new mechanical wagon with the awful name, the automobile...has come to stay...sooner or later it will displace the fashionable carriage of the present hour." Only the very wealthy could afford "horseless carriages" until Henry Ford introduced the standardization that would enable cars to be produced cheaply enough for the factory workers who made them to buy them. In 1900, there were 144 miles of paved road compared with over four million today. There were thirty-six traffic fatalities compared to roughly 40,000 in 2006.

Sears made two attempts at selling its own cars. In 1912, they unsuccessfully introduced a two-cylinder car for $500. In 1952, they partnered with Kaiser-Frazier to offer a four-cylinder model for $1,362. They called it the Allstate, hoping that would spur sales of its automotive product line. (The name "Allstate" had been selected in a contest in which over 900,000 people submitted over two million names. Hans Simonson from Bismarck, North Dakota, submitted the winning name and was awarded $5,000.) Unfortunately, the rise and consolidation of the Detroit powerhouses (and Sears's inability to serve cars throughout the country) made it impossible for Sears to compete; they discontinued the experiment the fol-

lowing year. (Another Allstate brand extension was more successful.)

In 1930, during a bridge game on a commuter train, insurance broker Carl Odell proposed the idea of selling insurance by mail to his friend, Robert E. Wood, then president and CEO of Sears. They decided to call it Allstate, after Sears's tire line. Their first year, the company wrote over 4,000 policies and collected $100,000 in premiums. During the '50s, Allstate expanded beyond auto insurance; in 1963, premiums for Allstate Life Insurance surpassed $1 billion. Sears sold their shares of Allstate in 1995.

In 1951, Sears introduced the Cruisaire, a Vespa scooter manufactured by Piaggio, for $279.95. Their initial order was for 1,000; soon after, they sent a rush order for 5,000 more and a standing order for 2,000 a month. In 1952, Audrey Hepburn and Gregory Peck starred in a Vespa advertisement, better known as Roman Holiday. Sears also sold scooters (as well as motorcycles and mopeds) under its Allstate brand. Steve McQueen had a 1960 Allstate motorcycle that sold at auction for $900 in 2006. Throughout the sixties, Montgomery Ward offered Lambretta scooters under their Riverside brand.

The moped, half bicycle/half motorcycle, was a success in the winding roads of Europe long before the fifties when Sears, Montgomery Ward, and J.C. Penney offered their Silverstone, Montgomery Ward, and Pinto brands. The energy crisis of the seventies fueled Moped Madness.

Neiman Marcus's transportation offerings were eclectic and outrageous. In 1960, they offered His and Hers airplanes. One man wrote, "I already have a plane, but if you will break the pair, I'd like one for the little woman who has been hankering for a plane of her own." They offered several other unconventional modes of transportation as His and Hers gifts including submarines ($18,700 each) in 1963, air balloons ($6,850 each) in 1964, Hoverbugs ($3,650 each) in 1974, and Chinese junks ($11,500 each) in 1962. In 1979, they offered a pair of dirigibles for $50,000. A ten-year-old boy wrote the following: "I have a list of questions I would like answered before I think of buying your Dirigible. If I decide to buy your Dirigible, my grandpa and I will half (sic) to put our money together. I plan to get a paper route and already have a savings account." He enclosed his own sketch with questions and suggestions for improvement. He wanted to know if the dirigible was self-inflating and whether it had an anchor rope, an antenna, and an emergency potty. That same year, they also offered a $32,000 jet-powered glider for which they received orders but not FCC certification, so they couldn't fulfill them. The Fortress of the Freeway—a Total Transportation Security Environment offered in 1971, was essentially an $845,000 highway tank. In 2005, they offered a flying car, the M400 Moller Skycar Prototype ($3.5 million), that boasted, "No traffic, no red lights, no speeding tickets!"

They sold eight junks including one to a Mexican television tycoon, who ordered it on the condition that they provide him with someone to rig it. Somehow a Neiman Marcus executive found an experienced junk sailor who was honeymooning in Dallas and persuaded him to complete his honeymoon in Mexico. They flew the sailor and his bride to Acapulco where he rigged the junk.

Neiman Marcus has also offered a wide array of luxury cars including the James Bond edition BMW Z3 roadster ($35,000 included two tickets to a special dinner party with Pierce Brosnan in Los Angeles) in 1995; a Ducati 748L motorcycle ($15,500) offered in 1997 came with a specially designed DKNY leather jacket and Dainese riding

gloves. One of only six Aston Martin DB7s ($150,000) offered in 1998 came with a black mohair convertible top and a matching set of leather luggage. A Limited Edition of 200 Ford Thunderbirds ($41,995) were offered in 2001 and sold out in two hours. Not to be outdone, the sixty Limited Edition Maserati Quattroportes ($125,000) offered in 2004 sold out in thirty-six minutes.

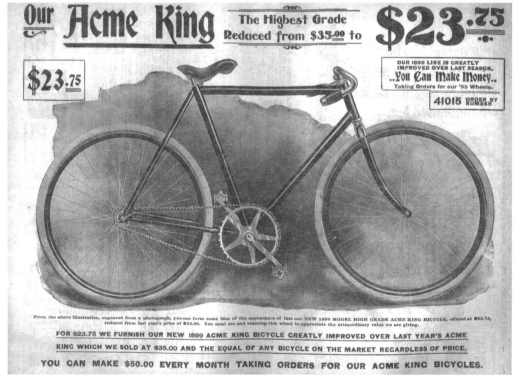

–6.1– Sears, bicycle, 1899

A Parts Manual, with illustrated service details, is included with every Motor Scooter Sears sells. However, if you need another, order it below for your particular Scooter.

28 K 9441—For 3 and 4-HP Scooters. Shpg. wt. 4 oz..........50c
28 K 9442—For Cruisaire Models 788.102, -103, -104. Wt. 4 oz...50c
28 K 9443—For Cruisaire Model 788.94490. Shpg. wt. 3 oz....50c
28 K 9444—For Cruisaire Model 788.94491. Shpg. wt. 4 oz....50c

NATION-WIDE PARTS SERVICE

-to-coast Parts Service for every Motor Scooter Sears has ever sold.
te stocks of Replacement Parts in centrally located areas for fast service.
ese parts by mail, by phone or in person from your Sears Mail Order
Sears Catalog Sales Office or Sears Retail Store. The Parts Manual you
Scooter gives complete details on how to order Replacement Parts.

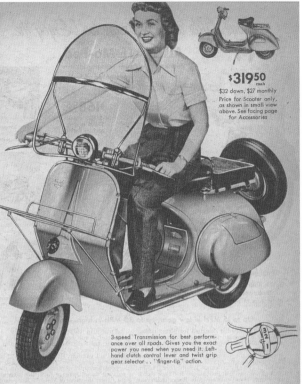

$319.50 cash
$32 down, $27 monthly
Price for Scooter only,
as shown in small view
above. See facing page
for Accessories

$259.50 cash
$26.00 down
$22 monthly

tter Motor Scooter .. ALLSTATE 4-HP

o 75 miles-per gallon of gas .. up to 40 miles per hour
. it's great for riding to school, to work, or just plain fun
age compartment is fine for parcel delivery.. . handy for trips
lutch eliminates gear shifting .. makes driving easier

fine features you get at this low price! Big size .. it's a full 6 feet,
g. Plenty of power and speed .. with a heavy duty centrifugal clutch
a smoother acceleration, smoother riding. Simple to operate ..
ing, and you control acceleration with twist grip, stop smoothly
of brake. 2-shoe cam-operated brake with 6⅛-in. drum. Put oil in
h holds 1 quart; 2-gallon gas tank. Bright 6-inch 32-candlepower
t headlight with dimmer switch; combination tail and stoplight.
mounts. Extra strong fork. Engine is 4-horsepower, 4-cycle; air-
ylinder; 2⅜-inch bore; 2¾-inch stroke, 14.9 cubic inch displace-
al adjustable carburetor. Drop-forged gear-driven camshaft, 1⅞-
ler chain drive. Locking luggage section; steel saddle with springs
tex cushion. Wheelbase 52¼ in.; 76½ in. overall. Color bright red
. Complete with 4.00-8 tires and tubes, service manual, instruc-
s list. *Be sure to see "Important Notice on Motor Scooters," below.*
asy Terms.
hipping weight 320 pounds.....................Cash $259.50

IMPORTANT NOTICE ON MOTOR SCOOTERS

CENSE: Before you can operate a motor scooter, you must have an
e, secured through your local authorities. So before buying your scooter, be
r local age requirements and any other requirements.
E AND TITLE: Upon shipment of Motor Scooter, Sears sends you the necessary
ng license and title in your state.

) low-priced

TE 3-HP

Scooter

d motor scooter buy—real low-cost transportation. Engineering is
big 4-HP ALLSTATE Scooter at top of this page—4-cycle 1-cylinder
cially designed for scooters. Has twist-grip throttle, kick starter,
comfortable steel spring-mounted seat. Rubber engine mounts to
ion. 32 candlepower headlight; combination tail and stoplight.
el frame and panels. Engine has big 2⅜-inch bore, 2¾-inch stroke,
ch displacement. Roller chain and sprocket. Automatic clutch—no
required. No mixing of gasoline and oil, either—crankcase holds 1
-gallon gasoline tank for miles of travel.
e—a regular highway type of motor scooter. Wheelbase is 52¼
all length 71 inches. Bright red baked-on enamel finish. Complete
-ply scooter tires and tubes, made for mileage and safety. Service
uctions, parts list are all included. *Be sure to see "Important Notice"*
bout our Parts Service at top of this page and see Accessories for our
rs on the facing page.
-Order now for spring. Shipping weight 270 pounds............$208.95

3-speed Transmission for best perform-
ance over all roads. Gives you the exact
power you need when you need it. Left-
hand clutch control lever and twist grip
gear selector . . "finger-tip" action.

Our Best .. 1957 4.95-HP Cruisaire

• Delivers up to 110 miles per gallon .. up to 46.6 miles per hour
• Continental styling by Piaggio & Co. of Genoa, Italy .. light green color
• Two-wheel braking .. right hand-grip controls front, foot pedal for rear
• Hydraulic shock absorber on rear wheel .. Coil springs front and rear

You know this is Our Best Scooter when you check its sleek "flow-together" design,
when you realize all the *power* it delivers at such *low cost* for fuel, when you see that it's
built almost like an automobile for safety and comfort .. both front and rear brakes are
standard equipment and its cantilever wheel suspension teams up with a concentric
shock absorber and coil springs. Check all these features:
 Engine: 2-cycle cast iron cylinder; compression ratio 6.5 to 1; "square" design, 2.12-
inch bore, 2.12-inch stroke, aluminum alloy cylinder head.
 Clutch: sturdy 3-plate type for sure, positive action; direct drive through clutch and gear.
 Handlebar control cables enclosed, like a motorcycle—clutch lever and 3-speed trans-
mission control on left hand-grip, throttle and front brake control on right hand-grip.
Both brakes are expanding shoe type. Powerful 2-beam headlamp for safe night-driving—
has recess for speedometer (order speedometer separately from facing page). Combination
tail and stoplight; built-in electric horn. Interchangeable wheels. Comfortable big heavy
leather saddle cushioned with special coil springs.
 Safety features— protective front shield, super-strong steel frame. It's big—wheelbase
44½ in.; overall length 65 in.; overall width 31 in. Complete with two 3.50-8 scooter
tires and tubes. Spring-action center stand. 1.3-gal. fuel tank; fuel mixture of ⅓ pint of
motor oil to 1 gal. regular gasoline. Sure-fire kick starter. Luster finish adds extra beauty
to the Continental light green enamel. Complete with tool kit, service manual, instruc-
tions parts list. *Be sure to see "Important Notice" at left, above.* See also Cruisaire Acces-
sories on the facing page (windshield, etc.). Buy the Cruisaire and Accessories on Sears
Easy Terms . . pay only 10% down.
28 K M9449—Scooter only, without accessories. Shipping weight 300 pounds.........$319.50

Passenger Sidecar for Cruisaire $87.95 cash
$9 dn., $8 mo.

Make your Cruisaire a 2-passenger vehicle or
Cargo Carrier with this streamlined Sidecar. Has
seat and backrest of foam rubber, plenty of leg
room and footrest. Seat is removable for Cargo
carrying. Torsion bar suspension. Easily attached
with 4 bolts. 16-inch wide seat, 42-inch leg room.
Complete with 4.00-8 tire and tube. Continental
green finish like the Cruisaire. Windshield not in-
cluded. Shipping weight 100 lbs.
28 K M9486—Sidecar only..............$87.95
Plastic Windshield for Sidecar above.
28 K 09489L—Shipping weight 4 pounds......11.75

USE EASY TERMS ON SCOOTERS AND ACCESSORIES

If you want a motor scooter now, why not buy it
now . . even though you may be temporarily short
of cash at the moment?
 Sears Easy Payment Plan is the answer. This
convenient way to buy has brought many a motor
scooter to many a customer's door. And such a
great variety of uses has been found for ALLSTATE
Scooters! They are being used as an economical

"second car" . . for deliveries or after-school
jobs . . or just for plain fun. Business people and
farmers find them very handy, too. So why not
buy your ALLSTATE Motor Scooter right now on
Sears Easy Terms? You need pay only 10%
down, balance is spread out in a series of conven-
ient monthly payments. Buy Accessories that way,
too. For details, see inside back cover.

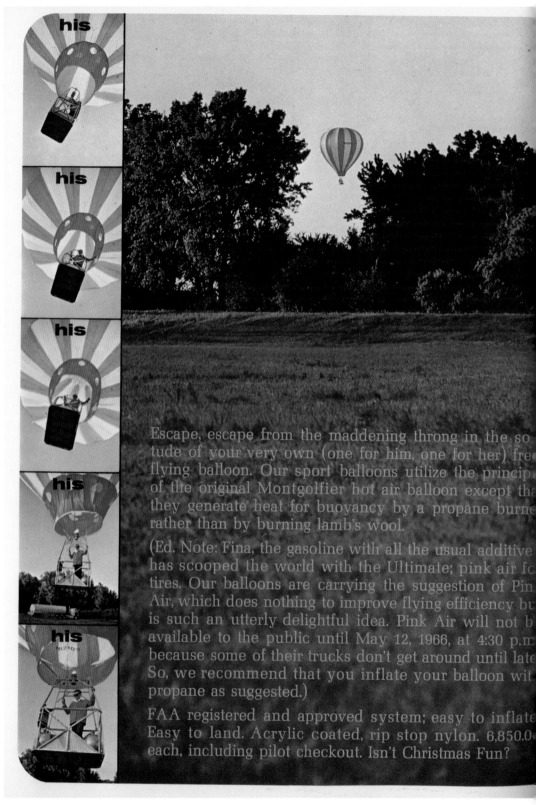

Escape, escape from the maddening throng in the so[li]tude of your very own (one for him, one for her) fre[e] flying balloon. Our sport balloons utilize the princip[le] of the original Montgolfier hot air balloon except tha[t] they generate heat for buoyancy by a propane burne[r] rather than by burning lamb's wool.

(Ed. Note: Fina, the gasoline with all the usual additive[s] has scooped the world with the Ultimate; pink air fo[r] tires. Our balloons are carrying the suggestion of Pin[k] Air, which does nothing to improve flying efficiency bu[t] is such an utterly delightful idea. Pink Air will not b[e] available to the public until May 12, 1966, at 4:30 p.m[.] because some of their trucks don't get around until late[r.] So, we recommend that you inflate your balloon wit[h] propane as suggested.)

FAA registered and approved system; easy to inflate[.] Easy to land. Acrylic coated, rip stop nylon. 6,850.0[0] each, including pilot checkout. Isn't Christmas Fun?

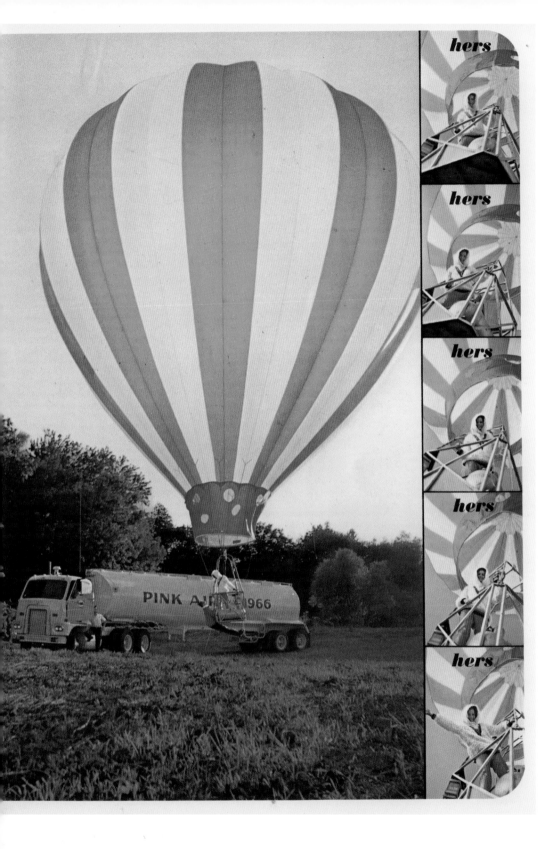

PINK AIR 1966

hers

hers

hers

hers

hers

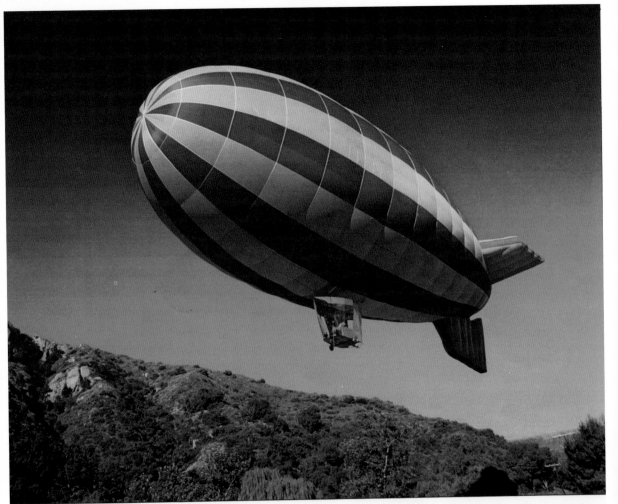

This year, rise above it all with our his and her dirigibles

♛ 49a

Here's a gift that will have them floating on air—our colorful, hot-air dirigibles to take them up and away from the madding crowd to transcend traffic and slip away from stress—riding with the wind into the sunset.

The passenger compartment is just right for two people (and a well-stocked picnic hamper) to escape into the ether for a leisurely 25 mph cruise that's really out of this world.

We've prudently provided full flight instructions for one person with each purchase, so the recipient should be able to handle even a *Texas Blue Norther* with full confidence.

These airships are completely collapsible and portable, so you can pack them off to launch anywhere from Peoria to Pago-Pago . . . and you can have them in any color and design.

Created exclusively for us by Stokes Airships and Balloons, Inc., the N-M airships are 120 feet long and powered by a 72 hp engine. 49A. Available at N-M through January 1, 1980. Each, 50,000.00.

For full information, please call AC 214/741-6911, ext. 1251.

VIRGIN GALACTIC CHARTER TO SPACE

Nieman Marcus, 2006

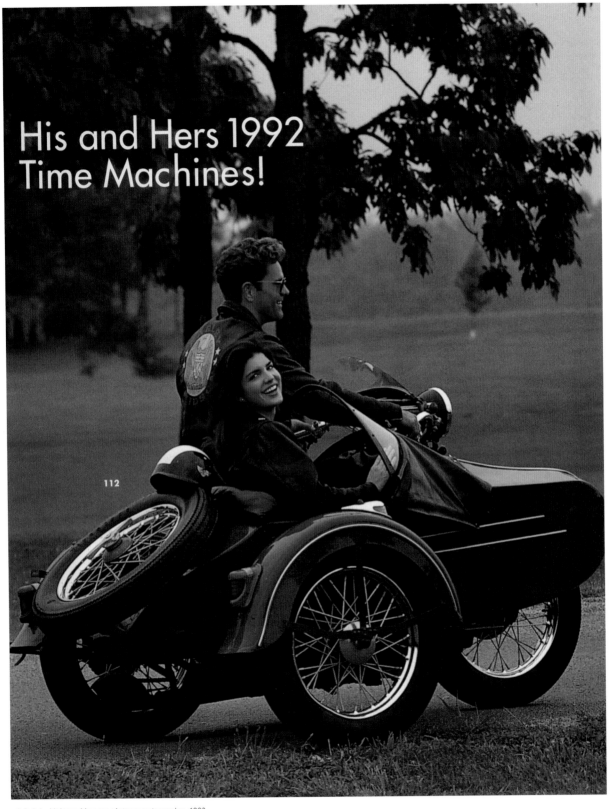

His and Hers 1992 Time Machines!

112

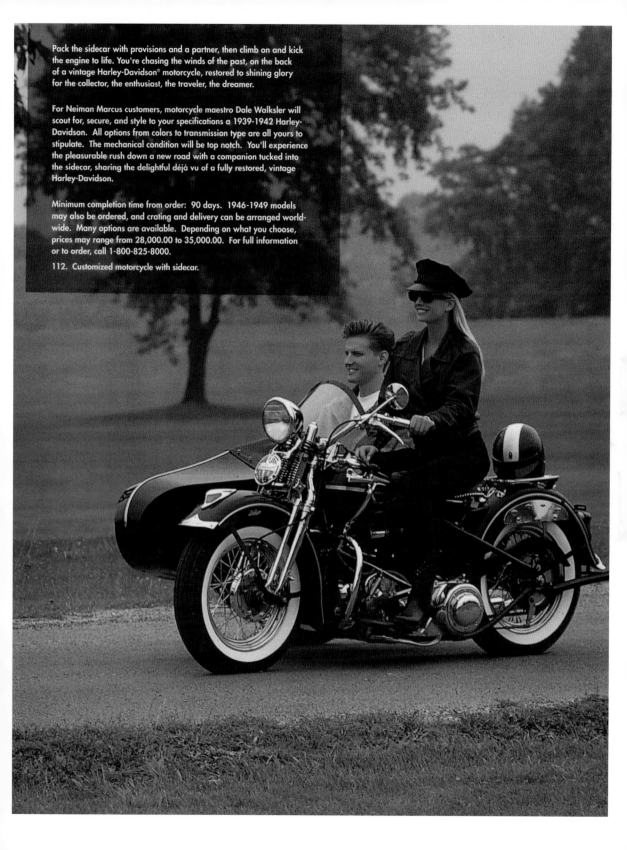

Pack the sidecar with provisions and a partner, then climb on and kick the engine to life. You're chasing the winds of the past, on the back of a vintage Harley-Davidson® motorcycle, restored to shining glory for the collector, the enthusiast, the traveler, the dreamer.

For Neiman Marcus customers, motorcycle maestro Dale Walksler will scout for, secure, and style to your specifications a 1939-1942 Harley-Davidson. All options from colors to transmission type are all yours to stipulate. The mechanical condition will be top notch. You'll experience the pleasurable rush down a new road with a companion tucked into the sidecar, sharing the delightful déjà vu of a fully restored, vintage Harley-Davidson.

Minimum completion time from order: 90 days. 1946-1949 models may also be ordered, and crating and delivery can be arranged worldwide. Many options are available. Depending on what you choose, prices may range from 28,000.00 to 35,000.00. For full information or to order, call 1-800-825-8000.

112. Customized motorcycle with sidecar.

Victorian velocipedes

A vagary of this gilded age was the reproduction of the horse-driven sulky used for trotter races. First made as small toy tricycles for children, later in France enlarged and used by adults for fun, for competition, for park rentals. We found modern versions of these sportive vehicles, sized for children and adults, exclusively for Neiman Marcus customers.

The 3-wheel sulky is constructed of steel, with wooden bench seat, real leather reins to steer, coaster brakes for the pedals, and cast polyester resin ponies originally designed by Marcus Illions. The adult size is 88 x 42 x 42", and holds 2 adults, or 1 adult and 2 children. The child's size is 65 x 31 x 36", and is designed for 1 child or 1 adult. Both require some assembly. Allow 6 weeks for delivery. For full information, call 1-800-825-8000.

17A. Adult size sulky, 2400.00 (X). 17B. Child size sulky, 1800.00 (X).

17A

17B

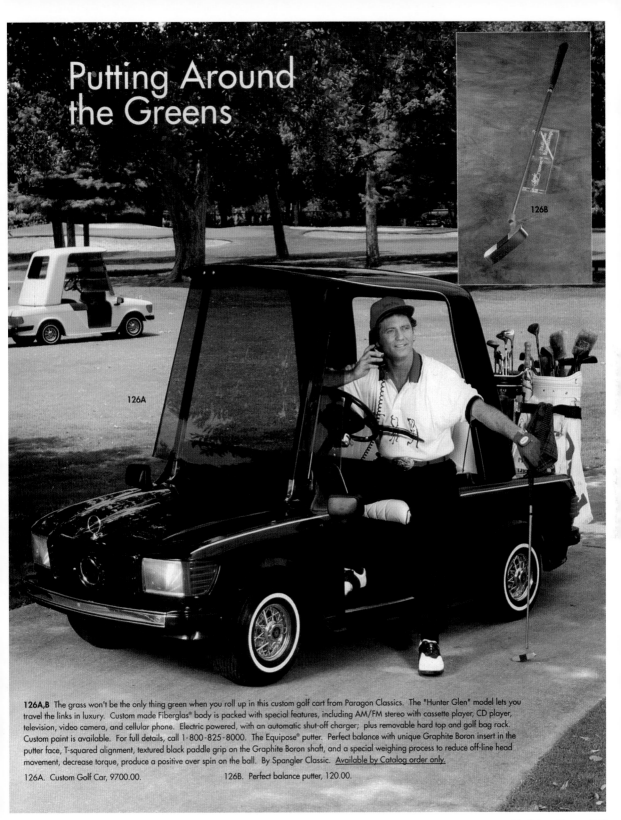

Putting Around the Greens

126A

126B

126A,B The grass won't be the only thing green when you roll up in this custom golf cart from Paragon Classics. The "Hunter Glen" model lets you travel the links in luxury. Custom made Fiberglas® body is packed with special features, including AM/FM stereo with cassette player, CD player, television, video camera, and cellular phone. Electric powered, with an automatic shut-off charger; plus removable hard top and golf bag rack. Custom paint is available. For full details, call 1-800-825-8000. The Equipose® putter. Perfect balance with unique Graphite Boron insert in the putter face, T-squared alignment, textured black paddle grip on the Graphite Boron shaft, and a special weighing process to reduce off-line head movement, decrease torque, produce a positive over spin on the ball. By Spangler Classic. <u>Available by Catalog order only.</u>

126A. Custom Golf Car, 9700.00. 126B. Perfect balance putter, 120.00.

74

–6.10– Neiman Marcus, Virgin to space, 2006

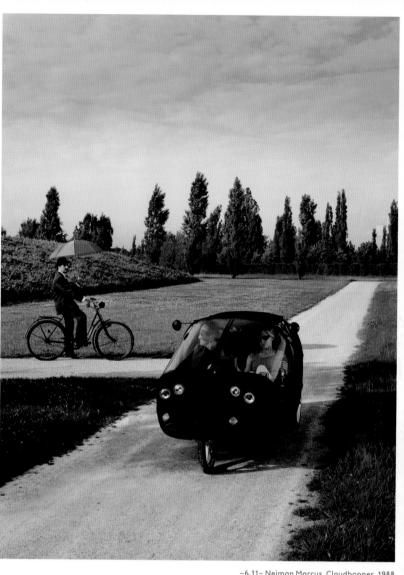

-6.11- Neiman Marcus, Cloudhopper, 1988

THE N-M TOUCH: HIS AND HER AIRPLANES

Have you a husband or wife who's utterly impossible to buy for? Here's the one great they'll-never-believe-it
Christmas gift you've searched the world to find! His is the incomparable, big 7-place Beechcraft Super G18.
Hers is the 4-place Beechcraft Bonanza. Both speed along the skyways at more than
three-miles-a-minute, both can be bought in your choice of color, style, cabin arrangement, and any number
of combinations of individual navigational equipment. **2A** Hers, 27,000.00. **2B** His, 149,000.00. Both are
"Fly Away Factory" prices. **2C** Her jacket adds the right dash in Russian white ermine
with a bleached white fox border. (A) 2,975.00 incl. Federal tax. Fur Salon.

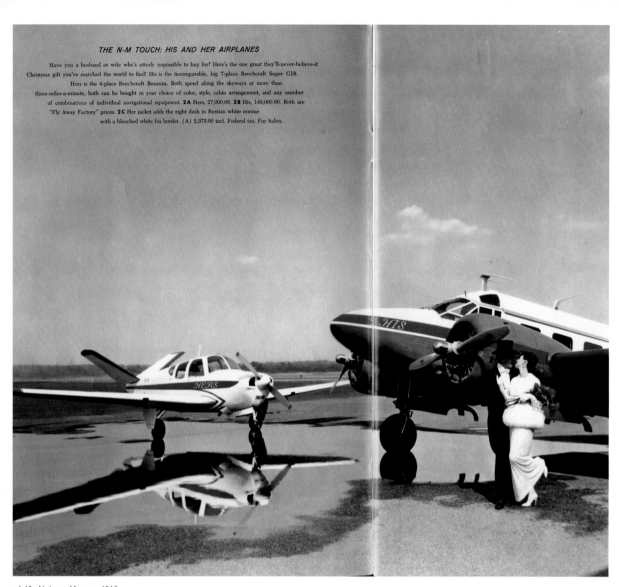

−6.12− Neiman Marcus, 1960

–6.13– Neiman Marcus, jet, 1999

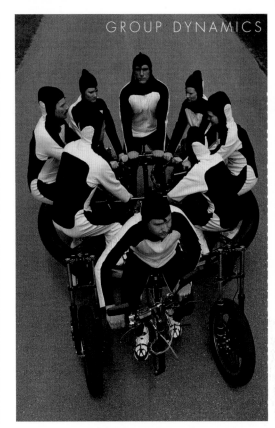

–6.14– Neiman Marcus, 1996

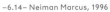

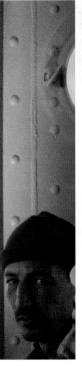

–6.15– Neiman Marcus, submarine, 2007

SKYCAR PROTOTYPE. Born too late for the Wright Brothers' first plane? Missed out on Henry Ford's Model T? You can still have a piece of transportation history: the prototype for an unprecedented mode of transportation that melds sci-fi and state-of-the-art technology. The M400 Skycar is the world's first personal vertical takeoff and landing (VTOL) aircraft, designed to elevate individual drivers above the headaches of commuting and the dangers of highway travel. In development since the 1960s, the Skycar has completed successful hovering flights, and its first manned, un-tethered flight is planned for Fall 2005. Developed by Moller International, the three-wheeled, folding-wing craft is designed to be as safe, affordable, and easy to use as an automobile, traveling at 350+ miles per hour and achieving an environmentally friendly 21 miles per gallon on alcohol, a cleaner fuel than gasoline. And because most auto emissions occur at idle or low speeds, the M400 will produce less pollution by burning fuel more completely. A limited number of M400s is expected to be available within the next three years, but you can purchase the actual prototype for yourself or your favorite commuter now. For more information and to order, please call 1.877.9NM.GIFT.

85 Skycar Prototype 3,500,000.00 (delivery not included)*

*Neiman Marcus is acting as the advertiser for this product. Certain regulatory requirements must be met for purchase of the prototype, including International Traffic in Arms Regulations and Federal Aviation Administration authorization. A purchase agreement will need to be signed by the purchaser.

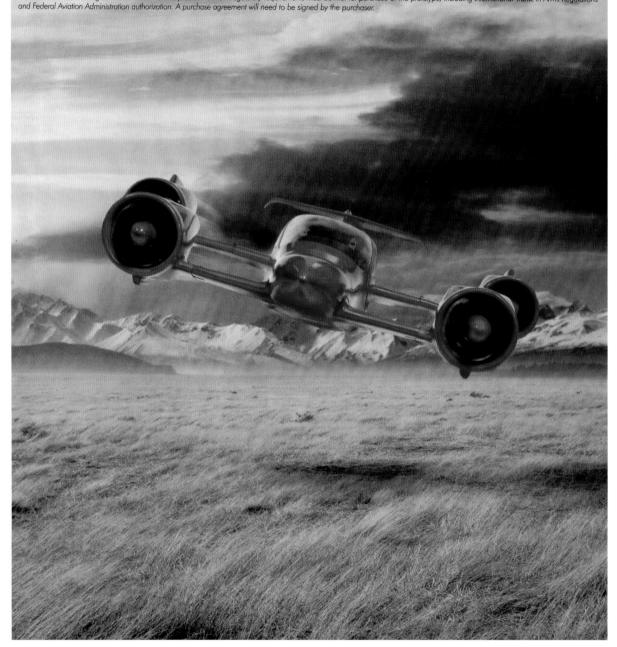

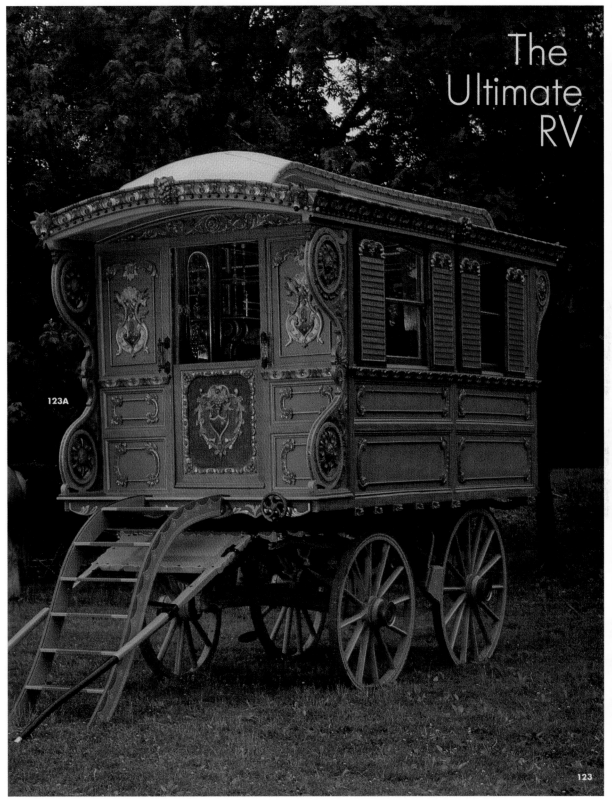

The
Ultimate
RV

123A

–6.17– Neiman Marcus, 1990

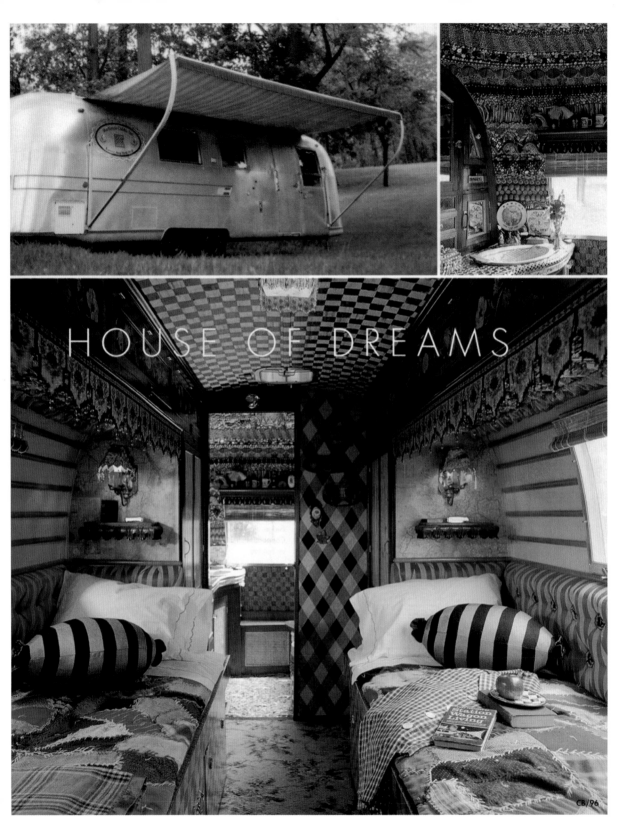

HOUSE OF DREAMS

CB/96

−6.18− Neiman Marcus, Airstream trailer, 1996

–6.19– Neiman Marcus, Tomahawk motorcycle, 2003

54 You can own a limited-edition luxury version of the BMW Z3 roadster, minus the guided missiles, that James Bond® drives as 007® in the upcoming film GoldenEye. The James Bond BMW Z3 roadster features a blend of modern and classic styling and performance — created as James Bond would design a car.

The limited-edition BMW Z3 roadster equipment package includes: a commemorative "Specially Equipped" 007® dash plaque, cellular telephone, hi-fi system with sub-woofer and CD player, high-tech beige leather sport seats, special alloy wheels, and a wind deflector. You also have your choice of automatic or 5-speed manual transmission. The cockpit of every James Bond Roadster comes trimmed with a custom wood package including wood shift knob, console, and steering wheel. The car, which comes in Bond blue-gray, is also outfitted with a deluxe chrome ensemble including a rear luggage carrier and special roadster luggage.

To complete your James Bond roadster experience, customers who order their BMW Z3 roadsters prior to October 31, 1995, will receive two VIP tickets to the GoldenEye Norris Cancer Center pre-screening and cocktail reception in Los Angeles in early November. The host for the evening is Pierce Brosnan, the new James Bond. You can be one of the few to hit the road in the luxury version of the James Bond next summer. As an added bonus, you'll earn 20,000 InCircle® points for your purchase. To learn more about this rare opportunity, call 1-800-825-8000, ext. 6303.

54. BMW Z3 James Bond® roadster, 35,000 (X).

The BMW roadster, 35,000.00, exclusive of taxes, title, destination and handling, license and transfer of title fees. Options additional. Delivery time based on availability. BMW equipment subject to change based on production specifications. Travel and accommodation expenses for the pre-screening are not included. James Bond and 007 are federally registered trademarks of GoldenEye © 1995 DANJAQ, INC. and UNITED ARTISTS CORPORATION ALL RIGHTS RESERVED. BMW® and its logo are federally registered trademarks of BMW North America, Inc.

–6.20– Neiman Marcus , James Bond BMW

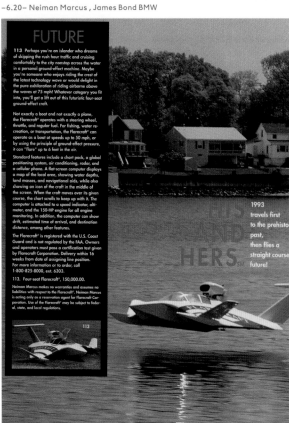

FUTURE

113 Perhaps you're an islander who dreams of skipping the rush hour traffic and cruising comfortably to the city nonstop across the water in a personal ground-effect machine. Maybe you're someone who enjoys riding the crest of the latest technology wave or would delight in the pure exhilaration of riding airborne above the waves at 75 mph! Whatever category you fit into, you'll get a lift out of this futuristic four-seat ground-effect craft.

Not exactly a boat and not exactly a plane, the Flarecraft® operates with a steering wheel, throttle, and regular fuel. For fishing, water re-creation, or transportation, the Flarecraft can operate as a boat at speeds up to 50 mph, or by using the principle of ground-effect pressure, it can "flare" up to 6 feet in the air.

Standard features include a chart pack, a global positioning system, air conditioning, radar, and a cellular phone. A flat-screen computer displays a map of the local area, showing water depths, land masses, and navigational aids, while also showing an icon of the craft in the middle of the screen. When the craft moves over its given course, the chart scrolls to keep up with it. The computer is attached to a speed indicator, alti-meter, and the 150-HP engine for all engine monitoring. In addition, the computer can show drift, estimated time of arrival, and destination distance, among other features.

The Flarecraft® is registered with the U.S. Coast Guard and is not regulated by the FAA. Owners and operators must pass a certification test given by Flarecraft Corporation. Delivery within 16 weeks from date of assigning line position. For more information or to order, call 1-800-825-8000, ext. 6303.

113. Four-seat Flarecraft®, 150,000.00.

Neiman Marcus makes no warranties and assumes no liabilities with respect to the Flarecraft®. Neiman Marcus is acting only as a reservation agent for Flarecraft Corporation. Use of the Flarecraft® may be subject to federal, state, and local regulations.

1993 travels first to the prehistoric past, then flies a straight course to the future!

–6.22– Neiman Marcus, seaplane, 1993

–6.21– Neiman Marcus, ATV, 2006

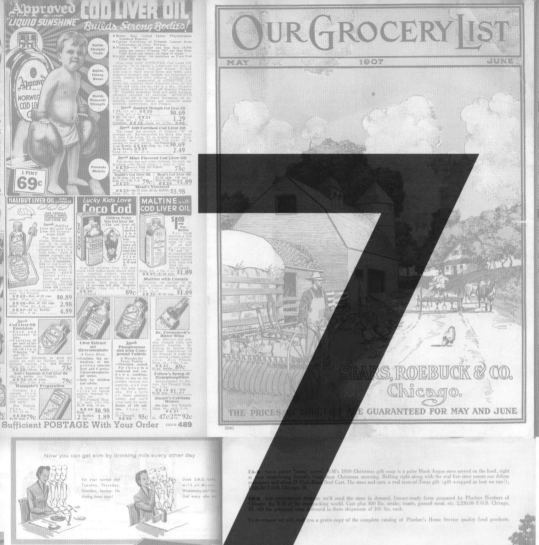
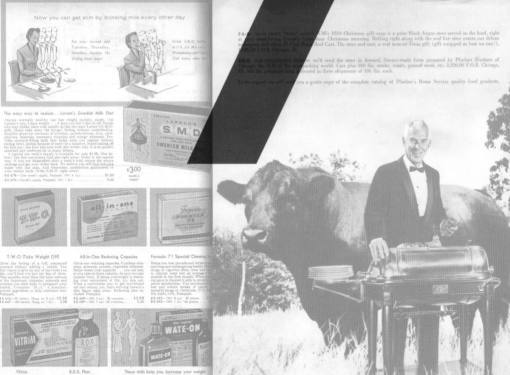

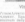

Food and Drugs

7

Food and Drugs

Food has been a mainstay of catalogs since the beginning. In 1896, Sears began offering groceries. The catalogs remained popular until after the Depression, when competition from local chains caused them to stop in 1941. The first known recipe for brownies was published in the 1897 Sears catalog. It was so popular that Sears introduced their own brownie mix.

Harry and David Holmes exported their Royal Riviera Pears to the grand hotels of Europe until the Depression dried up their business. Facing bankruptcy, the brothers came up with the idea of offering their pears as Christmas gifts by mail. In 1938, they started the Fruit-of-the-Month club. In 1947, they invented the Tower of Treats, a brightly wrapped stack of food gifts. Today, their deluxe tower includes Royal Riviera Pears and Apples, Cheddar Cheese, Mixed Nuts, Baklava, Lemon Shortbreads, Chocolate Truffles, Mint Chocolates, and Bing Cherry Chocolates.

The Collin Street Bakery of Corsicana, Texas, sends their Deluxe Fruitcake around the world during the holidays. In 2007, the bakery sent fruitcakes to 196 different countries. Ringling Brothers, their first mail-order client, still send their cakes to friends and associates. Every president since Woodrow Wilson has given or received fruit-cakes. The bakery recently started offering "Presidential Pastries" using recipes from Chef Roland Mesnier, the White House Executive Pastry Chef from 1979–2005. The White House Banana Cake was a favorite of President Bill Clinton. Princess Grace of Monaco sent an annual order, a tradition her daughter Princess Caroline continues. Other well-known clients have included Dom Delouise, Dr. J, Vanna White, and the Aga Khan. The company rejected an order from Iran's Ayatollah Khomeini in 1979 during the Hostage Crisis.

By the early sixties, advances in shipping materials and vacuum packaging enabled more perishable foods (such as Omaha Steaks) to be shipped. Over time, food catalog owners have diversified their product offerings, realizing that people who buy fruit or meat through the mail are also willing to buy other food and nonfood products through the mail. So today, you can buy flowers from Harry and David and cheesecake from Omaha Steaks.

In 1968, the most successful item in the Neiman Marcus Christmas book was a Mason jar filled with mint-flavored green peas that sold for $5.00. The candy was manufactured in a small village in Italy and when the company tried to order 20,000 jars, they got a call from their Italian office who thought it was a joke and explained that the mints were rolled by hand. The order was put through, but the mayor of the village called the buyer and said that even if all the women and children of the village worked on this project, it could not be done. A New York manufacturer was brought in to handle production. Alas, one woman who received the peas from her niece wrote to say how appalled she was when she put them in boiling water and they completely melted.

The increased sophistication of the American palate has spawned catalogs

offering artisanal products, foreign products and a dazzling array of spices, candies and meats. Zingerman's in Ann Arbor focuses on traditionally made products often produced in small quantities by artisans and small factories. In addition to (often, their own) great coffees, breads, butters, oils, vinegars, and cheeses, Zingerman's can be counted on for unique items like violet mustard, pomegranate molasses, and pistachio cream.

There's also been a throwback to earlier and, presumably, easier times. The Vermont Country Store satisfies customers' needs for traditional candies like Mallo Cups, Skybar, Zagnut, and Bit-o-Honey, as well as Necco wafers in chocolate, wintergreen, and assorted flavors. Other foods that Vermont Country Stores has saved from obsolescence include Green Goddess salad dressing and Maypo (maple syrup-flavored oatmeal). There are also niche catalogs: Gambino's Bakery sells their Mardi Gras King Cake, New Braunfels offers old-fashioned sausages, and Penzeys specializes in spices. Stalwarts Swiss Colony and Hickory Farm, founded in 1926 and 1959, respectively, continue to offer traditional Midwestern gift boxes featuring Sausage 'N Cheese bars (Swiss Colony) and Beef Stick Summer Sausages (Hickory Farm).

At the turn of the twentieth century, both Sears and Montgomery Ward devoted pages and pages to over-the-counter "patent medicines" that protected manufacturers from counterfeiters, though they did nothing to protect customers from the medicines. These so-called remedies were laced with alcohol, narcotics, and poison. Opium and morphine cures contained opium and morphine or cocaine, and "bitters" designed to cure alcoholism were often over 40 percent alcohol. In 1905, Sears offered Laudanum (tincture of opium), Catarrh powder (cocaine), and Arsenic Complex Wafers (poison). The "weaker" sex could avail itself of "Brown's Vegetable Cure for Female Weaknesses" a 40-proof medicinal compound that would cure everything from "a dragging sensation in the groin to impaired general health." Sears offered remedies for "TOO MUCH FAT, a disease and source of great annoyance." "Fat folks" would be relieved to know that Sears offered tonics and powders that would "reduce corpulency (sic) in a safe and agreeable manner." Articles about the fraud of patent medicines that appeared in *Ladies Home Journal* and *Collier's Weekly* led to the creation of the Food and Drug Act of 1906. By 1915, Sears had only one page of medicines, but the era of the medical miracle was over. Sears offered aspirin. Today, catalogs promising miraculous weight loss and unstoppable sexual stamina could be considered patent medicines' rightful heirs.

YES we Have Spruce GUM
If you've ever gouged spruce gum off Spruce trees, you know what hard work it is. That's why the supply is short . . . but I think we have enough this time so you can, if you send in your order now, have all you want. Approx. 12 pieces in box, 10 cents a Box.

–7.1– Vermont Country Store

CAVIAR
Like many people, I love Caviar, especially with champagne, before dinner. There is, of course, no question that for gourmets it surpasses all other hors d'oeuvres. But, I don't eat Russian Caviar because I won't give the Communists a penny of my trade. So, let me suggest something I have just tried and found excellent: *American Caviar* made from Whitefish, that has the real Caviar tang, taste and appearance. And at about one tenth the cost! Try it and see if you and your guests do not agree! Glass jar, 3½ oz., No. 11326 $1.00 *. Shipping Weight ½ lb. Glass jar, 8 oz., No. 11327 $2.25. Shipping Weight 1 lb.

–7.2– Vermont Country Store

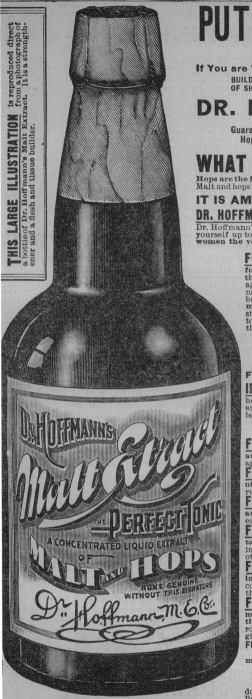

-7.4- Sears, medicines, 1901

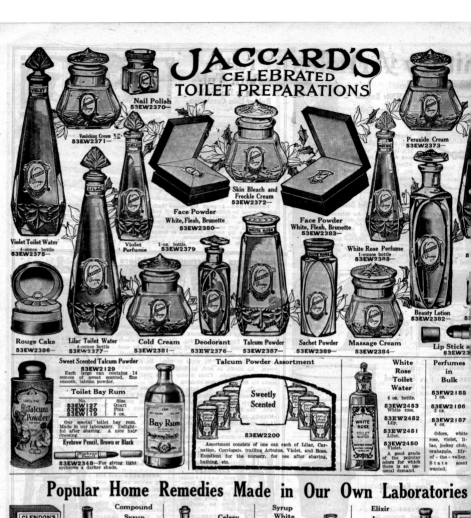

JACCARD'S CELEBRATED TOILET PREPARATIONS

Nail Polish
53EW2370—

Vanishing Cream
53EW2371—

Peroxide Cream
53EW2373—

Skin Bleach and
Freckle Cream
53EW2372—

Face Powder
White, Flesh, Brunette
53EW2380—

Face Powder
White, Flesh, Brunette
53EW2383—

Violet Toilet Water
4-ounce bottle
53EW2375—

Violet
Perfume
53EW2379—

1-oz. bottle.

White Rose Perfume
1-ounce bottle
53EW23R5—

Beauty Lotion
53EW2382—

Rouge Cake
53EW2386—

Lilac Toilet Water
4-ounce bottle
53EW2377—

Cold Cream
53EW2381—

Deodorant
53EW2376—

Talcum Powder
53EW2387—

Sachet Powder
53EW2389—

Massage Cream
53EW2384—

Lip Stick
53EW23

Sweet Scented Talcum Powder
53EW2129

Each large can contains 14 ounces of sweet scented, fine smooth, talcum powder.

Toilet Bay Rum

No.	Size
53EW127	Quart
53EW120	Pint
53EW119	8 oz.

Our special toilet bay rum. Made in our laboratory. Delightful after shaving. A nice hair dressing.

Eyebrow Pencil, Brown or Black

53EW2348—For giving light eyebrows a darker shade.

Talcum Powder Assortment

Sweetly Scented

53EW2200

Assortment consists of one can each of Lilac, Carnation, Corylopsis, trailing Arbutus, Violet, and Rose. Excellent for the nursery, for use after shaving, bathing, etc.

White Rose Toilet Water

4 oz. bottle.
53EW2453 White rose.
53EW2452 Lily.
53EW2451 Lilac.
53EW2450 Violet.

A good grade of the popular odors for which there is an unusual demand.

Perfumes in Bulk

53EW2185 1 oz.
53EW2186 2 oz.
53EW2187 4 oz.

Odors, white rose, violet, lilac, jockey club, crabapple, lily-of-the-valley. State scent wanted.

Popular Home Remedies Made in Our Own Laboratories

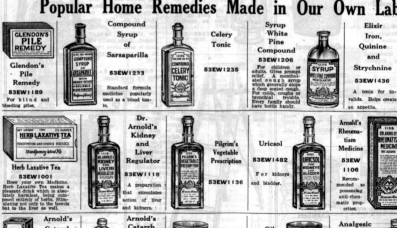

Glendon's Pile Remedy
53EW1189
For blind and bleeding piles.

Compound Syrup of Sarsaparilla
53EW1233
Standard formula medicine popularly used as a blood tonic.

Celery Tonic
53EW1235

Syrup White Pine Compound
53EW1206
For children or adults. Gives prompt relief. A mentholated cough syrup which generally stops a deep seated cough. For colds, coughs or bronchial trouble. Every family should have bottle handy.

Elixir Iron, Quinine and Strychnine
53EW1436
A tonic for invalids. Helps create an appetite.

Herb Laxative Tea
53EW1001
Brew your own Medicine. Herb Laxative Tea makes a pleasant drink which is absolutely harmless, being composed entirely of herbs. Stimulating not only to the bowels but to the liver as well.

Dr. Arnold's Kidney and Liver Regulator
53EW1118
A preparation that stimulates action of liver and kidneys.

Pilgrim's Vegetable Prescription
53EW1136

Uricsol
53EW1482
For kidneys and bladder.

Arnold's Rheumatism Medicine
53EW1106
Recommended as possessing anti-rheumatic properties.

Pilgrim's Cascara Laxative Tablets
53EW1154
Stimulates action. As pleasant to Relief for cons

Arnold's Catarrh Medicine
53EW1212
Taken internally as a medicine. Acts on the blood, helping to cleanse of impurities.

Arnold's Catarrh Jelly
53EW1215
A clear, pure white, medicinal jelly. Relieves colds and catarrhal affections of the throat and nose. Made in our laboratory.

Mentholated Ointment
53EW1152
Splendid for burns, bruises, chaps, sunburn, and after shaving.

Oil of Mustard Ointment
53EW1160—An excellent salve for external treatment coughs, colds in the chest, sore joints, etc.

Analgesic Balm
53EW1104
A penetrating balm which makes an excellent local application. Made in our laboratory.

53EW1154
53EW1155
The most natural remedy for constipation known. Absolutely harmless at passes through body without being absorbed. Tasteless and odorless. It acts a lubricating the bowels, making easier for them perform their regular functions, our own laborato

ell Known and Widely
OVERTISED ANTISEPTICS

Powdered Boric Acid U. S. P.
A mild effective antiseptic. Useful on cuts, abrasions, etc. Shpg. wt., 1 lb. 8 oz. and 14 oz. Not Prepaid.
1-lb. 8 E 207........31c
½-lb. 8 E 206........19c

Zonite
A nationally known non-poisonous non-caustic antiseptic. Not Prepaid. Shpg. wt., 11.00 size, 2 bs. 8 oz., 60c size, 1 lb. 10 oz.
$1 size. 8 E 216........76c
2 bottles for........$1.49
60c size. 8 E 214........47c

Peroxide of Hydrogen
Used for cuts, wounds, as a throat gargle, etc. Also used extensively as a hair and skin bleach. 16-oz. (pint) bottle. Not Prepaid. Shipping weight, 3 lbs 8 oz.
8 E 219........21c

Mercurochrome
The popular red, non-irritating antiseptic for cuts, wounds, etc. Especially desirable for use on children, because it does not smart. Applicator stopper. Not Prepaid. 1-oz. size.
8 E 205........19c

5-Star Antiseptic
A concentrated antiseptic in powder form. Safe and non-poisonous. Each package contains 3 envelopes—enough to make three pints dissolved in water. Not Prepaid. 5 pg. wt. 6 oz.
8 E 200—25c size........21c

Pepsodent Antiseptic
Prepaid. Shpg. wt., ea., 3 lbs. 8 oz.
2—76c 2 bottles for $1.49
8 E 211—Shpg. wt., 1 lb. 12 oz........43c

Lavoris
Not Prepaid. Shpg. wt., ea., 4 lbs.
$1.00 size. 8 E 202........76c 2 bottles for $1.49
50c size. 8 E 203—Shpg. wt., 2 lbs........43c

LISTERINE
The SAFE ANTISEPTIC

FOR NOSE OR THROAT SPRAYING — FOR DANDRUFF — SORE THROAT GARGLE

LARGE SIZE 59c

Protect Your Health Avoid Bad Breath
—Leaves the breath clean and wholesome.
—Helps reduce excessive dandruff.
—Protects against head colds and sore throats.
—Kills millions of germs per second, yet is SAFE.
Be sure your breath is beyond reproach. Listerine, as a mouth wash, leaves it sweet and clean. Cleanses the mouth, teeth, gums and throat, killing disease-producing bacteria by the million. Keep a bottle handy in your home or office. It is a protection against bad breath, and a safeguard to health. As a protection against colds and sore throats gargle full strength every two hours. Absolutely SAFE. Not Prepaid. Shpg. wt., each, 2 lbs. 8 ounces.
$1.00 size. 8 E 225—Each........59c
50c size. 8 E 226—Shpg. wt., 1 lb. 10 oz........39c

UALITY DIURETICS

Lithia Tablets
Make artificial lithia water, which aids in the removal of waste matter from the kidneys. Box of 40 tablets. 5 grains each. 8 oz. Not Prepaid.
8 E 375........29c
8 E 381 Each........55c 2 bottles for........49c

Buchu Compound Pills
Backache? Kidneys sluggish? Buchu Compound Pills aid in cleansing the system of poisons by stimulation of the kidneys. Not a narcotic and do not act on the bowels. 75c size. Not Prepaid. Shpg.
89c

Jad Salts
A refreshing effervescent natural fruit salt combined with sodium phosphate, sodium bicarbonate, etc. Intended to flush clogged kidneys. Not Prepaid. Shipping weight, 1 lb. 6 oz. and 3 lbs.
85c size. 8 E 378........69c
$1.25 size. 8 E 382........98c

n's Pills
or bladder disturbances. Do not on the bowels. aid. Shpg. wt., 75c size.
76........$0.59
........1.15

Cystex
This widely advertised preparation is used extensively to correct poorly functioning kidneys and bladder. Not Prepaid. Shpg. wt., 4 oz. 75c size.
8 E 379........$0.63
$1.50 size. 8 E 380........1.39

ANTISEPTICS for FEMININE HYGIENE

Loris Vaginal Jelly
Non-staining, greaseless antiseptic lactic acid vaginal jelly. Does not harm sensitive tissues. Large size tube with long hard rubber applicator pipe and soft rubber bulb cover. Not Prepaid. Shpg. wt., each, 8 oz.
8 E 218—Each........87c
2 for........$1.65

Lygel Vaginal Jelly
Made by makers of Lysol
A quality antiseptic. Large size tube and hard rubber applicator. Not Prepaid. Shpg. wt., 8 oz.
8 E 231—$1 size........89c
Lygel Refills
75c size. Not Prepaid.
8 E 232—Each........67c
2 tubes for........$1.29

Ortho-gynol
Made by Johnson and Johnson
An antiseptic vaginal jelly. Large tube (15 applications) complete with applicator. Not Prepaid. Shpg. wt., 8 oz.
8 E 221 $1.50 size........$1.39
8 E 215 Large tube only. Shpg. wt., 6 oz........$1.19

VAG-I-NOL IMPROVED VAGINAL SUPPOSITORIES

VAG-I-NOL Suppositories
Wedge shaped. Melt at body temperature. Soothing and antiseptic. A superior product. Box of 15. Not Prepaid. Shpg. wt., each, 4 oz.; three, 10 oz.
8 E 229........79c
3 boxes for........$2.00

Dr. H. H. Warner's Preparations
Suppositories
Melt at body temperature. Antiseptic and soothing. Shpg. wt., ea., 4 oz. Not Prepaid.
8 E 223 Box of 15........88c
3 boxes for........$2.29

Vaginal Creme
A soothing antiseptic lactic acid jelly. Not Prepaid. Shpg. wt., each, 8 oz.
8 E 224 2 oz. size........$1.39
2 tubes for........$2.69

Vaginal Petites
Non-greasy suppositories. 12 tablets. Not Prepaid. Shpg. wt., 6 oz.
8 E 230—$1 Size........88c

Liberties
The new greaseless suppository. Cleansing — non-irritating. Not Prepaid. Shpg. wt., 4 oz. and 6 oz.
8 E 217 $1.00 size. Box of 10........89c
8 E 220 $2.00 size. Box of 30........$1.79

SCELLANEOUS DRUGS

Plasters
f the fin-mpounding . Each , U. S. P.
repaid. t, 2 oz. t two. 658
........28c
icated r Plaster) 59 36c 2 8E2657 28c

BELLADONNA PLASTER SEARS, ROEBUCK AND CO. The World's Largest Store

Belladonna and Capsicum

Liquid Murine For Your Eyes
A safe and reliable eye lotion for children and adults. Soothes, cleanses and refreshes eyes irritated by exposure to sun, wind and dust. Not Prepaid. Shpg. wt., each, 6 oz.; two, 10 oz.
60c size. 8 E 360........52c 2 Bottles for........$1.00

e Flaxseed
popular for making s. Not Prepaid. , 1 lb. 6 oz.
4........21c

a Sodium ate Tablets
size. Not Prepaid. each, 8 oz. 100 tablets. 6........39c

ered Alum
n. Not Prepaid. weight, each. 7........19c

R ATHLETE'S FOOT eve Foot Powder
kes Athlete's Foot. Gives quick relief. asy—cannot spoil shoes ckings. A scientific developed by a well physician. Also useful foot disorders. wt., 8 oz.
217—50c size........39c

ixon's Nixoderm
y used ointment. Relieves itching of toes and Useful for minor skin s. aid. Shpg. wt., 4 oz.
43—$1.00 size........89c

orbine Jr. (Not Illustrated)
Prepaid. Shpg. wt., 1 lb. 2 oz.
42—$1.25 size........94c

Pure Glycerin
A highly refined product that has many uses in the home. Many use glycerin for hand lotions and for many other purposes. Approved glycerin is chemically pure—as fine a product as is obtainable. 8-oz. bottle. Shpg. wt., 2 lbs. Not Prepaid.
8 E 354........31c

Gum Camphor
Gum camphor in cake form. Three one-ounce cakes in sanitary package. Not Prepaid. Shpg. wt., ea., 4 oz.; 3, 12 oz. 3-oz. package.
8 E 363 Ea. Pkg. 26c 3 Pkgs. for 69c

Breethem
The new popular breath deodorant. 12 tablets in pocket size tin. 10c size. Not Prepaid. Shpg. wt., 4 oz.
8 E 364........3 tins for 24c

Saccharin Tablets
About 500 times as sweet as pure cane sugar. ¼ grain size. Bottle of 100. Not Prepaid. Shpg. wt., 4 oz.
8 E 358 Ea. 26c 2 Btles for 49c

Cream of Tartar
For medicinal as well as household use. An extra fine product. Not Prepaid. Shpg. wt., 14 oz. 8-oz. carton.
8 E 368........36c

Reliable Sanitary Napkins

FORM FITTING ROUNDED CORNERS
2 Boxes 45c

—Super size for super protection.
—New tapered ends eliminate bulkiness!
—Slightly larger through the center to insure adequate absorption.
—Outside layer of non-absorbent cellulose prevents seepage.
Reliable napkins are 30 per cent more absorbent than the average, yet they are not bulky. Form fitting. Ends are shaped so there is no tell tale bulge. Non-absorbent layer protects against seepage. 12 to the box. Not Prepaid. Shpg. wt., 2 boxes, 1 lb. 6 oz.; 4 boxes, 2 lbs. 12 oz.
8 E 2645 2 Boxes for 45c | 4 Boxes for 85c

Dys-Pel Tablets
For Periodic Pains
At the first twinge of menstrual pain take one or two Dys-Pel tablets. Within a short time you will be relieved. Absolutely harmless and do not affect normal functioning. Not a narcotic.
8 E 208—Purse size tin of 24 tablets........39c

Midol Tablets
For Periodic Pains
A relief for menstrual pains. Harmless and do not interfere with the natural process. Not a narcotic. 10 tablets in a little purse size. Nationally advertised. Not Prepaid. Shpg. wt., 2 oz.
8 E 204—50c size........44c

Asafetida Tablets U. S. P.
5-grain size. Used as a sedative. Chocolate coated. Not Prepaid. Shpg. wt., 4 oz. Bottle of 100.
8 E 365........69c

Formaldehyde Torches
1-oz. size for 1,000 cubic ft.; 2-oz. size for 500 cu. ft. Not Prepaid. Shpg. wt., 2-oz. size, 14 oz.; 1-oz. size, 10 oz.
2-oz. size.
8 E 2690........49c
1-oz. size.
8 E 2692........29c

arger Orders REDUCE Your Transportation Cost Per Pound C101P-B **493**

-7.6- Sears, antiseptics, 1934

Vine Peach, Vegetable Orange, or Mango Melon

This is one of the most beautiful of all vegetables. They resemble oranges in color, shape and size, and grow on vines. They present a most tempting appearance when canned; make delicious preserves and sweet pickles, and are fine for pies. There is nothing like them. Extremely early, they grow from seed in 80 days. They are enormously productive and can be used in every way as the peach, except that they are not quite as sweet and are not used raw. **Packet, 10 cents, three packets for 25 cents, postpaid.**

No. 5207. Vine Peach, Vegetable Orange, Or Mango Melon..................$0.10

First and Best Extra Early Pea

This is a very tall growing variety of peas and is regarded by experienced and successful growers as the best for all general purposes. It is excellent for home gardens, affording a very heavy crop. It requires no bushing or support. A special feature is its very large pods that are five inches or more long, filled with eight or nine delicious peas, superb in flavor. **Packet, 10 cents, three packets for 25 cents, postpaid.**

No. 5223. Extra Early Pea................$0.10

Apple Pie Melon

This is a wonderful novelty that you will find a delight in cultivating. The vine and fruit are quite similar to a watermelon and they are easily grown on any good soil. The fruit has a most delicious flavor, resembling the flavor of apples. Each vine produces 5 to 15 bushels of melons, producing on an average about 300 pounds of fruit. One melon will make as many pies as a half bushel of apples. The flesh is white and solid and of excellent quality for making pies, sauces, preserves, etc. They keep fresh and solid all winter, so can be used when wanted, and, owing to their value as stock food, any surplus not used for home cooking can be fed all winter to stock, in fact, it will pay to raise them for this purpose alone. **Packet, 10 cents, three packets for 25 cents, postpaid.**

No. 5210. Apple Pie Melon Seeds......$0.10 3 Packets for 25c. or 75c Per Doz. Postpaid

Wonderful Coffee Berry

You can raise your own coffee for one cent a pound and help cutdown the high cost of living. The New Domestic Coffee Berry makes a delicious, nourishing drink that gives health and strength to young and old. The best coffee substitute ever discovered. It has the rich, deep brown color of old Java. One of the hardiest, easiest grown and most productive of all plants. Can be successfully grown in any climate, and is sure to ripen even in the extreme North. As easily grown as corn or beans, and does well on all soils. You can raise all the coffee you want for your own use and sell the balance to your neighbors. Prepared like any other coffee. **Price, including directions for culture, 10 cents package, 3 packets for 25 cents, postpaid.**

No. 5178. Wonderful Coffee Berry......$0.10 3 Packets for 25c. or 75c Per Doz. Postpaid

JOHNSON SMITH & CO., RACINE, WIS.

–7.7– Johnson Smith & Co.

OUR GROCERY LIST

MAY 1907 JUNE

SEARS, ROEBUCK & CO.
Chicago.

THE PRICES IN THIS LIST ARE GUARANTEED FOR MAY AND JUNE

234G

REDUCING AIDS

Help in controlling the appetite but are not effective unless directions are followed and caloric intake is adjusted

Now you can get slim by drinking milk every other day

Eat your normal diet Tuesday, Thursday, Saturday, Sunday. No dieting these days!

Drink S.M.D. milk on Mo... Wednesday and... Diet every oth...

The easy way to reduce .. Larson's Swedish Milk Diet

Anyone normally healthy can lose weight quickly, easily. Use Larson's only 3 days weekly . . . 4 days you don't diet at all! People who may dislike plain milk usually do like the tasty Larson's S.M.D. milk. Helps take away the hungry feeling without underfeeding. Supplies generous amounts of proteins, carbohydrates, iron, phosphorus, minerals, necessary vitamins and energy elements. Provides stomach-filling bulk that helps keep you regular without feeling tired, listless because of need for a laxative. Starts taking off fat first day. See how this new milk diet works, why it is so quickly accepted and preferred by so many dieters.

A special one week's supply is available for only $1.00. (See below.) Get this convenient trial size right away. Order in the regular way. If you are dissatisfied after a week's trial, return the empty package and get your dollar back. We believe you will find reducing easier with this plan. And remember, satisfaction guaranteed or your money back. Order S.M.D. right away!

$3.00 month's supply

8 K 478—One week's supply. Postpaid. (Wt. 6 oz.)$1.00
8 K 479—Month's supply. Postpaid. (Wt. 1 lb.)3.00

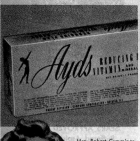

Mrs. Robert Cummings says, "I recommend AYDS to anyone wanting a slim figure."

Many famous personalities use AYDS as a slenderizing aid

Slim as the stars slim .. it's so easy when you use delicious AYDS

Safe, prompt reducing with AYDS candy. Doctors in a prominent New England Medical Center tested four reducing methods: bulk wafers, lozenges, pills and modern AYDS. Those taking AYDS averaged almost twice as much weight loss as those taking the next product. Helps reduce your desire for fattening foods, helps satisfy your "sweet tooth." Fortified with essential vitamins and minerals. Scientific reducing plan included.

AYDS are laboratory tested to help you lose weight . . . promptly, easily. Lose weight, look lovelier the convenient AYDS way. Try this wonderful plan right away. Order yours today.

Contains no harmful drugs. Postpaid. (Shipping weights 2 pounds; 3 pounds 8 ounces.)

8 K 373—Box of 104 pieces...... $2.98
8 K 372—Box of 208 pieces...... 5.00

T-W-O (Take Weight Off)

Gives the feeling of a full, contented stomach without adding a calorie. You don't have to give up any of the foods you like, you'll find you just eat less of them. Plan supplies more than the total amount of the important vitamins, minerals and proteins you need daily to safeguard your health. Contains "SL-3," a hospital-proved ingredient to help eliminate fats. Postpaid.

8 K 446—90 tablets. (Shpg. wt. 8 oz.) $3.50
8 K 447—180 tablets. (Shpg. wt. 1 lb.)... 5.98

All-in-One Reducing Capsules

All-in-one reducing capsules. Combine vitamins, minerals, protein, vegetable cellulose. Helps lessen your appetite . . . you eat less, so you take in fewer calories. In easy-to-take capsule form. If being overweight is lessening your enjoyment of life, try this aid. What a convenient way to get nutritional aid and reduce, too. Start striving toward a slim figure right away. Reducing plan included. Postpaid.

8 K 469—(Wt. 4 oz.) 80 capsules......$2.98
8 K 489—(Wt. 7 oz.) 160 capsules....... 5.50

Formula 71 Special Che...

Helps you lose pounds and ir... starving and endangering hea... drugs or rigorous diets, men... in clinical tests lost an ave... pounds in the first month! V... cial gum is chewed it aids in... petite satisfaction. You auto... less and reduce intake of... harmful drugs or chemicals. No. 2,631,119). Postpaid.

8 K 492—(Wt. 8 oz.) 80 piece...
8 K 493—(Wt. 1 lb.) 160 piece...

Brand New! Duets

Worried about your weight, but can't stick to diets? Here's a medically tested, scientific cookie that will help you return to your normal weight without special diets, without hunger. Only Duets are baked with new Protopectin, derived from the meaty portions of fresh oranges. Duets help curb hunger pangs, boost your energy and satisfy craving for sweets .. also provide needed bulk and aid digestion. 4½ dozen Duets (approx. 10 days supply). Postpaid.

8 K 476—(Shpg. wt. 1 lb.).....$2.98

Vitrim

VITRIM APPETITE CONTROL SUPPLEMENT. Equals or exceeds minimum daily need for Vitamins A, B_1, B_2, B_{12}, D. Also contains Iron, Calcium, Phosphorus, Niacin Amide. Helps cut down your appetite so that you take in fewer calories. At the same time it fortifies your diet with these important vitamins and minerals listed above. Shpg. wts. 6 oz.; 12 oz.

8 K 483—10-day supply....$1.89
8 K 484—30-day supply.... 3.89

R.D.X. Plan

R.D.X. REDUCING PLAN. Includes a scientific formula that helps you cut down your craving for fattening foods. You eat plenty . . lose weight. Pleasant tasting, safe. Helps you lose pounds without starving yourself and without endangering health. Supplement your reducing diet. No dangerous drugs, no hormones. Reducing plan. Postpaid. (Wts. 3 lbs.; 5 lbs.)

8 K 490—125 tablets......$2.98
8 K 491—250 tablets...... 4.98

These aids help you increase your we...

WATE-ON. Designed to increase daily calorie intake, fat intake, and to supply additional energy. Helps put on pounds, inches when underweight is caused by poor appetite or eating habits.

Fortified with blood-building Vitamin B_{12}, lecithin. Easy to digest. A homogenized fat emulsion. Postpaid. (Wts. 2 lbs. 4 oz.; 3 lbs. 8 oz.; 1 lb. 8 oz.)

8 K 324—liquid, pint.$3.00
8 K 325—liquid, quart. 5.50
8 K 328—120 tablets....... 3.00

NIRON . . . appet... for underweight needing a vitami... to help put on... Helps make you... more of the good v... ing foods you ne... tractive figure. If... because of a poor... a vitamin defici... your doctor say... gain weight . . . oz. bottle. Postp...

8K670—(Wt. 2 lb...

Add reducing aids to your Sears Easy Terms order. See inside back cover for complete ordering information

−7.9− Sears, weight loss products, 1957

Approved "Liquid Sunshine" Cod Liver Oil Builds Strong Bodies!

Sears, 1934

Our Tobacco: A Warning!

Ten years ago now, when in Philadelphia during the war, I got John Middleton to concoct for my personal use a unique blend of tobacco guaranteed never to bite my tongue (even though I smoked it 12 hours a day). Since then many clouds of smoke have floated over the horizon, my tongue remains unbitten, and we now find that our *Vermont Country Store Pipe Tobacco* (for that is what we call it now) is the best selling single item in our entire national mail order business.

On every can is the slogan *"It Won't Bite a Baby's Tongue."* My lawyer says I am open to trouble from the Federal Trade Commission on this, as we may be compelled to prove any day now that this assumption is true. And if we do says my friend the lawyer, we may be in jeopardy by contributing to the demoralization of minors . . . because babies are minors, says he. However, I have told him something he is now studying and when he comes to a decision I will let you know how it comes out. This is what I have asked him: *What is the legal definition of a baby?* I am *not* so old but what, not too long ago, a baby was a pretty girl . . . anywhere from 18 to 30. And believe me we have tried this mild non-tongue biting tobacco on girls. Many of these babies, coming to the store, buy a corn cob pipe and start smoking our tobacco because not only do they find it tastes good but it isn't so strong as cigarettes.

But, before we go further I want to utter this word of denial.

I swear that there is no opium, heroin, marihuana, or any derivative of opium, or any other pernicious habit-forming drug of any shape, or nature in this *Vermont Country Store Pipe Tobacco!*

So many people have accused us, because of the habit-forming propensities of this tobacco, of doping it, that I feel this denial is called for.

So far, most everyone who has ever started smoking this tobacco has ordered more. Not only the demand, but the reception is remarkable. We have dozens of letters about this tobacco which are nothing short of amazing. Here are two samples:

"You have a superb mixture in this tobacco and when I am no longer able to get it, I'll probably quit smoking."—R. B. DAY, OHIO

"By accident I was drawn into a conversation at the railroad station the other evening. I was smoking my pipe and a gentleman whom I did not know came over and inquired where I had purchased my tobacco. I told him and he promised to write you. He is a tobacco buyer down here and he said he admired the aroma of the tobacco very much."—JOHN OSTRUM, NORTH CAROLINA

Now . . . our regular tin is available (one-half pound net wt.), at $1.65 . . . a slight advance in price due to new costs. (Ship. wt. 1 lb.). (See page 30.)

SPECIAL OFFER: to those who would like to try this tobacco before ordering a regular tin, we will put in your order with other things (we can't ship this single item alone) a 1⅝ oz. foil of our Vermont Country Store Tobacco, for 35 cents.

Real Deerskin Tobacco Pouches

Nothing is so appealing, so soft, and so durable as genuine Deerskin and that's why we are proud to offer these new Deerskin Tobacco Pouches. Deerskin is, you know, washable in soap and water and never gets stiff when wet.

Our pouches with zipper tops are lined with special rubber to keep tobacco always moist.

LITTLE FELLA POUCH: size 5½ by 2½ inches, this narrow pouch is preferred by many men to the full size. $1.75. Postfree.

REGULAR SIZE POUCH: 6 by 3½ in. $3.00. Postfree.

"Just a note to let you know I was very much pleased with the calico, may I add, delighted! Have not seen anything its equal since Mother used to make me dresses and we pieced quilts. . . . I do not suppose you particularly care for these 'Female' remarks, but I wanted you to know I think you are doing the people a remarkable favor by offering so many really fine items."—MARY L. HELLINGS, NEW JERSEY

–7.10, 7.11– Vermont Country Store, pipes and tobacco warnings

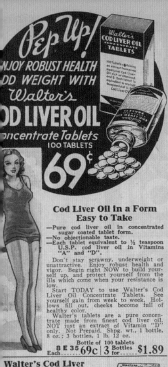

Pep Up!
ENJOY ROBUST HEALTH
ADD WEIGHT WITH
Walter's
COD LIVER OIL
Concentrate Tablets
100 TABLETS
69¢

Cod Liver Oil in a Form Easy to Take

—Pure cod liver oil in concentrated sugar coated tablet form.
—No objectionable taste.
—Each tablet equivalent to ½ teaspoon U.S.P. cod liver oil in Vitamins "A" and "D".

Don't stay scrawny, underweight or unattractive. Enjoy robust health and vigor. Begin right NOW to build yourself up, and protect yourself from the ills which come when your resistance is low.

Start TODAY to use Walter's Cod Liver Oil Concentrate Tablets. See yourself gain from week to week. Hollows fill out, cheeks become full of healthy color.

Walter's tablets are a pure concentrate made from finest cod liver oil. NOT just an extract of Vitamin "D" only. Not Prepaid. Shpg. wt., 1 bottle, 8 oz.; 3 bottles, 1 lb. 12 oz.

Bottle of 100 tablets
8 E 35 — Each .. 69¢ | 3 Bottles for $1.89

Walter's Cod Liver Oil Capsules

Double elastic filled Cod Liver Oil capsules each containing 20 minims of vitamin guaranteed U.S.P. Norwegian Cod Liver Oil. Each gram of the oil contains 500 units Vitamin A and 200-250 units Vitamin D. Not Prepaid. Shpg. wt., 12 oz.

16 — Box of 100 Capsules for ... 98¢

White's Cod Liver Oil Concentrate Tablets

Cod Liver Oil in tablet form that tastes like candy. 1 tablet equals ½ teaspoon of cod liver oil. Equally as good for adults as for growing children. Easy to take. Approved by American Medical Assn. Not Prepaid. Shpg. wt., 10 oz.

42 — $1.00 size bottle ... 89¢

McCoy's Cod Liver Oil Extract Tablets

Nationally advertised concentrated cod liver oil easy-to-take tablet form. Each tablet equivalent to ½ teaspoonful cod liver oil, splendid tonic. Not Prepaid. Shpg. wt., each 4 oz. size.

17 ... 79¢ | 3 boxes for ... $2.25

Maltine and Cod Liver Oil Concentrate Tablets

Pure cod liver oil concentrate abounding in vitamins A and D with Maltine added. Easy to take. Not Prepaid. Shpg. wt.

43 — $1.00 size 89¢

Beef Iron and Wine

A tonic, nutritive, stimulant. Pleasant to take—easily assimilated.

An exceptionally fine stimulant for convalescents and those in run down conditions. Possesses valuable properties in a most palatable form. Not Prepaid. Shpg. wt., ea., 2 lbs. 12 oz. 16-oz. bottle.

5 ... 79¢ | 2 Bottles for ... $1.49

Sulphur Cream of Lozenges

An old-fashioned remedy in an easy-to-take form. Box of 100. Not Prepaid. Shpg. wt., 8 oz.

13 — Ea. .. 28¢

Nux Vomica and Iron Tablets

Contains nux vomica, ¼ gr. and Blaud's mass ½ gr. Chocolate coated. Bottle of 100. Not Prepaid. Shpg. wt., 8 oz.

8 E 11 — Ea. .. 59¢

Blaud's Improved Iron Tablets

5-gr. Blaud's mass and ¼ gr. cascara. Chocolate coated. Bottle of 100. Not Prepaid. Shpg. wt., each, 12 oz.

Each ... 29¢ | 2 Bottles for ... 55¢

Approved COD LIVER OIL
"LIQUID SUNSHINE" REG. U.S. PAT. OFF. Builds Strong Bodies!

- Builds Straight Teeth
- Builds Strong Bones
- Builds Muscular Strength
- Prevents Rickets

1 PINT 69¢

★ Better than United States Pharmacopœia Standard Require.
★ Carries Certificate of Vitamin Content from University of Oslo, Norway.
★ Vitamin "A" Content not less than 14,000 units per ounce; Vitamin "D" not less than 7,000 units per ounce, at time of assay.
★ Light amber color. As tasteless as Pure Cod Liver Oil can be.

Give your child APPROVED Cod Liver Oil regularly. It is nature's substitute for lack of sunshine in Spring, Fall and Winter. It will help him to build strong bones and teeth, gain muscular strength and increase his resistance to colds, coughs and other common childhood diseases. . . A teaspoonful of APPROVED Cod Liver Oil contains more Vitamins than all the butter and milk you can eat in a day. Vitamin "A" helps children to ward off disease; Vitamin "D" supplies necessary bone and teeth building elements provided by sunshine. APPROVED Cod Liver Oil is the finest Norwegian oil obtainable, carefully tested and prepared under scientific supervision. Not Prepaid.

Approved Standard Strength Cod Liver Oil
1 Pt. (16 oz.) 8 E 20 ... $0.69
1 Qt. (32 oz.) 8 E 21 Shpg. wt., 2 lbs. 10 oz. ... 1.29
1-Gallon. 8 E 22 — Shpg. wt., 9 lbs. 3.98

Approved 10D Fortified Cod Liver Oil
Ten times the strength in Vitamin "D" of average oil. Recommended for those who want to take Cod Liver Oil in smaller doses. Considerably less 10D Fortified Cod Liver Oil is needed for proper results. Not Prepaid.
3-oz. Bottle. 8 E 50 — Shpg. wt., 1 lb. ... $0.69
16 oz. Bottle. 8 E 51 ... 2.49
Shpg. wt., 2 lbs. 10 oz.

Approved Mint Flavored Cod Liver Oil
For grown ups and older children. Its cool, refreshing mint flavor makes it easy to take.
8 E 33 — 1 Pint. Not Prepaid ... 73¢
Shpg. wt., 2 lbs. 10 oz.

Squibb's Cod Liver Oil | Mead's Cod Liver Oil
$1.00 size (12 oz.) | $1.25 size (16 oz.)
8 E 23 ... 79¢ Shpg. wt., 2 lbs. 4 oz. | 8 E 24 ... $1.09 Shpg. wt., 3 lbs. 8 oz.

Mead's Viosterol
8 E 28 — $4.75 size. 50 cc. bottle ... $3.98
Shpg. wt., 12 oz.

HALIBUT LIVER OIL AND CAPSULES

ONE CAPSULE EQUALS THREE TEASPOONFULS COD LIVER OIL

Approved Halibut Liver Oil with Cod Liver Oil Concentrate 250D

The ideal way to obtain Vitamins A and D in sizable quantities yet in a pleasant, easy to take form. Each 3 minim capsule supplies more Vitamin A than 3 teaspoonfuls of cod liver oil and more Vitamin D than 10 drops of Viosterol 250D. Doctors everywhere are recommending Halibut Liver Oil with Cod Liver Oil Concentrate for its convenience and effectiveness. Not Prepaid.
8 E 65 — Box of 25 capsules. Shpg. wt., 4 oz. ... $0.89
8 E 66 — Box of 100 capsules. Shpg. wt., 6 oz. ... 2.98
8 E 67 — 60 cc. Bottle. Shpg. wt., 8 oz. ... 4.59

Approved Cod Liver Oil Emulsion

—Easy and pleasant to take.
—Contains 50 per cent of the finest cod liver oil.—Rich in Vitamins "A" and "D."

Approved Emulsion is good for adults as well as children and it's pleasant tasting, too. Not Prepaid. Shpg. wt., 2 lbs. 12 oz.
8 E 25 — 16-oz. bottle ... 73¢

Scott's Emulsion of Cod Liver Oil
14¼-oz. bottle. Not Prepaid.
8 E 26 — $1.20 size ... 79¢
Shpg. wt., 1 lb. 12 oz.

Wampole's Preparation
Contains an extract from fresh Cod Liver Oil, without the oily taste. Not Prepaid. Shpg. wt., 3 lbs. 12 oz.
8 E 36 — $1.00 size ... 79¢

Lucky Kids Love Coco Cod

Children Prefer This Cod Liver Oil

—The cod liver oil that tastes like chocolate. —Contains all three vital life giving vitamins—A, B and D.

Give the children Coco Cod and watch their bodies grow almost daily with vigorous athletic strength. Scientifically prepared with egg yolk, yeast, and vegetables—flavored with pure cocoa. New large size contains 16 oz.—one full pint. Regular $1.25 bottle. Shpg. wt., 2 lbs. 4 oz.
8 E 39 ... 89¢
Not Prepaid

Liver Extract and Glycerophosphates
A Tonic Elixir
—Contains the extractives of 640 grains selected liver and 5 grains Glycerophosphates per ounce.
—Safe for children and adults.
A tonic of proved value for simple anemia, lowered vitality, etc. Not Prepaid. Shpg. wt., each, 2 lbs. 4 oz. $1.25 size, 12 oz.
8 E 49 ... $0.98
2 Bottles for ... 1.89

Approved Phosphorous and Iron Compound Tablets
A Wonderful Tonic Tablet
—Chocolate coated. For those in a weakened and run-down condition. Helps to pep up the system, restore lost appetite, and tone up the body generally. Try a bottle of these excellent tablets and you'll come back for more. Bottle of 100 tablets. Shpg. wt., 10 oz. Not Prepaid.
8 E 40 ... 95¢

MALTINE with COD LIVER OIL

$1.09 Per Bottle

For those desiring a rich source of vitamins "A" and "D" as well as vitamins "B" and "G." A concentrated extract of three malted cereals with pure cod liver oil. Not Prepaid. Shpg. wt., 4 lbs. 2 oz.
8 E 27 — $1.50 size ... $1.09

Maltine with Cascara
Contains the extract of 60 grains cascara sagrada per oz. Not Prepaid. Shpg. wt., 4 lbs. 14 oz.
8 E 32 — $1.50 size ... $1.09

Dr. Formaneck's Bitter Wine
An effective and popular stomach tonic and general laxative. By helping to restore the normal functioning of the stomach it tones up the entire system generally. Not Prepaid. Shpg. wt., 4 lbs. 3 oz.
8 E 41 — 21-oz. bottle ... 89¢

Fellow's Syrup of Hypophosphites
Recommended by doctors. Not Prepaid. Shpg. wt., 3 lbs.
8 E 19 — $1.50 size ... $1.27

Stuart's Calcium Wafers
60c size. Not Prepaid. Shpg. wt., each, 2 oz.
8 E 31 — Ea. ... 47¢ | 2 Boxes for ... 92¢

2 A-B TALK ABOUT "RARE" GIFTS! N-M's 1959 Christmas gift coup is a prize Black Angus steer served on the hoof, right at your steak-loving friend's front door Christmas morning. Rolling right along with the real live steer comes our deluxe mahogany and silver 21 Club Roast Beef Cart. The steer and cart, a real taste-of-Texas gift (gift wrapped as best we can!), 1.925.00 F.O.B. Chicago, Ill.

2 B-B FOR TENDERFOOT FRIENDS we'll send the steer in dressed, freezer-ready form prepared by Pfaelzer Brothers of Chicago, the N-M of the meatpacking world. Cart plus 300 lbs. steaks, roasts, ground meat, etc. 2,230.00 F.O.B. Chicago, Ill. 300 lbs. prepared meat delivered in three shipments of 100 lbs. each.

Upón request we will send you a gratis copy of the complete catalog of Pfaelzer's Home Service quality food products.

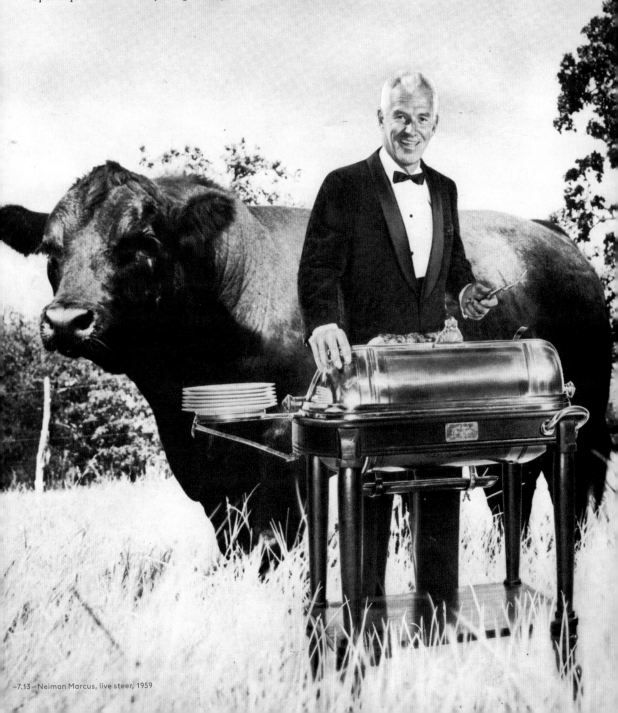

cake for cocoa lovers
zingerman's hot cocoa coffeecake

Three years ago our Bakehouse bakers came up with a cake that captures all the soft, subtle goodness of a cup of hot cocoa. The key ingredient is a very special cocoa, made for us by Scharffen Berger, one of the leaders in America's new pursuit of fine chocolate. They've found a special, natural cocoa powder that is more complex and elegantly excellent than any we've ever tried. Like a cup of well-made cocoa, this is a cake you can adore anytime--with morning coffee, for a subtle sweet snack, or to cap off a long day before you head off to bed. *Both sizes are packaged with tissue in the wooden ZingCrate.*

G-COA	fresser cocoa cake	$50
G-COA-S	nosher cocoa cake	$25

Lemon-speckled mornings
lemon poppy seed cake

This is probably the most underrated baked good we make. Virtually unknown, it's the secret sunrise snack of Zingerman's regulars who happily bypass bagels and muffins for a slice. It's made with fresh lemon juice, real lemon oil, loads of real butter, real vanilla, and a veritable passel of Dutch poppy seeds. With none of the artificial aftertaste that most lemon-flavored pastries have, it tastes like biting into a perfect morning: sunny, rich, delicious. *Both sizes are packaged with tissue in the wooden ZingCrate.*

G-LMC	fresser	$45
G-LMC-S	nosher	$25

the american original
wild blueberry buckle coffeecake

A buckle is an American coffeecake that dates back to colonial times. Our sweet and moist version has a bounty of blueberries, sweet butter, sugar and cinnamon, and is topped off with a remarkable butter-crumb crust. It's a beautiful, delicious gift, and can be the foundation of a fabulous weekend. (I've also witnessed it make a boring morning office meeting positively giddy.) *Both sizes are packaged with tissue in the wooden ZingCrate.*

G-BUC	fresser buckle	$40
G-BUC-S	nosher buckle	$25

Avocado Of The Month Club®

Gourmet
Avocado Gifts

RECIPE BOOK

www.avocadoofthemonthclub.com

1

PASS GO, and you'll collect 200 calories. N-M's exclusive replica of Parker Brothers'
famous Monopoly® Game could be the greatest finale to a dinner party ever
conceived. From board to dice, each and every familiar part is made of delectable
and completely edible candy: dark chocolate, milk chocolate, butter cream, and
butterscotch. This confectioner's coup may last only one game, but your creativity
as a host will linger deliciously. Also included is a non-edible, deluxe edition of the
standard Monopoly rules as a permanent keepsake. Confections by Sandra
under license from Parker Brothers. The set, 600.00 (x). From Epicure.

Sandwiches and Beverages

Lemonade with colored ice cubes and ice cubes with cherries frozen in center
Pinwheel Sandwiches — Page 18
made with cream cheese, jelly and cheese spread
Checkerboard Sandwiches — Page 18
Plain Pimento Cheese
Cream cheese with pecans, stuffed olives
Cottage cheese with crumbled hard-boiled egg
Peanut butter with radishes, hard-boiled egg
Mayonnaise with whole shrimp, stuffed olive
Mayonnaise with cucumber and radish

— 17 —

47A Our assortment of exotic meats from Broken Arrow Ranch includes: two 8 oz. wild boar loin chops; two 8 oz. axis or fallow deer rib chops; two 6 oz. South Texas antelope filets; a 12 oz. antelope Italian sausage; and a 12 oz. venison bratwurst. <u>Catalog only.</u>

47A. Exotic meats, 125.00 (15.00).*

47B A tempting new treat for holiday entertaining, ostrich is similar in taste to beef, but with less cholesterol, fat, and calories than beef, chicken, or turkey. Renowned for its taste and nutrition, these prime cuts come from Utah where the climate is perfect and only pure water and organic grains are used. Available in a versatile assortment of eight 4-oz. filets, eight 4-oz. burgers, a 1-lb. salami, and four ½-oz. packs of jerky (original, teriyaki, hot and sweet, and pepper flavors). Total weight, 5 lb., 2 oz. Available by special order through Catalog or Epicure.

47B. Ostrich sampler, 112.00 (15.00).*

wild game

CB/96

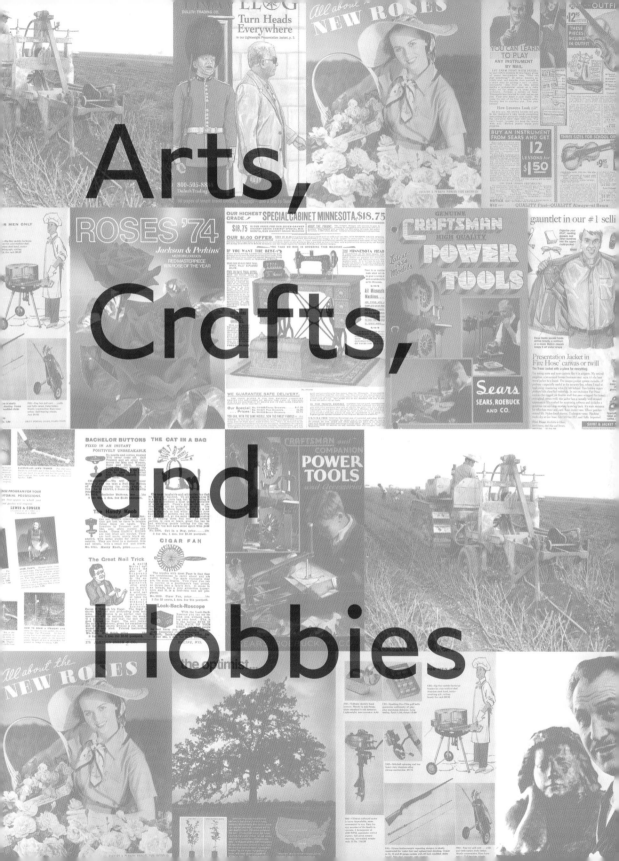

Arts, Crafts, and Hobbies

8

Arts, Crafts, and Hobbies

From Matchbox cars to firearms, basket weaving to bowling, cross stitch to cigars, catalogs cater to every craft and hobby. Also, collectors can find everything from Civil War and sports memorabilia to stamps, coins, and vintage fretted instruments.

As Americans discovered they had more free time due to increased efficiency and longer days thanks to electric lighting, they turned their attention to hobbies, sometimes called "productive leisure." Sears advertised that "hobbies sometimes become a profitable life work." Photography became a popular hobby, spurred by the launches of *LIFE*, *LOOK*, and other photo magazines.

Like toys, children's hobbies were divided along gender lines: little girls learned to sew and embroider; little boys learned to build models. Grandma Moses got her start in painting in the late thirties when she ordered a set of paints from Sears, Roebuck and collected some old planks, sheets of tin, and pieces of canvas she could paint.

The practical American pursuits of hunting and fishing were popular in the late-nineteenth and early-twentieth century, so several catalog pages were devoted to guns, hunting jackets, decoys, and bird calls, as well as rods and reels, and hooks, lines, and sinkers. Charles Orvis opened a fly-fishing shop in 1856 to appeal to the upper-class sportsman who was interested in "seeking civilized adventure in the wilderness at his doorstep." The company is best-noted for its fishing innovations, though today it also offers hunting gear and other products geared to sportsmen and women.

Guns continued to be available for purchase by mail order until, prompted by the assassinations of President Kennedy (who was killed by a mail-order gun) and later Dr. Martin Luther King, Jr., and Robert Kennedy, Congress passed the Gun Control Act of 1968. One of the act's central achievements was to ban the sale of rifles and shotguns via mail order. In 1986, the Firearm Owner's Protection Act was passed; interstate sales and mail-order guns were back.

In addition, the requisite equipment was offered for tennis, croquet, baseball, ice-skating, skiing, and boxing. (Sears's boxing sets came with a free copy of the official Marquess of Queensberry rules.) Footballs and golf clubs were offered, though the two sports were much less popular than they are today.

As life became easier, many Americans' level of physical activity decreased. Fortunately, increased leisure time precipitated a rising interest in sports, physical fitness, and exercise. European immigrants introduced gymnastics and calisthenics to the United States. President Theodore Roosevelt, an avid sports and fitness buff, encouraged Americans to get in shape, but it didn't take. As early as the 1920s, Sears offered a primitive rowing machine. After both WWI and WWII, government studies revealed that many American soldiers had been physically unfit prior to their military training. Post-WWI efforts to improve the fitness level of Americans were cut short by the Depression, but the end of WWII saw

a dramatic increase in interest in physical fitness.

A 1950 study revealed that the strength and flexibility of American children was significantly lower than that of European children, prompting President Eisenhower to hold a White House Conference that led to the creation of the President's Council on Youth Fitness. President Kennedy wrote an article called "The Soft American" for *Sports Illustrated* that stressed the importance of fitness and changed the council's name to the President's Council on Physical Fitness, to include adults. President Johnson changed the name to President's Council on Physical Fitness and Sports, advocating fitness through sports. Subsequent presidents have left the name alone.

In the seventies, both Sears and Montgomery Ward offered some machines of little worth (such as Vibrating Belt Machines) that hearkened back to the quack medicines of the early twentieth century. Bicycles, displaced by cars and other motorized forms of transportation, experienced a resurgence in the seventies thanks to both the fitness boom and the energy crisis.

In 1962, Montgomery Ward and Sears both offered vacations in the pages of their catalog. Montgomery Ward offered 775 different trips. Their prices were similar to other travel suppliers, but they offered convenience and the opportunity to pay in installments. The credit card, invented in 1950, was still in its infancy. Vacation options included a seven-day trip to Miami for $6 per month (paid over eleven months) and a journey that included stops in Japan, Hong Kong, Manila, Thailand, India, and Egypt for $126 a month (paid over 24 months).

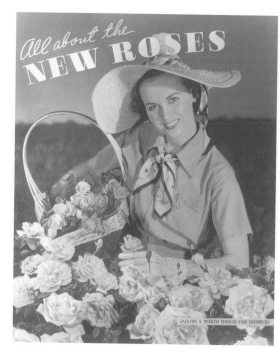

−8.1−Jackson & Perkins, new roses

BACHELOR BUTTONS

FIXED IN AN INSTANT
POSITIVELY UNBREAKABLE

No needle and cotton wanted Will never come off. Suit Trousers and all other Garments for Men and Women, Boys and Girls. Simply press the point through the cloth and push on the head. Can be used for a collar stud. Quite smooth front and back.

CHALLENGE:—We will return your money if you can take a Bull-Dog Button off without tearing the cloth. PRICE, 1 Box for 15 CENTS. 3 Boxes for 40 CENTS POSTPAID.

No. 2419. Bachelor Buttons, box......15c
3 for 40c, 1 doz. for $1.35 postpaid.

The Handy Knob

The knobs of pots and kettles are always coming off, and they get lost or there is trouble fixing them on again. The Drawers in Dressers and the like, also often require new knobs. These HANDY KNOBS are just what are wanted. They are well made, nicely black enameled, with metal plates for inside and outside. They are fixed in a moment, firm and secure, with a small nut and screw.
No. 4311. Handy Knob, price......5c

The Great Nail Trick

A solid metal nail about the size of a tenpenny nail is given to the audience for examination. After every one is satisfied that it is a solid nail the performer takes the nail and without a moment's hesitation forces it through his finger. The finger is shown with the nail protruding from both sides. The illusion is so perfect that the spectators will be satisfied that the wound is a genuine one, and that the nail really goes through the finger. The next instant the nail is withdrawn, given for examination, and the finger shown without a cut, scar or wound of any kind. Printed instructions with each nail.
No. 3183. Nail Trick, price......15c
3 for 40c, 1 doz. for $1.35 postpaid.

THE CAT IN A BAG

The most laughable and attractive toy that we have ever handled. To all appearances it is a little flat cloth bag, but by squeezing it slightly it produces a most perfect imitation of a cat squall. Pussy's gentle voice or excited tones can be perfectly imitated. You can have the whole family looking for a cat under the sofa or bed while you, with your hands in your pockets, can keep her meowing or crying aloud, at the same time pretending to be helping them find her. At private parties, in cars or boats, great fun can be had watching people looking for the cat. Send for one and have some sport with your friends.
No. 2076. Cat in a Bag, price......15c
3 for 40c, 1 doz. for $1.35 postpaid.

CIGAR FAN

The trouble with most Fans is that they are troublesome to carry about and are easily broken. The more expensive they are, the more fragile. This Cigar Fan can be carried in a gentleman's vest pocket, or thrust into a lady's belt. It opens in an instant, has a very attractive appearance and it is a first-rate cool air producer.
No. 3352. Cigar Fan, price......10c
3 for 25 cents, 1 doz. for 75c postpaid.

Look-Back-Roscope

With the Look-Back-Roscope you can see behind you without turning your head. Why, it is like having EYES IN THE BACK OF YOUR HEAD, and when people do not know you are looking, you see some interesting sights, sometimes.
No. 3391. Look-back-roscope, price......15c
3 for 40c, 1 doz. for $1.35 postpaid.

–8.2– Johnson Smith & Co.

Sifta-Pack Powder Bag

The SIFTA-PACK enables you to carry your favorite loose face powder with you in complete safety. The powder is placed INSIDE the powder puff, that is specially made so as to allow the powder to sift through the perforations in the puff as it is applied to the face. There is a 3¼ inch Amberite Bobby Comb that fits in the lower compartment, and a 2 inch mirror completes the outfit. The Bag, that is made of handsome silver cloth, measures 1x2½ inches closed, and closes with snap catch.
No. 7033. Sifta-Pack Powder Bag. 50c

SNAP CUFF LINKS

Besides being unusually handsome, these Snap Cuff Links are decidedly more convenient than the old-fashioned kind. The two Links close together with a snap, and will stay securely fastened until released. They are just as easily unfastened, for a little pressure with the thumb and finger easily pulls them apart. The manufacturers guarantee every link to be perfect, to lock easily, and to stay until released. The Links are made in silver finish, with genuine mother-of-pearl center, giving a very dressy effect that will go with any shirt. The price is less than half what you would expect to pay for Links of this quality. Each pair on individual card.

No. 4560. Snap Cuff Links......25c
½ pair for 65c., $2.25 per doz. pairs

Pocket Tool Kit

There was never before such a compact and generally useful Tool Kit. There is scarcely a purpose of daily need that these tools will not satisfactorily serve. Work of all kinds can be efficiently done with this kit; in fact you will wonder how you ever did without it. Just think, 10 most useful tools, all made of steel, that fit snugly inside of the handle, ready for instant use. The steel bit at the end of the handle holds any tool and is tightened by means of the screw ends.
No. 4217. Pocket Tool Kit......50c

Sewing Combination

A very compact and useful sewing set, comprising a case that contains one spool of black thread, some sewing needles and pins, and a gold-colored thimble that serves as a cap completes the combination. The quality is surprisingly good for the money. It is compact, measuring only 2½ inches in length, and takes up hardly any room.
No. 4545. Sewing Combination.
Price......15c

VANITY POWDER BAG

Made of beautiful silver cloth, fancy bound edges, containing velour powder puff and a good quality round mirror. Separate compartment for comb, etc. Fastens with snap catch, and is of convenient size, measuring about 3¼ x 2¾ inches when closed.
No. 7032. Vanity Powder Bag......25c
3 for 65c. or $2.25 per dozen postpaid.

–8.3– Johnson Smith & Co.

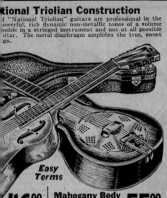
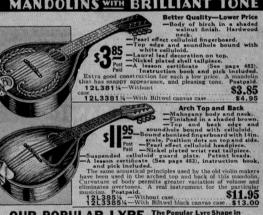
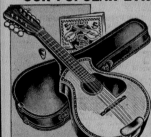

OUR HIGHEST GRADE SPECIAL CABINET MINNESOTA, $18.75

$18.75 IS OUR PRICE FOR OUR SEVEN-DRAWER HIGHEST GRADE CABINET SPECIAL MINNESOTA, OUR HIGHEST GRADE MACHINE

ABOUT THE FREIGHT. The freight charges will amount to next to nothing as compared with what you will save in price. The freight will average for 200 miles, 40 cents; 400 miles, 60 cents; 1,000 miles, $1.25. Greater or lesser distances in proportion.

OUR $1.00 OFFER.
SEND US $1.00 as a guarantee of good faith and we will send you this, OUR HIGHEST GRADE SPECIAL CABINET MINNESOTA, by freight, C. O. D., subject to examination. You can examine it at your freight depot and if found **perfectly satisfactory, exactly as represented** and equal to any sewing machine made regardless of price, if you are convinced that you are getting as fine a machine as has ever been seen in your section at any price, and that you are saving from $20.00 to $30.00 in money, pay the freight agent the balance, $17.75, and express charges.

YOU TAKE NO RISK IN ORDERING THIS MACHINE

IF YOU WANT THE BEST
If you want a sewing machine that combines the good points of every strictly high grade machine made, with the defects of none, order our special Minnesota Seven Drawer Cabinet, exactly as illustrated, at $18.75.

READ OUR 30-DAY FREE TRIAL OFFER, FULLY EXPLAINED BELOW.

FREE 30 DAYS TRIAL OFFER.
Read our liberal terms of shipment, as explained in front of book. By this special offer you are privileged to deposit the price of the machine with your local banker, take it to your home for 30 days' trial, and after you are satisfied that it is all we represent it to be, instruct the bank to send the money to us, otherwise in all cases of dissatisfaction, we pay the expense of return and all your money is refunded.

OUR BINDING 20-YEARS' GUARANTEE.
With every Special high grade Minnesota we issue a 20-years' binding guarantee, by the terms and conditions of which, if any piece or part gives out by reason of defect in material or workmanship, we will replace or repair it **FREE OF CHARGE**

THE MINNESOTA HEAD
is constructed on the most simple, wear resisting, anti-friction eccentric principle, which makes the machine run almost entirely noiseless and lighter than any other machine made. It is so light, in fact, that a child can operate it, and the machine can hardly be heard in a room when running to to its full capacity.

There is no machine made which will do as great a variety of work as satisfactorily as the Minnesota.

All Minnesota Machines....
ARE FITTED WITH A COMPLETE SET OF HIGH GRADE ATTACHMENTS, AND ALL ACCESSORIES WHICH ARE REQUIRED TO KEEP THE MACHINE IN PERFECT ORDER......

A COMPLETE LIST OF ATTACHMENTS AND ACCESSORIES, ALSO DESCRIPTION OF MECHANICAL CONSTRUCTION, SHOWN ON PAGES 1263 AND 1264.

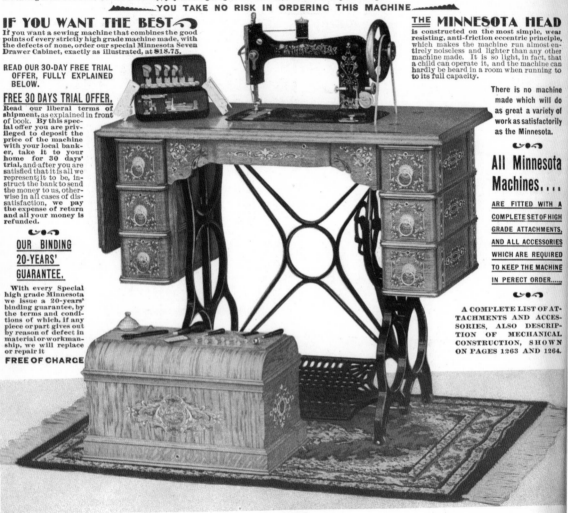

No. 991625

WE GUARANTEE SAFE DELIVERY.
THE PRICE QUOTED IS FOR THE MACHINE CAREFULLY CRATED AND DELIVERED ON BOARD THE CARS IN CHICAGO, AND WE GUARANTEE IT TO REACH YOU IN THE SAME PERFECT CONDITION AS IT LEAVES US.

Our Special ... Prices
No. 991605 Three Drawers		$17.25
No. 991615 Five Drawers		18.00
No. 991625 Seven Drawers		18.75

YOU CAN, WITH THE SAME NEEDLE, SEW THE FINEST FABRICS or the coarsest woolens. In fact, one of our customers, in writing, says that it will sew anything, from the finest tissue paper to sheet iron. Don't be deceived by the many flattering advertisements that are circulating throughout the country from concerns that pretend to be sewing machine manufacturers, and who would endeavor to lead you to believe that they can furnish you with a high

grade sewing machine for less money than the Minnesota. If you send for their machine, send for ours also. Put them side by side, pass judgment on their general appearance and construction, then put them to the more important test of work. The result will be our machine will stay in your house, the other will go back.

WE HAVE CHEAPER MACHINES, machines that are good, machines that we guarantee, machines that will compare with other machines that sell at double the price, but for a strictly high grade sewing machine, one that will last a lifetime, one there is no wear out to, a machine combining the good points of every strictly high grade machine with the defects of none, we recommend by all means our highest grade Special Seven-Drawer Minnesota at $18.75.

$18.75 IS A PRICE based on the actual cost of material and labor; $18.75 represents the actual cost of the lumber and the work in the cabinet, the iron, nickel and other material and labor in the stand and head, with but our one small percentage of profit added. $18.75 is the lowest price ever made by anyone on any machine that will compare with our Minnesota.

A82—Volkano electric hand lantern. Shoots ½ mile beam, takes standard 6-volt batteries. Lightweight, non-corrosive. **6.95**

C82—Spalding Kro-Flite golf balls guarantee uniformity of play plus maximum distance. Long lasting. Each **1.10**; dozen **13.00**

FOR MEN ONLY

G82—Big Boy mobile barbecue brazier for your outdoor chef. Stainless steel hood, motor-revolving spit, cutting board, fire rack **89.95**

D82—Mitchell spinning reel has heavy duty stainless alloy pickup mechanism. **29.75**

B82—Clinton outboard motor is more dependable, more economical to run. Easy for any member of the family to operate. 4 horsepower at 4000 RPM, automatic rewind starter, full pivot reverse steering. Air-cooled, weighs only 25 lbs. **114.50**

E82—Ithaca featherweight repeating shotgun is ideally constructed for water fowl and upland bird shooting. Comes in 12, 16 and 20 gauge models with 28-inch modified choke barrel. Five shot capacity, safe ejection. Pistol grip, checkered stock. **91.16**

F82—Mitchell Fiberglas spinning rod. **23.50**

F82A—Six-pound-test platyl line, 100 yards. **1.80**

H82—Bag boy golf cart . . . pulls and folds easier, looks better. Sturdy construction. Easy knee-action. Ball-bearing wheels. Just **29.95**

82 SIBLEY'S SPORTING GOODS, FOURTH FLOOR

–8.6– Sibley's Sporting Goods, 1954

BEGINNERS OUTFITS

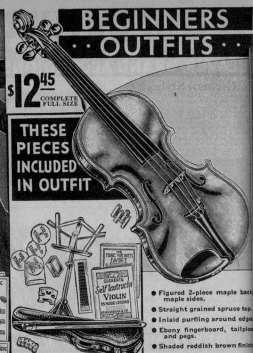

$12.45
COMPLETE FULL SIZE

THESE PIECES INCLUDED IN OUTFIT

- Figured 2-piece maple back, maple sides.
- Straight grained spruce top.
- Inlaid purfling around edges.
- Ebony fingerboard, tailpiece and pegs.
- Shaded reddish brown finish.

Comes in Full or ¾ Size

YOU CAN LEARN TO PLAY
ANY INSTRUMENT
BY MAIL

LET THEM POINT WITH PRIDE—to you—when someone in your happy group of peppy merrymakers asks, "Who can play something?" Or better, practice secretly now, and surprise them yourself in a short time by playing a tune on some instrument. And later on, who knows maybe a professional career as a radio artist, on the stage or in some famous orchestra. Perhaps a soloist of fame. Thousands have learned by mail, and so can you. *Your own home is your studio.* We make the cost of the first 12 lessons unbelievably low to convince you. Test your talents!

How Lessons Look ☞

As you see, the mailed lessons tell you in the instructor's own words everything concerning that particular lesson, as though the instructor were right with you. You can't forget, because you keep the lesson with you. Marked papers check your progress.

What more convincing proof do you need that learning to play a real instrument is easy. A fine appearing, excellent toned, well constructed violin right here. Every helpful and needed accessory included. Surely, you can learn to play with this easy opportunity waiting.

Even the lessons are an amazing bargain for the home student—your first 12 introductory lessons from the well known National Academy. The three-quarter size for younger students (10 to 14 years) is available.

"A good violin" need not be expensive! By all means get a good violin and all the needed accessories. But why put a big sum of money in a high priced violin until you are sure that the violin is the instrument you want to learn? We recommend this outfit. It is complete—it has fine appearance—excellent tone—good construction. It will give you a good start.

Outfit consists of 1 Stradivarius Model Violin as described; 1 shaped case, imitation leather covered nickel plated lock and clasps; 1 good quality Bow, ebony nickel silver lined frog, leather grip; 1 Four-Pipe Tuner; 1 Ebonite Chin Rest; 1 Piece Rosin; 1 E-String Adjuster. 1 Inset Bridge for Steel E-String; 1 Mute; 1 Extra Set Strings; 1 Guckert's "Self-Instructor"; 1 Black Japanned Music Stand; 1 Fingerboard Chart; Certificate for 12 lessons included (see at left). Not Prepaid.

12 E 107—Complete Outfit, with full size violin, Shpg. wt., 10 lbs................. **$12.45**

THREE QUARTER SIZE
12 E 108—Complete Outfit, same as above but three-quarter size violin for children from 8 to 12 years of age. Not Prepaid. Shpg. wt., 10 lbs.......... **$12.45**

BUY AN INSTRUMENT FROM SEARS AND GET

12 LESSONS for $1.50

Sears make your musical start easy by selling good instruments at really low prices. Further, Sears enable you to take the all important first 12 lessons by mail from a recognized school for only $1.50.

A Scholarship Certificate from the NATIONAL ACADEMY of MUSIC, in Chicago, is included with the Sears instrument you buy. (See list below.) With it, and only $1.50 you are on the road to musical enjoyment, and a possible career.

These important beginner's instructions are so simply written and illustrated even those who don't know one note from another can learn to play at home without difficulty. Follow these lessons, practice regularly, and your progress will be rapid. Amaze your friends—and yourself!

USE YOUR LESSON CERTIFICATE!

The Scholarship Certificate is included with any of the following Sears instruments: Alto Horn . . . 5-String Banjo . . . Baritone Horn . . . Clarinet (Boehm system) . . . Cornet . . . Guitar (Regular or Hawaiian) . . . Mandolin . . . Mandolin Banjo . . . Mellophone . . . Piano . . . Piano Key Accordion . . . Plectrum Banjo . . . Saxophone . . . Tenor Banjo . . . Tenor Guitar . . . Trumpet . . . Violin. All lessons corrected by the Academy's competent staff, and given individual attention.

NOTICE Lessons are obtained by writing direct to National Academy of Music. (See certificate given with instrument.)

THREE SIZES FOR SCHOOL ORCHESTRAS

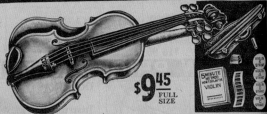

$9.45
FULL SIZE

—Stradivarius model. Full size. (See other listings.)
—Carefully constructed of two-piece maple back and spruce top. Reddish brown shaded to natural color.
—Ebonized fingerboard, tailpiece and pegs.
—Maple sides and neck.

If you have intended paying up to $18.00 for the beginner's violin—just to see if you or a younger member of your family really had musical possibilities—this outfit will meet your need at a saving. However, for better tone, and a more complete combination we most earnestly recommend 12 E 107 above, and only a few dollars more and still less than you planned to pay. School or Sunday school orchestras will like this well-priced violin for the youngsters from six years up . . . half and three-quarter sizes. Set consists of 1 Violin as described; 1 shaped Case, covered with imitation leather, with nickel plated clasps; 1 Bow, ebonized frog, nickel silver trimmed; 1 Ebonite Chin Rest; 1 Piece Rosin; 1 Violin "A" Tuner; 1 E-String Adjuster; 1 Extra Set Strings. 1 Instruction Book with fingerboard chart, Certificate for 12 lessons (see at left).
Not Prepaid. Shpg. wt., 5 lbs.
12 E 105—Full size only.......... **$9.45**

Low Priced—Three Sizes

Same but in cardboard case less chin rest, E-String adjuster and tuner. Not Prepaid. Shpg. wt., 5 lbs.
12 E 100—Full size.............................. **$6.95**
12 E 101—¾ size for children 8 to 12 years **$6.95**
12 E 102—½ size for children 6 to 8 years **$6.95**

QUALITY First—QUALITY Always—at Sears

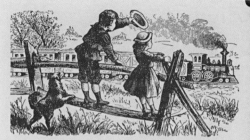

Our Own Real American Calico

We were the first to revive the 1860 American Calico and we still sell the best. After much research we got the people who had the original plates to make us some of this fine cotton cloth. We can now offer you, not a reproduction of Calico but THE REAL THING . . . printed from the same designs as were used 60 to 75 years ago. These lovely and charming small pat-

terns are now just the style for children's dresses, female aprons, blouses and skirts as well as dresses, and they have many other uses such as for very attractive window curtains and quilts.

Note also, on page 19 our men's shirts made of this handsome material.

Now it's impossible to show you, in a black and white photo, what the colors or patterns are, but rest assured, they are all good and all authentic. The only way we can sell yard goods by mail is to ask you to tell us what color you want and we will send you what pattern we have available in that color. They come in Lt. and Dk. Blue, Lt. and Dk. Green, Yellow, Pink, Lt. and Dk. Red, Lt. and Dark Gray and Black and White. *Set of swatches showing 4 colors, 25 cents.*

Price 60 cents a yard, figure on two yards weighing about 1 lb. See page 30. *36 inches wide.*

ROSES '74

Jackson & Perkins
MEDFORD, OREGON
RED MASTERPIECE
1974 ROSE OF THE YEAR

–8.9– Jackson & Perkins, 1974

Your own home is your studio!... Test your talents!

Sears, 1939

AVOID HOUSEMAID'S KNEE — Carry this little Garden-ade into the garden and kneel comfortably on its padded surface. Trough in front for tools or small plants. Handles to help you up and down. Cadmium-plated to defy rust, **3.50.** With 4 useful tools, **4.95**

EFFORTLESS SPRAYER — Attaches to garden hose. Water flowing through dissolves cartridge and forms effective insecticide. You merely guide the spray onto bushes and shrubs in need of protection. With 6 cartridges — pyr-o-spray, sulph-o-spray, nic-o-spray, arsen-o-spray, fung-o-spray, rot-o-spray — **4.75**

RAZOR-BLADE LAWN TRIMMER — Put old razor blades to profitable use in this Lawn Razor. Swung with one hand, it's an efficient tool for giving those hard-to-get-at lawn spots and edges a "once-over lightly". **2.00**

DEFENSE PROGRAM FOR YOUR TERRITORIAL POSSESSIONS.

Outdoor fixer-uppers to which your lawn and garden will respond.

LEWIS & CONGER
6TH AVENUE AT 45TH STREET, N. Y.
VAnderbilt 6-2200

1ST PRIZE

HANDI-CART FOR GARDENERS — Simplifies hauling of plants, earth, grass cuttings, leaves. Fill it like a dustpan; to unload, merely tip. Sturdy metal, rubber-tired wheels. Long handle saves stooping. With tool bag holding trowel, fork, flower shears and Kremeskin gloves, **8.95;** Cart alone, **4.75**

BEST WAY TO PROP PLANTS — Far more convenient than tying them up to stakes. Stick this 48" metal rod with its self-bracing foot into the ground. As plant grows, slide the ring up! Doz., **2.00.** Extra rings for taller plants, doz. **1.50**

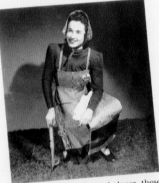

KNEEL PANTS — Darned clever, these garden Chaps. There's a cushioned pad on each knee, and the shoulder straps are adjustable for big or little gardeners. Two big pockets and a cigarette-pocket as well; a chain to hold scissors captive, a clamp for string or gloves. Denim in navy, California blue or blue-and-white stripes, **3.95**

A VINE COVERED WALL IS EASY TO ACHIEVE — Just put these flexible little Vyn-tach hooks to work. They'll train your vine to spread out gracefully over wall or fence. Easy as can be to drive them into any surface. For wood-box of 25, **1.00.** For brick or stucco — 25, **2.00;** 100, **5.00**

SPRINKLER CONNOISSEURS say this is the finest sprinkler extant. Slides into position on runners, is non-clogging and delivers water in a waving back and forth mist that's as good for lawns as the fogs of England. **15.00.** (Right) Set Rain King's handy dial for any circle from 5 to 50 feet — it does the rest. **4.75**

HOW TO DRAW A STRAIGHT LINE along the edge of your garden, driveway or hedge. Use Trimstick — 50 feet of strong line in an anti-snarl reel, and two sharp stakes to insert at the terminal points. Height of line is adjustable, for ground or hedge trimming. **1.25**

26

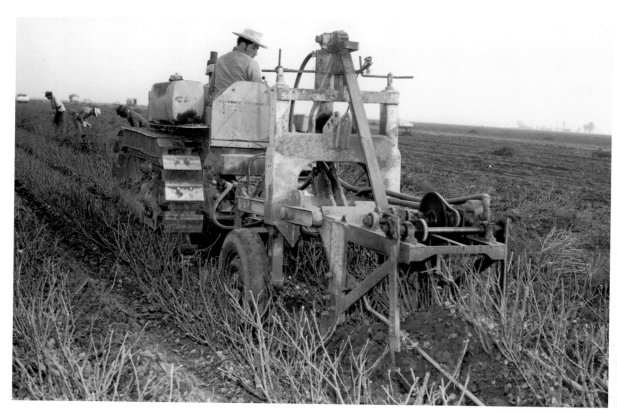

–8.11– Jackson & Perkins, Wasco Fields

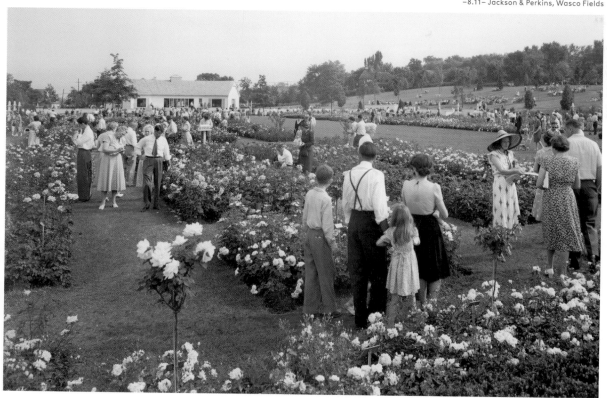

–8.12– Jackson & Perkins, Newark Rose Garden

–8.13– Sears, 1934

–8.14– Sears, 1933

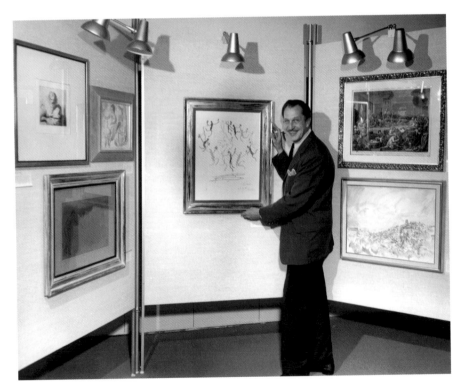

–8.15– Sears, Vincent Price, 1964

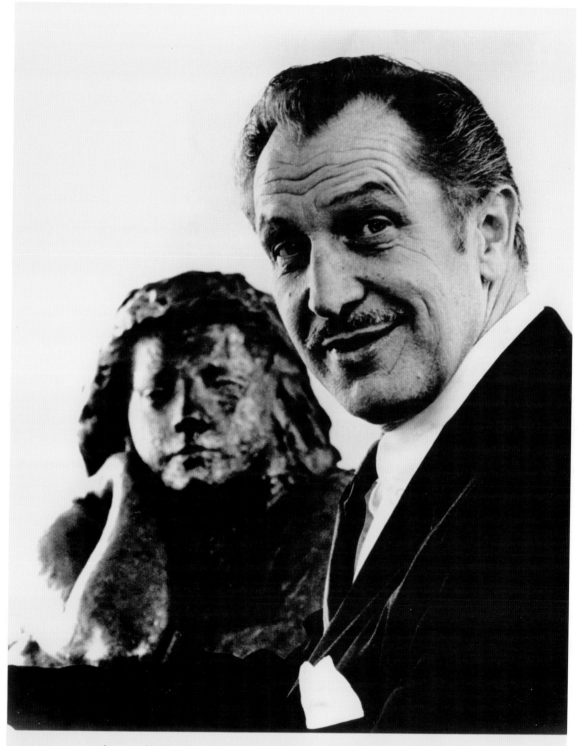

A new dimension has been added to the Vincent Price

Collection of Fine Art in the form of works of sculpture.

the optimist...

... takes the long view and plants an oak tree to become his family's living heirloom. We deliver to their door a young tree over two feet high, complete with its own Austrian-made Christmas ornament. The tree – in temperate zones, the native Live Oak; for colder climes, an oak variety selected for suitability to that particular area – is shipped potted, with instructions for care and proper nutrients to see it over the shock of transplantation. Guaranteed healthy* by our expert nurserymen, it could, with love, grow to a height of 30 feet or more . . . to make wonderful shade and nest a tree house for their great-grandchildren. **1A** each 10.00 (1.95)

Live Oak Other suitable variety

Other suitable variety

Live Oak

*Important: due to climate changes during shipment, tree may arrive partially or completely defoliated. This is not an indication of damage or poor health.

the pessimist

Code:

A-D		Passenger staterooms
1	(P)	Sauna
	(S)	Hair stylist
2	(P)	Fur and Jewel storage
	(S)	Objet d'art storage (Temperature controlled)
3	(P)	Microfilm library
	(S)	Infirmary
4-6	(P)	Quarters for
	(S)	ship's personnel
66	(P)	Meat locker/ pantry
	(S)	Kitchen
43		Dining room (convertible to theatre/music room)
10-55		Animal quarters
56		Veternarian quarters and infirmary
57		Aviary
58		Aquarium
59		Animal food storage
68		Animal exercise area
61		Bridge/Ballroom and salon
62		Swimming pool

PEOPLE DECK MACHINE DECK ANIMAL DECK TOP DECK

FIBERGLASS THATCH SUNDECK
BRIDGE BALLROOM & SALON POOL
EXERCISE AND GAME DECK STATEROOM A 1 2 STATEROOM B 4 5 6 CREW MUSIC ROOM - LIBRARY - THEATER CAPACITY 8 PEOPLE DECK
WATERLINE SMALL ANIMAL AREA 23 24 25 26 27 28 29 30 ANIMAL DECK
50 CUBIT 7 8 9 10 11 12 13 14 15 16 17 18 19 20 21 22
30 CUBIT FUEL HEAT AND AIR CONDITIONING MACHINE DECK
BILGE BILGE BILGE

NOTE ONE: WHILE A SHORT OR COMMON CUBIT EQUALS 17.47 INCHES, NOTHING IS THE SAME AS IT WAS. THUS 300 CUBITS EQUAL 90 FEET.

40 80 120 160 180 220 260
300 CUBIT
SEE NOTE ONE

ARK, NOAH, Model 2-NM

PROJ ENGR	John Tucker
STR DSGN	A. Noah
GROUP	2-0
DRAWN BY	England Ltd 8-15
ENGRG UNIT	2-51700
CHECKED BY	TR

...plans for any eventuality. Before the deluge, he prepares the perfect retreat from come-what-may. Our Noah's Ark, updated and refined, is guaranteed to be more comfortable than the original, albeit not as capacious (see Note One, above). It sleeps 8 passengers; 4 ship's crew; one each: French chef, Swedish masseur, German hair stylist, English valet, French maid, Italian couturier, English curator/librarian, Park Avenue physician, and Texas A & M veterinarian. The animal deck accommodates (in pairs by specie) 92 mammals, 10 reptiles (could your wife stand more?), 26 birds, 14 fresh-water fish and 38 insects.

*Partial listing of animals (subject to availability and state of the market – endangered species given first priority): Lions, tigers, musk oxen, Komodo Dragons, rhinoceri, elephants, hippopotami, alligators, llamas, penguins, walruses, aardvarks, lemurs, camels (Bactrian), American bison, polar bears, gnus, giraffes, kudus, cheetahs, North American otters, wombats, three-toed sloths, mongooses, ocelots, okapis, springboks, wallabies, gorillas, platypuses; plus assorted domesticated animals.

2A Noah's Ark, with animals* (allow 4 years) 588,247.00 (est.)

TRAVEL⊛G

DULUTH TRADING CO.

Turn Heads Everywhere

in our Lightweight Presentation Jacket, p. 3.

Adapt yourself comfortably

Universal Adapter Plug

Compatible in over 150 countries.

Don't make the mistake of getting to your destination and finding your shaver, hair-drier or phone charger don't work. And don't buy 17 adapters either. This one compact 2⅛"W x 2⅞"L x 1¾"H **Universal Adapter** is all you need. Has three interlocking pieces that adjust in varying combinations so you can plug into wall sockets in any country using the European Union, Great Britain, Australia or US standards. *Note:* Ensure that your mobile electronics adapter is rated to handle both 100-125 and 220-250 standards. Imported.

#91086 $19.50

Stores as one compact unit

Worldwide Adapter and USB Charger

Adapts to nearly any country, charges your mobile electronics.

Not only will this adapter work in the more that 150 countries that use the European Union, Great Britain, Australia or US plug standards, it's also built to charge any USB-connectable electronics (PDA, MP3 player, digital camera and more). There's also a built-in power-surge protection fuse (spare fuse included) for added peace of mind. For use with voltage converters, transformers and dual-voltage appliances. Measures 2½"W x 2½"L x 1¾"H. *Note:* Ensure that your mobile electronics adapter is rated to handle both 100-125 and 220-250 standards. Imported.

#91085 $34.50

Compact storage size

How to Travel Practically Anywhere

An indispensable guide for novice and pro traveler alike. Travel reporter Susan Stellin shares a wealth of insider tips, so you don't have to learn them the hard way: how to find the best deals, what to research before you book your hotel, how to avoid hidden fees and charge penalties and where to look on the web for useful travel advice. Soft cover. 321 pages. 5½"W x 8¼"H. Printed in USA.

#96094 $15.95

Quick Pass Luggage Tag

Put all your metal items in the attached pouch and fly through airport security.

Yes, it's a luggage tag for your carry-on, complete with an adjustable buckle strap and ID window. But it's also a handy folding pouch that eliminates emptying your pockets at security. Pre-pack your phone, keys and coins, fold it closed and attach it to your carry-on so it can ride through the X-ray machine; then unpack it later at your leisure. Ballistic nylon with leather trim. 3"W x 4"H when folded, opens to 9"W x 10½"H. Black. Imported.

#91097 $14.50

Pack metal items in pouch, fold closed and attach to bag

Noah's Waterproof Briefcase

For rainstorms of biblical proportions.

If it's monsoon season where you're headed, or if you're crashing around on the waves in a boat, this is your bag. The fabric is 420-denier oxford nylon coated with PVC (think commercial-lobsterman's rain suit) while the seams are tape sealed for a 100% watertight finish. Zipper is waterproof and there's a sculpted "hood" that flaps over the top. UV-resistant material will stand up to outdoor use. Inside you'll find a removable organizer sleeve complete with file pocket and padded laptop slot – cushioned at bottom. You'll also find pen, pencil and PDA/calculator pockets inside the sleeve. Adjustable shoulder strap is padded with soft neoprene. Comfortable, ergonomic "grip tooth" carry handle locks together. 17"W x 4½"D x 12"H. Black. Imported.

#92129 $69.50

Waterproof hood locks over zipper

Leaktight zipper

Impenetrable PVC-coated heavy nylon

Removable sleeve holds your briefcase essentials:
- Padded laptop pocket
- File slot
- Calculator and PDA pocket
- Pen slots

44

gauntlet in our #1 selling jacket!

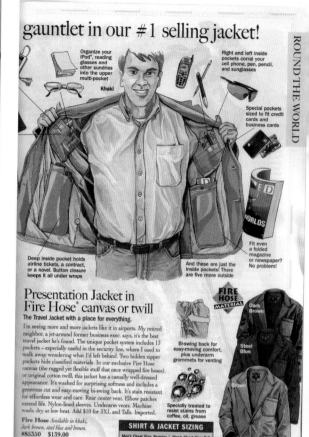

Organize your iPod®, reading glasses and other sundries into the upper multi-pocket

Khaki

Right and left inside pockets corral your cell phone, pen, pencil, and sunglasses

Special pockets sized to fit credit cards and business cards

Fit even a folded magazine or newspaper? No problem!

Deep inside pocket holds airline tickets, a contract, or a novel. Button closure keeps it all under wraps

And these are just the inside pockets! There are five more outside

Presentation Jacket in Fire Hose® canvas or twill

The Travel Jacket with a place for everything.

I'm seeing more and more jackets like it in airports. My retired neighbor, a jet-around former business exec. says, it's the best travel jacket he's found. The unique pocket system includes 13 pockets – especially useful in the security line, where I used to walk away wondering what I'd left behind. Two hidden zipper pockets hide classified materials. In our exclusive Fire Hose canvas (the rugged yet flexible stuff that once wrapped fire hoses), or original cotton twill, this jacket has a casually well-dressed appearance. It's washed for surprising softness and includes a generous cut and easy-moving bi-swing back. It's stain resistant for effortless wear and care. Rear center vent. Elbow patches extend life. Nylon-lined sleeves. Underarm vents. Machine wash; dry at low heat. Add $10 for 3XL and Talls. Imported.

Fire Hose *Available in khaki, dark brown, steel blue and brown.*
#85350 $139.00

Twill (not shown) *Available in khaki, fatigue green and navy.*
#85373 $145.00

FIRE HOSE MATERIAL

Bi-swing back for easy-moving comfort, plus underarm grommets for venting

Dark Brown

Steel Blue

Brown

Specially treated to resist stains from coffee, oil, grease

Fatigue Green

Navy

SHIRT & JACKET SIZING

Men's Chest Size: Regular	Men's Chest Size: Tall
S (34-36)*	L (42-44)
M (38-40)	XL (46-48)
L (42-44)	XXL (50-52)
XL (46-48)	
XXL (50-52)	
3XL (54-56)	

Not available in this size for #94046

11

–8.20, 8.21– Duluth Trading Company

SHURE® SOUND-ISOLATING EARPHONES. Tune out distracting noises and into your tunes. With sound-isolating design and micro-speaker technology, professional-quality earphones deliver an incredibly clear aural experience and minimize outside noise. Behind-the-ear fit is perfect for use with stereos, MP3 players, and airline sound systems. 60"L. Includes a pocket carrying case.
80A Earphones and Case 179.00

PANASONIC® ULTRA-THIN TRAVEL SHAVER. In about the size of a credit card, this shaver has floating stainless steel blades and a powerful motor for a smooth, clean, and very portable shave, whenever you need it. Uses two AAA batteries (not included). 3⅜"H x 2¼"W x ½"D.
80B Electric Shaver 66.00

MEADE® CAPTUREVIEW™ DIGITAL CAMERA BINOCULARS. Wouldn't you love to take photos and video through your binoculars? Meade combines 8X zoom, 30mm binoculars with a 2.0 megapixel color digital camera to give you incredible options. It has a 1½" color LCD screen, 32MB of internal memory, standard memory card port, and three resolution settings to let you get the shot you want. And it's water-resistant, to boot. Includes a comfortable neck strap, carrying case, cable, and software. Uses two AAA batteries (not included). 2½"H x 4¾"W x 5¾"D.
80C Digital Camera Binoculars 199.00

AIPTEK® DV CAMCORDER. The Aiptek 4.0 megapixel digital camcorder captures digital video, audio, and digital photos and fits easily in the palm of your hand. With built-in MP3 player, 1½" color LCD display, standard memory card port, tripod, software, and cable. When you download pics, it draws power from your computer to save battery power. Unplugged, it runs on two AA batteries (included). 3⁷⁄₁₀"H x 2⅛"W x 1⁷⁄₁₀"D.
80D Digital Camcorder 150.00

BMW® MP3 PLAYER/WATCH. Enjoy up to five hours of MP3 files on this extremely cool BMW watch. Record and play audio, display and store messages, and transfer data to and from your computer. Face, 1⅛"Dia. Includes earbuds. Uses two watch batteries (included).
80E MP3 Player/Watch 275.00

BLADEZ® RACING CART. Who says being grown up has to be dull? With his midnight blue G47R racing cart from BladeZ, he can make like greased lightning. With a peppy 47cc gas engine on a steel frame, it can achieve up to 26 mph. It's a blast with aluminum alloy rims, rubber tires, rack-and-pinion steering, a clutch-and-chain drive, and rear disc brakes. Just go easy on the skid marks. With an impact-resistant resin seat, it's recommended for big little boys up to 250 lbs. 16"H x 50"W x 24"D.
81 Racing Cart 800.00 (200.00)

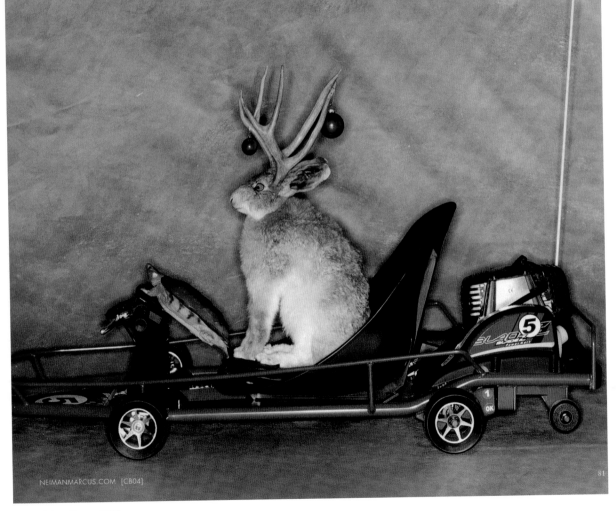

LOGITECH DIGITAL WRITING SYSTEM. The fastest way to convert handwritten words to digital information. Without retyping or scanning, the io2 Digital Writing System directly inputs digitized handwritten notes, e-mails, calendar entries, and images to your PC and favorite software applications. Also lets you export to popular graphics applications. Includes rechargeable lithium ion battery with charging cradle, two digital notepads, USB cable, and PC-compatible software. Additional 128-page digital notepads also available; sized to fit inside standard 8.5" x 11" portfolios.
72A Digital Writing System 200.00
72B Three Additional Digital Notepads 12.00

GPS VEHICLE NAVIGATION SYSTEM. Removes and installs in seconds, so you can have award-winning GPS navigation in any car. Powered by Motorola® and Microsoft®, Royal AmeriGo provides voice-prompted, turn-by-turn guidance, so you can keep your hands on the wheel and your eyes safely on the road. Directs you to virtually any US destination with pinpoint accuracy and has a dedicated home key for the return trip. Includes detailed street maps, complete mounting kit, and adapter. 4"H x 5.1"W x 1.2"D. Imported.
72C GPS Navigation System 800.00

GIGABEAT 20G MP3 PLAYER. Records up to 332 hours of music, with 11 hours of playback time. Features 2.2" LCD screen and sampling frequency from 22.05 – 48 kHz, with built-in lithium ion battery and AC adapter. *Specify* Black or Silver. Includes headphones and USB cable. 4.2"H x 2.5"W x .6"D. Imported.
72D Gigabeat MP3 Player 430.00

CANON® DIGITAL CAMERA AND ACCESSORY KIT. The elegantly designed Coach®-edition PowerShot SD500 Digital Elph with 7.1 megapixel, 3X optical zoom, 2" LCD, enhanced movie mode, nine special scene modes, and digital macro mode. Accessory kit includes a Coach leather case and custom metal neck strap, 128MB memory card, NB3L battery and charger, tabletop tripod, and digital editing software.
72E Digital Camera and Accessory Kit 649.00

STARCK MULTIFUNCTION CLOCK AND THERMOMETER. Radio-controlled precision timekeeping is just the beginning — this multifaceted device from Oregon Scientific, designed by the renowned Philippe Starck, includes easy-to-read weather forecast icons, barometric pressure chart with past-23-hours history, alarm with snooze feature, indoor/outdoor temperature and humidity, moon phases and tide levels, and digital AM/FM radio with 16 presets. And it projects the time onto your ceiling at night. Clock/calendar automatically sets itself with the US atomic clock; 5.5"H x 5"W x 1.5"D. Comes with thermometer/hygrometer sensor to measure temperature and humidity in a remote location; 3"H x 3"W x 1.5"D.
72F Multifunction Clock and Thermometer Set 225.00

GLOBALPETFINDER. The first patented GPS location device for pets 35 lbs. or more, it lets you set fences of any size and continuously transmits readable updates of the wearer's exact location to your cell phone, PDA, or computer. Snaps easily and securely onto collar or harness and weighs less than 5 ounces. Dial F-O-U-N-D from your cell phone for your pet's location on demand. Also provides environmental temperature and battery status monitoring. Includes three AAA batteries, 3-cell charger, and snap guard. 4.5"L x 2.25"W x 1.25"D. Made in the USA.
72G GPS Petfinder 350.00

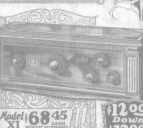
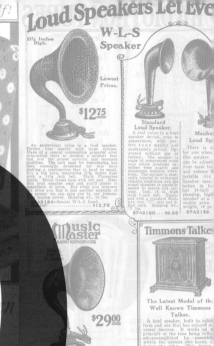

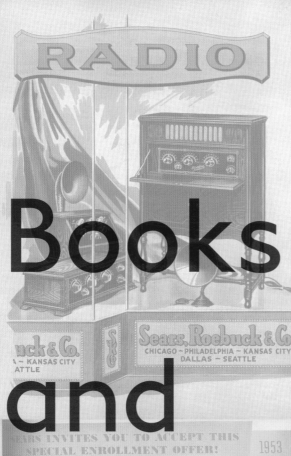

Books

and

Music

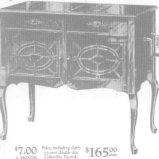

9

Books and Music

In 1897, the Bible was the best selling book in the world. Sears offered Bibles, atlases, etiquette books, and, for $19.95, the thirty-volume, 26,200-page *Encyclopaedia Britannica*. Sears actually ran *Encyclopaedia Britannica* for eighteen years from 1928 to 1946, at which point it transferred ownership to the University of Chicago.

Book-of-the-Month Club (BOMC) was founded by Harry Scherman in 1926, to bring books to rural people who he thought were being underserved by big city stores. The first ad for BOMC proclaimed that "You can subscribe to the best new books just as you do a magazine." Harry Abrams, the famous art publisher, was BOMC's first art director. Members signed up to receive one book, known as the main selection, once a month for twelve months. Scherman's colleague Max Sackheim proposed that the main selection should be sent unless the customer returned a postcard requesting that it not be sent. This practice, known as negative option, would endear book and record clubs to lawyers for years to come. The first promotions were sent to the New York Social Register. By the end of its first year, BOMC had 4,750 members. By the end of 1929, it had 110,588. BOMC sold its one-millionth book in 1949.

To ensure that people didn't think main selections were chosen for commercial purposes, Scherman set up a panel of "strictly disinterested people" to serve as judges. These were prominent authors and literary figures. The judges' system was described as elitist and terminated in 1994 but reinstated in 2001 with Anna Quindlen, Nelson DeMille, Bill Bryson, and Annie Proulx as judges. It was terminated again in 2004 in an effort to cut costs. The first book offered was *Lolly Willowes* by Sylvia Townsend Warner. Richard Wright's *Native Son*, a main selection in 1941, was the first by an African-American, though the judges required that the author delete some passages to make it "less disturbing." The deleted passages, which showed that the black protagonist, Bigger Thomas, was sexually attracted to the white woman he accidentally killed, were deemed too racially and sexually provocative for the club's members. In 1991, the Library of America released an edition of *Native Son* with the missing passages restored. William Shirer's *Rise and Fall of the Third Reich*, offered in 1960, was BOMC's all-time best-seller.

Using a similar model, Samuel W. Craig founded The Literary Guild in 1927 promising to offer "Literature—Not Just Books." Shortly after that, book publisher Doubleday and Company founded its own book club. Deciding it was harder to beat them than own them, Doubleday acquired The Literary Guild in 1934. Sears teamed up with Simon & Schuster to launch its own book club in 1943, The Peoples Book Club. The club offered vapid love stories, often with religious overtones, to a primarily female clientele. One such title, a Biblical novel called *The Emperor's Physician*, by Rev. Jacob Perkins, was the Christmas selection for 1944; it sold almost 250,000 copies.

In 1946, BOMC launched a new advertising campaign with the express intent of overtaking Doubleday as the country's

largest club. Literary Guild countered by advertising in Montgomery Ward's Spring Catalog. While BOMC started with the noble aim of offering Americans "the outstanding book published each month," the reality of the marketplace has been that underwhelming titles have frequently proved more popular than classics. In August of 1951, a BOMC editor told *TIME* magazine, "We're not missionaries, we're merchandisers." That being said, the judges were generally good at spotting classics, though they passed on *The Caine Mutiny* by Herman Wouk and *The Grapes of Wrath* by John Steinbeck. In 1929, the judges selected *The Cradle of the Deep*, Joan Lowell's account of her seventeen-year sea voyages with her father as a main selection. Her account turned out to be fake and is considered one of this country's greatest literary hoaxes. BOMC was forced to issue refunds, though Lowell was unrepentant and said, "Any fool can be accurate—and dull."

The cultural importance of BOMC in the middle of the twentieth century was summarized by Random House president Bennett Cerf who said, "The book club is not only here to stay but has become, in fewer than twenty years, one of the most important factors in the distribution of books and influences on the people's reading habits ever developed in America." President Harry Truman wrote Scherman to thank him for making his memoirs a main selection. In 1962, Supreme Court Justice William O. Douglas reviewed Rachel Carson's *Silent Spring* and Adlai Stevenson reviewed Barbara Ward's *The Rich Nations and the Poor Nations*. BOMC also had two radio shows, *The Author Meets the Critics* on WQXR and *Let's Go to the Opera* on WOR. They also expanded their business by successfully offering art miniatures in conjunction with The Metropolitan Museum of Art; 500,000 miniatures were sold between 1951 and 1956.

In the fifties, BOMC was the first club to test offering music the same way, when they introduced the Metropolitan Opera Record Club and Music Appreciation Records. The Music Appreciation Records offered analysis of a classical work on one side and a performance on the second. BOMC used top orchestras like the New York Philharmonic and the Cleveland Orchestra, but they would have to record under a made-up name to get around the orchestra's recording contracts. Leonard Bernstein recorded five symphonies and commentaries with the New York Philharmonic performing as the Stadium Symphony Orchestra. The recordings were rereleased as *Leonard Bernstein: The 1953 American Decca Recordings* by Deutsche Grammophon in 2005. But the bestseller was Mendelssohn's Violin Concerto, performed by Fredell Lack, a young student of Scherman's son and the New York Philharmonic, performing as the Stadium Symphony Orchestra.

Columbia House was founded in 1955 to sell music through the mail. To induce people to join, the club offered a free monophonic record with membership. Their first record was *Christmas with Arthur Godfrey*. By the end of the first year, the Columbia House Record Club had 128,000 members, and they had purchased 700,000 records. Within two years, it had shipped over seven million records to its members. Having outgrown its New York City facility, in 1953, they moved their warehouse to their manufacturing center in a cornfield in Terre Haute, Indiana. Terre Haute was chosen for its good railroad access. A bonus was that employees could cultivate corn and hunt rabbits after their shifts ended. The first LP (long-playing) records were produced in 1957; stereophonic records were introduced in 1958. By 1965, Columbia House accounted for 10 percent of all money spent on music in the United States; that year they shipped nearly

twenty-four million records. In 1960, a reel-to-reel club was launched in order to attract audiophiles.

In 1964, 8-track cassettes were invented by a consortium headed by Bill Lear of the Lear Jet Corporation. Columbia House introduced an 8-track club in 1966 (and although retail stores stopped offering 8-tracks in 1982, Columbia House offered them until 1988). The last 8-track produced was Fleetwood Mac's *Greatest Hits*. The last 8-tracks are prized among collectors. Two of the rarest are Stevie Ray Vaughan's *Texas Flood* and Bruce Springsteen and the E Street Band's *Live/1975–85*, which was one of the very few box sets to be released on vinyl, cassette, CD, and 8-track. Cassettes came on the scene in 1969. A video club was launched in 1982, a CD club in 1986, and a DVD club in 1997. Ken Lemry, a company vice president, used to try to get artists to visit the Terre Haute facility, but it was difficult to lure them to the former cornfield. One artist who did visit was Tom Jones, and he was a hit. As Lemry recalled, "He could only visit the midnight shift. I swear, he kissed every girl in that factory."

CBS's primary competitor, RCA Victor, founded its own record club in 1956 and Capital Records started the Capital Record Club in 1958. Capital decided to offer only their own labels' recordings. Fortunately, their artists included Frank Sinatra, Dean Martin, Nat King Cole, The Beach Boys, and The Beatles. Capital's Record Club was shut down in 1972.

In 1986, the German media conglomerate Bertelsmann acquired both Doubleday and RCA Victor. Doubleday merged with Book-of-the-Month Club in 2000. In 2005, Bertelsmann's Music Group, in partnership with Sony, acquired Columbia House. Bertelsmann subsumed BOMC completely in 2007. It is a sign of the clubs' diminished cultural importance that the Federal Trade Commission would see no antitrust implications to having all the major book and music clubs under one roof. Today, there is a book club for everyone including African-Americans, Hispanics, conservatives, Christians, cooks, crafters, children, romance novel readers, and new age followers.

Catalogs offered musical instruments from the very beginning and their mass production and promotion is responsible for the popularity of musical instruments in America to this day. Pianos were required parlor furniture, and player pianos were popular with the musically challenged (until the advent of the phonograph). In 1905, Sears was a precursor to the *U.S. News and World Report* college rankings; their guitars were named for prestigious universities. The Stanford cost $4.25, the Princeton was $16.95, and the Harvard was a staggering $21.95. They also offered a Universal Folding Organ, equally well-suited for schoolchildren, wandering Evangelists, and home use.

In 1909, Sears's banjos started at $2.45, violins at $2.95, and mandolins at $5.65. Sears even bought Harmony, the largest producer of ukuleles, in hopes of cornering the lucrative 1916 ukulele market.

In 1924, Sears founded its own radio station called WLS, which stood for World's Largest Store. The station aired congratulatory messages from Rudolph Valentino and Ring Lardner. Actress Ethel Barrymore was so nervous when she saw the mike, she simply said, "Oh my God" before being led away. WLS was sold to a local newspaperman four years later. Gene Autrey worked on WLS's show, *National Barn Dance*, for four years, and before they took on their famous names, both Amos 'n' Andy and Fibber McGee 'n' Molly worked there.

Sears's musical instruments were the first for many future stars. Andy Griffith got a slide trombone from Spiegel when he was

234

fourteen, and golfer Sam Snead once called the four-string Gibson banjo he got from the Sears catalog when he was the same age "the most precious thing I own."

Silvertone was the brandname for both radios and guitars from 1915 to the present. Silvertone guitars were manufactured by a number of guitar manufacturers from 1941 to 1970. They were the first guitars of Chet Atkins, Bob Dylan, and Jimi Hendrix, among many others. Gregg Allman of the Allman Brothers got a paper route for eight weeks so he could buy a Silvertone acoustic. He rode his bike to Sears with $21, but the guitar cost $21.95. He couldn't convince the salesman to front him the balance, so he had to ride home and borrow 95¢ from his mother. Gary Rossington, a founding member of Lynard Skynard, was more industrious. He got a paper route *and* collected Coke bottles and scrap metal to pay for his first Silvertone. Pete Townsend used a Silvertone when The Who played live, ending the show memorably by smashing it to pieces. Sissy Spacek bought her first guitar by mail order, a $14.95 Silvertone from Sears, Roebuck & Co. Paul Stanley of KISS still plays a Silvertone, while Jack White of the White Stripes plays a vintage Airline guitar, manufactured for Montgomery Ward in the sixties.

Silvertone was also used for the Sears record label; featured artists included Benny Goodman, Vic Damone, Sammy Kaye, Kay Kyser, the Chicago Philharmonic, and Sears's own Silvertone Concert Orchestra. A Silvertone Record Club was started in 1946.

In 1960, Neiman Marcus offered the complete Modern Library of Random House—suggesting it as the perfect gift for the couple stranded on a tropical island. In 1980, they offered a one-of-a-kind Martin D-45 guitar made of aged Brazilian rosewood for $9,500. When two orders arrived simultaneously, the Vice President of Mail Order Operations tossed a coin to determine the recipient. In 2005, Neiman Marcus would even sell you Elton John for $1.5 million. The money, a donation to the Elton John AIDS Foundation, actually bought an Elton John Signature Series Red Piano designed by Yamaha that Sir Elton would play at a private concert for you and five hundred of your closest friends.

–9.1– Johnson Smith & Co.

235

Columbia

We Pay the Postage or Express Charges on Columbia Records.

20H5184—In ordering state catalog number (20H5184) and give selection number of record wanted. It is not necessary to write out the names of selections; just give the number, and price of each record are listed under the selection number.

Vocal Selections

All with orchestra accompaniment unless otherwise noted.

Alabama Jubilee. Memphis Blues. Both by Collins, baritone, and Harlan, tenor.	A 1721 10-in. 75c
Alcoholic Blues, The. Billy Murray, tenor. I'm Goin' to Settle Down Outside of London Town. Murray and Peerless Quartet.	A 2702 10-in. 75c
Alexander's Ragtime Band. (Berlin.) Byron G. Harlan, tenor, and Arthur Collins, baritone. It's Nice to Be Nice to a Nice Little Girl Like You. Ada Jones and Walter Van Brunt.	A 1032 10-in. 75c
Alice Blue Gown. From "Irene." Do You Hear Me Calling? From "Little Old New York." Both by Margaret Romaine, soprano.	A 3273 10-in. $1.00
All She'd Say Was "Umh Hum." In Napoli. Both by Van & Schenck, comedians.	A 3319 10-in. 75c
All the Boys Love Mary. Van and Schenck. Way Down Barcelona Way. Harry Fox. Character songs.	A 2942 10-in. 75c
All the World Will Be Jealous of Me. Henry Burr, tenor. Mother, Dixie and You. Sterling Trio.	A 2275 10-in. 75c
And He'd Say Oo-La-La! Wee- Wee. Billy Murray, tenor. Oh! Oh! Oh! Those Landlords. Irving Kaufman, tenor.	A 2765 10-in. 75c
Are You From Dixie? Peerless Quartet. My Lady of the Telephone. (Gilbert.) Sam Ash, tenor, and Mixed Quintet.	A 1921 10-in. 75c
Argentines, The Portuguese and the Greeks, The. Nora Bayes, comedienne. Sally Green (The Village Vamp). Nora Bayes.	A 2980 10-in. 75c
As I Sat Upon My Dear Old Mother's Knee. With All Her Faults I Love Her Still. Both sung by Will Oakland, counter-tenor.	A 1306 10-in. 75c
Baby Mine. Mammy's Lullaby. Both by Lucy Gates, soprano.	A 2911 12-in. $1.00
Barbiere Di Siviglia. "Ecco ridente in cielo." ("Lo, Smiling in the Eastern Sky.") (Rossini.) Charles Hackett, tenor. (Single disc.)	49604 12-in. $1.50
Beautiful Ohio. Henry Burr, tenor. I'm Forever Blowing Bubbles. Campbell and Burr. Tenor duet.	A 2701 10-in. 75c
Belgian Rose. Campbell and Burr. Tenor duet. My Daddy's Star. Robert Lewis, tenor.	A 2559 10-in. 75c
Bless My Swanee River Home. I Lost My Heart in Dixie Land. Character songs by Harry Fox.	A 2828 10-in. 75c
Bonnie Sweet Bessie. (Gilbert.) Hulda Lashanska, soprano. (Single disc.)	49443 12-in. $1.50
Break the News to Mother. Burr, tenor, and Columbia Stellar Quartet. Just as the Sun Went Down. Peerless Quartet.	A 2436 10-in. 75c
Broadway Blues, The. Singin' the Blues. Both by Nora Bayes, comedienne.	A 3311 10-in. 75c
Broadway Rose. Peerless Quartet. Mother's Lullaby. Sterling Trio.	A 3333 10-in. 75c
Broken Blossoms. Charles Harrison, tenor. While Others Are Building Castles in the Air, I'll Build a Cottage for Two. Campbell and Burr, tenors.	A 2793 10-in. 75c
Bye-Low. Campbell and Burr, tenors. I'll Always Be Waiting for You. Charles Harrison, tenor.	A 2827 10-in. 75c
Carolina Sunshine. Sterling Trio. Give Me a Smile and a Kiss. Charles Harrison, tenor.	A 2770 10-in. 75c

Carry Me Back to Old Virginny. (Bland.) Massa's in de Cold, Cold Ground. (Foster.) Both by Lucy Gates, soprano, and Columbia Stellar Quartet.	A 6015 12-in. $1.50
Casey Jones. Irving and Jack Kaufman. Tenor duet.	A 2809 10-in. 75c
Steamboat Bill. Irving Kaufman, tenor.	
Casey Jones Went Down on the Robert E. Lee. Byron G. Harlan and Arthur Collins. Whistling Jim. (Morse.) Peerless Quartet.	A 1271 10-in. 75c
Chong. Irving Kaufman, tenor. One and Two and Three and Four, Rock-a-Bye. Peerless Quartet.	A 2714 10-in. 75c
Climbing Up the Golden Stairs. (Great Jubilee Song.) Browne. Banjo and piano acc. Johnny, Get Your Gun. Browne, baritone. Banjo and orchestra accompaniment.	A 2430 10-in. 75c
Crazy Blues. Royal Garden Blues. Both by Mary Stafford and Her Jazz Band.	A 3363 10-in. 75c
Darktown Strutters' Ball. Collins and Harlan. I'm All Bound 'Round With the Mason-Dixon Line. Al Jolson, comedian.	A 2478 10-in. 75c

The Season's Big Song Hits

Peggy O'Neil. Chas. Harrison, tenor. If Shamrocks Grew Along the Swanee Shore. Broadway Quartet.	A 3438 10-in. 75c
Sweet Lady. From "Tangerine." You're Just the Type for a Bunga- low. Both by Frank Crumit, tenor.	A 3475 10-in. 75c
Tuck Me to Sleep in My Old Ken- tucky Home. Edwin Dale, bari- tone, and George Reardon, tenor. My Sunny Tennessee. Broadway Quartet. (Male quartet.)	A 3465 10-in. 75c
April Showers. From "Bombo." Al Jolson, comedian. Weep No More (My Mammy). Vernon Dalhart, tenor.	A 3500 10-in. 75c
When Francis Dances With Me. Da, Da, Da, My Darling. Both by Frank Crumit, tenor.	A 3521 10-in. 75c
Ain't We Got Fun. Van and Schenck, comedians. Oh! Dear. Edward Furman, tenor, and William Nash, baritone.	A 3412 10-in. 75c
Look for the Silver Lining. "Sally." I'm Gonna Do It If I Like It. Both by Marion Harris, comedienne.	A 3367 10-in. 75c
Rosie. Frank Crumit, tenor. My Gee Gee (From the Fiji Isle). Tod Weinhold, tenor.	A 3346 10-in. 75c
When the Autumn Leaves Begin to Fall. Fred Hughes, tenor. Like We Used to Be. Fred Hughes.	A 3344 10-in. 75c

Dear Old Pal of Mine. (Rice.) Magic of Your Eyes, The. (Penn.) Both by Oscar Seagle, baritone.	A 2684 10-in. $1.00
Ding-A-Ring A Ring. Al Jolson, comedian.	A 3375 10-in. 75c
Home Again Blues. Frank Crumit, tenor.	
Dixie. Stanley and Harlan. Fife and drum effect. De Little Old Log Cabin in de Lane. Carroll C. Clark. Banjo accompaniment.	A 696 10-in. 75c
Don't Take Away Those Blues. Good-Bye, Dixie, Good-Bye. Both by Frank Crumit, tenor.	A 2965 10-in. 75c
Down by the Old Mill Stream. Brunswick Quartet. Sally. Brunswick Quartet. Unaccompanied.	A 1047 10-in. 75c
Down in Sunshine Valley. Campbell and Burr. I Want a Girl Just Like the Girl That Married Dear Old Dad. Columbia Male Quartet.	A 1034 10-in. 75c
Dreams. Sterling Trio. Alabama Lullaby. Both tenor duets by Campbell and Burr.	A 2717 10-in. 75c
Dreamy Alabama. Hawaiian Lullaby. Both tenor duets by Campbell and Burr.	A 2781 10-in. 75c
Eyes That Say I Love You. When the Bees Make Honey Down in Sunny Ala- bam'. Tenor duets by Irving and Jack Kaufman.	A 2726 10-in. 75c
For Me and My Gal. M. J. O'Connell, tenor. Cross My Heart and Hope to Die. Ada Jones, soprano.	A 2190 10-in. 75c
Freckles. Ev'rybody Calls Me Honey. Both by Nora Bayes, comedienne.	A 2816 10-in. 75c
Friends. Sterling Trio. I'm Going to Climb the Blue Ridge Mountains Back to You. Campbell and Burr, tenors.	A 2744 10-in. 75c
Funiculi, Funicula. Riccardo Stracciari, bari- tone and Columbia Male Chorus. (Single disc.)	78404 10-in. $1.00
Gates of Gladness, The. If You Don't Stop Making Eyes at Me. Both by Arthur Fields, baritone.	A 2774 10-in. 75c

Good Morning, Mr. Zip-Zip-Zip. Camp Song. Buckley, baritone, and Peerless Quartet. K-K-K-Katy. Camp Song. Eugene Buckley.	A 2497 10-in. 75c
Grieving for You. Yankee. Both by Marion Harris, comedienne.	A 2939 10-in. 75c
Hear Dem Bells. Keemo Kimo. Both by Harry C. Browne, baritone, and Peerless Quartet. Orchestra and banjo accompaniment.	A 2204 10-in. 75c
He Comes Up Smiling. Arthur Fields, baritone. Cows May Come, Cows May Go, but the Bull Goes on Forever. Peerless Quartet.	A 2647 10-in. 75c
Her Bright Smile Haunts Me Still. Ben Bolt. Both by Frank Coombs, counter-tenor.	A 2188 10-in. 75c
Hesitating Blues, The. Adele Rowland. I'm Goin' to Break That Mason-Dixon Line. Harry Fox, character singer.	A 2730 10-in. 75c
Hiawatha's Melody of Love. Lewis James, tenor. Underneath the Southern Skies. Lewis James and Charles Harrison.	A 2993 10-in. 75c
Hi, Jenny, Ho, Jenny Johnson. Razors in the Air. Both by Harry Browne, baritone, and Peerless Quartet.	A 2249 10-in. 75c
Hortense. Oh, Sweet Amelia. Both by Frank Crumit, tenor.	A 3383 10-in. 75c
How 'Ya Gonna Keep 'Em Down on the Farm? Nora Bayes, comedienne. When Yankee Doodle Sails Upon the Good Ship Home, Sweet Home. Nora Bayes.	A 2687 10-in. 75c
I Ain't Got Nobody. O'Connor, tenor. Everybody's Crazy 'Bout the Dog- gone Blues, but I'm Happy. George H. O'Connor, tenor.	A 2426 10-in. 75c
I Am Climbing Mountains. Golden Gate. Both by Lewis James and Charles Harrison.	A 3313 10-in. 75c
I Can't See the Good in Good-Bye. Lewis James, tenor. That Wonderful Mother of Mine. Henry Burr, tenor.	A 2668 10-in. 75c
I Could Have Had You, but I Let You Get By. Nora Bayes and Hickman's Orchestra. Love Nights. Nora Bayes, comedienne.	A 2972 10-in. 75c
I'd Love to Fall Asleep and Wake Up in My Mammy's Arms. Harry Fox. Rockabye, Lullaby Mammy. Harry Fox.	A 2961 10-in. 75c
I Don't Want to Get Well. Arthur Fields, baritone. Long Boy. Harlan, tenor, and Peerless Quartet.	A 2443 10-in. 75c
I Know What It Means to Be Lonesome. I Never Knew. Both by George Meader, tenor.	A 2824 10-in. 75c
I'll Be With You in Apple Blossom Time. If I Wait Till the End of the World. Tenor duets by Campbell and Burr.	A 2967 10-in. 75c
I'll Say She Does. From "Sinbad." Just as We Used to Do. Billy Murray.	A 2746 10-in. 75c
I'll See You in C-u-b-a. Jack Kaufman. That Wonderful Kid From Madrid. Al Jolson, comedian.	A 2898 10-in. 75c

Photo at right
is of
AL JOLSON,
comedian.

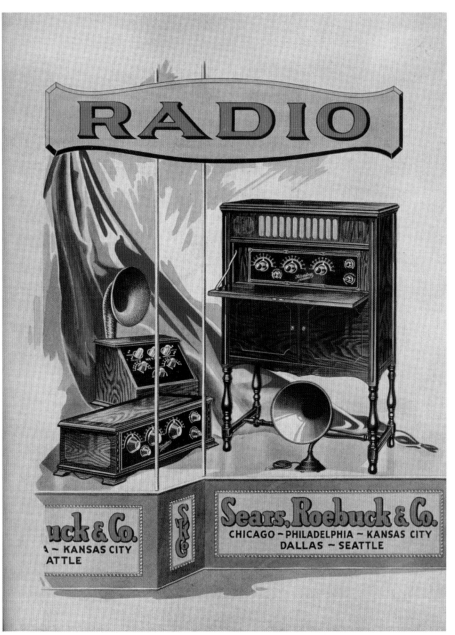

−9.3− Sears, radio, 1925

NEW! SILVERTONE Portable Television Set
clear, bright picture at low price

With Indoor Antenna

$149⁹⁵ Cash
$15.50 Down; $7 Mthly.

- Lightweight, portable as a table radio
- Full-toned sound and steady picture "locked-together" for fast, easy tuning
- 7-inch picture tube - 12 channel tuning

No fuzzy, out-of-focus pictures (at left)—Silvertone gives you a sharp, steady, bright picture | Ideal for the "Shut-in" or convalescent | Easy tuning and focusing— only 4 controls

SILVERTONE TELEVISION ANTENNA

SILVERTONE Outdoor Television Antenna Kit. (Shown installed at left.) Receive better, clearer reception from your television set—use an outdoor television antenna. It's easy to install—one man can do it! And once you have correctly installed it—no more adjustments are necessary. You'll get greater distance reception—and interference from hills, tall buildings, etc. will be minimized when you use an outdoor antenna. Complete with all necessary mounting hardware, wire, etc. and easy-to-follow installation instructions. Sold only with Television set listed at right.

Silvertone Indoor Television Antenna. Simple, easy to use. Bakelite base and chrome plated elements. Instructions.
57 K 06738—Mailable. Shipping weight 10 lbs...........$3.95

IMPORTANT! Before ordering, READ this

Television is here to stay, but not for all mail order customers at this time. Your distance from the station, your location in respect to hills, tall buildings, etc. are factors that limit the reception of television. This SILVERTONE Television Set will give you good reception if you live within 15–20 miles of the station. If your neighbor has a television set that gives satisfactory reception, it's a good bet that you too can get good reception with this SILVERTONE Portable Television. However, for the best reception we strongly recommend the use of the Outdoor Television Antenna kit listed and described at the left.

Note: When ordering, specify approximate miles your location from station. We may refuse your order if, in our opinion, your location is unsatisfactory for television reception. Compact . . . lightweight . . . superpowered. This NEW SILVERTONE Television Set brings you clear, bright, steady, "picture-perfect" performance at a low budget price. It's expertly engineered and built to give you good reception from all the stations in your reception range. Has beautiful natural-like tone . . . and it's easy on your eyes.

Weighs only 26 pounds. Easy as a table radio to move. Enjoy it now in your living room—or move it to any room in your home. It's ideal to take to parties and to your friends' homes. Simply plug this SILVERTONE Television Set into an AC outlet, adjust the indoor antenna—and you'll have a front row seat for all the great television entertainment.

Easy, sure tuning with automatic station selector. No guessing! No fumbling! Just turn station selector and presto—you get the station you want. Easy-to-operate controls—brightness, picture steadying and volume controls—are conveniently located on the front of the cabinet. Handsome cabinet is made of sturdy plywood covered with alligator-grained artificial leather. Has leather handle; beautiful brushed brass trim. Size 15½x9x 15¾ inches. Operates on 105–125 volts, 60-cycle AC only. With complete operating instructions. Shipped freight or express.

57 KM 9117—With portable antenna. Shipping weight 30 pounds. *Easy terms $15.50 down, $7.00 monthly* . . . New low monthly payments...Cash $149.95
57 KM 9118—Same as above except with outdoor television antenna kit described at left. Shpg. wt. 45 lbs. *Easy terms $17.50 down, $8.00 a month* . . . New low monthly payments..............Cash $169.95

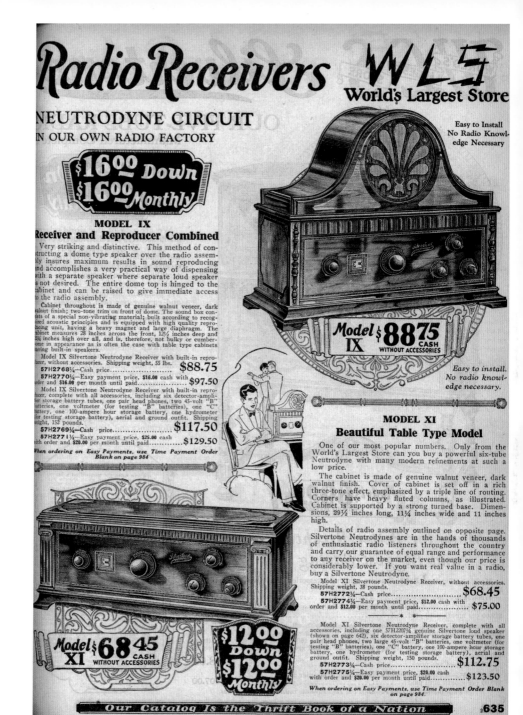

Radio Receivers

WLS — World's Largest Store

NEUTRODYNE CIRCUIT
IN OUR OWN RADIO FACTORY

Easy to Install
No Radio Knowledge Necessary

$16.00 Down
$16.00 Monthly

MODEL IX
Receiver and Reproducer Combined

Very striking and distinctive. This method of constructing a dome type speaker over the radio assembly insures maximum results in sound reproducing and accomplishes a very practical way of dispensing with a separate speaker where separate loud speaker is not desired. The entire dome top is hinged to the cabinet and can be raised to give immediate access to the radio assembly.

Cabinet throughout is made of genuine walnut veneer, dark walnut finish; two-tone trim on front of dome. The sound box consists of a special non-vibrating material; built according to recognized acoustic principles and is equipped with high quality reproducing unit, having a heavy magnet and large diaphragm. The cabinet measures 28 inches across the front, 12½ inches deep and 18¾ inches high over all, and is, therefore, not bulky or cumbersome in appearance as is often the case with table type cabinets having built-in speakers.

Model IX Silvertone Neutrodyne Receiver with built-in reproducer, without accessories. Shipping weight, 55 lbs.

57H2768¼—Cash price...................... **$88.75**
57H2770¼—Easy payment price, $16.00 cash with order and $16.00 per month until paid...... **$97.50**

Model IX Silvertone Neutrodyne Receiver with built-in reproducer, complete with all accessories, including six detector-amplifier storage battery tubes, one pair head phones, two 45-volt "B" batteries, one voltmeter (for testing "B" batteries), one "C" battery, one 100-ampere hour storage battery, one hydrometer (for testing storage battery), aerial and ground outfit. Shipping weight, 152 pounds.

57H2769¼—Cash price...................... **$117.50**
57H2771¼—Easy payment price, $25.00 cash with order and $20.00 per month until paid............. **$129.50**

When ordering on Easy Payments, use Time Payment Order Blank on page 984

Model IX $88.75 CASH WITHOUT ACCESSORIES

*Easy to install.
No radio knowledge necessary.*

MODEL XI
Beautiful Table Type Model

One of our most popular numbers. Only from the World's Largest Store can you buy a powerful six-tube Neutrodyne with many modern refinements at such a low price.

The cabinet is made of genuine walnut veneer, dark walnut finish. Cover of cabinet is set off in a rich three-tone effect, emphasized by a triple line of routing. Corners have heavy fluted columns, as illustrated. Cabinet is supported by a strong turned base. Dimensions, 29½ inches long, 11¼ inches wide and 11 inches high.

Details of radio assembly outlined on opposite page. Silvertone Neutrodynes are in the hands of thousands of enthusiastic radio listeners throughout the country and carry our guarantee of equal range and performance to any receiver on the market, even though our price is considerably lower. If you want real value in a radio, buy a Silvertone Neutrodyne.

Model XI Silvertone Neutrodyne Receiver, without accessories. Shipping weight, 38 pounds.

57H2772¼—Cash price...................... **$68.45**
57H2774¼—Easy payment price, $12.00 cash with order and $12.00 per month until paid............ **$75.00**

Model XI Silvertone Neutrodyne Receiver, complete with all accessories, including one 57H2200¼ genuine Silvertone loud speaker (shown on page 642), six detector-amplifier storage battery tubes, one pair head phones, two large 45-volt "B" batteries, one voltmeter (for testing "B" batteries), one "C" battery, one 100-ampere hour storage battery, one hydrometer (for testing storage battery), aerial and ground outfit. Shipping weight, 150 pounds.

57H2773¼—Cash price...................... **$112.75**
57H2775¼—Easy payment price, $20.00 cash with order and $20.00 per month until paid............. **$123.50**

When ordering on Easy Payments, use Time Payment Order Blank on page 984

Model XI $68.45 CASH WITHOUT ACCESSORIES

$12.00 Down
$12.00 Monthly

Our Catalog Is the Thrift Book of a Nation

–9.6– Sears, 1922

Loud Speakers Let Everybody Hear

W-L-S Speaker

21¾ Inches High.

Lowest Prices.

$12⁷⁵

An exceptional value in a loud speaker. Perfect tone quality with large volume. Made of a special composition prepared after exhaustive tests to develop a product that had just the proper acoustic and resonant qualities. The unit used for reproducing has been especially developed for this horn making a combination that is hard to equal. It's a big horn, measuring 21¾ inches high with a 14½ inch bell. Black Florentine finish. Metal frame base with felt pad. Hear this loud speaker once and you'll prefer it regardless of price. But when you compare the price you find it just another example of the money we can save you by our tremendous buying power. Shipping wt. 14 lbs.
57A2154—Special W-L-S Loud Speaker**$12.75**

Standard Loud Speaker.

A real value in a loud speaker device, neat in appearance, with perfect tone quality and moderately priced. Operated without use of battery. The speaker is made of compressed wood pulp which produces excellent tone quality and eliminates metallic vibrations. The surface is especially treated to withstand climatic conditions and the sound chamber is carefully sealed to insure full volume. Size, 18 in. high with 7-inch bell. Equipped with a standard Baldwin type "C" unit and 6-foot cord. Shipping wt., 7 lbs.
57A2180 **$9.95**

Manhattan Loud Speaker.

There is a surprise for you when you hear this speaker. The tone can be adjusted to suit your taste for clearness and volume by an adjustable diaphragm. Speaker measures 30½ inches in height and has 14-inch bell. A pleasing, high grade speaker at a very reasonable price. Shipping weight, 14 pounds.
57A2156..**$22.25**

METEOR Speaker

An Unusual Loud Speaker.

Biggest Values.

$7⁰⁵

For the greatest enjoyment of radio a good loud speaker is necessary. Here is one that we can earnestly recommend. Made of special pressed composition with a popular black flake finish. It has a phone unit of unusual character recently developed. Nothing to come loose. Height, 22 inches; diameter of bell, 10 inches; base, 6½ inches; 5-foot cord included. A loud speaker that will give unusual satisfaction. We have never found a better speaker for the money. Shipping weight, 18 pounds.
57A2155—Each **$7.05**

Music Master
RADIO REPRODUCER

Height, over all, 21 inches.

$29⁰⁰

A high grade loud speaker built to reproduce pure mellow tones. Simple in construction with practically nothing to get out of order. This speaker may be used with any set using two or more tubes. The 14-inch bell of the horn is made of finely grained mahogany wood. This bell fits into a black enameled cast aluminum gooseneck and is held in place by a nickel plated ring of special alloy. The base which contains the reproducers is of art metal, having a felt bottom to prevent scratching. Attractive in appearance and requiring no batteries for its use. Shipping weight, 14 pounds.
57A2153—The Music Master**$29.00**

Timmons Talker

The Latest Model of the Well Known Timmons Talker.

A loud speaker, built in cabinet form and one that has enjoyed universal success. It works on the principle of the tone being reflected—accomplished by assembling within the cabinet two horns, one facing the other. This device is very sensitive, will not distort and produces a pure, true tone. An outstanding feature is that with a slight turn of the knob shown, it can be adjusted to give a loud or soft tone as desired.

The Timmons Talker is designed along very attractive lines a dark, rich mahogany finish. The cabinet measures over all, 9⅜x9⅜x8¾ inches. Shipping weight, 15 lbs.
57A2190¼**$32.50**

MAGNAVOX

14-Inch Bell 27½ Inches High.

11-Inch Bell 18 Inches High.

$32²⁰ **$22⁴⁵**

Sensitive and true in tone quality and powerful in volume. High grade material and workmanship, beautiful finish. Horn is 27½ inches high and has 14-inch bell. Curved design with a flaked finish. Reproducer is mounted on a black insulated base. The type R3 requires the use of a storage battery for maximum efficiency. Radiophone speech and music may be reproduced to such a degree that it can be easily heard in any part of a large room. We advise that an outfit using two or more tubes be used. Shpg. wt., 17 lbs.
57A2151—Type R3**$32.20**
Type M4 requires no storage battery for operation. Has slightly reduced volume. Size, 18 inches high with 11 inch bell. Shipping weight, 10 pounds.
57A2152—Type M4**$22.45**

—9.7— Sears, 1924

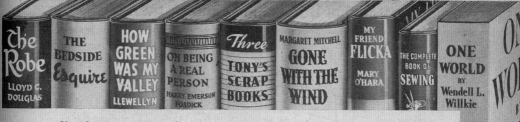

Nationally famous Books for your library . . . at low prices

New nation-wide Best Sellers

The Robe by Lloyd C. Douglas. The great story of the robe of Christ.
3 F 2009—Clothbound. Postpaid........$2.75
Bedside Esquire. Stories and articles in typical Esquire style—by 25 famous authors.
3 F 2042—Clothbound. Postpaid........$1.89
How Green Was My Valley by Richard Llewellyn.
3 F 2015—Clothbound. Postpaid........$1.39
On Being a Real Person by Dr. Harry E. Fosdick. A foremost preacher helps man to be his best—intelligent advice on his personal life.
3 F 2010—Clothbound. Postpaid........$2.50
I Married Adventure by Osa Johnson. The thrilling stories of two famous explorers.
3 F 2041—Clothbound. Postpaid........$1.45
Gone With the Wind by Margaret Mitchell.
3 F 2060—Clothbound. Postpaid........$1.49
My Friend Flicka by Mary O'Hara. The story of a boy on a Wyoming ranch and the wonderful horse that was "all his own."
3 F 2046—Clothbound. Postpaid........$2.50
The Powers Girl by John Robert Powers. The real life stories and the careers of the world's most beautiful models. Illustrated.
3 F 2047—Clothbound. Postpaid........$1.39
Berlin Diary — by William Shirer. The intimate story of Nazi Germany. Bold, revealing.
3 F 2013—Clothbound. Postpaid........$1.39

Douglas MacArthur — Fighter for freedom. The real-life story of our number one hero.
3 F 2077—Clothbound. Postpaid........$1.29
Tony's Three-in-One Scrap Book by Tony Wons. The beloved bits of wit, philosophy and verse collected from three different volumes.
3 F 2261—Clothbound. Postpaid........$1.19
101 Famous Poems. The most famous poems in the world. Whittier, Browning, Poe and others.
3 F 2259—Clothbound. Postpaid........49c
It Can Be Done by Edgar Guest. Inspirational poems of deep understanding by the poet beloved by millions. From his radio programs.
3 F 2257—Clothbound. Postpaid........$1.00
Lassie Come Home by Eric Knight. The dog story of all times—for all ages.
3 F 2037—Clothbound. Postpaid........$1.89
Valley of Decision by Marcia Davenport. The story of one woman's influence on a great, important family. Deeply moving and interesting —a story everyone will soon be talking about.
3 F 2001—Clothbound. Postpaid........$3.00
Mrs. Parkington by Louis Bromfield. The colorful lifetime of a fabulously wealthy woman.
3 F 2062—Clothbound. Postpaid........$2.75
Saratoga Trunk by Edna Ferber. An exciting story of the famous New Orleans railroad in the roaring '80's. Vivid and revealing.
3 F 2061—Clothbound. Postpaid........$1.25

One World by Wendell Willkie
Brilliantly written personal account of Mr. Willkie's meetings with Joseph Stalin, Chiang Kai-Shek, General Montgomery and other United Nations leaders. Courageous and outspoken . . . one of the most discussed books today. Heavy paper-bound edition.
3 F 2069—Postpaid...................$1.00

Thrifty Cooking for Wartime
by Alice Winn-Smith. Practical, economical recipes for the home. All have been tested and tried in the author's own kitchen.
3 F 2337—Postpaid...................$1.50

Complete Book of Sewing
by Constance Talbot, famous fashion editor. Money-saving short-cuts to beautiful clothes. Remodeling, making, mending, embroidery, etc. Over 2,000 items, 750 illustrations.
3 F 2207—Postpaid...................$2.89

Better Dressmaking
by Ruth Wyeth Spears. How to tell fabrics, colors, lines for your type. How to design clothes and make them. Dictionary of terms.
3 F 2217—Postpaid...................$2.89

The Path to Home—When Day is Done
by Edgar Guest. A double volume—2 books in one—of the charming poems of the man who writes for regular folks. You'll find peace and solace in his words. Clothbound.
3 F 2298—Postpaid...................$1.00

Detective and Mystery Choice 48c ea. Home Library Selections Choice 65c

Thrilling Mystery and Detective Stories

Spellbinding tales of crime, intrigue and murder. Stories that will baffle you from the first page to the last word. Plots that hit the top . . . solutions that will seem impossible until you read them. All by mystery masters—many have appeared in movie versions—so inexpensive because they are reprints of the original—but each is the complete uncut, story. Full library size books in bright colorful jackets. Clothbound. Ideal gifts. State titles.

Any book 48c Postpaid

Dragon's Teeth.........Ellery Queen
Four of Hearts.........Ellery Queen
Appointment With Death.A. Christie
Easy to Kill.........Agatha Christie
Saint Wanted for Murder...Charteris
Follow the Saint.........Charteris
Rio Casino Intrigue. Van Wyk Mason
Hong Kong Air Base Murder . Mason
This Is Murder. Earl Stanley Gardner
Murder Up My Sleeve.....Gardner
Clue of Forgotten Murder....Gardner
Cases of Susan Dare. Mignon Eberhart
Hasty Wedding....Mignon Eberhart
The Door....Mary Roberts Rinehart
The Bat....Mary Roberts Rinehart
Glass Key.........Dashiell Hammett
Lady of Burlesque...Gypsy Rose Lee

Keeper of the Flame . . . I. A. R. Wylie
Tales of Sherlock Holmes.A. C. Doyle
While the Patient Slept
....................Mignon Eberhart
The Dark Garden . Mignon Eberhart
The Thin Man....Dashiell Hammett
The Spanish Cape Mystery
....................Ellery Queen
The Chinese Orange Mystery
....................Ellery Queen
The Saint Bids Diamonds...Charteris
The Dragon Murder Case
....................S. S. Van Dyne
The Crying Sisters....Mabel Seeley
Background to Danger. . . Eric Ambler
The D. A. Calls It Murder
....................Erle Stanley Gardner

3 F 225—State Titles wanted. Postpaid. Each................48c 2 for 92c

FREE! Sears New Book Catalog

Hundreds of Best Sellers . . . many originally published at prices from $2.50 to $10.50 . . . NOW ONLY 69c to $3.95 in Sears new book catalog. Includes fiction and biography, books on music, art, technical and reference—also juvenile and many other types. Many are original publications, made available by quantity printings at unusually low prices, and many are handsome new editions of best sellers—complete and uncut. Write for Catalog 754F today.

Outstanding Non-Fiction Books—Any book 65c

Modern Chemists, their Work
By Christy Borth. All about the modern men who are making 1001 necessities from the things we used to throw away. Clothbound.

An Introduction to Literature
An Introduction to Modern English and American Literature edited by W. Somerset Maugham. Clothbound.

Medical Magic
By David Dietz. An easy-to-read book including explanations of safeguarding motherhood, the horsemen of death, the magic of glands, the magic of digestion, the war on contagion, and X-Ray.

The Story of Science
By David Dietz. Physics and Chemistry, Astronomy, Geology, Biology. An accurate story of these great divisions of science. Extremely interesting and one of the best books out on the subject.

The Story of Man and His Food
By C. C. Furnas and S. M. Furnas. One of the cleverest, most accurate books on this important subject.

Home Book of Music Appreciation
By Helen L. Kaufmann. Learn to know music and to enjoy Symphonies, Ballets, Operas, etc. Clearly written.

Any book 65c Postpaid

Successful Business Girl
By Gladys Torson. A practical guide for the young business woman who wants to improve herself. Tells all you need to know to win regular promotions. Written by a successful business girl.

How to Write Letters
By Alexander L. Sheff and Edna Ingalls. An authoritative guide for all correspondence. Contains hundreds of sample business and social letters. Shows you how easy it is to make a good impression with a good letter.

20,000 Years in Sing Sing
By Warden Lawes. The famous, true inside story of what happens to criminals in the nation's most famous prison. More exciting than a mystery story.

Strange Customs of Courtship
Customs of Courtship and Marriage by William J. Fielding. An unusually interesting book of the marriage ceremony and the customs practiced in relation to it in many parts of the world.

Practical Book of Home Nursing
By Mary Wright Wheeler, R. N. An experienced registered nurse tells how to deal with the common complaints and diseases which can be cared for at home. Has an excellent chapter on First Aid—knowledge everyone should have.

3 F 250—All above books are Postpaid and clothbound............................65c

Order any of the books in this group by giving above catalog number. State titles wanted.

☐ PAGE 597 BOOKS

–9.10– Sears, transistor radio, 1961

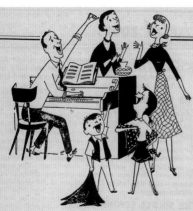

MASTERPIECES OF PIANO MUSIC

BOOK-DIVIDEND CREDIT
GIVEN WITH EACH SET

AT the request of music-minded members—particularly those in out-of-the-way places—the Club has arranged with the Schirmer Music Publishing Company to make available these volumes of outstanding musical compositions arranged for the piano. Each is fully cloth bound. All will be indispensable additions to your music library.

MOZART SONATAS

One Volume ...$5.25

These nineteen Mozart Sonatas are unquestionably among the great piano compositions of all time. While challenging to the piano virtuoso, they are yet so pure in form and simple in construction that anyone who plays the piano will derive deep enjoyment from them.

THE BEST OF CHOPIN

One Volume ...$7.95

Virtually all of Chopin's delightful scores were composed for the nd in this volume you will find

110 of the best-loved of them. They include all of the Waltzes, Mazurkas and Preludes, as well as many other works. Every home with a piano should have this volume.

BEETHOVEN SONATAS

Two Volumes$10.00

The famous Hans von Bülow edition, published by Schirmer, revised and fingered for authoritative and simplified expression. Contains all thirty-two of the sonatas of Beethoven's master-period, including the *Moonlight, Pathétique, Appassionata* and *Waldstein Sonatas.*

24

–9.11– Book of the Month Club

Broadens the Mind Stirs the Ambition

The Wonder Book of
Knowledge, Johnson
Smith & Co.

The officers of Sears, Roebuck and Co. and the management of Peoples Book Club present this golden opportunity to join PBC through the most important catalog offer made in Peoples Book Club hist

General R. E. WOOD
the Chairman of the Board
of Sears, Roebuck and Co.,
Says:

To offer entertaining reading suitable for the entire family, at the lowest possible price has been the guiding principle of Peoples Book Club for almost ten years.

I invite every Sears customer to share in the savings and reading pleasure offered by Peoples Book Club.

THEODORE V. HOUSER
the Vice-Chair-
man of the
Board of Sears,
Roebuck and
Co., Says:

Peoples Book Club is typical of Sears' value —one which has greatly contributed to the welfare and pleasure of thousands upon thousands of American families.

F. B. McCONNELL
the President of
Sears, Roebuck and Co., Says:

The comments of Charter members expressed below tell more about Peoples Book Club and what it means to you and your family than any statement Sears can make on its behalf. These warmhearted tributes are the richest possible testimony to the fact that PBC is truly a "peoples" book club.

Tributes from members of Peoples Book Club who have belonged to the Club since its founding in 1943
A random sampling from thousands upon thousands of charter members

Written words seem somehow to be quite inadequate to express my very real appreciation of the books which have come to me thru the Book Club these years. It is a pleasure to read the type of books which the Club puts out: uniformly clean and wholesome, always interesting.
Mrs. Lucy Holmes Smith, Bradenton, Fla.

In my ten years of membership in the Club, I have only missed one selection. Most of the specials are on my library shelves, too. I have built up a very fine library at a much lower cost than would otherwise have been possible.
Mrs. Harley Longfellow, Lewiston, Idaho

As a charter member of the Peoples Book Club, I would like to express the pleasure and satisfaction I have derived from your high quality, good, clean, wholesome books. In the past ten years I have never turned down a book and I have never been disappointed.
Mrs. Lyle V. Walker, Tigard, Oregon

78 . . SEARS, ROEBUCK AND CO. PCBRME

Start your membership in Peoples Book Club with the magnificen worthwhile and entertaining reading pictured and described on page. Worth $15.75 at publishers' list prices, all 4 books are yours fo This means that you receive over 1500 pages of wonderful readi you save $13.88 before you even buy another book from Peoples

SPECIAL ANNIVERSARY OFFER!

This year—1953—marks the Tenth Anniversary of Peoples Book Club which was founded to fill what Sears believed in 1943 (and still believes) was a basic desire on the part of most Americans to build a home library of good, clean, wholesome, entertaining books, and to obtain them at a price to suit the average budget.

And to celebrate the importance of this Tenth Anniversary event, Peoples Book Club—just as it did in its very first announcement to the public— is offering another great book, destined to become a classic. Ten years ago it was **The Robe** by Lloyd C. Douglas. Today, it's **The Big Fisherman**, by the same author—a story told with a beauty and reverence bound to rekindle the faith of its readers—and superbly illustrated by Dean Cornwell.

But that's not all. This remarkable enrollment offer brings you not only **The Big Fisherman**, but also **A Hungry Man Dreams** and **Adventures in Two Worlds** as additional enrollment gifts, plus **Keepsake** as your regular Club selection—**all four for only $1.87!**

Success of Club Assured from Beginning

The response from the very first announcement of Peoples Book Club back in 1943 assured the success of the Club.

Thousands upon thousands of families who had always loved books, wanted to read more of them, longed to build a home library of interesting, entertaining and worthwhile new books, at last were able to do so.

One Low Price for All Books

Only $1.87 each to members

Peoples Book Club was typical of Sears' value, as it is today. Members receive books which sell everywhere in publisher's editions from $3.00 to $4.00 for the amazingly low price of $1.87 each plus 13c for postage and handling. This one low price of $1.87 is made possible by the huge printings of the Club editions for its vast membership. And with every fourth book purchased, an earned-bonus book worth from $3.00 to $5.00 is given without extra charge. To bring members advance notice of forthcoming selections, **The Peoples Choice Magazine** is sent regularly and without charge. To retain full privileges of membership, members need take only four books a year.

Books Chosen with the Help of Me

But the bargain app one low pri benefits.

For the club went c bers for h selections. on the judg experts or books are c of a uniq selection known as the Peoples Jury.

Good, Clean, Wholesome Books fo

It's this that virtua books you and own . . you whole reading fre tionalism subject ma will always in your ho confidence—for your friends and all y

Just picture the pleasure you and y from reading and owning the popu offered to you on these pages! Can y pleasant and economical way—*part with children*—to build a home library

ACT NOW
SEND NO MO

Don't wait another moment. A offer right now, and sign and ma prepaid enrollment card, won't y be glad you did.

–9.12– Peoples Book Club, Tenth Anniversary edition, 1953

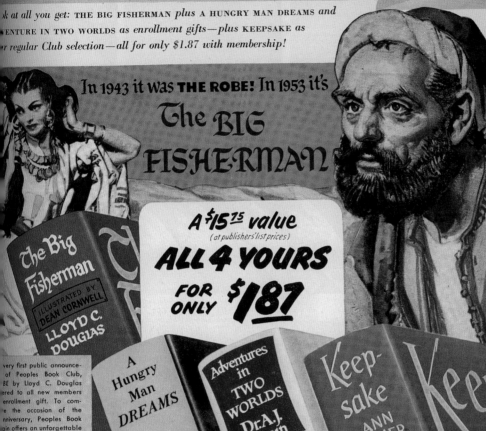

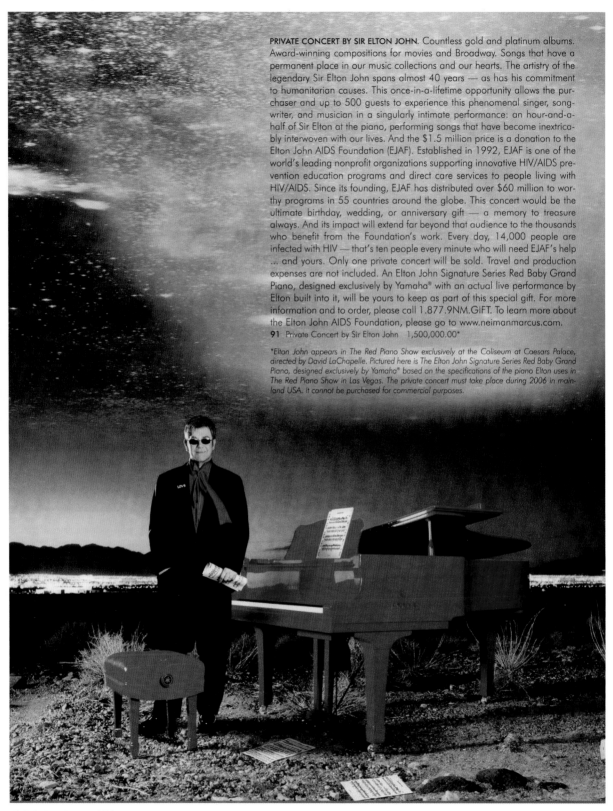

PRIVATE CONCERT BY SIR ELTON JOHN. Countless gold and platinum albums. Award-winning compositions for movies and Broadway. Songs that have a permanent place in our music collections and our hearts. The artistry of the legendary Sir Elton John spans almost 40 years — as has his commitment to humanitarian causes. This once-in-a-lifetime opportunity allows the purchaser and up to 500 guests to experience this phenomenal singer, songwriter, and musician in a singularly intimate performance: an hour-and-a-half of Sir Elton at the piano, performing songs that have become inextricably interwoven with our lives. And the $1.5 million price is a donation to the Elton John AIDS Foundation (EJAF). Established in 1992, EJAF is one of the world's leading nonprofit organizations supporting innovative HIV/AIDS prevention education programs and direct care services to people living with HIV/AIDS. Since its founding, EJAF has distributed over $60 million to worthy programs in 55 countries around the globe. This concert would be the ultimate birthday, wedding, or anniversary gift — a memory to treasure always. And its impact will extend far beyond that audience to the thousands who benefit from the Foundation's work. Every day, 14,000 people are infected with HIV — that's ten people every minute who will need EJAF's help ... and yours. Only one private concert will be sold. Travel and production expenses are not included. An Elton John Signature Series Red Baby Grand Piano, designed exclusively by Yamaha® with an actual live performance by Elton built into it, will be yours to keep as part of this special gift. For more information and to order, please call 1.877.9NM.GIFT. To learn more about the Elton John AIDS Foundation, please go to www.neimanmarcus.com.
91 Private Concert by Sir Elton John 1,500,000.00*

Elton John appears in The Red Piano Show exclusively at the Coliseum at Caesars Palace, directed by David LaChapelle. Pictured here is The Elton John Signature Series Red Baby Grand Piano, designed exclusively by Yamaha® based on the specifications of the piano Elton uses in The Red Piano Show in Las Vegas. The private concert must take place during 2006 in mainland USA. It cannot be purchased for commercial purposes.

EMILIO PUCCI. Violet signature-print lamb leather MP3 player case with leather trim. 4"H x 2⅛"W x ⅜"D. Made in Italy.
111A Standard Case 230.00

GUCCI. MP3 player cases in chocolate Guccissima leather with web strap. Standard, 4"H x 2½"W x ½"D. Small, 3¾"H x 2"W x ½"D. Made in Italy.
111B Standard Case 235.00
111C Small Case 215.00

PRADA. Leather MP3 player cases with signature logo plate detail. *Specify Gold or Silver.* Standard, 4⅛"H x 2⅝"W x ½"D. Small, 3½"H x 2⅛"W x ½"D. Made in Italy.
111D Standard Case 230.00
111E Small Case 215.00

VALENTINO. Swarovski® crystal-covered silvertone mini MP3 player case, 3¾"L x 2¼"W x ¾"D. Made in Italy.
111F Mini MP3 Player Case 840.00

BURBERRY. Shadow-check MP3 player cases in canvas with leather trim. Standard, 4½"H x 3½"W x ¾"D. Small case (not shown), 4"H x 2½"W x ¾"D. Each arrives gift boxed. Made in Italy
111G Standard Case 160.00
111H Small Case 150.00

DOLCE & GABBANA. NM® exclusive bronze Ayers snakeskin MP3 player case with shoulder strap and signature goldtone logo charms. 5⅛"H x 2½"W x ½"D. Made in Italy.
111J Snakeskin Standard Case 395.00

111

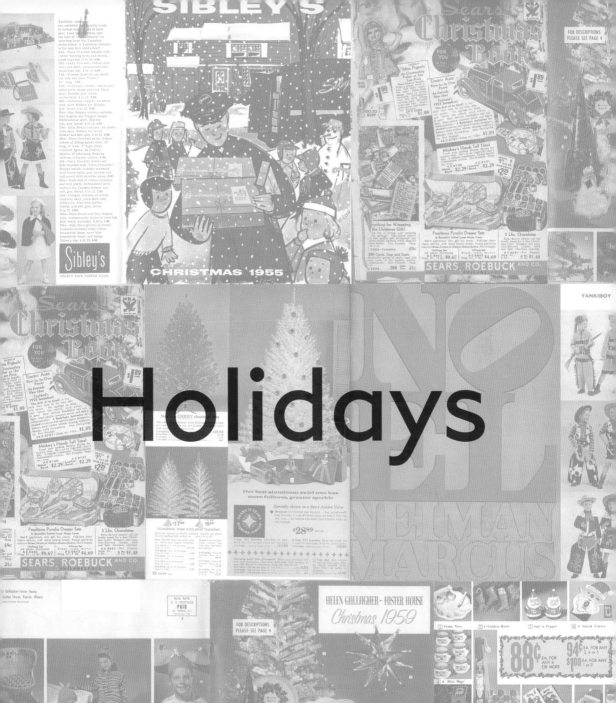

Holidays

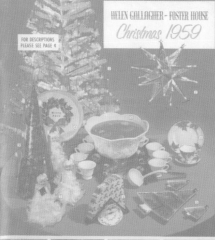

10

Holidays

From the turn of the century until well into the seventies, the arrival of the Sears and Montgomery Ward catalogs was the holiday harbinger. The Sears Christmas Book premiered in 1933. The 88-page, predominantly black-and-white catalog's offerings ran the gamut from two-pound fruitcakes for $0.49 to a quarter-carat diamond ring for $54.50. It also offered a Mickey Mouse watch, Lionel Trains, and live canaries. In 1968, the Christmas Book was rechristened the Wish Book, the name it had been called by generations of shoppers.

Christmas trees go back centuries, but a number of modern innovations can be tracked through the catalogs. Before WWI, European trees were decorated with hand-blown glass ornaments from Central Europe, while most American Christmas trees were adorned with largely handmade ornaments of metal and paper. After the war, America's handmade baubles gave way to mass-produced ones. There was also a post-war infatuation with plastic ornaments that continues to this day. In 1984, as penance for purchasing the tree stand that collapsed and destroyed his family's collec-

tion of over two thousand European ornaments, Christopher Radko launched his own line of glass ornaments. Today, ornaments from his collection of over ten thousand designs can be purchased in high-end catalogs like Saks, Bloomingdale's, and Gump's. The mid-twentieth-century fascination with man-made materials also extended into the trees, themselves. Artificial trees made of aluminum were introduced in the late fifties and were a popular catalog item throughout the sixties.

A colleague of Thomas Edison was the first person to use electric lights to decorate his Christmas tree in 1882. Sears introduced their first Christmas lights, miniature fruit lamps, in 1908, but they were advertised as table, not Christmas tree, decorations. Montgomery Ward accountant Carl Otis invented the Bubble Light, but his employer declined to purchase his invention. Another company (NOMA) chose to manufacture it. The Bubble Light, which resembled a glass test tube filled with bubbling liquid, created a sensation when it was introduced in 1947. Bubble Lights remained popular through the seventies. Montgomery Ward offered the light, as did Sears. In the fifties, the popularity of miniature lights overtook large cone-shaped lights, though the large lights returned to favor in the late eighties.

When Montgomery Ward copywriter Robert L. May created Rudolph in 1939, his boss was initially concerned that the red nose, often associated with excessive alcohol consumption, might be inappropriate for children and holidays. However, he was overruled. The recording of the Rudolph song, written by May's brother-in-law, also had to overcome initial concerns, as a number of artists declined to record the song, fearful of taking on Santa Claus. Gene Autry's wife encouraged her husband to record it; his recording went on to sell one million copies in its first year.

In the late twenties, both Sears and Montgomery Ward started offering miniature Christmas villages: whimsical cardboard houses that were frequently sprinkled with glittery "snow." They remained popular through the fifties. Interactive Christmas games lost their allure in the sixties when families gathered around the television to watch new classics like *A Charlie Brown's Christmas*, *Frosty the Snowman*, and, of course, *Rudolph* (narrated by Santa look-alike Burl Ives). Romeo Mueller embellished Rudolph's story by adding new characters like the inhabitants of the Island of Misfit Toys, the Abominable Snowmonster, Yukon Cornelius, and Hermey, the elf who just wanted to be a dentist.

Neiman Marcus, which mailed its first Christmas promotion in 1915, continues to make news with its opulent Christmas offerings. They started small, with a six-page, 5x6-inch brochure. Their next promotion wasn't until 1926 when a sixteen-page, 5x3-inch brochure was mailed. The first large magazine-size catalog was introduced in 1939. At the time, Dallas was low on good fashion photographers (Neiman Marcus, itself, would change that) so the catalog used sketches. The 1942 catalog introduced a quilted satin Treasure Chest for all gifts over $100. An editorial also told customers that buying war bonds was their patriotic duty. They also offered gifts for servicemen.

The idea of offering extravagant holiday gifts came to Stanley Marcus when, in 1952, Edward R. Murrow called to ask if Neiman Marcus had unusual gifts that might interest his listeners. He offered him a live steer from his brother's prize-raised black Angus herd alongside a silver-plated serving cart like those used in Simpson's and The Savoy in London for $1,925. After he got off the phone, he changed the catalog to accommodate his new item. Because of the popularity of the over-the-top products, Stanley Marcus was constantly bombarded with unusual proposals. In Paris, one potential buyer was dismayed when Marcus rejected his twenty-two karat gold, life-size sculpture of a certain part of the female anatomy.

Neiman Marcus is known for above and beyond customer service. When noted producer Leland Hayward's order of three boxes of Godiva chocolates hadn't arrived by December 10th, he sent letters of complaint to the candy department, the mail-order director, and Stanley Marcus himself. All three sent a letter of apology and air-mailed a replacement. The arrival of twelve boxes of chocolate prompted Hayward to send Marcus a letter pointing out (correctly) that "obviously the left hand of Neiman Marcus doesn't know what the right hand is doing."

In the sixties, a Greek shipping magnate ordered a 5-foot-high giant stuffed panda three days before Christmas with instructions to ship it by air. When informed that no shipper could make the deadline, he instructed the company to buy two first class tickets for the panda and a chaperone. His only demand was that they not fly Olympic Airlines, owned by his competitor, Aristotle Onassis. The chaperone was given a one-week holiday in Greece with the magnate's compliments.

In 1967, Neiman Marcus offered a ten-pound, 24-karat gold wig for $35,000. It was purchased by a television star. With the price of gold today, it would be worth over $130,000. In 1971, the His and Hers gifts were his and her mummy cases. A man in London had offered the female mummy case to Stanley Marcus at a cocktail party. Marcus said, if he could find a male case to go with it, he would offer it as a His and Hers gift. Two years later, the man found one. However, when the cases arrived in the United States, a store manager found there was still a mummy in one of them. Concerned

about being fined for illegally transporting a corpse into the country, he was instructed to find a doctor to issue a death certificate. The mummy was declared dead and donated to a local museum.

A man ordered ten gifts for his wife that were to be individually wrapped and placed inside a papier-mâché Santa Claus made especially for him. The package was to be delivered to a ski resort in Colorado where the couple was vacationing. When the gift hadn't arrived by Christmas Eve morning, the man called to complain. They tracked down the package, but it was going to arrive too late to make the truck going to the resort. The shipping manager found a friend who had a postal route that went by the resort, but he was not authorized to stop there. The driver said if the customer would meet him on a bridge three miles from the resort, he would slow down and push the package off the truck as he drove by. At 10:30 p.m., in the middle of a blizzard, the customer retrieved his package from a snowbank.

One woman, who was divorced and remarried, wanted to make sure her address was not visible on the gifts she sent to her children at their father's home because she feared he would come kill her. When she realized she had forgotten to inform the company, she called in a panic, and twenty people were dispatched to go through 35,000 boxes to find her purchase. They found it in a UPS van and removed the information.

In his book *His & Hers: The Fantasy World of the Neiman Marcus Catalog*, Stanley Marcus relayed a number of snafus. The first year Neiman Marcus put their mailing list on the computer, one customer received 732 copies of the catalog. One year Neiman Marcus offered crystal paperweights with the seal of each of the fifty states. A customer ordered one Wisconsin paperweight and received forty-four. When he called to complain, the supervisor researching the problem was dismayed to have to inform him that, because of a computer glitch, he could expect to receive fifty-five more. The glitch also screwed up the company's projections, resulting in years of overstocked Wisconsin paperweights. A straight gentile man ordered a Bagel Butler for a gay Jewish friend and was mortified when his friend opened the gift to find Neiman Marcus had accidentally sent him a fruitcake. In 1979, the company offered a product with an Iranian component. The hostage crisis forced them to cancel several thousand orders. One Christmas, Stanley Marcus was caught by surprise when a watch with twelve Chinese characters in place of numbers that he'd been told were advice given to the emperor to help him win back the love of his wife, turned out to say "We shall take America by force."

In 2005, Neiman Marcus celebrated forty-five years of "His and Hers" gifts. December gift giving has always been, and continues to be, every catalog company's most important season.

A few other novelties: if you wouldn't touch it with a ten-foot pole, Neiman Marcus had a solution. In 1977, they introduced a collapsible eleven-foot pole in a black leatherette carrying case for $50. Everyone should have a skeleton in their closet, and Neiman Marcus offered a four-foot one on a hanger for $25. It offered a $600 chocolate Monopoly set that Christie Hefner ordered for her father, Hugh. In 1964, they scored a success (that surprised Stanley Marcus) with toothpastes flavored like brandy, martini, orange Curacao, rum, or eggnog. In 1981, the company offered ComRo I, a domestic robot that performs mundane tasks like opening doors, serving cocktails, and picking up around the house for $15,000. For an additional $650, you could buy Wires, a computer pet to keep ComRo I company. A $1,000 stuffed animal menagerie from Steiff received six orders including one from the

Neiman Marcus His & Hers Christmas Gifts

Year	Gift
1960	Airplanes: His—Beechcraft Super G18, $149,000; Hers—Beechcraft Bonanza, $27,000
1961	Ermine Bathrobes, pair, $6,975
1962	Chinese Junk, each, $11,500
1963	Submarine, each, $18,700
1964	Balloons, each, $6,850
1965	Para-Sail, each, $361; Boat, $1,994
1966	Bathtubs, set, $4,000
1967	Camels, pair, $4,125
1968	Jaguars: His—XKE Grand Touring Coupe, $5,559; Hers—Jaguar Coat, $5,975
1969	Vasarely Collection, pair, $750
1970	Thunderbird Cars, pair, $25,000
1971	Mummy Cases, pair, $6,000
1972	Mannequins, each, $3,000
1973	Greek Krater, pair, $5,000
1974	Hovercrafts, each, $3,640
1975	Dinosaur Safari, each, $29,995
1976	Buffalo Calves, pair, $11,750
1977	Windmills, each, $16,000
1978	Natural Safety Deposit Boxes, each, $90,000
1979	Dirigible, each, $50,000
1980	Ostriches, each, $1,500
1981	Robots, each, $15,000
1982	Lasertour, each, $20,000
1983	Chinese Shar-Pei Puppies, each, $2,000
1984	Custom Wooden Steer or Horse Desk, each, $65,000
1985	Diamonds, pair, $2,000,000
1986	California Spangled Cat, each, $1,400
1987	Day at the Circus, per couple, $7,500
1988	Cloudhopper, each, $18,000
1989	Quest for the West, each, $12,585–$121,407
1990	Portrait Chairpersons, each, $6,000
1991	LTV Hummer, $50,000
1992	Vintage Motorcycles, each, $28,000–$35,000
1993	Flarecraft, each, $150,000; Baby Tyrannosaurus Rex, each, $63,000; Triceratops, each, $93,000
1994	BOB (Breathing Observation Bubble), each, $7,500
1995	Name the United 777 Plane, $177,732
1996	MacKenzie-Childs Airstream Trailer, each, $195,000
1997	Windjet, each, $32,600
1998	Cracker Jack Prizes: His—Cuff Links; Hers—Ring, $400 & $950
1999	A Lasting Legacy: gift to The Nature Conservancy, $200,000
2000	Rokkaku Kites, pair, $2,000
2001	Rockettes and NY Knicks Fantasy Weekend, each, $15,000
2002	Action Figures, each, $7,500
2003	Robots—life-size & multifunctional, pair, $400,000
2004	Bowling Center, $1,450,000
2005	Photo Booth, $20,000
2006	Twike Commuter Vehicles, $40,000

embassy of an iron curtain country. In 2007, Neiman Marcus offered a dragon topiary that would be built on your land using plants indigenous to your area for $35,000 and a Swami talking robot that can hold conversations, recognize family members, and give advice. It also offered a futuristic tree house with hardwood floors by Dutch sculptor Dré Wapenaar. Victoria Beckham is rumored to have purchased the $50,000 "Treetent" for her children.

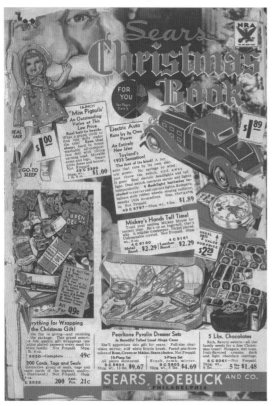

−10.1− Sears, Christmas Book, 1933

−10.2− Neiman Marcus, Christmas Book, 1951

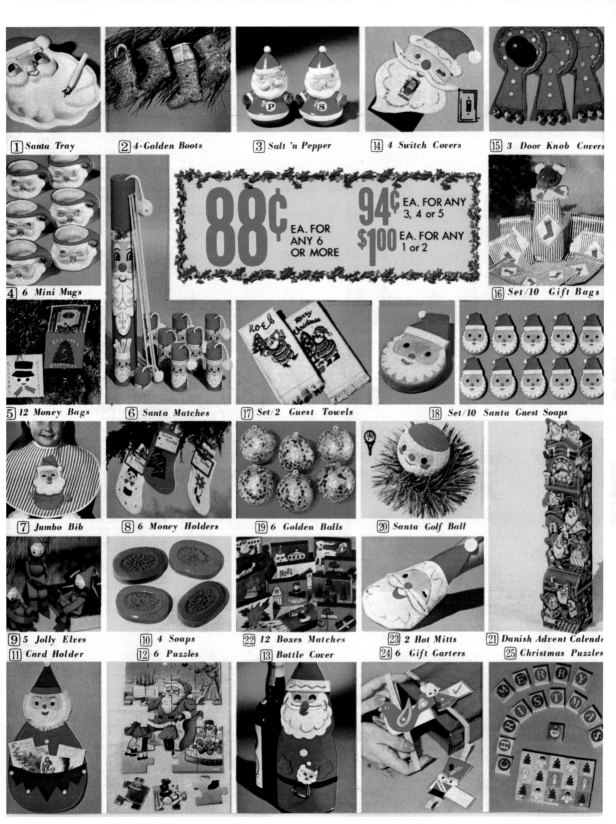

1 *Santa Tray* 2 *4-Golden Boots* 3 *Salt 'n Pepper* 14 *4 Switch Covers* 15 *3 Door Knob Covers*

4 *6 Mini Mugs*

88¢ EA. FOR ANY 6 OR MORE

94¢ EA. FOR ANY 3, 4 or 5

$1.00 EA. FOR ANY 1 or 2

16 *Set/10 Gift Bags*

5 *12 Money Bags* 6 *Santa Matches* 17 *Set/2 Guest Towels* 18 *Set/10 Santa Guest Soaps*

7 *Jumbo Bib* 8 *6 Money Holders* 19 *6 Golden Balls* 20 *Santa Golf Ball*

9 *5 Jolly Elves* 10 *4 Soaps* 22 *12 Boxes Matches* 23 *2 Hot Mitts* 21 *Danish Advent Calendar*

11 *Card Holder* 12 *6 Puzzles* 13 *Bottle Cover* 24 *6 Gift Garters* 25 *Christmas Puzzles*

YANKIBOY COSTUMES FOR THE WORLD OF "MAKE BELIEVE"

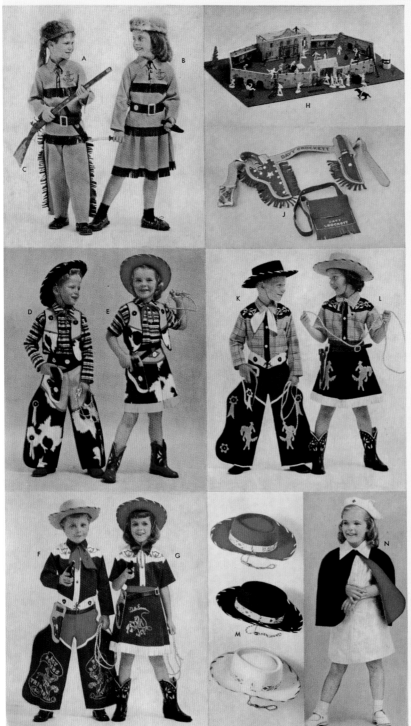

Yankiboy costumes are *washable* and sturdily made to outlast many hours of hard play. Lead your children into the land of "Make Believe" by selecting from the Yankiboy styles below. A Yankiboy costume is the way to a child's heart.

A84—Davy Crockett himself with rubber hunting knife and sheath, plush-type hat. 4 to 14. 4.98

B84—Lady Crockett. Cotton drill skirt and shirt; ornamented belt, plush-type hat. 4 to 14. 4.98

C84—Pioneer flintlock cap shooting rifle and case. Plastic. 34" long. 1.98

D84—Palomino cowboy. Black-and-white print chaps and vest. Plaid shirt. Holster, gun, lariat, neckerchief. 4 to 12. 3.98

E84—Palomino cowgirl. As above with skirt. Ribbon tie. Holster, gun, lariat. 4 to 12. 3.98

F84—Roy Rogers cowboy costume. Roy Rogers and Trigger design. Embroidered shirt. Holster, belt, gun, lariat. 4 to 12. 4.98

G84—Dale Evans costume. As above with skirt. Ribbon tie, lariat, holster and belt, gun. 4 to 12. 4.98

H84—Davy Crockett at the Alamo. Alamo of lithographed steel: 12" long; 4" wide; 7" high. Davy Crockett figure, 20 frontier figures, 10 attacking Mexican soldiers, 6 horses, cannon. 4.98

J84—Davy Crockett holster set. Belt branded with "Davy Crockett." Trophy buckle. Leather scabbard with bowie knife, gun, powder and ball pouch with shoulder strap. 3.98

K84—Dude suit of cotton corduroy and drill pants, embroidered shirt, western tie. Leather holster and belt, gun, lariat. 4 to 12. 5.98

L84—Cowgirl costume of cotton corduroy skirt, plaid shirt with ribbon tie. Also with leather holster and belt, gun, lariat. 4 to 12. 5.98

M84—Dale Evans and Roy Rogers hats. Authentically styled in wool felt. Red, black, buckskin. S,M,L. 1.98

N84—Just like a grown-up nurse! Costume includes white cotton broadcloth dress, navy blue broadcloth cloak, red lining. Nurse's cap. 4 to 12. 4.98

−10.4− Rochester, New York–based Sibley's offered children's costumes in 1956.

SIBLEY'S

CHRISTMAS 1955

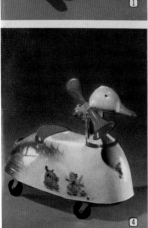

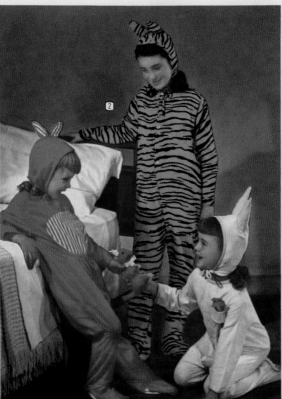

FOR DESCRIPTIONS
PLEASE SEE PAGE 97

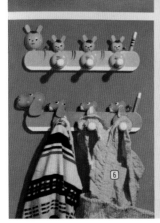

–10.6–Peoria, Illinois–based Helen Gallagher-Foster House offered novelty gifts. The company, later known as Foster & Gallagher, was best known for its horticultural products. It folded in 2001.

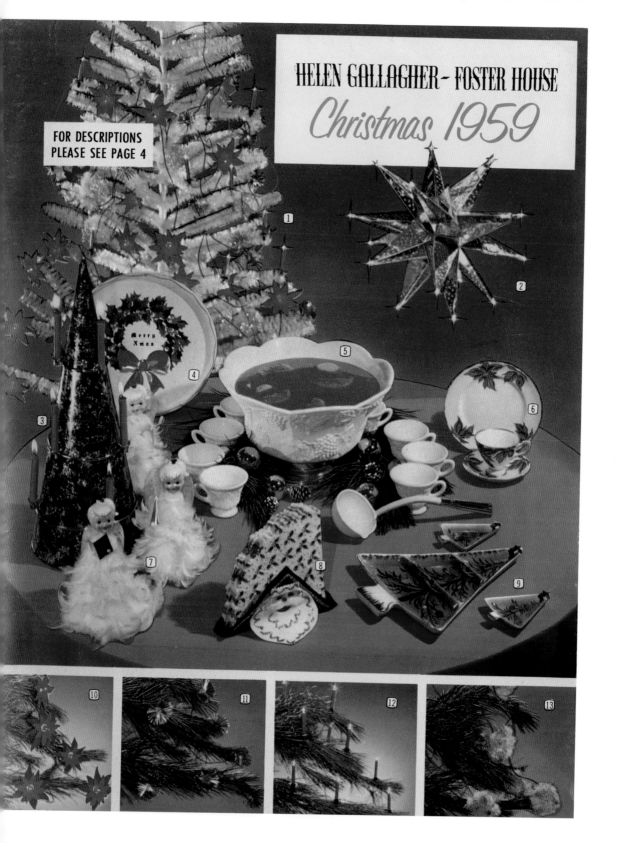

HELEN GALLAGHER - FOSTER HOUSE

Christmas 1959

FOR DESCRIPTIONS
PLEASE SEE PAGE 4

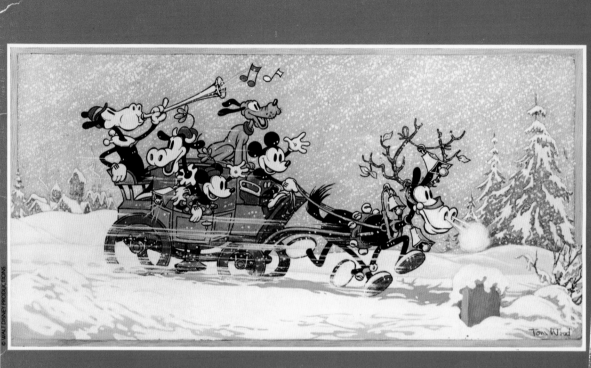

CHRISTMAS BOOK 1981

Neiman-Marcus

–10.7– Neiman Marcus, 1981

"Miss Pigtails" Real hair in braids. What a grand thrill to find this dolly under the tree!

Sears, 1933

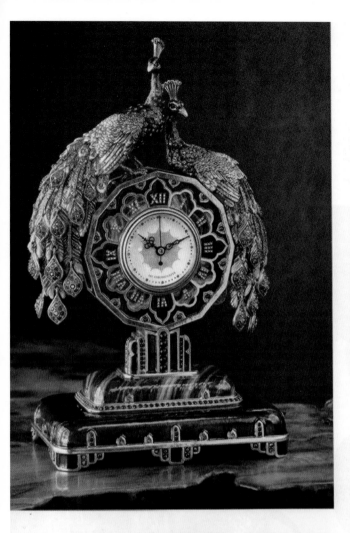

🦚 NM EXCLUSIVE **JAY STRONGWATER CLOCK, VASE, AND MAGNIFIER.**
Time flies when you enjoy what you're doing, and we sure love
what Jay Strongwater does. All of our <u>exclusive</u> objets are hand
enameled and hand set with Swarovski® crystal. For our 100th
anniversary, Jay created the "Stanley" double peacock clock,
elaborately enameled with delicate hanging jewel-tone accents.
Powered by one battery, included, it stands 13.25"H x 7.75"W x
5"D and is limited to an edition of just 100. Jay's "Sea" mini bud
vase in golden-sparkled glass has a jewel-tone bee collar, 3"H x
3"Dia. His enameled "Gwen" turtle magnifier is 1"H x 4.5"W x
3.5"D. All are made in the USA. Also available in Gift Galleries.
56A "Stanley" 100th Anniversary Clock 6,500.00 (65.00)
56B "Sea" Mini Bud Vase 125.00
56C "Gwen" Turtle Magnifier 395.00

JAY STRONGWATER DREIDEL. To celebrate the Hanukkah season,
Jay's master artisans hand enameled this collectible "Isaac" drei-
del and set it with Swarovski® crystal accents. It arrives with an
equally beautiful display stand; 3"H x 1"Sq. Made in the USA.
Also available in Gift Galleries.
56D "Isaac" Dreidel and Stand 350.00

FABERGÉ. Elegantly – and intricately – handcrafted in exquisite
detail, our Fabergé keepsakes celebrate the creative art of Peter
Carl Fabergé. All are hand enameled and set with hand-cut
crystal. The 8" enamel guilloche egg objet is a museum-quality
reproduction. Matching frame holds a 3" x 4" photo, 5.5"H. The
pavé wildflowers box is 3.75"H x 2.625"W. Made in Russia.
57A Egg Objet 3,500.00
57B Frame 750.00
57C Box 500.00

−10.8− Jay Strongwater's dreidel was offered by Neiman Marcus in 2007.

Now .. a *GREEN* aluminum tree

The color, shape, delicate white flocking give it the look of a real tree, freshly cut. It's durable, too—color won't fade, needles can't loosen, ravel.

71 N 9397L2—7 ft. 165 branches. Shpg. wt. 24 lbs......$28.98
71 N 9396L—6 ft. 125 branches. Shpg. wt. 16 lbs......... 21.98
71 N 9394—4 ft. 73 branches. Shpg. wt. 8 lbs............. 11.29
71 N 9393—3 ft. 31 branches. Shpg. wt. 3 lbs. 8 oz...... 4.67

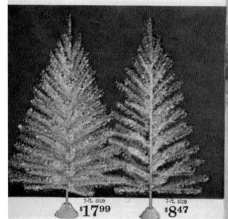

7-ft. size **$17⁹⁹** 7-ft. size **$8⁴⁷**

Aluminum trees with swirl branches

Branches tapered to lifelike fullness. Needles are glued on and mechanically locked on .. won't drop off.

Fine. Thicker than our good quality. More and longer branches.
71 N 9377L—7 ft. 154 branches. Shpg. wt. 12 lbs.............$17.99
71 N 9376C—6 ft. 121 branches. Shpg. wt. 9 lbs............. 14.29
71 N 9375—5 ft. 91 branches. Shpg. wt. 6 lbs............. 10.39
71 N 9374—4 ft. 46 branches. Shpg. wt. 4 lbs............. 4.98
71 N 9373—2½ ft. 31 branches. Shpg. wt. 2 lbs............. 3.27

Good. Like our fine trees, except less branches therefore less glitter.
71 N 9353C—7 feet.73 branches. Shpg. wt. 7 lbs.............$8.47
71 N 9352—5 feet. 52 branches. Shpg. wt. 4 lbs.............$5.59
71 N 9350—2½ ft. 22 branches. Shpg. wt. 1 lb 8 oz.......$2.27

Our best aluminum swirl tree has more fullness, greater sparkle

SEARS 75 YEARS · DIAMOND JUBILEE

Specially chosen as a Sears Jubilee Value

◆ **Because** it's swirled and tapered .. has *exceptionally long branches*, it costs *$4.08 less* than our best 7-foot tree last year .. we believe you won't find a better value on the market.

$28⁸⁹ 8-ft. size

7-foot, 201 branches. Like tree at right. $8.98 less than our best 7-foot tree last year.
71 N 9387L—Shipping weight 16 lbs......$23.99

8-foot, 233 branches. Even the trunk has 2 coats of aluminum paint for added luster.
71 N 9388L—Shipping weight 19 lbs......$28.89

Gleaming Solid Color Ornaments. Make your artificial tree even more handsome. Glass with metal caps. Order hangers on page 304. Box of 12 ornaments. *State color* blue or red.
49 N 6024—3¼-inch size. Shpg. wt. 1 lb. 3 oz......Box **$1.85**
49 N 6088—2½-inch size. Shpg. wt. 1 lb.............Box 1.15
49 N 6087—2¼-inch size. Shpg. wt. 10 oz.............Box 89c

[1] **Tree Mat.** For natural and artificial trees. Plastic, bright metallic finish. Silver color. 41 inches in diameter.
71 N 9759C—Wt. 1 lb. **$3.98**

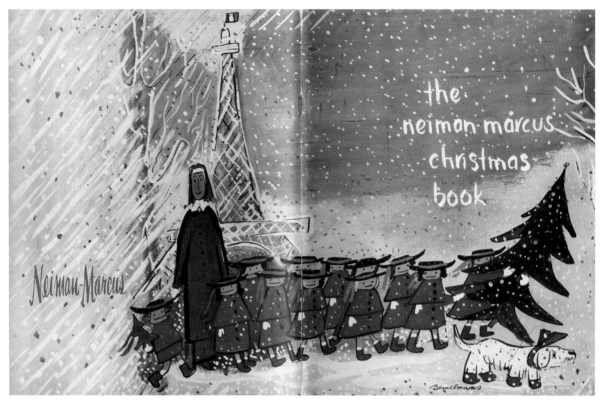

the
neiman-marcus
christmas
book

Neiman-Marcus

–10.10– 1955 cover by Ludwig Bemelmans

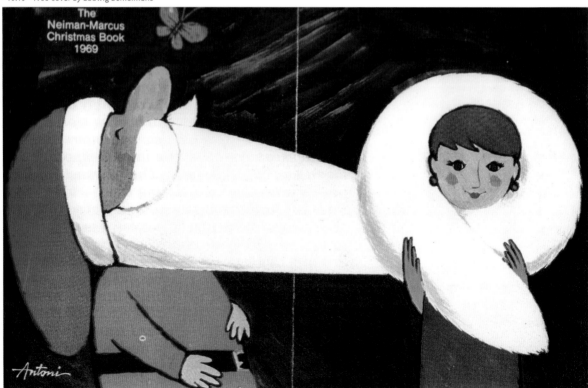

The
Neiman-Marcus
Christmas Book
1969

–10.11– 1969 by Antoni

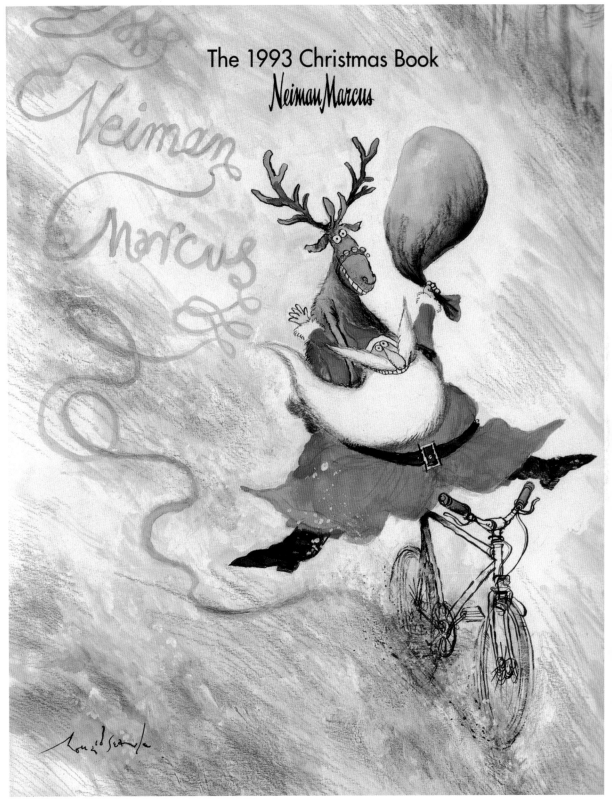

The 1993 Christmas Book
Neiman Marcus

−10.12− 1993 cover by Ronald Searle

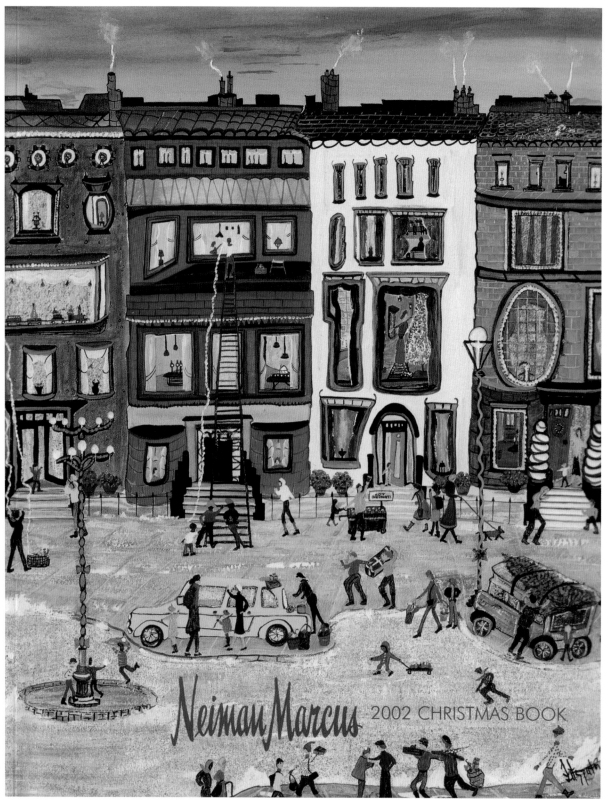

Neiman Marcus 2002 CHRISTMAS BOOK

SANTA SALT & PEPPER SET. Catalog <u>exclusive</u> set of four roly-poly shakers adds a lighthearted touch to your holidays. Imported of silver plate. Arrives in a gold crocodile-embossed NM® gift box.
142A Set of Four Salt & Pepper Shakers 40.00

NM® EXCLUSIVE PETIT FOURS. Three dozen artfully decorated bite-size treats, perfect for a holiday dessert buffet or hostess gift. 18 servings. Made in the USA. Arrives in a gold crocodile-embossed NM® gift box. Also available in Epicure.
142B 36 Petit Fours 30.00

NM® EXCLUSIVE DOG SWEATER. In ribbed Peruvian cotton with a fun row of pompons. From Woozie Wear. *Specify color:* Pink/Red or Blue/Green and specify size: 10", 12", 14", or 16". For size measure from neck to base of tail. Imported.
142E Dog Sweater 75.00

NM® EXCLUSIVE PACKAGE WINE STOPPER. A stellar hostess gift with silver-plated detail. 5.5"H. Arrives in a gold crocodile-embossed NM® gift box. Also available in Holiday Glories®.
142F Stopper 30.00

LYNN CHASE 2005 ORNAMENTS. Set of four hand-painted porcelain animals includes a zebra, 2"H x 3.25"W; monkey, 3"H x 2"W; lion, 2"H x 3"W; and hippo, 1.5"H x 3.25"W. Also available, but not shown, large zebra, 4.5"H x 3"W. Imported.
142C Four Ornaments 98.00
142D Large Zebra Ornament, not shown 50.00

Bibliography

Amory, Cleveland. Introduction to *The 1902 Edition of the Sears Roebuck Catalogue*, by Sears Roebuck and Co. New York: Crown Publishers, 1969.

Baker, Patricia. *Fashions of a Decade: The 1950's*. New York: Facts-on-File, 1991.

———,ed. *Everyday Fashions of the Twenties as Pictured in Sears and Other Catalogs*. Mineola, NY: Dover Publications, 1981.

Blum, Stella, ed. *Everyday Fashions of the Thirties as Pictured in Sears and Other Catalogs*. Mineola, NY: Dover Publications, 1986.

Boyett, Joseph H., and Jimmie T. Boyett. *The Guru Guide to Entrepreneurship*. Hoboken, NJ: John Wiley and Sons, 2000.

Casey, Constance. "Spade to Order: What to look for in Gardening Catalogs." *Slate*, February 5, 2007.

Cohn, David Lewis. *Good Old Days: A History of American Morals and Manners as Seen through the Sears, Roebuck Catalogs, 1905 to the Present*. New York: Simon and Schuster, 1940.

De Castelbajac, Kate, E. Nan Richardson, and Catherine Chermayeff. *The Face of the Century: 100 Years of Makeup and Style*. New York: Rizzoli, 1995.

Emmett, Boris. Introduction to *Montgomery Ward and Co., Catalogue and Buyers' Guide, No. 57, Spring and Summer, 1895*. Mineola, NY: Dover Publications, 1969.

Emmett, Boris, and John E. Jeuck, *Catalogues and Counters: A History of Sears Roebuck and Company*. Chicago: University of Chicago Press, 1950.

Ettinger, Roseann. *Fifties Forever! Popular Fashions for Men, Women, Boys & Girls*. Atglen, PA: Schiffer Publishing, 1998.

Ewing, Elizabeth. *History of Twentieth Century Fashion*. 1974. Edited by Alice Mackrell. Lanham, MD: Barnes & Noble Books, 1992.

Font, Lourdes M. "The Fashion Front." *CNN*, May 4, 2003. http://edition.cnn.com/SPECIALS/cold.war/experience/culture/fashion essay.

Gottwald, Laura, and Janusz Gottwald. *Fredericks of Hollywood, 1947–1973: 26 Years of Mail Order Seduction*. New York: Drake Publishers, 1973.

Grams, John, and Terry Thompson. *The Legendary Lionel Trains*. Waukesha, WI: Kalmbach Publishing, 2004.

Harrison, Charles. *A Life's Design: The Life and Work of Industrial Designer Charles Harrison*. Chicago: Ibis Design, 2005.

History.com. "The History of Toys and Games." The History Channel http://www.history.com/exhibits/toys/index.html

Heller, Steven, and Louise Fili. *Typology: Type Design from the Victorian Era to the Digital Age*. San Francisco: Chronicle Books, 1999.

Holcomb, Benjamin. World's Greatest Toys. http://www.worldsgreatesttoys.com.

Holland, Thomas W., ed. *Girls' Toys of the Fifties and Sixties: Memorable Catalog Pages from the Legendary Sears Christmas Wishbooks 1950–1969*. Calabasas, CA: Windmill Group, 1997.

———, ed. *Boys' Toys of the Fifties and Sixties: Memorable Catalog Pages from the Legendary Sears Christmas Wishbooks 1950–1969*. Calabasas, CA: Windmill Group, 1997.

———, ed. *Boys' Toys of the Seventies and Eighties: Toy Pages from the Legendary Sears Christmas Wishbooks 1970–1989*. Calabasas, CA: Windmill Group, 2001.

———, ed. *Girls' Toys of the Seventies and Eighties: Toy Pages from the Legendary Sears Christmas Wishbooks 1970–1989*. Calabasas, CA: Windmill Group, 2001.

———, ed. *More Boys' Toys of the Seventies and Eighties: Toy Pages from the Great Montgomery Ward Christmas Catalogs, 1970–1985*. Calabasas, CA: Windmill Group, 2001.

Horchow, Roger. *Elephants in your Mailbox: How I Learned the Secrets of Mail-Order Marketing Despite Having Made 25 Horrendous Mistakes*. New York: Times Books, 1982.

Hunter, Anita. "A New Look." *New Millennium*, May 1, 2003. http://www.garfnet.org.uk/new_mill/spring97/ah_dior.htm.

Ikuta, Yasutoshi, ed. *'50s American Magazine Ads. 2: Fashion Apparel*. Tokyo: Graphic-sha Publishing, 1987.

Israel, Fred L., ed. *1897 Sears, Roebuck Catalogue*. New York: Chelsea House Publishers, 1968.

Katz, Donald R. *The Big Store*. New York: Viking Penguin, 1987.

Kennett, Frances. *The Collector's Book of Fashion*. New York: Crown Publishers, 1983.

Liggett, Lori. "The American 1890's: A Chronology." In *American Culture Studies*. Bowling Green, OH: Bowling Green State University, 1997.

Marcus, Stanley. *His & Hers: The Fantasy World of the Neiman-Marcus Catalogue*. New York: Viking, 1982.

Melinkoff, Ellen. *What We Wore: An Offbeat Social History of Women's Clothing, 1950 to 1980*. New York: William Morrow and Co., 1984.

Olian, Joanne. *Children's Fashions, 1900–1950, As Pictured in Sears Catalogs*. Mineola, NY: Dover Publications, 2003.

———. *Everyday Fashions, 1909–1920, As Pictured in Sears Catalogs*. Mineola, NY: Dover Publications, 1995.

———. *Everyday Fashions of the Forties, As Pictured in Sears Catalogs*. Mineola, NY: Dover Publications, 1992.

———. *Everyday Fashions of the Fifties, As Pictured in Sears Catalogs*. Mineola, NY: Dover Publications, 2002.

———. *Everyday Fashions of the Sixties, As Pictured in Sears Catalogs*. Mineola, NY: Dover Publications, 1998.

Peacock, John. *Fashion Sourcebooks: The 1930's*. London: Thames & Hudson, 1997.

———. *Fashion Sourcebooks: The 1950's*. London: Thames & Hudson, 1997.

———. *Fashion Sourcebooks: The 1960's*. London: Thames & Hudson, 1998.

———. *Fashion Sourcebooks: The 1970's*. London: Thames & Hudson, 1997.

———. *Fashion Sourcebooks: The 1980's*. London: Thames & Hudson, 1998.

Rubinstein, Ruth P. *Dress Codes: Meanings and Messages in American Culture*. Boulder, CO: Westview Press, 1995.

Schroeder, Fred E., ed. *Sears, Roebuck and Co. 1908 Catalogue No. 117: The Great Price Maker*. Gun Digest Company: 1969.

Scranton, Phillip. *Beauty and Business: Commerce, Gender and Culture in Modern America*. New York: Routledge, 2000.

Shih, Joy. *Fashionable Clothing from the Sears Catalogs: Late 1950's*. Atglen, PA: Schiffer Publishing, 1997.

———. *Fashionable Clothing from the Sears Catalogs: Mid 1960's*. Atglen, PA: Schiffer Publishing, 1997.

———. *Fashionable Clothing from the Sears Catalogs: Late 1960's*. Atglen, PA: Schiffer Publishing Ltd., 1997.

———. *Fashionable Clothing from the Sears Catalogs: Mid 1970's*. Atglen, PA: Schiffer Publishing, 1999.

Skinner, Tina. *Fashionable Clothing from the Sears Catalogs: Early 1930's*. Atglen, PA: Schiffer Publishing, 2007.

———. *Fashionable Clothing from the Sears Catalogs: Mid 1940's*. Atglen, PA: Schiffer Publishing, 2003.

———. *Fashionable Clothing from the Sears Catalogs: Mid 1950's*. Atglen, PA: Schiffer Publishing, 2002.

———. *Fashionable Clothing from the Sears Catalogs: Early 1960's*. Atglen, PA: Schiffer Publishing, 2001.

———. *Fashionable Clothing from the Sears Catalogs: Mid 1970's*. Atglen, PA: Schiffer Publishing, 1999.

———. *Fashionable Clothing from the Sears Catalogs: Late 1970's*. Atglen, PA: Schiffer Publishing, 1998.

———. *Fashionable Clothing from the Sears Catalogs: Early 1980's*. Atglen, PA: Schiffer Publishing, 1999.

———, and Lindy McCord. *Fashionable Clothing from the Sears Catalogs: Late 1940's*. Atglen, PA: Schiffer Publishing, 2004.

———, and Jenna Palecko. *Fashionable Clothing from the Sears Catalogs: Early 1940's*. Atglen, PA: Schiffer Publishing, 2003.

———, and Tammy Ward. *Fashionable Clothing from the Sears Catalogs: Late 1930's*. Atglen, PA: Schiffer Publishing, 2006.

Smith, Desire. *Fashionable Clothing from the Sears Catalogs: Early 1950's*. Atglen, PA: Schiffer Publishing, 1997.

Thomas, Pauline Weston. *www.fashion-era.com*

Thornton, Rosemary. *The Houses that Sears Built: Everything You Ever Wanted to Know about Sears Catalog Homes*. Alton, IL: Gentle Beam Publications, 2002.

Walsh, Tim. *Timeless Toys: Classic Toys and the Toymakers Who Created Them*. Riverside, NJ: Andrews McMeel Publishing, 2005.

Weil, Gordon L. *Sears, Roebuck, U.S.A.: The Great American Catalog Store and How It Grew*. New York: Stein and Day, 1977.